D0716749

I would like to deeply thank my friends and collaborators for their invaluable support and for always being there for me: my translator, Eleni A. Stasinou, and my translation editor, Christopher James Hewitt.

Sundy Kyriaki Iliadou

A RAINBOW
IN THE DARK

AUSTIN MACAULEY
PUBLISHERS LTD.

A CIP catalogue record for this title is available from the British Library.

ISBN 9781786293350 (Paperback)
ISBN 9781786293367 (Hardback)
ISBN 9781786293374 (eBook)

www.austinmacauley.com

First Published (2017)
Austin Macauley Publishers Ltd.
25 Canada Square
Canary Wharf
London
E14 5LB

To my loved ones.

Introduction

'Once upon a time there was...'

These are the words with which fairy tales began when we were children and, almost always, they resulted in a beautiful and happy ending.

In life, of course, and in everyone's course within it, tales unfold with a happy ending, tales conclude with a bad ending, and many times there are tales that are inexplicable: the latter are the ones that come to an end creating many questions, and most of the time we are unable to decide where to put the full stop.

All this may occur simultaneously and in parallel to our lives. Some tales should make life easier and joyful, others should make it difficult and painful, and others should confuse our discretion in such a way that it results in a multitude of errors.

From all this, of course, a painting is created and an artist within each and every one of us; a painting with rich and perhaps controversial topics on which the final touch determines its definition; the title by which the artist signs.

When young Sophia was born, she was given an almost pure white canvas to paint. On it, fate had faintly etched some basic lines, which she had to tone, to change if she could, to paint with natural dyes, such as blood, tears, hope, joy, and pain.

The title for this painting and the review will be given by each and every one of us, depending on how we perceive it,

how we can feel it in our heart, and how we will understand it within our mind.

We shall find items that decorate our own life-painting. Maybe we will empathise with her; we might be happy for her; we might wonder; we might compare.

Each one of us will make our own translation using our own individual dictionary and our own outlook on life, reconstructing thereby a new story.

CONTENTS

SOPHIA

MICHAEL

AMERICA

APOCALYPSE

SOPHIA

CHAPTER 1
'A Painful Journey'

Sat on a large, white, wooden chest, which was well fixed on the ship's deck, she was holding her mother's hand tightly.

On that tiny face, you could detect sadness and anger. She could see the shoreline drawing away as if on a set of wheels, like the ones she had on her childhood cart when she used to roll it down the huge hill playing with her friends. A torrent of sweet childhood memories, which emerged as if it were yesterday, made her tiny, brown-haired head hurt as they rushed into it.

Sweet moments, innocent moments, sprinkled with Grandma's icing sugar, had a scent of cinnamon that flooded into her mouth as she tried to fit a large handmade candy into it. Every now and then she would place it on her palm, stroke its vibrant pinkish colour and dip it back into her mouth with pleasure.

Two clear, small drops appeared on the threshold of her green eyes, but they suddenly flew away among the disorderly hovering of white seagulls. Like formidable fishermen, they would dunk impetuously into the froth of the waves formed by the ship in its course.

For a moment, she forgot all about the sadness she was feeling, caused by the separation from all the sweet and tender moments she had had the chance to experience in her first childhood years.

She observed the birds that dropped impetuously into the water, fishing for their meal, and she would squeal ecstatically, clapping her hands with every dive they took.

It was from that moment on that her strength of will started to show. She could feel it inside her overflowing like a river, reaching with force up to her dark red lips at the exact moment she would see the seagulls rising triumphantly back up from the waves, holding their prey in their beaks.

Leda's heart, her mother's heart, was thrilled with her daughter's happiness. In the past few days, she had really had to fight to explain the rush for this journey. Her child's mind had immense difficulty understanding this sudden change in her life. It was impossible for her to understand, despite Leda's explanations, why she was not present at her school's last celebration with all her classmates.

Not to mention that there was no way she could talk to her about the bitter truth that had suddenly turned their lives upside down, but Sophia's reaction was really intense. It really affected Leda not seeing her wearing that beautiful vibrant smile on her face, not having that spark in her green eyes.

And her pain would duplicate; it became unbearable.

Orestes, Sophia's father, stood straight, right next to them. He stared at the two women in his life and clenched his teeth. He had to withstand, to hold out: he was their protector.

The shoreline had long disappeared from their view.

A few grey clouds had started to gather in the sky, as if wishing to travel with them. A strong wind stormed in from the horizon with aggressive intentions.

'Come Sophia darling, we need to go inside,' he told her and pulled her gently by the hand.

All three of them entered the ship's lounge. A few passengers were sitting comfortably on the small blue sofas, examining closely those that entered for the first time.

They picked a sofa to sit on. 'Let's sit by the window so that Sophia can stare at the sea,' Leda said to Orestes.

Her eyes were filled with very much love for both of them.

She knew deep inside her, she could feel it, that her life's thread was being cut short. She had no idea where the ending was, but the thread had shortened dangerously. She did still have some hope, though, that she could possibly tie at the end of it a new thread from a healthy, neatly wound skein, but would the knot withstand the weight of all the existing problems? That ate away her soul, and not just Leda's soul, but that of Orestes too, who felt helpless, unable to do anything to help her.

It was only six months ago that Leda was making dreams for their life and had decided, with Orestes, to give Sophia a little brother or sister. And exactly there, within paradise's serenity, a huge, ugly thorn started growing. Any way they tried to uproot it, it would prick their fingers. The initial examinations already showed its flesh-eating intentions. Every day it would dig its roots deeper and deeper. 'Malignant tumour' was the diagnosis from the biopsy.

With sharp tools and a fighting spirit they dived, face first, to eradicate it from their lives. They fought with immense pain and toil, and believed that they could make it, that they would never again see its horrible dirty flowers with the ominous ability to destroy anything beautiful that had tried to bloom right next to them.

The process of uprooting was a painful disaster, but they never gave up, and a new battle for recreation began.

New flowers were planted in the place of the old ones. They were taken care of, they were watered with a lot of love, and Leda and Orestes waited impatiently for them to bloom, to spread their sweet fragrance, to make their life prettier.

Day by day they grew. Leda and Orestes were proud of their hopes that grew taller and started growing leaves.

Nothing was now reminiscent of the old ugly setting. Everything was covered by their desire to live.

They waited for two full months in anguish of that morning when they would cut off the first flowers of their efforts, filled with joy.

But something was not right. The flowers were there, beautiful, ready to be placed into the basket of hope. But when they approached they were faced with a horror that made them take a step back.

A strong, disgusting and familiar stench was spreading around the beauty that was fighting to balance on a stretched rope.

They searched desperately with their eyes, their hands, their feet, to find the evil that had restarted its destructive deed.

Nothing was left standing alive. All the beauty was trampled, destroyed. It had fallen victim of a desperate search. And there, right in the middle of nowhere, under a few green leaves that were still standing, the sneaky destruction was reborn to finish off its diabolical deed.

A new war, a chemical one this time, was the doctors' proposal. It was their last hope.

With that hope, they marched now, all three of them, sat in the lounge of the ship that was sailing towards Thessaloniki[1].

They were tied up with the ropes of Destiny that ran ahead, dragging them heartlessly behind her over rough roads, hurting them deeply on their bodies and in their souls.

Sophia Galanou's family was not a rich family. Her father, Orestes Galanos, was employed by a private company in Chora, on the beautiful island of Patmos[2].

Her mother, Leda, had a small seasonal shop in Chora with items of folk art that were mainly designed for tourists.

Their everyday life was calm and carefree. That was the life that Sophia did not want taken away from her; she did not want to be robbed of the sweet mornings with Grandma Sophia, Leda's mother, who was very fond of her and spoiled her... She

[1] **Thessaloniki**, also known in English as Thessalonica, Salonika or Salonica, is the second-largest city in Greece and the capital of Greek Macedonia, the administrative region of Central Macedonia and the Decentralised Administration of Macedonia and Thrace.

[2] **Patmos** is a small Greek island in the Aegean Sea; one of the northernmost islands of the Dodecanese complex.

was the only grandchild, and Grandma fulfilled all her wishes. She made her sit on the 'throne' of the 'blue paradise'. That is what Grandma Sophia called her back garden, which was filled with colourful geraniums and fluffy basil trees; with concrete mantels and the 'throne' where young Sophia used to sit gazing over to the sea and the ships that sailed in and out of Scala's pier. Grandma also told her stories that were real or fake: it did not matter to her. For Sophia, they were all fairy tales that made her travel far away.

It was just that her first real journey was a bad fairy tale and with a much more bitter truth.

Their relentless fight all these months, with the endless hospital visits, led their financial situation to a tragic point. Their tiny savings grew wings very quickly. And now their last hope was this trip to Thessaloniki and Leda's emergency admission to a specialised hospital for which they had the best references; hanging off this last hope was also a very painful decision to sell their small house in Chora.

Leda was against it initially. That house was Sophia's inheritance. They had worked so hard to acquire it, but Orestes was uncompromising with his decision.

A horrible air was created in an already tense atmosphere. A prompt solution was given by Grandma Sophia.

Seeing her daughter in this horrible predicament, that no mother would want to find herself in, she found a way to calm Leda down by leaving her own house as an inheritance to young Sophia.

Grandma Sophia never allowed her tragedy to unfold in front of her daughter's eyes. She always comforted her and gave her hope. Only when she was left alone would she soak her headscarf in tears and pray to God.

The house sold really quickly as time was pressuring them immensely. The result was for a great part of the house's real value to be lost, but nothing compared to the value of life.

For the final days before their departure to the north, they had no choice but to stay at Grandma's. A lot of their things

were sold, but most were stuffed and crammed into Grandma's house. Young Sophia was cheering with joy because they were going to stay at the 'blue paradise'. She could not have imagined that those would be her final days on the island where she was born and bred.

It was only on the last day, when they started gathering their things into suitcases, that she realised that her mother's words, which she had refused to accept deep inside her, came true.

Leda, of course, never told her the whole truth about the severity of the situation. She wanted to exhaust every possible ray of hope that existed. So she confined to a few words: that she had to undergo a therapy for some time and that, after that, they would come back.

Sophia, with her green eyes and an examining look, was trying to see through her mother's words, but Leda was hiding her painful secret very well, for her daughter's sake, exactly the same way her mother in her way, of course, was hiding the immense pain that was eating her inside.

CHAPTER 2
'Stolen Moments of Happiness'

Sophia put her elbows on the round plastic table and buried her chin in her palms. Leda was looking at her with interest while she was trying to create her own observatory in front of the large ship lounge window.

Outside, the weather was getting wild. Thick drops of rain began to pound on the glass window. The sea had turned into a dark pencil colour, and the foaming waves painted a dull canvas with white touches. A grey curtain of rain spread from one side of the window to the other. Small rivers started flowing on the outside of the glass window, which lost its clarity and started looking like viscous gelatine. Like a cat that gets stimulated when watching a mouse passing in front of her, Sophia stood up happily from her observatory and approached the window, pulling aside the light blue and yellow curtain that seemed to bother her. She had finally found a game to defuse her bloated childish energy. With her eyes fixed on the creeks that flowed endlessly like tiny snakes, she walked by the table, carelessly giving it a nudge. Leda hastily stretched out her hand to protect a can of juice that was about to dive onto the blue carpet of the ship's lounge.

'Watch out darling, nothing is going away, do not rush...' she remarked sweetly.

Sophia did not even hear her what she said as she had already reached the window. She stretched the index finger of her right hand and, following the water sliding down, she

pretended to draw while she played with inexhaustible imagination.

Orestes placed his hands on Leda's shoulders and embraced her tenderly.

'Did you give Maria a call?' he asked.

'Yes, I called her and she is waiting for us. My cousin Maria is such a gem, but that woman has been so unlucky in her life. As much as she loved children, she was never able to have a family. Now she lives alone and her only companion is Lucy, her little dog... Lucy is her only company.'

'Everyone has his mishaps, Leda dear,' he said while sighing, bearing in mind their own wounds.

Sophia came back to them grouching, protesting that her game had to come to an end. The rain had stopped abruptly, and the small rivers dried up like water evaporating on those hot summer days.

She sat in her spot reluctantly, exploring around for something worthy of her attention. At the end of her exploration, her attention was drawn to a boy, about the same age as her, who was sitting with his parents at the next table. She stood up impatiently and started searching in Leda's handbag for her electronic game, huffing, puffing, and muttering.

'Don't search in vain, it is in the suitcase that we left in the berth,' Leda explained, cutting off her rush.

Sophia crooked her face, but decided to attack without any ammunition. She got up and approached the table right next to them. Her eyes quickly became glued on a board game that was left on the couch, next to the youngest boy of the family.

She had figured out a point of contact. A smile filled with confidence appeared on her lips as she leaned over, offering to play a few rounds with him.

The hours went by relatively quietly, except for some cries of victory every now and then from the battlefield of the board game.

Orestes and Leda were so engrossed in their conversation and did not realise that dinner time had approached. Sophia, however, although exhausted by countless game rounds, reminded them openly, feeling cheerful about her score.

The restaurant in the ship was full when they got there. They contemplated coming back later, but with some good luck, a table at the back of the dining room had just emptied.

While Leda and Sophia sat at the table, Orestes headed to look at the trays of cooked food, arrayed one next to the other along the buffet.

The elders' preference was something light for dinner, but not Sophia, who placed in front of her a plate of spaghetti with red sauce and lots of cheese, and then began to move it into her stomach. The new apartment, however, proved much smaller than what her gluttony had made her believe. She ate enough, but left most of it there and decorated the white plate, making pink nests.

When they finished their meal and got up, ready to leave, young Sophia rushed into the ship's lounge, having other things on her mind… But Orestes cut her run short, grabbing her by the arm and saying to her:

'Mommy is quite tired for us to sit in the lounge any longer. I think you too must be tired, my little one,' and he looked at her, smiling. 'We had better go to our cabin,' he insisted politely.

Her eyes turned to her mother, and with the manners of an obedient puppy, she grabbed her mother's hand.

Leda's troubled health did not allow her much sturdiness.

The sweet lullaby from the restless rumbling engines of the ship quickly plunged all of them into a life-reviving sleep.

Several hours later, the deep sound of the ship's horn ceased the engines' rhythmic work, as well as, what turned out to be, Orestes' restless sleep.

He pulled aside the small valance slightly to see outside. The drops of the sea on the outer side of the window did not allow him to see clearly. It was barely the crack of dawn, and darkness and a few lights far away on the shoreline were all he

could see. The sound he heard, however, was not something created by his imagination. It was their first notification that the ship was approaching the port. He touched Leda gently on the back.

'Leda, I think we are almost there,' he whispered.

She opened her eyes slightly. The sweet light of the lamp on the bedside table created a peaceful atmosphere.

'If I could, I would not get up all morning,' she said to him, visibly rested, as she stretched out her hands towards the partitions of the cabin.

He sat beside her on the bunk and embraced her tenderly.

'I know, sweetheart, you still have some time to rest... enjoy it...' he said quietly.

He did not want to wake up Sophia yet. Her vitality was explosive, and most of the time Leda needed calm as much as possible.

The second roar of the great beast that was carrying them in her belly forced them to give it proper attention.

'Girls, enough with the snoozing,' Orestes said in a supposedly strict manner to the mother and daughter, who were giving hugs and kisses to each other on Leda's bed.

He rejoiced every time he saw them embracing. He feared so much the moment they would be forced to part from one another. It drove him crazy when he had that thought, because Orestes did think of that too: be prepared for the worst possible outcome. Doctors were sparing with their forecasts. They did not discuss it much with his wife, but they both knew deep inside them; they could see it in each other's eyes.

CHAPTER 3
'A Young Rascal'

The day had now revealed itself, tossing from her back the black veils of the night. The city put on its best sunshine to welcome them.

The third notice of arrival by the ship found them ready on the deck. They left their suitcases beside them and leaned on the railing. Their gaze slid over the beautiful buildings of the seaside avenue. It ascended far away along the beautiful castles of the old city up to the green forest of Seich Sou[3].

In the centre of the seaside avenue, the White Tower[4], a sleepless guard of the city, welcomed every ship and all the visitors coming into the harbour.

The rhythmic beating of the ship's engines, which had accompanied them throughout their journey, ceased as the large bulk came to a halt. A loud noise was broadcasted throughout the ship, causing it to shake as if an earthquake was breaking out.

This only lasted a few minutes until the captain managed to impose his control and turn the ship around towards the pier of the port. Another loud metallic clatter gave them a final earthquake scare while the hatch was lowered onto the cement,

[3] **Mount Chortiatis**, or **Hortiatis**, known in Antiquity as Cissus or Kissos, is a mountain in Central Macedonia, Greece. The mountain's landscape is wooded, with part of these woods making up Thessaloniki's **Seich Sou** Forest National Park.

[4] The **White Tower** of Thessaloniki is a monument and museum on the waterfront of the city of Thessaloniki.

and then everything calmed down. Now, only a quiet sound made the ship's presence felt, like the beats of a heart that is resting after a hard and tiring day.

Men, women, children, baggage, cars with their engines on, waited patiently for the signal to disembark.

Leda put a cardigan on Sophia, who had just woken up. The morning humidity of the sea was piercing their skin like tiny needles. Orestes walked out first, dragging behind him two large suitcases. Leda followed right after him, holding the smaller sized bags, and then Sophia with a travel bag worn sideways on her chest.

Leda was almost dragging her by the hand. She was walking mechanically, while her bag was dangling, beating on her knees with every step and jerking powerfully in front of her. A sense of sweet sleep could be discerned under her half-closed eyelids.

They went along with the rest of the crowd, which came out of the ship like a colourful wave from a strange source.

When they stood in front of the big iron gate of the passenger terminal, the city had already woken up; it was forcibly entering its everyday noisy rhythm.

At the green traffic lights, the cars revved up, obeying their drivers' madness. Pedestrians would run through the crossings, chased by their own selves.

The three of them stopped on the sidewalk, trying to acclimatise to the vibrations that were overcoming their nerve cells.

With all the fuss, Sophia finally woke up and cried aloud to her mother, while pulling down on her hand.

'Mommy, I'm hungry…'

The time of arrival at the port coincided with the time that they would normally be offered breakfast in the ship's restaurant. In the past few days, she had only felt that particular physical need.

Leda turned to Orestes and asked him:

'Could we get something for breakfast? A coffee for us …'

Orestes looked around. He could not find anything that was suitable.

'Let's cross to the other side of the road and check around the corner…' he told Leda, but was a bit hesitant.

'We also have all the suitcases in hand! I hope we find something close because moving around is difficult.'

When the traffic-light turned red for the cars, they rushed across the pedestrian crossing with the suitcases behind them bouncing around. They had barely made it onto the sidewalk when the parade of cars poured out behind them.

'Wait. Let me have a look, so that we don't all have to run around pointlessly!' Orestes said while leaving their suitcases beside Leda.

He walked away a short distance and then took a turn around the corner.

Sophia sat on a suitcase, looking eagerly towards the spot where she lost sight of her father.

But her concentration on him reappearing vanished quickly as she was drawn to a small visitor who stood beside and looked at her.

'Mom, look at it! It wants to eat!' she told Leda, pointing at the small, black and white dog with her hand.

'I think you are judging by your own hunger, my darling Sophia! But…' she stopped and looked at it, 'it might be hungry…' she said while watching the little rascal licking itself and wagging its tail.

'There! Dad is coming! Let's see if he found something!' Leda said.

'I found a small shop with traditional bougatsa[5] that has a few tables outside… Let's go! We will feed our girl well!' he said, and looked at Sophia, smiling widely.

[5] **Bougatsa** is a Greek breakfast pastry containing either semolina custard – the most common filling – cheese, or minced meat filling between layers of phyllo. It is said to originate in Serres, in the Macedonia region of northern Greece, and is especially popular in the northern Greek port of Thessaloniki.

The three of them, with a canine tail following, walked the few metres' distance that, fortunately, was all that was required. They sat at a table. As they waited for their order, Sophia paid attention to the young rascal who sniffed the food and made all the necessary diplomatic moves.

His earnings were a few pieces off Sophia's plate that landed in front of him and which he ate with immense pleasure.

'Sophia enough!' Orestes scolded.

'Finish up with your food, we have to go, your aunt will be waiting for us.'

She smiled at him diplomatically, throwing another piece of food onto the ground as secretly as she could.

She drank the last sip of her milk through a pink straw, and they got up.

They had to go back to the main road if they wanted to find a taxi, Orestes informed Leda while grabbing their suitcases by the handles.

Dragging them like a peddler, or even better a porter, they arrived at the point where they had been before.

They stood on the sidewalk and waited.

Soon after, a white and blue car with the distinctive sign on its roof stopped in front of them.

Orestes sat in the front, while Leda and Sophia settled in the back seats of the royal lounge of the spacious car.

The driver, a burly, dark-haired man, lifted their suitcases like feathers and placed them in the boot. He gently closed the boot of the car and sat comfortably in the driver's seat.

Their destination: a suburb in the industrial area of Thessaloniki, on the west side of town, very close to the first toll stop to Athens, and almost right by the international road.

The taxi took off slowly, making a circle around a green park at Liberty Square, where, at that moment, cars were queuing up to park, and then took the exit to the main avenue heading towards the west side of the city.

All three lanes were full of cars carrying people to the factories. The area was filled with traffic.

Somewhere near the vegetable market, they went past a long blue bus that was almost empty. A few months later, that same bus would be packed full of students from the University of Sindos.

At the motorway exit to Sindos[6] and a narrowing of the road, a long queue of trucks on their way to unload at the industrial area riveted them: thank God it was only for a while. Further down, the road was free of traffic, to the satisfaction of all.

They passed in front of the closed gate of the school, the centre for drug rehabilitation 'ITHACA', and then continued on a long, straight road. At the end, they followed a narrow path that led them to the main square.

A group of children playing in the courtyard of a school that had closed for the summer holidays caught Sophia's eye. She looked at them in a way that betrayed her longing to be amongst them.

Little did she know how quickly and painfully what she craved for would become a reality.

They went along the main road slowly. The shops on the right and left had opened their doors for some time to welcome their customers. The morning dew forced several people to the market for their daily shopping.

Leda glanced subtly at a big wooden sign above the entrance of a shop on the left of the road.

'POEMS made from BREAD' it read, and a doubtful smile planted on her lips, mixed with a sense of homesickness.

'Around this time, I'd usually be at Mrs Stavroula's bakery choosing a musky loaf of bread for my little Sophia,' she thought; it was almost like a mere mention without any other taste in her soul, without a single trace of warmth: colourless images, life performances racing.

[6] **Sindos** is a suburb of Thessaloniki, Greece. It is home to the Alexander Technological Educational Institute of Thessaloniki and the city's Industrial Zone.

For her it was like running in reverse, one step forward and two backwards: that is how it felt and it tortured her mind.

At the point where the main road ended, a clump of tall ancient pine trees harboured in their hearts the beautiful building of the railway station.

A charming coexistence of centuries unfolded in front of them: a modern building surrounded by elderly guards.

They went past it on their right, and on the next right turn, a white and red bar came down, halting them urgently.

Sophia pointed emphatically at the guard at the crossing, who was waving the 'STOP' sign from an elevated post.

Always fascinated by trains, it was something that she was not allowed to see from up close. Every time she happened to see a train on TV, she would stand in front of the screen and observe carefully.

It was unexpected for her. She eagerly sat between the two front seats and would not let anything go unchecked from her supervision. Impatiently, she moved her body up and down in her seat waiting for the train to pass, looking once on one and once on the other side. The driver turned his head and gave her an annoyed look.

She did try to gather herself a bit, by not performing the seesaw, but she did not stop looking around with her voracious gaze.

She saw the train passing in front of her with its red engine sparkling. It made a loud roar and she could feel the jolt from it rolling on the iron rails to the depths of her soul.

A sensual smile shone on her face. When the last wagon disappeared from her sight in the distance, she sat back comfortably in her seat, as if she had experienced the biggest sugar rush that her system could withstand.

The prohibitive bar rose and the driver started the car. It jumped several times passing over the humps that the weight of the trains had created: little bumps lifting the asphalt up. After the last landing, the driver indicated and turned right into a small road parallel to the train tracks.

CHAPTER 4
'Maria's Donuts'

Maria washed the very last spoon and let it drain along with the other dishes. She glanced out to the garden from the kitchen window.

Lucy, her small beloved poodle, was playing happily, chasing a yellow butterfly in the garden.

She took a napkin from the tray, opened it up and covered the hill of donuts that she had just taken out of the pan.

The one and only time she visited her cousin on the island – Sophia was maybe seven or eight years old at the time – she went crazy for the donuts she had prepared for her.

Therefore, she thought that today they would be the sweetest treat that she could offer as a welcome.

She looked at the clock on the wall of the living room, restlessly.

It was one of her favourite objects: the finest, an heirloom from her mother. There were many times when she would sit comfortably in her chair and admire the embossed patterns on the copper façade, the subtle indicators that were white so they could be seen clearly in their every movement. But today every movement of the minute hand had acquired a strange noise, like someone was beating a hammer on a table, and the sound would reach her heart, causing it to flicker.

Maria loved her cousin. When Leda called and told her about her problem, Maria did not sleep all night. Her mind could not digest that information. She was talking to herself, addressing God: 'Let me go! I am a lonely stump down here...

Why Leda, who has a family? ... Who has a gorgeous girl to raise? ...' and she would burst into tears. All that and more so: 'Why? ...' Maria kept asking Him again and again, with much bitterness.

For many years, ever since her mother – Leda's mother's sister – had died, Maria lived alone. Her only company and companion was Lucy, a white curly-haired poodle that was, literally, her family. She had one more cousin who lived in Ioannina[7], from her father's side of the family. She did not have much contact with the rest of her relatives.

Her home was a low, scenic house, next to the station, that was drowning in flowers. Her great love was her garden. Most hours of the day she spent with her plants, and she treated them like her own children. She was unfortunate not to have a family or her own children, and that was one of the reasons she loved her niece so much. With this longing, she considered Sophia as her own daughter.

A bouquet of freshly cut, red morning roses flooded the open-hearted living room with their beauty and fragrance, arranged with care in a crystal vase. She leaned over and enjoyed their fragrance. Everything was perfect; nevertheless, she kept twirling into the house, tidying up what was already tidy!

[7] **Ioannina**, often called Yannena, is the capital and largest city of Epirus, an administrative region in north-western Greece.

CHAPTER 5
'A Gentle Soul'

The taxi went to the very end of the street, passing by the first houses. Observing ahead, Leda recognised on the left of the road the familiar iron gate of the courtyard.

'On the left, in front of the "purple mountain",' she said to the driver, showing him an enormous flowered wisteria with purple bunches that were hanging all the way to the ground. It had climbed all around the fence, even on the arch above the door of the court, hardly leaving a free passage to the garden.

The car cut its speed and stopped. Orestes emerged first, then the driver; Leda followed, and finally Sophia. An exquisite aroma engulfed their brain cells, forcing them into profound involuntary inhalation.

'I feel like we are in paradise,' the driver, with the appearance of a builder – due to his well-shaped body – and with the heart of a poet, said. He smelled the purple flowers with their characteristic shape – like a dog's mouth – and he reached to cut one from the endless torrent. There were only flowers, not a trace of a green leaf or even a stump anywhere; it seemed as if it was floating from the sky.

He put it on the black leather surface of the dashboard above the steering wheel, and went back to the boot to unload the suitcases. He placed them down on the ground in front of the gate of the 'green paradise'.

From the moment the guests descended from the car, a bark of warning indicated the presence of the loud guard of the house. Sophia approached the steel door cautiously, waiting for

a wild presence that would mirror the voice heard. Instead, she saw a white-haired, little ball that wagged its tail, showing its good disposition, but also held some formality by being a bit rough.

Hearing Lucy, Maria was alerted to their arrival.

'Finally,' she whispered, and, taking a deep breath, she ran to welcome them.

'Auntie, Auntie, we are here!' Sophia cried when she saw her coming towards them.

Maria opened the door and her arms.

'Hello, my green-eyed princess,' she said with immense love, and put her arms around her, letting Lucy jump around them expressing, in her own way, the joy perceived by the cordial reception of her owner.

Maria released Sophia from her arms and turned to Leda. She spread her hands over her shoulders, looked at the green water in her eyes – Sophia had taken all of Leda's features apart from the colour of her hair, that deep brown colour she had taken from Orestes – distinguishing in their depth a trembling fear obscuring their clarity.

She pulled her to her chest, wanting to share her intimate pain that reached her heart through Leda's crying eyes.

'Sweetheart…' she whispered with her heart.

Orestes paid the taxi driver and stood now beside the suitcases he had been dragging.

'Welcome! Finally! I was starting to worry!' Maria said, looking at him and hugging him.

'Did you have a good trip?' she asked.

'Very good, I would say. We almost had perfect weather, apart from a small summer storm… everything was great,' he replied.

All together, apart from Lucy who led, bouncing around, they walked along the narrow concrete corridor across a colourful, vibrant, fragrant carpet and entered the living room through the main entrance of the house.

Orestes, loaded with the suitcases, followed Maria deep into the corridor. She opened the door to a spacious room. She

approached the window and pulled open the flowery curtain. A cool wind came rushing in, winnowing anything that was before it.

'I think you'll be comfortable here,' she said pulling a small table in front of the double bed. She stood motionless, putting her hands on her waist, and looked around. 'Everything is in place,' she said to herself, seeing the fluffy white towels that she had placed neatly on the dressing table the day before.

Orestes put the big suitcase on the small table and the smaller case belonging to Sophia on the side.

'I would recommend… Sophia stays with me…' she said, looking at him, but she meant much more than that, and she was sure that he would understand.

'So that you get to be more comfortable,' she said, and she waited for his answer.

'If Sophia agrees, I have no objection… let's discuss it with Leda too,' he said, and they headed back to the living room.

Leda was sitting comfortably on the double sofa, resting her feet on a stool.

Sophia was nowhere to be seen, possibly in the kitchen with Lucy, when she heard Orestes calling her.

She appeared in the living room all flustered, followed by Lucy who had gone crazy playing with her.

She barely heard Orestes' question, and blurted an 'okay' then disappeared again, with a white tail following her.

With pleasure on her face, Leda turned to Orestes.

'I am glad our little one has found some company. She has been rather moody lately.' She then turned to her cousin.

'Cousin, would it be much trouble for you to look after her for a few days?' she begged.

'Are you even asking me, Leda? It's my pleasure… You know that I consider her as my child. I do not want you to worry at all. You do what you need to do for your health and we … will be fine with Sophia … don't worry.'

'We do not know exactly how long we need, Maria,' Orestes added reluctantly.

'Tomorrow we will start a new drug and we hope to have good results.'

Melancholy tried to sneak out, but Maria slammed the door in its face.

Realising it was an awkward moment, she stood up and changed the subject successfully.

'I'm going to fetch the donuts I have prepared for you, especially for Sophia! And some chilled sour cherry juice that I know you like very much,' she said turning to Leda with a grin.

Entering the kitchen, she saw Sophia playing with Lucy, holding in her hands a red ball, the toy of the mischievous dog.

'Sophia, go wash your hands and come and eat! Your favourites! Is that not what you said when we were on the island?' she asked, and took a plate from the cupboard. She filled it with golden balls, adorned them with lots of honey under her greedy gaze, and then placed it in front of her with an air of formality.

'My Auntie, thank you very, very much!' she said politely, putting a donut in her mouth sensually.

'Can I give Lucy one?' she asked, seeing the little beggar lying next to her, looking into her eyes.

'Very little and with no honey. You should know that dogs should not eat sweets because they can go blind,' she explained like an expert.

She left her in her enjoyment and went to the kitchen counter to prepare the cherry juices.

Maria shook the last petals off the rose's stems, pruned them, and carefully put them in the big green bag with the dried leaves. A pink carpet formed by fallen leaves. She left them there to make a delicious fertiliser for the plants. Their first flowering season was so great that it left her filled with pride.

A round fruit shook and dropped to the ground from the power used to cut a difficult thick branch. Lucy ran after it, but quickly gave up as she heard the kitchen door open.

A dark-haired head appeared in the opening.

'Come, come Sophia. Come and help me!' Maria called to her sweetly.

She went to her. Her eyes stopped and looked at the brown leather garden gloves Maria was wearing to prune the roses.

She gave her a small hoe and instructed her to prune a small flowerbed. She showed her how to clean up all the little grass that grew greedily around the plants and which should not be touched by hands to avoid getting pricked.

Sophia was paying attention and started on her new occupation with zest.

'Caring for the garden is the best creative way to keep Sophia occupied,' Maria adjudged in her thoughts.

There were days that were psychologically overstressed on which Maria would come out into the garden in the afternoon sunlight and would still be watering the small vegetable garden even after the sun set.

When entering the house, she would forget everything that bothered her and a sweet feeling would numb her body while lying on the couch, watching her favourite series on television.

Much later, when the sun had set, Orestes and Leda went out to the garden. They sat comfortably on the bamboo chairs in the garden, enjoying the evening coolness and fascinating aroma of a primrose which was awaking in the first shadows of the night.

When Maria brought the tray with the pieces of cheese pie she had baked for the evening, she noticed tiredness in Leda's eyes that worried her. She did not say anything but served the pie on the plates, teasing Sophia for her impatience.

Leda barely took a bite; the little she did eat was mainly to please her cousin.

'Lately, I do not have much of an appetite,' she complained. It seemed like she was pushing herself to behave normally.

Sophia ate three pieces, feeding Lucy with a few mouthfuls as she kept nudging her with her front legs.

'Come on Dad! I can't not give her a piece when she is looking at me as if she is saying "I want some!"' she justified herself to Orestes when he told her off.

'OK, OK…. but no more! You have given her enough!'

After a while, Leda, obviously overstrained, apologised and got up. She was not feeling very well. She stressed to her daughter to be prudent, then went to her room.

Orestes looked at Maria meaningfully. She understood without them having to say a word to each other. She nodded her head understandingly, and he went after her.

Sophia gazed in wonder at her parents leaving, forming a sad look and putting the piece of pie she was holding back onto her plate.

Maria had to act immediately.

A brilliant idea came to her mind: to unravel the tangled life of her small pet. She mentioned every detail: how she found her, a tiny little puppy in a cardboard box outside the supermarket where she used to shop.

Sophia was spellbound, literally hanging off her words, when Maria said that the next day she learned that Lucy's mother was hit by a car and little Lucy – she had not yet given her a name – was orphaned. At that very moment, Sophia realised what loss means, and how much you can love a tiny animal: your own pet that lives and grows with you. Maria eloquently conveyed the feelings that this little soul offered her.

'As for the rest, darling Sophia, we have plenty of time to talk about it. We must now gather and take the dishes inside. You will help me to the kitchen, and then you have to get ready for bed. When I'm finished, I'll join you.'

Their relationship developed much better than they could have imagined.

When Sophia woke up the next morning, Leda and Orestes had long gone. Their appointment with Doctor Anastasiadis was at ten. They were going to meet him at the outpatient hospital infirmary. He had been recommended by a very good friend who was a doctor, who happened to meet him during an oncology seminar in Crete. He was the keynote speaker on the

topic of liver tumours, and his speech included a presentation of a new drug that, though it was still at an experimental stage, had produced positive reactions in many patients, with a relatively good life extension.

This was their last ray of hope after the undesired metastasis to the liver. For this reason, the trip took place as soon as possible.

Sophia knew nothing of all these painful details. She had heard Leda allude, in general and vague terms, to a treatment she had to undergo. And maybe she would have believed this reassuring explanation but for a terribly painful crisis that overtook Leda only a few days before starting their trip to Thessaloniki, when she almost faced death.

Since then, Sophia had gathered as many details as possible that leaked accidentally from their conversations. Her antennae were always raised. Somewhere inside her, she had the feeling that something was wrong, and most of all that her mother's health was deteriorating. But Sophia's parents' hidden words about this were spoken so quietly that most of the time, no matter how hard she tried, she could not hear them.

But even though they were not telling her the truth and even concealed it from her, she would trust her instinct that was sending distress signals straight into her young little heart and would tie it into a knot.

All the time Orestes and Leda were absent, Sophia spent her time in the garden with her ears strained to the sound of every approaching car.

With Lucy constantly running around her, she found some ways to alleviate her thoughts. They spent some time playing with anything they could turn into play.

Sophia would throw a toy away to the north fence with the oleanders, and Lucy would run flustered trying to find it.

With the trophy in her mouth after a few minutes or more, depending on where the toy had squeezed itself into, she would come towards her proudly and decorated with green medals

entangled inside her curly white coat. This process was repeated many times.

In the end, with her tongue hanging out with thirst, Lucy would abandon the game, looking for her water bowl.

Sophia entered the kitchen covered with sweat. She took a large glass from the cup holder, filled it with water, and drank it in one gulp.

Maria was preparing lunch, always paying attention to Sophia. While she was washing the dishes, she kept a watchful eye from the kitchen window. She did not want her to be left without something to draw her attention.

She was ready to give her the already cleaned cutlery to pat dry again when Lucy warned them of the long-awaited arrival by barking.

She put the cutlery that she was holding in her hand back into the drawer and pushed it shut. She hung the towel on the wall hanger and went towards the kitchen door, out of which Sophia had burst out like a tornado, leaving it wide open. She gazed beyond the gate.

Leda and Orestes entered the yard smiling.

Leda leaned over and kissed Sophia while Orestes closed the gate behind him. Lucy was jumping around them like a spring trying to draw some proper attention.

Maria watched them from afar.

'Motherly love is countless,' she thought, watching Leda's face radiate when she was holding Sophia.

Orestes put his hand on Leda's shoulders and pulled the two of them into the house. He knew that Leda was quite tired, but did not want to spoil these moments. All of them were in need of some spiritual food.

Maria's appearance at the entrance of the hall brought them inside. She welcomed them with a smile. Her eyes carefully examined their every expression, every movement, even the imperceptible ones on their lips, trying to figure out what could be hidden behind the show they gave. But they were good actors, 'very good', she thought.

Orestes, sensing her anxiety, went over to talk to her, a bit like a medical announcement given by doctors for a VIP. He stood straight, as calmly as he could, took a deep breath and began.

Maria, with her hands clenched into the pockets of her apron, was talking to herself by saying 'Go on Orestes, talk!' But Leda interrupted him, forcing them to look at her in amusement.

'Orestes wait! First I want to give my gorgeous little girl something.'

She took Sophia by the hand and they sat on the couch. She put her hand in her bag while watching Sophia observing her every move with evident excitement. She pulled out a small packet wrapped nicely with colourful paper. She let it rest on her palm and said:

'Open it! Let's see if you like it?'

Sophia held it reverently in her hand and scrutinised it with interest. Green flashes in her eyes mirrored the exact same ones in her mother's eyes.

Orestes and Maria were the witnesses of a tender moment. 'Come on baby, open it!' Orestes urged her.

She finally decided to open it. With slow, subtle, ladylike movements, she undid the ribbon and unrolled the paper.

A small, shiny purse shaped like a slice of watermelon and embroidered with coloured beads made her cry out with a little voice of admiration.

'Oh! Mommy, it is wonderful' she said, and she opened her arms, giving her a big hug.

Leda could not get enough of her. Those moments were her best painkiller.

Sophia looked at the purse, then looked at it again and again, turning it on all sides, stroking the smooth glass surface with her fingertips, and becoming lost in the colours.

'Now, Orestes, you can continue.'

Sophia got up to leave when Orestes began to speak.

'Sophia darling, do not leave. I want you to hear this too.' She sat down again, adopting a serious look.

'Tomorrow we will be starting a new treatment.'

He sat beside Sophia and held her hands in his own. He wanted her to feel his presence, to feel that he would always be there for her, in every way possible.

'This treatment that Mommy needs to have will keep her in hospital for several days.' He did not know how many exactly, so what was he supposed to tell her? He was talking to her and staring her right in her eyes, wanting for her to thoroughly understand what he was saying.

Leda stared at them silently. A light smile was covering the knot in her soul.

'You and I, though, will go to see Mommy every day and keep her company so that she does not feel sad being alone. Right?' he asked, anxiously waiting for her reaction.

Sophia opened her eyes widely and looked at him.

This was a first for her. The previous times she did not even understand. They would come and go on the same day. What changed now? Her thoughts were confusing her.

Like the red ladybugs that close their wings when landing on the green leaves, so Sophia closed the wings of her soul and just replied with a single 'OK' and a tremulous 'Dad'.

Like bullets ricocheting off obstacles that commute back and forth, hurting anything that crosses their path, these painful emotions pierced their hearts, using their eyes' gates. Their blood was beating forcefully through their veins, like a torrent bloated after a storm.

She escaped from his hands and ran to the warmth of her mother's embrace. She need so much to become lost in the safety of her arms, far away from all the things that cut her breath short and forced her to grow up quickly: very quickly.

The afternoon went by in very low tones. Leda was not feeling well. She sat at the table with them, mainly for Sophia. She pushed herself to keep up the beautiful routine today as well.

No one knew how things would evolve tomorrow.

She struggled to swallow a few mouthfuls of the delicious food prepared lovingly by Maria. She concluded that the food

was delicious by the greedy way Sophia ate, and she rejoiced, watching with her heart, thanking God that she was overcoming the difficult moments quickly. That was the relish Leda received. The dish seemed to her indifferent and tasteless, like everything she ate lately.

She felt like vomiting, and that made her leave the table in a rush.

The illusion set by the white tablecloth dissolved very quickly. As if someone had pulled it away in front of them with everything on it: plates with colourful salads, dishes, glasses full of red wine, delicious fruits. They were left standing there looking at the dark wooden surface, still holding forks in hands.

No one was looking at each other. They did not dare to allow their eyes to confess the tragic thoughts that flooded their minds.

They stood up silently. Orestes went to check on Leda, who was walking with heavy footsteps in the hallway.

Maria pressed the button in her mind that read 'normal and comfortable posture', and grabbed Sophia's melancholy by the hair.

'Will you help me arrange the kitchen, since you are a big girl now?' she asked her as she began gathering the dishes.

'Of course, Auntie!' she replied willingly, taking a deep breath like a swimmer who reaches the water's surface after a desperately deep dive. She needed to refocus on something else, to get out of the rough path of thorns that she was forced to cross.

A mixed cry and barking reminded them that someone had been forgotten outside in the garden.

Maria emptied their leftovers onto a plate: there was quite a lot.

'Come, let me show you where I put Lucy's food. In the summer, I have a bowl under the gazebo and that is where I put her food. But, in the winter, I put it here in the kitchen, in a corner near the door,' and she indicated where with her hand as she opened the door for them to go out into the garden.

The moment Lucy realised Maria had a plate in her hands, she began jumping up and down like a ball that bounces off the concrete. She was forced to lift the plate up higher as they walked towards the elevated green meadow of yellow jasmine, resting lazily on an iron grid bed. It was resting on four elaborately constructed iron leg columns, creating a gazebo which provided a thick, deep shadow during the hot hours of the day.

She emptied the food into the bowl and Lucy rushed greedily upon it. Then she lifted the plastic bowl for water off the floor and sent Sophia to fill it up.

A bronze lion head mounted on a stone structure acted as a tap, letting the water run through its open mouth. Sophia turned the tap on and out of the lion's mouth the transparent dew flowed.

She filled the water bowl and put it down next to the food bowl.

They both sat for a while on the bamboo armchairs, watching the afternoon traffic of flying bugs on the blooming flowers.

Maria explained in detail how the bugs find their food flying around; what they call the green bug that just disappeared deep into the heart of a yellow petunia, and the one with the strange, black, hairy legs that selectively chooses the delicate white jasmine flowers.

She used a thousand ways to keep her soul alive.

Her love for her was overflowing, and where it dripped, sweet fruits blossomed.

She watched her playing with Lucy happily. She had grown into a young girl, a brunette with green eyes. She emitted an exotic beauty that grabbed your attention from the first glance, Maria thought, while briefly closing her eyes in the coolness of that 'green paradise'.

Leda spent almost the rest of the day in her room. Towards the evening, she sat with them for a while in the living room.

The colour on her face reminded her of a pale lemon, as if with every moment that passed life abandoned her. Orestes was

restless. He kept looking at his watch, as if time was stuck. Tomorrow was going to be tough and the evening ahead of them seemed arduous.

The night reserved for him a merciless come and go, from the bedroom to the living room and vice versa. He could not find peace anywhere.

He was watching over Leda vigilantly: her breath, her reactions, her discomforts.

'We need to catch time,' he said to himself.

'Time…'

CHAPTER 6
'Leda's Teachings'

In the morning, he found himself with two engraved grooves between the eyebrows: the gift of a cruel night.

Fortunately, Leda woke up feeling better than the night before, like she had shared with him all the difficulties that she was going through.

The hospital admission happened relatively quickly, though, of course, they were unable to avoid the bureaucratic procedures. Orestes was running around from office to office signing and stamping papers.

Leda waited for him in the waiting room of the department of nuclear medicine, outside the office of Doctor Anastasiadis, who, a while ago, had explained to them the course of treatment.

Even though their financial situation was measured, Orestes asked for a quiet, single room with a TV. It was the minimum luxury that he could provide for her.

A multitude of tests was planned and a number of therapeutic drugs were administered. The next few days were filled with tension, anxiety and pain. Countless journeys between CT and MRI scans, ionising radiation and chemotherapies. The present was bitter; the future was poisonous.

Life circled around not knowing whether to stay or leave, devouring every last reserve of hope.

Every afternoon, Orestes would take Sophia to see Leda. On the first day of her visit, Sophia was impressed by the

imposing entrance to the large hospital, the automatic glass doors that just opened when approached, the endless hallways filled with people anxiously arriving to see their friends and family.

The first visit was painless, overcome by the external beauty and luxury. The pain was well hidden, deeper: where the distant corridors ended, behind the big white doors that opened and closed, and which let crying, tears and pain leak: a lot of pain.

Leda's room had a view of a little, rather green for this time of year, park.

It was a quiet room. The comfort offered to her by Orestes helped to keep her calm, as much as possible of course, by avoiding the arduous additional influence of the pain and anguish of nearby patients.

Sophia scrutinised the room quietly while Orestes and Leda were discussing the morning examinations. What surprised her most and made her wander around it for a while, looking at it and touching it, was the bed, with its many components and buttons, as well as various medical instruments behind it hanging on the wall. Above it all was the image of Christ, overseeing everything.

After her little exploration, she approached them and the topic of conversation changed.

Leda's interest was intense. She wanted to know how she had spent the morning with Maria. She wanted her daughter to be well when she was away from her.

From time to time when she was alone, she would consider the possibility of not making it… not for herself, nor even for Orestes: her main worry was for Sophia.

That was her biggest pain; no pain killer could cure that pain. Only during quieter times, and especially when she was well and could think calmly, she looked into her husband's eyes with a simultaneous look of solicitation and order.

'Orestes, I want you to take doubly good care of Sophia,' she told him.

'You promise me? Right?'

In fact, she was not asking him. She was just confirming it to herself.

And he, feeling sore, had no words to answer that question.

The stifling pain was hiding the tears of his soul that he was holding double-locked inside him.

The days that followed were sterile. They did not give birth to the tiniest ray of hope.

A harrowing stagnation that hovered over the edge of the cliff hardened everyone's gaze.

Sophia had started to slowly understand the ugly turn of events. At every new visit, she felt like someone was choking her round the throat. A knot gathered at the back of her tongue, and as hard as she tried to free herself from it, she did not succeed.

She no longer talked about what she did every morning in Maria's divine garden, or how she played with Lucy.

She saw her mother next to her, but she felt her drifting away from her; she would look at her in the same identical green eyes as her own, but did not see her like she did before.

Leda's situation was worsening day by day, and a melancholy was overshadowing her face.

A month later, all attempts had been exhausted to no avail.

Leda was released from hospital, placing her last hope in God's hands. She returned home, visibly overstrained, with only a glimmer of life shining inside her.

The atmosphere at the house was stifling, from time to time almost depressing. She would spend all day lying down in her room. Any strength she had left had abandoned her.

Maria, like a heavenly angel, tried to soothe most of her emotional pain by inventing a thousand different things to make her forget.

But Leda knew that the end was approaching.

In the afternoons when the air got cooler, Orestes would gently help her get out into the garden.

She really liked sitting together with Sophia under the beautiful magnolia.

Maria had moved two armchairs from the kiosk and placed them next to the green tree adorned with large white flowers, spreading their delicate aroma around. It had not produced many this year, but all six of them were beautiful.

The two of them sat in the chairs and talked.

Leda wanted to pass on to Sophia all the valuable material she had guarded for her: food for her growing up.

Now she had to offer all of that to her early, as much as she could bear, because time was running out dangerously. She felt that she was forcing her to grow up early, but she had no other choice.

At times, she spoke to her gently with beautiful parables. At other times, she spoke to her harshly, hoping to lead her towards the right path in her life.

'Life, baby, is a painting that you will create on your own. God will give you all the colours and you, as a great artist, will blend them up and create your own unique hues; will give life your own unique designs.'

'Do not be scared when you get to the hard black, brown or grey colours. Tighten up your little heart for a bit, until you see next to them, alive, the pink, light blue and white. Calmly then, mix them up to lighten your soul, and after growing up you will gain the experience, you will be able to use them on their own, and then you will understand that the white would never be so bright if it did not have the black beside it; and the pink would never look so sweet if it did not have the blue right next to it.'

'Do not give up my baby, be strong!'

'And do not forget that you will fall many times on the way. What is important is how quickly you get up to carry on.'

Sophia was desperately trying to understand. Her childish mind could hardly manage everything she was hearing. Many sentiments she understood; others she guarded well as a precious treasure in the depth of her mind, as Leda advised her wisely.

'Guard everything I say to you well. There will come a time when you will find yourself in need of using them and then you will understand, sweetheart.'

Sophia took the cooled juice from the refrigerator and filled two glasses. Maria made sure to always have some sour cherry ready for Leda to drink. The moment she was putting the jug back onto the shelf in the refrigerator door, one long howl from Lucy scared her. She stayed there with the door ajar and listened. Silence. She closed the door shut and took the glasses in her hands, one in each. She went out and, puzzled, she called out loudly for her mother. For the first time, she did not respond to the call.

She looked at her mother from afar. A light smile was peeking across her lips. At first, she thought that she had fallen asleep. Her blonde hair was waving in the breeze and hanging off the back of the chair.

Sophia looked at her with a smile and left the glasses on a table next to her. She had not seen her so beautiful, sweet and calm in such a long time. She leaned over and kissed her on the cheek.

That was her last kiss. A freezing wave moved with the speed of lightning from the lips to the heart and the mind. She froze. At first, nothing came out of her mouth. Her heart started beating like crazy.

'Mom… Mom…' she whispered, and nudged her lightly on the shoulder.

The seconds of eternity plunged her into an icy lake of tears. All movement was impossible. Only her eyes had become two lush, green waterfalls.

And then Leda's last words echoed in her ears like a key in the lock, and they unblocked her frozen mind: 'What is most important is how fast you get back up.'

She ran back into the kitchen, letting the tears bring out her pain that was overflowing.

Through sobs, she tried to say a few words: 'Mom's gone…'

Maria understood immediately. She buried her in her arms and cried out for Orestes.

Inconsolable, he kneeled before Leda and cried in her arms, kissing her hands that were still holding two white petals. He

lifted her up in his arms and took her to the room. The curtain closed with a tragic ending.

With eyes full of tears, he made the hardest phone-call of his life, to Mrs Sophia, her mother.

With a heavy heart and words that would not come out, he had to give her the greatest pain that a mother can accept: the death of their only child.

As tough as this islander widow had been for many years, she was shattered by what she heard; she drowned in his words.

At Leda's funeral, she was a wreck. She never had the chance to get over it; she passed away in one pained breath six months later.

In this long journey, only a few of her closest people bid their farewell. The burial was simple and quiet, just as she had left, on a September afternoon.

It was there, on a sweet September afternoon, sitting on the white chair beneath her favourite magnolia, where Leda left her last breath. In her hands, she held the fallen white petals from her last flower.

CHAPTER 7
'The Second Mother'

Orestes realised very quickly that there would be no return trip to the island for him and Sophia. The house had already been sold, but the most important thing was that he could not endure his memories. He had to think of Sophia, take doubly good care of her as he had promised Leda, and Maria was her strongest support.

The little one was numb in the early days of her loss. Maria's embrace became her refuge.

'She needs her time, Orestes,' Maria kept telling him, seeing him distressed because Sophia was becoming more and more introverted.

'My little sweetheart is in pain...'

'Can I suggest something to you?' she asked.

With his head bowed, looking at the floor, only with his eyes because his mind was travelling elsewhere, he turned around and met her gaze.

'In any case, you are the one who decided not to go back. Leave her here with me. Until you figure out your work situation, it will do her a load of good being here with me. She's been with me for so long, and I think we are getting on very well.'

She noticed that he was thinking about what she had said and continued: 'Later on, you can discuss it again with her. Think about it, Orestes, I believe it is the best solution.'

'Maybe you're right, Maria. At this time, your own logic is clearer than mine. But I would like to ask her...'

Maria, having experienced Sophia as a woman much closer than Orestes, knew in advance of her positive response. Moreover, that was the main reason why she proposed it. She had sensed her need for a mother, a woman that could help her in her early teenage steps.

The fact that she grew deeply attached to her was expected: it was Leda's seeds from when they first arrived, and day by day, when she saw the river ready to dry up, she would make sure to dig new water channels that would help her own flower grow.

In the end, time showed that Orestes' decision regarding Sophia was the best. She was growing up warm and nicely with Maria, focused on her homework. She had set a goal to be great… though in what exactly she still had not decided.

Early on, Orestes had found a good job in a company doing public construction. The only problem was that he was forced to travel around to different cities: anywhere the company sent him to. He would always take care of her, though, and she lacked nothing. He would regularly come to see her, and when he couldn't, they would talk for hours on the phone.

He always wanted to know her news, how she was doing at school, especially now with exams approaching for university; he would ask of her thoughts and her wishes. He was very close to her, even though they were separated by many kilometres' distance most of the time.

Maria gave her as much love as she had kept for her own child, sometimes spoiling her with her oversupply of love. And sometimes Sophia, as a child, unwillingly exploited that, but loved her also very much… like her real mother.

When she went to her mother's grave, always with a few flowers in her hands from the garden of the 'green paradise', she would sit and speak to her inside her head, especially when under pressure from problems; when she was contemplating. But she would always also discuss her joyful moments; how tenderly she was looked after by Dad and Aunt Maria. Sophia

had no complaints, but she would always finish each confession with: 'I miss you, Mommy… I miss you!'

After years of loneliness, Orestes tried to rebuild his life and met a young woman who stood beside him.

He was now tired of running around from city to city. In the beginning, it was like a balsam as the new places he travelled to made him forget about Leda's loss.

The time, however, passed, and life dropped Despina into his path: a polite, emotional girl who managed to touch his heart. He met her through a colleague on a visit to Thessaloniki. When he decided to formalise the relationship with her, he introduced her to Sophia.

He brought her to Maria's house on a Sunday afternoon. 'Baby,' he put his hand on Sophia's shoulders and pulled her next to him, 'let me introduce you to Despina,' he said.

She smiled politely and gave Despina her hand.

'I am very pleased to meet you. Dad has told me such good things about you.'

Despina, a short brunette with feisty eyes and a kind look, reciprocated the smile. Looking first at Orestes with love, she then turned her eyes to Sophia.

With a look of sincere confession, she said:

'Your Dad is the best man I've ever met … and,' she stopped, wanting to give a special tone to what she was about to say, 'Sophia, you should know that he loves you more than himself.'

It was a truth that Sophia was experiencing daily, and she appreciated that Despina was so close to her father and understood his sensitivities.

'And over here,' he pointed at Maria, 'our guardian angel,' meaning his and Sophia's. 'If Maria wasn't here, I do not know how we could have managed!' He squeezed her hand that was on Sophia's shoulders, and pulled her towards him and kissed her.

'Come on, come on… don't exaggerate!' Maria replied with a humility that distinguished her.

'I am glad, my dear, that I get to meet you and I wish for you to be happy because Orestes deserves a lot: he is a good man and a very good father. Since you are close to him, you do understand how he cares for his family.'

Shortly afterwards, Orestes' and Despina's wish became a reality. They were joined with the bonds of marriage in a modest ceremony in a small chapel, with a few relatives and friends. For the first time in years, Sophia saw her father very happy.

'I am so happy for you, Daddy... you really deserve it. I wish for you to always be happy,' Sophia wished him with love.

With the same love, she also gave Despina her blessings.

She was really his type of woman and also suited him as a person.

When they first met, Sophia felt a little weird seeing her in her mother's place, but logic helped her resolve her tangled emotions and reach correct conclusions.

'He needed a companion in his life. He tasted loneliness for many years.'

After they got married, Orestes asked Sophia to go and stay with them. He would now live in Thessaloniki permanently.

He had asked to be given a position in the company offices, something he was entitled to after so many years. In a stroke of good luck, an urgent departure of an employee made his wish come true.

He joyfully awaited his daughter coming to live with them.

But Sophia had other plans in mind. She did not know how to tell him, of course, and how he would react to it.

'Dad, I do not want you to get upset,' she mumbled. 'For many reasons, I want to stay here. Please, I want you to understand!'

Orestes looked at her, disappointed.

'I dreamed of us living together as we used to, as a family!'

'We're not the same as we used to be, Dad! So many things have changed, and one of them is that I do not want to leave Maria alone, I do not want to change my school now at the end

of the school year, let alone if I get accepted into university somewhere far from here, which would make this move meaningless,' and she continued:

'One thing is for sure, wherever we are, our hearts will always be together... you know that, right Daddy?' she sweet-talked, coaxing him. She did not want to hurt anybody. Only when she saw a sympathetic smile, which emerged a bit forcefully, in truth, did the tightness in her stomach begin to release.

Maria, who was present in the discussion, listened discreetly but did not intervene, allowing them to find their balance on their own.

But deep in her heart, she did not want to part with Sophia.

Of course, she did keep in her mind that the time was approaching for Sophia to go off to university, but she could not think negatively. She secretly hoped inside her: 'Maybe my little girl might get accepted into university here!'

She was now dependent upon their coexistence, more so than a true mother.

Lucy appeared proudly in the living room, as if she understood that the discussion had come to an end. From her mouth, the red leash with which Sophia took her for walks was hanging, and she was dragging it behind her like a huge tail.

She came and stood in front of Sophia. Letting the strap fall at her feet, she whined purposefully, as if she was saying: 'It is time for our walk'.

'What does my girl want?' she asked her, pretending that she did not understand.

Lucy, perceiving the attention, began jumping, touching Sophia's knees with her front legs, forcing her, in her own way, to get up.

'Dad, are you going to go soon?' she asked Orestes.

'It's time for our walk... but we will not be late,' Sophia said apologetically.

'Sophia, I shall leave too, I have some work to finish up and I have to get back on time because we expect some guests at home,' he said standing up.

Sophia kissed him and went out to the garden with Lucy, who was running ahead of her up to the courtyard door. She sat there and waited eagerly for her to pass the strap through the ring of her red collar. Everything she was wearing was girly. Sophia had purposefully picked them up from the pet shop. Every time she went past the pet shop window, she'd get lost in the jars with the colourful fish, the puppies in their baskets, countless birds of all shades of blue and yellow that combined to produce the most erratic chorus; in the end, she would succumb to the temptation and enter.

She would always find something to buy for Lucy: a fake bone, a ball to play with. What, of course, went on at home when she showed it to her, ostentatiously holding it up, cannot be described. She would let her jump up high enough to reach it – Sophia would, of course, help her by lowering it more – wanting her to feel the satisfaction that she had succeeded.

'Let's go, Lucy!' she shouted, and opened the door.

She came running out, forcing Sophia to hold the leash tightly until the door was closed shut behind her.

The route had been established and was the same almost daily. Only on rainy days would they remain trapped at home.

The sun was coming and going, playing hide and seek with the grey clouds that were dangerously threatening to soak up that sunny day.

Sophia looked at the sky thoughtfully.

'I think we will manage to get back,' she said out loud, addressing the little dog as if she was talking to a friend.

Lucy certainly paid no attention as she was busy pulling ahead, occupied with her favourite pastime.

She checked every spot she had marked on her previous walks in the characteristic manner dogs use, i.e. peeing on any foreign odour.

The road ran alongside the train tracks.

On this part of the route, she always kept Lucy on the leash to control her, as the train lines were unguarded and Lucy was 'barmy'. That's what Sophia called her when she would yell at her to come back and she would not obey.

The walk was a bit like the bus route of a city bus that makes stops: stop-go, go-stop. During such a stop, on a respectable green piece of grass, Sophia glanced at the train station. The platform had quite a few people on it. The train was going to arrive any minute now.

She always longed with enthusiasm when she saw it approaching. Her eyes would fill with a powerful expression that took her a long way away.

She was snapped violently out of her seductive thoughts by Lucy, who went about exploring carefree.

The road stopped abruptly at the train crossings.

A man around the age of sixty came out of the guard's house, wearing silver glasses, a blue hat and holding in his hand a 'STOP' sign for trains.

She approached and greeted him.

'Good evening, Mr Nick. Are you on the afternoon shift today?' she asked.

'Yes, yes, Sophia dear,' he said with a smile on his face.

'We are going for a walk I see!'

He bent down and patted Lucy on the head. She wagged her tail, reciprocating his affection.

'Is there a train coming?' Sophia asked with interest.

'Yes, the train from Athens,' he replied, and looked away into the distance.

'It should be arriving in about five minutes!' he said.

She had created a polite friendship with him from the very first day the walks for the sake of the small, mischievous dog had started.

Nick had a daughter the same age as Sophia, his one and only child, as he used to say, and every so often they would discuss their future plans. He was always interested and he would ask:

'So where have you decided to apply to, Sophia dear? Medical school? Pharmaceutical school?'

'I haven't decided yet, Mr Nick. We'll see…' she would answer, obviously over-stressed. The time to finally decide was approaching and she had to choose.

'Now we're going for a walk with Lucy to think about it,' she said humorously.

'Where? At the usual place?' he asked, and winked at her craftily.

'Yes, yes,' she yelled laughing, and took the narrow path behind the guard's room, following a grassy railway line unused for many years.

On it, several metres away from the guard's room, a few old train carriages had been abandoned, forgotten and worn out from the weather. In their early days, they must have been well-preserved and polished. Now, they stood with doors gaping wide open and sometimes, Sophia concluded from certain objects she found from time to time, they definitely must have served as a hotel for some homeless guys.

She was always cautious when approaching them, listening to Mr Nick's advice. Anyway, she had the 'beast' with her, who warned her about anything threatening.

That's how Nick called Lucy as a joke: 'beast'!

When Sophia first discovered this wagon graveyard, she chose one – the most durable – and decided to visit it often: it was their secret hideout.

'Lucy, this will be ours,' she told her seriously, as if she was speaking to a person.

Its door faced the train lines and the station beyond.

Sophia would sit on the iron floor, like an observer in front of the open door. At one time, she would look across checking the train traffic, and at another time, she would lose herself in her dreams with Lucy scurrying around her legs, chasing anything that flew by and everything that crawled on the ground.

Later, she changed its name to: 'the wagon of dreams', where she processed her dreams, her aspirations, and would make her decisions.

And the most important decision of this period of her life she made here; in a way that was painful, shocking, but catalytic.

CHAPTER 8
'A Catalytic Decision'

The once beautiful and carefree days of Easter celebration were now spent reading and with private tuition lessons for Sophia.

Only on Easter Sunday did they all gather for lunch around the festive table: Orestes with Despina, two more couples, their friends and, of course, Sophia with Maria at the 'green paradise'.

The cause of this gathering was Maria, who insisted on inviting them without accepting 'no' for an answer from Orestes.

'Why go through all that hassle!' poor Orestes kept telling her. 'We'll go out and eat somewhere...' and stuttering he continued, 'there will be quite a few of us...'

He looked at her straight in the eyes, waiting for her to consider his words and relax her insistence. But it was pointless.

'Listen Orestes!' she began to say in a heavy manner.

'Most years I've been spending these days like a solitary blade of grass on the edge of a cliff. Since God sent this treasure to me,' – and she touched Sophia sweetly with her hand, wanting to emphasise whom her 'treasure' was – 'my life has acquired new meaning.'

'Yes, I agree... but...' Orestes intervened.

'Do not interrupt me, I have not finished on this matter,' she made herself clear and continued. 'So I was saying that I always used to spend those days alone, and lately with my darling Sophia. But this time my family has grown,' meaning

Despina, 'and I want us to gather here in the garden, to barbecue, to celebrate, to do all the traditional stuff, and don't you worry, as the traditional folk saying goes: 'when your friends are good, all one thousand of them are welcome!'

Orestes gave up trying to convince her otherwise and happily – to tell you the truth -- he agreed. He granted Maria her wish. She enjoyed more than anyone all the customary celebration traditions: from the cracking of the red eggs to the roasting of the lamb on the large skewer.

After Easter was over, there was no single day that could be wasted. Sophia was thrown face first into studying.

Only the evening strolls with Lucy were extended so that she could clear her head from the burden of studying. Her books had become her second skin. She would hold them in her arms wherever she went. Inside the house, she had tested all the possible places for studying, even out in the garden under the gazebo with the jasmine. Many times, she would study with a classmate from the same department, and, especially lately, that was a regular occurrence.

Early morning, on the Sunday of Thomas[8], Ellie showed up at her place: a tall redhead, one of Sophia's classmates and her 'luminary', as she very often used to call her.

She came with a handful of notes and books in her hands, and they set up camp out in the garden with a huge appetite for studying.

They laid everything out on the table and for five whole hours they did not lift their heads up.

[8] **Thomas the Apostle** (called Didymus which means 'the twin') was one of the Twelve Apostles of Jesus Christ according to the New Testament. In the Greek Orthodox Church the next Sunday after Easter (Pascha) is celebrated as the Sunday of Thomas, in commemoration of Thomas' question to Jesus, which led him to proclaim, according to Orthodox teaching, two natures of Jesus, both human and divine.

Only Maria was coming and going, bringing the supplies such as pies, juices and cool water. The afternoon went by without them noticing. Lucy reminded them.

She stood up idly from the corner where she had made herself comfortable all this time, when no one was giving her any attention, and decided to attest her rights.

So she went near Sophia's chair, placed her front legs on the armrest, and began making some strange grunts in a quiet tone, as if she was speaking to her in her own way.

Only then did Sophia realise that it was nearly evening.

The time had come for the usual walk.

'Ellie, can we stop for a while? I say we take this demanding and impatient-looking creature for a walk! Let's also take a breather. What do you say?'

'Why not?' the 'luminary' agreed, and put her pen down over the chaos of notes.

'I'm going to go get her leash and I'll be right back,' she said and headed towards the house with Lucy running behind her, bouncing.

Ellie got up from her chair and stretched her arms high to relieve the numbness of staying still for so many hours.

Sophia entered the house through the kitchen door, leaving it open.

Maria was mixing the dough for a cake she had decided to bake for the girls. She turned and looked at her, puzzled.

'Ellie and I are going to take Lucy for a walk,' she said, fetching the red leash from the wooden hanger. When Lucy saw it in her hands, she was overcome by some kind of madness; she would go back and forth, leaping and barking with joy.

She was at the door when Maria shouted:

'If you see Nick, the station guard, give him my greetings and ask him to come by tomorrow so that I can give him some apricots to take home.'

'Okay,' she replied, without hearing a word. She blamed the noisy mixer and its dedication to the flour dropping into the bowl, little by little, creating a white, cloud-like mist.

She closed the door and signalled Ellie with her hand to come to the door.

They started making their way out, passing through the purple tunnel of wisteria. Ellie cut a small flower and held it in her fingers. Sophia looked at her strangely without saying anything to her, and she thought: the 'luminary' has hidden sensitivities that, every now and then, reveal themselves, and she laughed in secret.

Opposite, at the station, a passenger train was stationary. The girls paused for a moment and observed the passengers that had stood up and were gazing out of the half-opened windows.

Sophia looked at them with great jealousy, as always: she envied them. Her imagination was eating her alive. Where are they going to? What are they are planning? In which city will they be arriving in a few hours? Such things were stifling her thoughts and firing up her desire to find herself in their place one day.

Ellie, on the other hand, was wondering in her own world. She had turned her face and it seemed like she was watching them, but so superficially and indifferently that she always wondered whatever took over Sophia when she looked at them so enviously.

'I have the impression that I have discovered in you a new disease. I think you are suffering from 'train fever'. I just don't know whether it is treatable!'

She did not reply.

Lately, she had realised that the 'luminary' could not palpate her dreams. She only smiled back at her, before becoming got lost in them again.

At the crossings, the lowered bars had caused tailbacks on both sides.

Her friend, Mr Nick, was standing between the train tracks with the 'STOP' sign in his hand. His gaze was turned away in the opposite direction of the train station.

Sophia greeted him from afar, raising her hand.

'Good morning, Mr Nick.'

'Good morning, Sophia. I see you have a lot of friends with you today,' he said, looking at Ellie and Lucy, who undauntedly kept pulling Sophia towards the path they followed every time.

'So, girls? Have you finally decided?' he teased them out of interest, as usual.

Lately, every time he bumped into her, he would always ask her the same, and she would always reply with the same serenity: 'We'll see, we'll see'. Today, however, for some prophetic reason, she changed her answer.

'I have the impression,' she said seriously, 'that today, though I do not know how, I will decide.'

'As for Ellie, there is no reason to ask her. She is going to law school: it is already predetermined,' she said, looking at Ellie, who was walking slowly towards the passage, a narrow descent behind the guard's house.

'Oh! I almost forgot! My aunt orders you to come by the house sometime tomorrow, when you can: she wants to give you some apricots. The apricot tree is making generous offers,' she said, laughing.

Finally, she stopped holding Lucy tight against the leash. She set her free and followed her.

Although Ellie was almost marching, she was already several metres away.

She stood gazing at the tall brown rushes that peeked from the green reeds at the edge of the large opening, next to the dirt trail.

Their thick leaves, like a big green mouth, swallowed and made the fence that guarded the train lines on this side disappear.

The 'vegetation', which is what Ellie called plants, was her second great interest after books.

'Did you know that the rushes get painted in different colours?' Ellie asked Sophia.

'Yes, my aunt has some in her living room. They are painted gold and she has put them in a tall vase on one side of the corridor. They have a simple and austere beauty.'

Ellie tried to reach for one, but it was so difficult to access that she abandoned the effort.

The train wagons appeared from afar. First of them all: 'the wagon of dreams'.

A few metres separated them from the strange shelter when, at the back of the large opening, the red engine of the arriving train bellowed, in its own way, of its presence.

For a while, Sophia stood looking at the train heading towards the station.

It was a commercial train, loaded with various goods. Distinguishable from afar were the colours of the cars that were loaded onto special ramps on the wagons. It ran like a bug with a red head and a colourful belt at the waist.

As Sophia followed the train with her eyes, Ellie made sure to find the pieces of cardboard that had been hidden inside of the wagon, next to the large sliding door that was jammed because of the rust. She placed them carefully in front of the opening.

With one leap, she sat on one of them and took a position as if preparing to enjoy a performance of some great work.

Sophia freed Lucy of her shackles and set her free to wander around. She never ventured too far. Once Sofia had lost her and had to look around for her like crazy. Her punishment lasted for a whole month: she would take Lucy there and always keep her on the leash next to her.

When Sophia released Lucy after her punishment and realised that she no longer wandered away now, she felt proud: 'she got it,' she said to herself, and rejoiced at seemingly becoming an experienced dog trainer.

'Don't go too far!' she shouted at her, knowing that she would obey the tone of her voice.

She hung the leash on an iron piece that remained from the door's locking mechanism, and put her palms on the iron floor of the wagon.

She was getting ready to give her body a boost to sit up next to Ellie.

A deafening noise from one long brake squeal filled the air. It was followed by a devastating crash, and thumps on the ground made her jolt as if it was an earthquake.

Sophia's sudden agitation caused her to lose her balance and she landed on the grass. Lucy got such a fright that she returned like a bullet and jumped on Sophia, who was on the ground, and snuggled in her arms.

Seated low on the ground, with Lucy in her arms, she raised her eyes and was ready to ask questions of Ellie, who had a better view of what had happened. Her words vanished in Ellie's dumbfounded eyes, as if some wicked fairy froze them to the most wild and scared expression.

She stood up, numb, dropping little Lucy onto the ground, on which she dared not take one step because she was overcome with fear.

In one leap, Sophia found herself standing in the wagon. She tried to look towards the spot where the harbinger of disaster was heard. The same magic wand transformed her own face too. It was impossible for her to comprehend what she saw in her mind.

An almost shapeless mass of iron had formed in front of the station, raising a menacing black cloud of smoke to the sky. The distance made it difficult for her to see as well as she wanted to. She squinted her eyes trying to focus better.

The cars she had seen just a short while ago, proudly passing by in front of them, all ready for their maiden voyages, were found either hanging from the ramps or mashed up on the adjacent tracks.

Then what came to her mind, like lightning, was the image of all those happy people who loitered carefree behind the passenger train windows a few minutes ago, patiently awaiting their condemnation by fate itself.

'Get up Ellie, let's go and see what happened!'

She grabbed Lucy in her hands and they began to run back along the trail, with agony written all over their faces.

When they arrived, panting, near the crossings, it was already mayhem. The first two carriages of the parked train,

with the engine that was burning, were lying on the train lines. Broken glass everywhere. People trying to get out through the windows. Suitcases, chairs and sheets of metal tossed and scattered around; and in this tragic picture lay the bodies of some people who never managed to reach their destination.

Sophia shivered, shocked by the sight, the smell of death: a violent death. It was the second time she came so close to death that she could feel its frost. Her heart was ready to break. Ellie had turned white with terror.

'Hold Lucy, I want to go closer,' she said, and she passed the leash into her hand.

She clenched her teeth and approached... 'Hell'. The cries of anguish heard were the most heartbreaking sound that made her heart ache. She watched and listened to the people who were crying and pleading for help, and she melted. Some brave people gave as much help as they could in this havoc, risking their own lives. Soon, the sirens of ambulances and the fire brigade were heard, and, behind them, TV reporters followed.

People with red and white uniforms rushed among the debris trying to save precious lives.

The engines of both trains had become a flaming iron weapon, threatening everything beside them. Inside, the misery spread in the air like a curse. The only life-saving fact was that the fuel did not ignite, and it prevented a tragedy without boundaries.

Within minutes, a black stroke of the pen heartlessly deleted everything beautiful life had begun writing.

The smell of fire and destruction swept every inch of her nose and her mind. At first it brought her nausea. She grabbed her stomach and tried to defeat it by taking some sharp breaths, turning her head elsewhere... But she turned it back very quickly. Something like a magnet attracted her to this harsh and hideous scene. These moments of human pain etched deep inside her. Sophia finally reached the decision she had been contemplating for so long. She would help, with all of her being, human suffering: the cry of distress that was beating like a drum in her ears.

The ambulances multiplied, carrying inside them people that were fighting for their lives, waging their biggest battle. Forty-eight people were taken to the emergency room. Eight people left their last breath among the debris, invited to a macabre encounter with fate. Two out of the eight were small children, early to serve in the battalion of angels.

The consequences of the accident plunged many families into mourning.

Twenty-four hours later, the lines were freed from the rubble that the 'black shadow' left in its wake; but the scars left took a long time to heal and, for some, that was simply impossible.

Nick never came to pick up the apricots Maria had kept for him. They detained him with a few more employees until the causes of the accident were investigated and charges were pressed.

The region became the sad centre of attention for the first few days. It was the opening topic on all media channels.

Sophia had temporarily lost her balance. Her mind could not settle from the harsh images she saw.

She had not prepared some place in her mind for such a catastrophe, and, now, she was practically forced to do it, already under the pressure of exams.

She avoided going out as much as she could. As for the daily walks, they just stopped. She sat in the garden with her books in front of her, fighting the unwanted thoughts that were dragged in front of her eyes and into her mind. In the end, and with Ellie's help, she managed to control it.

Ellie had become a daily visitor. Paradoxically, after the accident, she had changed. She saw more in things, not with the eyes, but with the heart. Something had a catalytic role inside of her. Some positive sentiment emerged to the surface and released her from the defensive coldness she previously had.

They studied, supporting each other; encouraging each other. Several days later, one afternoon, they attempted to go

out for their usual promenade to the 'wagon of dreams'. Only now the dream threatened to become a nightmare.

They immediately recognised the brain infection trying to enter the source that gave their own lives dreams and hopes. From that day, their route changed.

They kept their dreams uncontaminated and their hopes clear.

On the eve of their exams, Orestes came by the house to give them his best wishes for good luck.

He saw Maria, who was obviously distressed, and he did not miss the opportunity to joke with her.

'So Maria, what exam are you sitting tomorrow?'

She looked at him, annoyed, and lifted the wooden spoon she was using to aggressively stir the food.

'Orestes!' she cried, knowing that her manner complemented what she wanted to say.

Sophia watched them and laughed.

'Truly, you two are very funny!' she commented.

She took a carton of juice from the refrigerator, grabbed two glasses, and left them in the kitchen to joke around like little toddlers.

She was at the door when Orestes shouted:

'Sophia, before I forget, Despina is also sending her "good luck" wishes. Despina's order was clear: "please also wish her strength".'

'Tell her I said thanks. Thank you very much.'

The exams lasted for twenty-five days and nights of intensive work and stress, fortunately in most cases controlled. Sophia was pleased with herself. She knew she did the best she could.

The next two days, she was overcome with all the fatigue and insomnia. She buried herself in bed and only got out of it when the sun came up on day three.

Maria was the leading lady in a mute film, trying not to disturb her. She had even evicted Lucy out into the garden so that she did not concern Sophia with her barking.

When she recovered and regained her normal biorhythms, she realised that the days of waiting had to be filled with something pleasant, so that they did not result in an anxiety attack.

Ellie's proposal for a summer break came at the right time.

'So... listen. We are leaving to go to Litochoro[9] for ten days.'

'We have a free house and we will also find a car waiting for us there. Everybody is coming: Iro, John, Dimitra, Paul and us. I think we are going to have a fantastic ten days.'

She spoke waving the straw in her fingers from the coffee she was drinking, like a conductor's baton emphasising her words. In the end, she placed it on her chest like a magic wand and asked:

'So... what do you say? Shall we go?'

'We should definitely go! 1,000 times yes! To use one of our literature teacher Mr Demetrius' phrases,' she said excitedly.

'Girlfriend, you are an absolute treasure. I was looking for ways to enrich my days, and you came like a star in the sky. I admit that your offer is the best.'

Maria appeared with a big bowl of red cherries in her hands.

'So what am I hearing, girls? What are you getting ready for?' Maria asked as she heard something was brewing.

'Auntie, we are going on vacation,' she said joyfully.

'So where exactly are you heading to?'

'We'll go to my parents' cottage in Litochoro,' Ellie intervened.

'These days no one is there. My parents will only get their leave in August since they are lawyers and they are working a lot. Anyhow, as I've already told you, that is the main reason why I decided to go to law school. So we decided to take

[9] **Litochoro** is a town and a former municipality in the southern part of the Pieria regional unit. The town is a popular destination for those wishing to climb Mount Olympus as almost all climbing routes begin to the southwest of the town.

advantage of it. We will also go for a swim because we still have not seen what colour the sea is this year!'

'Oh! Very nice! Have fun and… take care…' Maria said with immense motherly interest.

'And do let your father know!' she said to Sophia, then left them to make their plans with the enthusiasm that characterised their age.

The summer passed much faster than Sophia imagined. It was very generous in giving her what she had been denied all winter. She enjoyed everything that pleases someone her age: playing games in the sea, romantic evenings on the coast with guitars and, most importantly, adolescent flirting.

'Extreme situations! The switch from romance to coldness and the reverse seems to be due to hormonal turmoil,' Maria contemplated as she sat in the garden chair, observing the group debating verbally, sat in the dining room some distance away.

But what puzzled her the most was the coexistence of two opposite feelings. They could speak in the harshest way but their eyes would also emit sweetness and interest for the opposite sex.

'Things were so different when I was growing up!' Maria sighed, and turned back to reading the book she was holding in her hands.

'Perhaps the tension of waiting for exam results is to blame,' she added as a last thought.

Tomorrow reserved radical changes for the tender group of friends: no matter how tough they pretended to be, deep within their souls' paths, a tranquil eye could see many pink neighbourhoods.

The appointment was at ten in the morning. Sophia hardly got any sleep the night before. Maria, who was listening, counted her standing up and walking around the living room and the kitchen, five times… The sixth time it had dawned. She saw her ready and dressed, with her long hair combed into a ponytail tied up with a red clasp, forming a brown curl at the back of her head. She was sitting in the kitchen holding a cup of milk, and feeding Lucy from the cookies she was eating.

'I see you got up early today!' Maria said, pretending to be indifferent, seeing her swollen eyes: a sign that sleep was absent in the evening that passed.

'I did not sleep well last night…! Once I closed my eyes, I saw white papers filled with names. I was in distress to track down my own name, it always ended up being a nightmare and I ended up waking up every time. At some point, I decided that I would definitely not fall asleep and I just started wandering around.'

'I could hear you. And to tell you the truth I didn't sleep either because I was worrying about you. I do not think that you have any reason to worry, with all the studying you did!' Maria said, trying to encourage her.

'You'll see! Everything will be fine.'

Shortly before ten, she was standing outside the entrance to the high school.

The whole group, united, stood there waiting for the 'white pages of dreams'.

At quarter past ten, Mrs Taxiarchis, the philologist, came out of the teachers' office with a 'mobile bomb' in her hands. She pinned the papers on the announcement board with small pieces of adhesive tape, forming a lengthy list, as cool as a cucumber.

The panic of the moment was inevitable.

The hours of a full year were confronted in a particular moment. Dozens of eyes were searching up and down, looking for the dream, the desire, the goal.

Like a roulette ball that stops on a lucky number, two green eyes froze on the fifth row of the middle column. Sophia's eyes were stuck there on that golden glow that the letters forming her name radiated: "GALANOU SOPHIA, Father: Orestes, Passed: Medical School, Athens".

She released a sweet breath that gently slid down to her lower lip: warm, full of emotion. It left her body relaxed, to be washed up by the agony of others outside the circle that had formed in front of the 'magical cards'.

She left them and went out to the courtyard. She wanted to cry, but she didn't; she wanted to laugh, but she didn't. She walked a few steps away from everybody, near to the oleander trees, and stopped.

She closed her eyes and brought her mother's sweet face into her mind; she felt the warmth of her gaze.

She wanted her to be the first she announced her success to.

'Mommy, I did it. My dream is beginning to take flesh and bones! I did it!' she cried out inside of her, and she knew that her mother had listened and rejoiced with her. A tear of happiness rolled down her eyes. She took a deep breath. Now she could say it; she could enjoy it; she could shout it out. She wiped her eyes and turned back smiling to her friends, who were looking for her.

Almost everyone passed. Ellie, as expected, was accepted into law school in Thessaloniki; Paul would go to military medical school; only Iro and John did not make it. Iro, of course, had an alternative to follow another of her desires in hairdressing, but John had already decided to retake the exams.

They celebrated gracefully in Antoine's 'Coffee-Ice-Home': a coffee bar in the main square; the place they had all gathered in the difficult past year; the place that hosted, for a whole year, their concerns for the future, their quarrels over nothing, their joys for now.

A huge tray, full of colourful, layered and fully decorated ice cream bowls, landed on the table with formality from Antoine's hands.

He knew them all too well, their good sides and their bad sides, but today they looked so light, and more worthy of a reward were those who rejoiced in the happiness of others: those who did not make it but were happy for their friends. This particular point was something Antoine did not fail to compliment and mention to the group.

The tasty temptation transformed very quickly into a tasty treat and sealed their success sweetly.

Meanwhile, within their family homes, a festive atmosphere prevailed. Anyone Maria saw, she would treat.

'This is on behalf of my little girl who passed her exams!' she would say, and boasted even more than Orestes, who arrived at noon along with Despina, loaded with a beautiful bouquet of pink lilies and a box of candy. The cake that was revealed had written on its white icing in pink jelly:

"Congratulations from all of us"

When Sophia saw it, she was astonished.

'And when did you prepare all this? How were you so sure?' she asked with joy.

'A father's instinct! Instinct!' he replied proudly, enveloping her tightly in his arms.

'I wish Leda was here... She would be so proud!' Maria whispered, seeing them embracing and happy.

They drank to her success and lavished her with cordial greetings and gifts.

Despina bought her a trendy watch, silver with a black dial, that embraced the wrist like a bracelet. Sophia loved it so much that she complimented Despina on her choice. As for her favourite aunt, she made sure to provide her with a valuable gold cross, to protect her from all the difficulties in life.

'Now that you are going far away from us, always wear it! It will protect you!' she said, unfastening the chain and putting it around her neck.

Listening to her words, Sophia suddenly realised that her life had already begun to change.

When they finished with the gifts and wishes, Orestes embraced Despina tenderly and pulled her close to him. The two looked at each other. With a nod, she gave Orestes consent. In a cheerful manner, he made a pleasant announcement.

'We've got to tell you something important. In a few months, our family will grow with the arrival of a new member.' He then turned to Sophia. 'You will have a little brother or sister!' he told her, and he could not hide his excitement.

Sophia could not believe her ears.

'A little brother or sister!' she reiterated, to hear it again.

Her heart flooded with a warm wave of love.

She embraced Despina warmly, actively showing her her love.

'I'm so glad, Daddy. I hope it's a boy! I have always wanted a brother!' she said, and planted upon him a sweet kiss.

It was a day of joy for all that was generously given to them by life, perhaps paying off some old accounts.

CHAPTER 9
'A New Life'

Their first and basic obligation, or, to use a better word, 'need', was to arrange for the house where Sophia was going to stay.

After a two-day search in the neighbourhoods of Athens and with some luck, they managed to find a nice room in an apartment building: a two bedroom flat in Pangrati.

On first impressions, although sometimes the first impression might convey the wrong information, Lena, the roommate, seemed nice. She was studying English Literature and was in her third year of study.

From the few words they exchanged in their first contact, Sophia concluded that she was not a very talkative person. Not that she really cared much, because Sophia herself was not a babbler, and maybe that would help them live together better.

She liked the house. She found it quite convenient, not very clean for her liking, but she was going to 'take care of that later', she thought, evicting a small doubt that entered her mind.

They arranged the rent and obligations they would have to share between them. Fortunately, it was furnished and she would not have to do any extra carrying: she would just have to bring her clothes and her personal belongings.

Orestes thought it was cute too, and Sophia always counted on his opinion. He also liked the area. She was going to settle in easily as around the apartment there were all kinds of shops to meet her needs.

The issue of 'home' was thus settled relatively quickly.

Sophia came back with the keys to the new house in one hand and a basket of dreams in another.

Now the only thing left was for her to prepare everything she wanted to take with her. The basics: clothes, shoes, jacket. These she arranged quickly. It was the other small details which consumed most of her time.

Maria was going up and down holding various things in her hands, and kept asking:

'Are you going to take this? Are you not going to need that?'

Whether she liked it or not, she was forced into a mandatory questioning process.

'Should I take it? Should I not?' She did not even realise how many times she stammered these particular words.

Everything went through this 'control' with a single exception: the little purse with the beads. Her mother's last gift. She held it in her hands reverently and placed it lovingly in her suitcase with her most precious things.

This beautiful and inanimate object was carrying in it infinite memories, moments from a life left only at the level of matter.

Whenever Sophia touched the purse, it seemed to open a chest with Leda's treasures, as if she was seeing her mother in front of her, as if she was speaking to her, laughing with her.

In a metaphysical way, she felt the warmth of her presence, the flame of love surrounding her heart and lifting her to heaven, as light as if she had abandoned her natural body down upon the earth where it really belonged.

Eventually, she managed to collect everything into two large suitcases.

She put them against the wall on one side of the hallway, allowing Lucy to smell them by sticking her brown snout everywhere with great curiosity.

She bent down and stroked her small curly head as she always used to.

'Girlfriend, now that I am leaving, I want you to take care of my Auntie,' she said wistfully. She was upset that she had to part from them both, but life has its own unique way to drive human travel and sometimes intervene: cold, impartial, but always fair, even if, sometimes she is characterised as unfair. In the long term, her peculiar form of justice is understood.

Maria watched them from the door opening that led to the kitchen. She sensed her grief, although she was drowning in it. Once again, she showed the greatness of her heart. She approached them.

'We will be fine together and we will be thinking of you,' she said, and touched lovingly with her hand the dog's hairy head.

'You make sure that you take care of yourself now that you're alone. Eat well! Dress warm!'

She filled her head with useful advice, as any good mother would. And Maria was her second mother.

The day of departure arrived and there were mixed feelings. Sophia had chosen to travel on the night train, at eleven.

Orestes was responsible for buying her ticket. He was going to give it to her when he came to pick her up to take her to the station.

She had already bid her friends farewell earlier on.

None of them would be attending a university in Athens. She would have preferred to have a friend with her or even, at least, someone she knew.

Sitting in the lounge, relaxing after endless hugs and advice, Maria and Sophia waited for Orestes whilst pretending to watch TV.

Lucy was the first to realise he had arrived.

She notified them with her usual barking, like a good watchdog.

After a quick 'good evening', Orestes loaded the suitcases into the car. The last greetings were very teary! Maria's eyes could not withstand the barrage of her tears and they burst out. She tried to wipe them quickly in any way she could. When she

wished her a 'good trip', she had finally found tranquillity and her voice was firm and clear.

She stood at the gate, forming the sign of a cross with her hand in the air until she lost sight of the red lights of the car.

When they arrived at the station, the only free place to park was a completely illegal spot, but Orestes had no choice. He parked making a wish: hoping to find the car in the position he put it in when he returned.

It was pretty busy outside the station at this time.

They unloaded the suitcases and entered the grand entrance. At the ticket counter, it was mayhem. They went past the marble bust of Alexander the Great, imposingly adorning the space. Behind them, a manual trolley, a well-preserved antique of a bygone era, reminded travellers of their present privileges.

Sophia examined it while Orestes sought information on the departure platform for the train. Once he got the details he needed, he motioned with his hand which direction they would follow. She approached, dragging one of the two suitcases. The second one was taken care of by Orestes.

'You are leaving from platform three!' he said while walking.

In front of the station lockers, he stopped for a while. Sophia stared at her father in amazement and it quickly made sense to her when she saw him searching in the pocket of his shirt. He pulled out a folded white ticket and gave it to her.

'Keep it with you all the way,' he said, bending down to retrieve two small pieces of paper that had escaped his pocket when he removed Sophia's 'dream'.

Sophia unfolded and read it.

Her name was printed in bold uppercase letters.

"From Thessaloniki to Athens, Departure Time: 11 pm."

You could spot a trembling that was also attentive in her fingers, as if she was touching something fragile, sensitive.

This simple, white printed paper would, for somebody else, merely be something necessary. They would throw it away,

crumpled, into the first dumpster they found in front of them after descending from the train.

For Sophia, it took on magical dimensions.

The vision became a reality. Her eyes sparkled like the shiny paper of Christmas gifts, bringing up to her lips the delicious, warm, short breath of enthusiasm that pulls the corners of the lips at the edges and paints a broad smile of happiness.

She folded it carefully in half without creasing it, gently and carefully placing it safely in an external pouch of her bag that hung on one shoulder.

'Everything okay?' he asked, trying to calm his fatherly concern.

She answered affirmatively, nodding her head up and down.

They proceeded to the basement corridor, Orestes in front with Sophia following behind him.

In some places, the aged worn tiles on the walls gave the grim, dirty appearance of a public toilet. Many of the tiles had fallen off, creating open sores in an already ugly sight.

On the right side, a long nylon partition kept the travellers' eyes away from a renovation site that was going to save the city's honour. Sophia peeked through a poor attempt to cover up with the nylon and, as a stealthy viewer, she looked inside.

Piles of broken cement gave the impression of a building that had been bombed. The sight frustrated her. She pulled her head out the moment Orestes stopped in front of the stairs and shouted at her to follow him.

She grabbed the suitcase in her hand and began to climb the half-broken stairs to platform three.

He turned and looked at her asking: 'Are you going to be ok climbing up these stairs?'

'Yes, yes, I'm coming!' she replied, and lowered the long suitcase handle with which she had glided the suitcase comfortably up until now.

She grabbed the suitcase by the short handle and started walking up the stairs.

She pulled it up step by step. It was actually heavier than she thought, but she clenched her teeth and carried on.

As she climbed up the last step, a deep breath and a gasp finally admitted her struggle.

They walked a few metres along the concrete platform that separated the train lines, looking at the people that were waiting patiently with their luggage parked next to their feet. They found an empty spot and stood there imitating everyone else.

A few glances of acknowledgement were flying across between the fellow travellers. Some, anxious, were pacing nervously in the crowd, bending over the narrow opening of the train lines every now and then, looking away towards the spot where the train was going to appear.

A young man, carrying small bottles of water, politely apologised for his unintentional nudge in a desperate move to save a bottle that escaped from his lap, and was ready to dive into the invisible river that the two platforms formed.

Sophia looked at him from behind while he was walking away.

Her eyes had time to browse over him in detail.

Black military trousers, a belt with a big buckle that connected to the left pocket of his trousers with a silver chain. A tattoo in the shape of an eagle adorned his left arm. Her gaze slid higher to his shaved head. The only hair he had was that forming an artistic beard on his chin.

She thought she had concluded her observation when an earring shining on his ear lobe caught her eye.

Despite the meticulous exploration, she could not reach a conclusion on how such a bizarre occurrence could conceal such kindness in his behaviour. The group of people that he approached, from what she gathered, seemed to hold the same philosophy.

Sophia was always preoccupied with these types of guys. They were generally causing trouble and somewhat rough around the edges, which is why she was confused with his more inexplicable behaviour.

The sartorial social analysis was violently interrupted by the noise of the train wagons appearing on line three. The train's engine was pushing them softly backwards. Three wagons were waiting patiently to connect with the train and continue on their way to the south.

A man with long hair and a dark blue jumpsuit leaped from the last wagon while it was still flirting with its parked other half.

He landed with great ease between the iron rails, and as the wagon crept towards its stationary partner, he stood poised above the connection point.

Two experienced hands joined the two huge cars in a coupling at the moment of contact.

Many travellers unwittingly turned into spectators while satisfying their curiosity.

Sophia took the ticket that she had placed for easy access out of her bag. She searched for the wagon and seat number.

'Wagon seven, seat number thirty-three!' she said loudly to Orestes.

He started looking for the wagon number in the white painted frames right next to the doors. An employee standing in the opening of a door put him out of his misery!

'Second wagon from the engine,' he answered to Orestes' question.

They walked several steps ahead searching for it.

The dust stuck on the train actively revealed that its trip from Orestiada[10] in Evros had been long. Halfway through its journey, it had acquired a companion to continue with together to their final destination: Athens.

[10] **Orestiada** is the northeasternmost and northernmost city of Greece and the second largest town of the Evros regional unit of Thrace. Orestiada lies in the plain of the river Evros and forms a natural border between Greece and Turkey.

Many people had already taken their seats in wagon seven, some of whom were already in the process of completing their forms with their place of origin.

Orestes lifted the suitcase he was holding in his hands through the narrow stairs of the door. Sophia gave him hers too and climbed in. They went down the corridor. Sophia advanced looking at the small signs with the seat numbers. When she found her seat, she waved at Orestes to go towards her.

They arranged her suitcases in a special compartment.

'Are you going to manage with two suitcases when you arrive in Athens?' he asked her, wondering, obviously troubled.

'I should have gone with you!' he said full of guilt.

'Come on Daddy! I'm sure I will find someone to help me out when I get there!' she said to reassure him.

'I will have all the time I need when I get there... don't worry... it is not an urban bus stop! ... I'm getting off at the terminal station.'

Orestes took a breath from her words.

'Will you call me when you get there?'

'Yes, Dad, don't worry!'

'Come, let me give you a kiss!' he said and, clearly moved, he opened his arms. 'My baby, have a safe trip. Take care!'

Sophia did not reply. She only nodded her head patiently. She was bombarded with so many tips of advice during the last day that she found herself at the end of her tether.

Orestes stepped off the wagon and stood outside, watching her through the window. While they waited for departure, a young man about her age, with a red baseball cap – that is what got her attention – sat in the seat next to her.

Opposite, a couple of immigrants, possibly Albanians from what she gathered when they were speaking, had already taken their seats with two kids in their arms. At the back of the wagon, a family of Pomaks, with their characteristic black chador, were gazing curiously at the newcomers. As the highlight of multiculturalism, the Chinese dialect reached her ears from the passengers sitting behind her. She could not hold back a giggle at the thought that blossomed in her mind.

'Who could imagine that this wagon is Noah's Ark!'

Her laughter drowned quickly when she turned her head and her eyes met Orestes' gaze, as he stood outside with his arms folded across his chest.

A feeling of melancholy brought a bitter taste to her mouth. She felt uncomfortable. She did not like goodbyes.

She was now begging inside her for the train to leave quickly.

And her request was heard. A colourless female voice announced the departure of the train.

'Bam-bam.'

The doors of the wagons started to be closed by a train conductor. When he got to the last door, he leapt inside, pulling it shut behind him.

The train started moving slowly. Sophia looked at Orestes, who waved his hand goodbye, smiling, until she lost sight of him.

She stayed motionless with a thought of nothingness nailed in her head. She did not understand how much time she sat drugged like that, as if her mind had been left behind at the station near him and her body was travelling alone.

A needy cry from the small rebel opposite reassembled her two pieces. She looked around her, trying to communicate with the environment, as if she was coming around to it just now. Her eyes stopped on the red cap beside her.

A huge smiling mouth, like a cartoon hero's mouth proudly showing a white set of teeth, was printed above the brim of his hat. It spontaneously made her lips come to a resounding laugh. The owner of the cap turned and smiled.

'You thought it was funny, huh! Me too! That is why I bought it!' he said.

'Truly! It is very inventive! And healthy too!' she said, continuing to smile. 'Anyhow, laughter is a sign of good health.'

The red cap held out his hand and acquired a name.

'Michael,' he introduced himself.

'Sophia,' and she gave him hers.

MICHAEL

CHAPTER 1
'A Karmic Meeting'

Her interest was strangely spurred. In a paradoxical way, an invisible hand pressed an invisible button and a magnetic field was turned on.

Two honey-coloured eyes filled her up with a sweet look. She let his hand go slowly and her eyes became pinned on her fingers, unconsciously.

A strange sense of loss grew inside her, as if something had robbed her of this momentary contact. She looked back at him. Michael pulled the cap off his head, revealing the brown waves of his hair.

Grown at length down to the neck, they gave him an intense charm. Sophia did not resist this feeling of fascination that overcame her; she let that feeling roll into the void of loss she felt before.

A magical tranquillity spread across her green eyes, generating a dreamy look. She tried to protect and hide it by lowering her gaze down to the fingers of her hands: they were doing a crazy dance together, relieving all the tension that suddenly superseded her calmness.

He placed his hat on his knees and with manifested kindness in his voice, he asked her, forcing her to lift her eyes:

'Where are you travelling to? Athens?'

Sophia pulled her long hair back like a movement of breath.

'Yes. I am going to Athens for studies…'

'Studies!' he sat up with interest.

'So… Where?'

'Medicine. First year. You?'

'First year, Psychology. They are related professions.'

He shook his head, smiling.

'Is this your first time in Athens?' he asked.

'If you disregard the two-day trip to find a place to live… yes, it is my first time.'

'Did you at least find something decent?'

'At first glance I did find something practical. As for it also being "good", only time will tell. My roommate is also a student, in her third year studying English Literature.'

'I think I am lucky and unlucky at the same time. Lucky because I did not have to look for a place to live, as I'll stay at my mother's house. She inherited it from my grandmother. We were not renting it out so it was empty and it paid its dues as a 'hotel' whenever we went to Athens. Now I will become a permanent resident of Athens, and this is where I am unlucky. Having Mrs Rena, my mother and the owner, over my head, things will be difficult. She repeatedly stressed to me that: 'you are solely responsible for this house.'

Sophia enjoyed his quirky sense of humour, the way he spoke, the timbre of his voice. She was about to be swallowed whole into the 'trap of love'. Her logic was not reacting and she gave it indefinite permission to stop reacting. She had never faced such a frontal attack by the 'winged god'. She surrendered to him unconditionally, without second thoughts, nor even first thoughts.

Nor could she have imagined that the handsome man sitting next to her, with this disarming comfort and his innate humour, would scale great heights in his life, and the instigator was her. He found out a little later, when they decided to look into the future together and both had to put their cards on the table of a newly formed relationship.

They chatted for almost the whole train journey.

Michael knew well the city that would host them for years. He gave her detailed instructions about the main metro routes and urban bus stops she would have to use to move around the city. He gave her a complete guide of "how not to get lost in

Athens!" When the tour came to an end, the discussion proceeded timidly to exchanging the more personal information that outlined their lives until that point in time, when their paths met.

They could not really understand how they opened up to each other so quickly.

When the inspector came over to check their tickets, the kids in the seats opposite had already fallen asleep in their parents' arms. A small commotion took place until everyone managed to find their 'legal evidence of travel' in their bags and pockets, and until it finally reached the inspector's hands to be checked. He would carefully inspect each ticket. After that, a hollow sound was heard from the hole-puncher: 'Click - Click' and two small black holes like wells would appear on the white paper.

Sophia thought he was somewhat brusque, but then decided to blame the discussion they were having that had taken on a very pink colour, making everything else just look and sound dull.

This small break for the ticket check brought her back to her prosaic everyday life, and that gave her time to wonder.

'Maybe I am rushing and revealing too much?' she thought with some doubt.

She leaned her head back on the seat and was lost in a silence flooded with so much sweetness that could not be hidden away, even if she wanted to. Her face was radiating. Her doubts went strolling away.

Michael put the ticket given back to him by the inspector into the pocket in his trousers – the one that was sewn low on his thigh – causing him to crouch slightly. He was trying to button that pocket with such meticulousness that Sophia was puzzled.

'He can't be trying to snap a pocket for five minutes now!' she heard her mind's inner voice speak as she watched him with the corner of her eye, fiddling with the pocket flap.

'His mind is travelling elsewhere,' she concluded.

At some point, Michael stopped fiddling with his pocket and his raging thoughts – Sophia would give anything to find out what he was actually thinking – and he managed to get back to the mood he was in before, after closing a parenthesis of internal wondering.

He turned and looked at her. She returned his gaze. Their eyes met. The light of their souls lit up like the small flames of two candles ignited into a large and stronger fire when approaching close together. Two magical hands were nudging both of them into this wonderful union.

For a moment, everything around them disappeared. The only thing that existed was him and her; they existed in everything and they were everywhere, their gazes embraced, twisting in an upward vortex so hot that it could cut your breath, sending a small pant over the lips.

The first to come back from 'paradise' was Michael. He knew that the path he discovered had to become a road that would accommodate both of them.

With much diligence, he focused on his goal.

His heart jumped when he felt that the branches hindering that road could fall down before he could even reach out to touch them; before they could set him free.

Words leapt beautifully, unhindered from their lips.

They externalised their thoughts honestly, with purity, and each thought encountered a further response.

The sun rose without haste on the horizon. The birth of a new day arriving that was going to be filled with an abundance of beauty.

Life: like a fairy godmother who took some coloured pencils in one hand and some gold ones in the other.

Like a fairy godmother who balanced herself in the centre of the blue sky and diverted all her interest down to earth; down low. To the red iron-headed breadwinner of souls that was running hastily, searching for her. She could see everyone's imaginary thoughts.

Mixed feelings accumulated in front of her ready for ratification. She, with eyes the colours of the iris, turned and looked at the golden balloon that rose slowly, approaching her. Its warmth attracted her to it like a magnet.

Flushed, she grabbed the red, pink, gold and silver pencils. She gave the 'applicants' a final look and chose a girl and a boy.

She would lend them the warm coloured pencils she was holding.

She would give them the opportunity to paint with her own colours, their own shapes, dreams and hopes. When she put the pencils in their hands, she believed with all her strength that they were worthy of the prize she gave them.

The train began to descend among the green northern suburbs. A sweet sleep hugged their eyelids for the last two hours of their trip.

Michael opened his eyes, trying to understand where they were. He lazily stretched out his hands with an obvious pleasure drawn on his lips. They were almost there. He leaned over towards Sophia. She had leaned her head onto the window with her jacket serving as a pillow.

Her sweet face made him hesitate to wake her up. For a while, he stayed there looking at her holding his hand, suspended. In the end, he decided to gently touch her shoulder.

'Sophia,' he said softly, 'Sophia! Wake up, we will be arriving soon.'

Sophia opened her eyes and, as she was leaning onto the window, she saw him looking straight into her eyes. His gaze was glued on her.

'The most beautiful awakening,' she said to herself secretly.

She smiled and sat up in the seat, trying not to confess that thought unwittingly.

'We have arrived?' she asked.

'Very soon we will reach the terminal station. Do you have many things?' he asked with interest.

'I have two suitcases…' She was just about to ask him to help her out, but she stopped and thoughtfully asked him:

'What about you? Do you have many things?'

'Oh! Not really. I have most of what I need in the house. I only took a few clothes with me,' he replied.

'Could you help me? Can you carry one of my suitcases?'

'Of course! It will be my pleasure to help a fellow countryman!' he said with great joy.

Intimacy had started taking shape and form, like a planted seed that sweetly lifts the soil to reveal a new life.

The first braking of the train on the rails was felt strongly. It then continued slowly towards the station until it completely stopped.

The train doors opened and people started walking out. Those who did not have heavy luggage came out first, quickly and comfortably. Everyone else, and amongst them Sophia and Michael, formed a queue in the hallway waiting for their turn. The kids that were sitting opposite them moaned, protesting at a rough morning awakening. Their mother tried to calm them down in various ways while their father, who was loaded with their things, was trying to lower their luggage off the train.

Sophia stared at them with a sorrowful look. A bold thought crossed her mind like lightning, leading her to come to a fair conclusion: 'It could have been us in this position.' She was completely turned off by that thought.

She turned around and looked at Michael.

He, with his beautiful smile and charming eyes, was looking at her cunningly beneath the red cap, and that brought her back to reality in the sweetest way possible. And she stayed there, determined to enjoy it; to live it.

They went with the crowd to the exit of the station, each of them dragging a suitcase behind.

Michael threw his backpack over his shoulder. Admittedly, it was a bit heavy. He had to tilt his body to the right because of the weight, but fortunately that was offset by the suitcase he was pulling with his left hand.

Sophia walked ahead, opening a passage through the river of people who were entering the station at the time.

With a few nudges and a few 'sorrys', they managed to reach the taxi station.

They did not have to wait as they encountered a yellow flood of taxis outside, confessing that their drivers were aware of the arrival time of the train. They entered the first one that was stopped at the front of the line.

Sophia gave the driver her address and the taxi drove off. At this hour, traffic in the town centre was disappointing. At times the taxi was driving at the speed of a turtle. This, of course, gave Sophia plenty of time to absorb all the new developments unfolding in her life. She did some window shopping through the taxi window, and stared at all the people that had already started flooding the sidewalks: all the new places, all the new people that had slowly started merging into her own world.

She turned and looked at one of these new people, who was smoothly entering right at the start of her new life.

For the first the time in her life, she felt so strangely sweet, as if syrup, instead of blood, was flowing inside her veins. Syrup that reached her smallest taste buds and gave her an overdose of sweetness. She instinctively drank a sip of water from the bottle she had in her purse.

Moving away from the busy city centre, the road was beginning to become free of traffic. The only time they had to stop was at the traffic lights.

At an intersection of the main road, they took a right turn into a smaller road. Then, after a maze full of turns, they finally reached a dead end. Sophia recognised that road immediately, although she had only seen it once before. The taxi stopped a few metres down the road. The driver came out and helped Michael, who was already at the back of the boot getting their things out.

Sophia left one of the suitcases the driver gave her on the sidewalk and got out her wallet to pay him. Michael was responsible for collecting the rest of their stuff.

When the taxi left, they looked at each other, feeling like they were standing on either side of a dark mountain that rose between them.

'I hope you remembered to take your keys?' Michael said jokingly.

She pulled her hand from her bag holding a key ring. On the one side, a white teddy bear was hanging, and on the other, two silver keys. She defiantly waved it in front of his eyes, giving him a silent answer.

'Well, let's go then!' was Michael's response, having been defeated.

They somehow shared the things between them and walked to the entrance. A huge volume of garbage welcomed them in a very ugly way. They bypassed it with a grimace of disgust and went to the elevator. The size of it confused Sophia.

'The first time I came here this elevator seemed bigger!' she mumbled, and decided that they had to go up one at a time, separately.

'It's on the third floor, Michael!' she cried, closing the elevator door behind her and pressing the illuminated button for the third floor.

When the elevator door opened and Michael came out with the suitcase and his backpack, there was a flat directly opposite, with its door wide open.

'Sophia?' he said timidly.

'Come in!' her voice was heard from deep inside the flat.

He pulled the suitcase and left it in the small hallway. There was barely enough room next to it for him to put his own backpack down. He walked into a small living room furnished with two old-fashioned armchairs, dressed in a patterned faded velvet, and a small wooden table sandwiched between them. That was all the living room furniture, and all that it could accommodate anyway.

'I think this space was intended only for storage,' he commented, pointing with his hand at this small 'rat hole' of a

lounge when he saw her emerging from another room. 'You are probably right,' Sophia said lifelessly, 'but fortunately the bedrooms are large, the kitchen is quite decent and the bathroom has been renovated. A refined rat's hole!' she said, and put her hands on her waist.

She gazed towards her luggage. A 'thank you' was spontaneously blurted by her lips.

'I am really grateful for your help,' she said and pointed at the luggage.

'I owe you dinner or a drink, but,' she stopped and looked towards the kitchen, 'I would just like to settle in first and I double promise you that I'll take you out.'

'Sure, okay,' Michael agreed.

'I should head home and fortunately I have no cleaning up to do as Mrs Toula, the cleaning lady, takes care of all of that.' He stopped and looked at her with much promise in his eyes.

'Shall we meet up tonight? What do you say?' he asked while lifting his backpack onto his shoulder.

'Why not?! I'd love that,' she said eagerly, opening the door for him.

She closed it behind him gently. The first thing she had to do was arrange her things, 'her dowry', as she tended to call all the things those two suitcases contained, but after having a quick look around, she decided that the priority was a quick clean.

Not that she was obsessed with cleanliness, but the fact that a stench was provocatively wandering around the room, erecting with it the 'celebration' of a thick layer of dust, forced her to use whatever detergent she could find.

As for the kitchen, she did not like at all the fact that it was occupied by a black group of 'friends', who annoyedly ran to hide under the cupboards after realising her presence.

'When was the last time this girl cleaned this kitchen?' she wondered in amazement, cutting a piece of paper from a forgotten paper bag. She took a pen out of her bag and began to write a list of all necessary cleaning products and, first and foremost, an insecticide for the unwanted kitchen 'visitors'.

CHAPTER 2
'Living Together'

It was late afternoon when she heard the key in the door. When it opened, Lena, her roommate, appeared holding some supermarket bags in her hands. She greeted her with a wide smile once she realised her presence.

'Welcome!' she told her cheerfully.

'From what I can see, you arrived a while ago!' she said, a little startled by the frenzy of order and cleanliness that prevailed at home.

Even though Sophia wondered if there was any type of detergent in her shopping bags, she did not say a word. She greeted her too and went to continue with her tidying up, but Lena cried after her happily:

'I am going to prepare something for us to eat! Come with me so that we can have a little chat,' she said, and headed to the kitchen that was unrecognisable and which made her exclaim in startled admiration.

Lena was a soft-spoken person. She was a little older than Sophia and resembled more of a northerner as she was tall and blonde. But from what Sophia gathered from their first few meetings, she did not open up to people easily and she did not say much. She would count her words. At first, Sophia thought the fact that they did not know each other well was to blame, but Lena remained like that for months after.

They did not really hang out much, but nevertheless there was an understanding between them. They never had any

serious controversy such as often happens in cohabitations, especially between impetuous young people.

The only few times they raised the tone of their voices was on the subject of cleanliness, until they eventually found a balancing formula.

Sophia obviously took on the task of cleaning, since Lena found it impossible to learn, and therefore Lena was responsible for all household shopping and various obligations in the house.

This is how harmony occurred in their common lives, while each was focused on her target.

When Sophia's mobile rang, it was nine o'clock. She had already organised all her everyday munitions. She had also managed to take a quick shower and she was now ready and dressed, lying on her bed, observing the new space that would host her life.

She answered the phone sounding a little tired. Michael realised that and asked a bit hesitantly,

'Would you rather get some rest and I am being a pain? Shall we reschedule for tomorrow?'

'No, no! I want us to go out,' she said hurriedly, to avoid a possible refusal on the other side of the phone.

'Besides, I have to start getting acquainted with the city and I think you are best equipped to show me around, right? Or am I wrong?'

'You are not wrong, I'll do my best! I'll be there in half an hour to pick you up. Is that ok?'

'Sure, yes, I'll be waiting for you,' she said and hung up.

At nine-thirty, a hoarse noise from the intercom made the two girls look at each other.

'This bell has such a stupid ring!' Lena justified 'the noise' as if it was her fault.

Michael went up to the flat for a very short time. Sophia made all the necessary introductions and they left almost immediately for the evening exploration.

They walked side by side, descending the road like good old friends. Sophia could not believe that not even twenty-four

hours could be equal to years. As if she had known him for a while now, perhaps forever.

Similar thoughts were swirling around Michael's mind too, as he observed himself responding to any topics related to Sophia's home with such interest that he even surprised himself.

It started as a short walk but ended up being a long flight of reconnaissance.

Michael proved to be a brilliant tour guide. He was on point, showing her streets, subway stations, schools and anything they encountered before them in this ultimate big tour.

The only time they stopped and caught their breath, while simultaneously satisfying their hunger, their need for fuel, was to have a souvlaki[11]; and that was done almost standing up.

'Fuel!' That is exactly how Michael referred to the souvlaki after his nose was lured in by the smell of a taverna. That smell, as a siren who spread her white veils which drifted away in a light breeze, got stuck in his nostrils and dragged him back up there; back into a queue of peers who also waited to refuel.

The regular service of urban buses had long since stopped running by the time they got back to Sophia's house.

With their legs numb from walking, Michael said goodnight to her and departed in the back seat of the first taxi he found before him.

It was their most tiring but beautiful day, all the way up until the last few minutes.

[11] **Souvlaki** is a popular Greek fast food, consisting of small pieces of meat and sometimes vegetables grilled on a skewer. It is usually served in a pita sandwich with garnishes and sauces, or on a dinner plate, often with fried potatoes. The meat usually used in Greece and Cyprus is pork, although chicken and lamb may also be used.

CHAPTER 3
'University'

The next morning found Sophia following in the footsteps of the previous evening's night tour. She got off the bus with a large group of children. Walking past the Public Hospital, she headed for the main building where the secretariat of the School of Medicine was located.

Her ignorance made her feel like a fish out of water. She watched others move comfortably on the premises though some, probably freshmen as herself, were trying to locate the buildings of the faculty with such focus as if they were looking to conquer Mitika, the highest peak of Mount Olympus.

She chose to follow such a group of people who were searching for the Anatomy Department. By the time she reached the building with the animals used for experimental purposes, she had made all the necessary contacts and acquaintances.

John from Sparta, Maria from Crete, twin brothers from Athens, who had both passed their medicine exams, and some other kids whose faces she remembered, though she could not remember their names.

There was mayhem in the amphitheatre. Some rival political groups of third-year students, from what she gathered, were arguing intently.

Maria murmured quietly to Sophia as they went past them:

'Let's go, let's go, I don't want to get into trouble! We have only just stepped foot in school!'

John paused for a bit to hear the topic of controversy. The group waited for him a bit further on. When he finally approached them, Sophia asked him curiously:

'Did you understand what this is about? Why such a fuss?'

'From what I gathered, they were arguing about the votes of the student elections. Are you prepared?! They will try to get freshmen from all camps on their side with perhaps some form of trade-offs,' he said, slyly winking at the group that formed a circle around him.

Sophia's mobile rang in her bag. She took it out and moved a little further away in order to speak, leaving the group discussing its views loudly.

'Hello? … Who is it?' the voice was unrecognisable.

'Hi Sophia, it is Michael,' he explained.

She was suddenly awakened by hearing his name.

'Hi Michael.' She actually wanted to say 'Michael darling', but she was the only one to hear this. 'I'm in school! I came to check out my schedule, but nothing has been posted yet.'

'Would you like to meet up around twelve?'

She looked at her watch. It was eleven.

'Can we push it half an hour later? I met some fellow students, also freshmen, and I would like to get a bit more familiar with them. You know how it works. We'll go for a coffee, I'll ask them for their phone numbers and I think that I'll be there on time. But where?'

'Make your way to the town centre and I will call you to let you know where. I have a list of books I have to buy for my psychology class. Oh! I forgot to tell you… I'm in school.' This was probably the last thing that interested Michael at the time. He had not seen her for ten hours and he was experiencing some sort of withdrawal symptoms, but did not even confess that to himself. 'I'm finishing off what I'm doing and I'm making my way to town.'

Sophia hung up the phone with a sense of fullness. She approached the 'panel' who were still struggling with 'words'.

Manos, one of the twins, nailed her with his blue eyes; she felt a chill that made her uncomfortable.

'He's the one you should watch out for!' she heard a little voice inside her head warning her about this arrogant person.

She turned and looked at Marios, the other twin. His blue eyes emitted such a different blue: calm, sweet, human.

John, the self-appointed leader of the newly formed group, stood next to Mary, folding his arms across his chest.

His dynamic style vindicated his position. Admittedly, this position was somehow offered to him by everyone.

'Sophia, will you join us at The Apple?' he asked.

'What is The Apple?'

'It is the student haunt. A café nearby. It was the first information that was generously offered to us by two graduating students. As for the rest of the questions we posed to them, they did not seem in much of a mood to give any more information as they were apparently in quite a hurry.'

'Sure, why not?' she replied cheerfully.

They all walked together like old acquaintances, with, last but not least, Manos following in a foul mood.

'We have been privileged by his presence!' Sophia thought after looking at his expressionless face.

When they arrived, the cafe was crowded and noisy. They found a small table at one end of the café which hosted them, but, in truth, it was a bit crammed. The only one, though, who huffed and puffed like an elephant was Manos.

'He must be a right idiot!' Mary whispered, leaning towards Sophia, who began to notice how arrogant he was.

They all let him suffer 'in silence' and drank their coffee undisturbed. They exchanged some information between them about each other, opinions and phone numbers, and promised to help one another in the upcoming challenges.

Manos's participation in all this was negligible to non-existent. 'Well, thank God for Marios!' he said to them impudently.

From that day on, around that picturesque little round table reminiscent of the sixties, a lovely group of friends was formed with John (the leader), Marios, Sophia, Mary and… Manos.

They began their fifth year of studies in the same mood as their very first day. Manos did too, with the same distaste that followed him, having actually betrayed them several times, satisfying his inner need to show off. He had a tendency to always find some wickedly smart people who brutally took the piss out of him, and, finally, he would usually return to the group for much-needed TLC!

After their first year, when almost everyone got to know each other quite well, they used to verbally challenge him many times, telling him some bitter truths. He'd get annoyed, hold it against them and detach himself from the group, but when 'his own people' would end up 'spitting him out' of their gang, he would give up and return to the group, setting his ego aside, unfortunately only for a short while.

The same 'play' was performed until the end, with identical repetitions.

'The Incurable'. That was the nickname that the group had given him, when, of course, he was not present or when he was on his best behaviour, which was very rare.

The group went their separate ways around midday. Sophia took the bus to Syntagma Square.

She held her phone in her hands in fear of it ringing and her not hearing it. She was caressing it with her fingers, just like she wanted to caress the person that was going to make it ring.

Surrounded by these sweet thoughts, the sound of the phone that started ringing made her jump up abruptly. She came close to dropping it on the floor. She opened it and answered by colouring with the necessary sweetness that one word: 'Yes?'

'Hello beautiful! Where are you?' he asked.

'Beautiful!' This expression sounded surprisingly welcoming to her ears. She was swirling, stroking her ears until she met him in front of the Benaki Museum.

She was a bit little late. She saw him sitting on the stairs. The red shirt that he wore – red was Michael's favourite colour – matched perfectly with the brown colour of his hair. Her heart

jumped naughtily. She could not believe all those unprecedented things that were happening.

As he saw her approaching, he stood up, smiling at her.

'Hi beautiful!' he repeated and touched her cheek with his fingers in the same manner he would caress a rose.

'Hello guide!' she said laughing, referring to the tour.

He smiled and put his hand gently on her waist.

'Will you follow me?'

'I don't have a choice! You are the guide!'

In Kolonaki Square, the tables were filled with people enjoying a drink under the shade of the few trees.

They went by, walking slowly. Warm waves of a budding love overcame their bodies at the points of contact.

The glamorous designer window displays attracted their eyes like a magnet, but did not attract them for long. Their souls, which were in need of different types of emotions, felt adequately full.

She felt so confident beside him and that feeling did not give her any margin to wonder about where they were going.

They climbed the narrow streets of Lycabettus.

The picturesque stairs to the cable car seemed to rise in front of them, surrounded by beautiful shops.

In a folk art shop, her soul plunged into the memories of a bygone era: when, as a child, she used to twirl between all the different little things that adorned her mother's shop, letting her eyes suck up all the energy that spoke deep inside her.

Michael gently pulled her away from the magic of the display and they continued walking up the paved streets.

On a plateau of the long ladder, at the point where it intersects with a very small alley, an old arbour welcomed them into her arms.

The little tavern that was housed beneath its cool foliage, with all the photographs that adorned its interior, was reminiscent of the years this tavern was carrying on its back, as well as how old his 'girlfriend' was.

From that afternoon onwards, a fairy tale began to unfold, painted in that pink colour of the wine that sparkled in their glasses.

A new planet appeared in the sky: that of Michael and Sophia. They were its exclusive and unique residents and owners. They made sure it was kept clean with their sincerity, beautified with their positive thoughts, and sustained with their love.

And when heavy clouds and thunderstorms were nesting in their hearts, they did not visit that planet. They tended to remain here on earth and faced everything with the power they were filled with by its existence, craving to quickly reunite with it.

CHAPTER 4
'Sophia's Present'

A beautiful day dawned five hundred kilometres north.

The bright April sun had risen to the sky for a while now. A large bundle of rays found a narrow passage between the wooden shutters, tied together by the latch without being secured.

Maria changed sides and took her hands out of the red acrylic blanket. One of her arms hung off the bed; hanging like that on its own, it constituted a huge challenge for Maria's little dog.

Lucy perceived some movement and dug her head out of the large pillow where she had hidden it in her straw bed. She climbed out of her bed slowly.

She stretched her front legs, then her back legs, and, after a short delirium, she sprang up, losing her balance slightly.

She sat on her back legs looking at the pink hand that served as an alarm clock.

Slowly but decisively, she thought it was time to wake the boss up. She aimed for the palm and shoved her wet pink snout into it.

The first nudge was a failure. She tried a second time and she was luckier.

Lucy's 'alarm' suddenly came alive and started showing some love by stroking her head.

Convinced that she had succeeded, she barked out of joy and impatience.

Maria pulled the blanket over her and sat on the bed.

A shameless sunray slipped beneath the bedside table, revealing a tiny little spider that had not missed the opportunity to build its home between the table's short legs.

'I should not forget to clean up on Monday!' Maria instructed herself.

'For now, let's get up and ready because Orestes will come over and I am still only wearing my nightgown!' she said to Lucy: her loneliness had led her to such endless soliloquies on many occasions. Lucy twirled uncomfortably at the door opening, indicating it was time she went out for her morning 'business'.

Maria stood up cheerfully and headed to the kitchen. She opened the back door that led to the garden, allowing Lucy go to the toilet while she went back inside to get ready.

Today was a big day for her. She was going to her little girl. She had not seen her in several months and missed her enormously.

Orestes had ordered her to be ready at twelve.

Their journey had to be made by car. They had to take Lucy with them. Although Maria had a neighbour who could have kept her for the weekend, she avoided this. She did not really trust that woman and her insecurity prevailed.

She got ready relatively quickly. Her mind was busy trying to decide what gift she would get for Sophia.

She put the coffee pot on the stove, threw a tablespoon of musky coffee into the water with some sugar, and stood beside it, keeping a watchful eye so that it did not spill.

Unjustly, though, Sophia's gift was a priority.

'Ooooh! No!' she cried, stunned, when she heard the coffee sizzling on the hot eye. A brownish foam poured from the rim of the metal pot and flooded everything.

She lifted it off with the black handle and looked inside. Almost half the coffee had created a chocolate lake in front of her on the white enamel. What remained inside – or rather half of what remained – she threw frowning into a white cup and placed it on the table.

Muttering about her carelessness, she gathered the water of the lake in a few paper towels and threw them into the trash.

The kitchen door opened slightly and in came Lucy. Satisfied by her morning stroll, she approached her food dish with a huge appetite, wagging her bushy tail.

Maria had made sure to put some canned food with the pellets. Lucy sniffed carefully and, satisfied, she rammed her tongue into her food dish with immense pleasure.

Disappointed with her failed coffee preparation Maria sat at one end of the table and picked up the coffee in front of her. She took a sip and made a grimace of dissatisfaction. She took another sip and, slightly annoyed, got up and poured the coffee – what was left of it – down the sink.

'I'll make another when I get back,' she thought, and went from the kitchen towards the hallway.

'I forgot to close the kitchen door! I'm so distracted!' she loudly scolded herself and turned back to close it.

'What is the matter with me today?! Nah! I'm not with it!' she said, shaking her head.

She stretched her hand to reach a hanger, grabbed an olive-green knitted cardigan, and threw it over her back. She slung her bag over her left shoulder, glanced at Lucy who was licking off the last scraps from her plate, then opened the door and stepped out.

'Beautiful day,' she commented, proudly glancing over at her flowers which had begun to awaken from their winter sleep.

She threw her keys into her bag and crossed the paved yard.

At the gate, she stopped to survey the blooming bunches of the wisteria. In a few days, they would spread their wonderful aroma and purple riot of colour, helping spring with her triumphal entry.

The morning chill made her put on her cardigan. As she stretched out her arm to fill the sleeve, her gaze followed the imaginary line that her hand created as it stretched. She paused upon a big mound of freshly washed-out colour near the whirling thick trunk of the wisteria.

'Ha!' she expressed with surprise.

'I see we have visitors! I have not seen you in a while, dear!' she spoke, addressing the mischievous, unwanted guest who always caused problems. The grey wee dormouse had an excellent destructive capacity and unimaginable speed in digging. Each of his appearances cost the garden several sliced roots and a lot of uprooted lawn. He used his two front feet like electric shovels.

When he dug tunnels close enough to the surface of the ground, just below the green lawn, you'd think that the grass was dancing. Lucy went mad and barked at every move, trying to identify the real perpetrator whom she could only perceive from his odour.

'I'll deal with you appropriately when I return,' Maria said, closing behind her the iron gate with the two angels: one at the centre of each iron leaf.

She looked at her watch.

She had more than an hour available to decide between two options that had impressed after a previous search in the shops.

In the past few days, she could not think of anything but what Sophia would like most. Last week, as she was coming home from the dentist, she went for a brief walk to do some window shopping, in an attempt to forget a banker who was tormenting her for months and made her a frequent visitor to the dentist.

When she came out of the dentist's office she had an intense pain in the left side of her face, as if a calliper had caved its iron teeth from her eyebrows all the way to her chin. She stood for a moment, weighing up her strength. She was not at her best, but the thought of her beloved Sophia gave her the strength to continue.

The light of day had almost vanished. A faded moon, surrounded by the mist of the evening humidity, appeared in the dark sky.

Maria crossed the street.

The large bright window of a footwear store was her first stop. Many designs, many colours, some with heels, others with a flat heel, paraded before her eyes.

Her eyes stopped upon a pair of shoes completely contradictory to ordinary shoes.

It was a kind of athletic design, but also formal at the same time, with a brown colour decorated with gold sequins and gold stitching.

She could not even imagine herself wearing them, but she thought that Sophia would really like them and that was all that mattered.

Looking closer, her mind ran a few years back, when at this same window display she was gobsmacked by a relatively similar choice in shoes that she had made.

At that point, her taste in shoes had seemed so strange, but over the years she realised that this, along with some other similar preferences, belonged to a youthful revolution against conservatism. She adopted this taste without any doubts and now her eyes were used to distinguishing between dozens of pairs of shoes staged provocatively before her eyes.

She descended the three steps at the shop entrance and found herself on the sidewalk once again. She turned left and started walking across the pedestrianised area. Once she started ascending the hill, she felt much lighter. The pain had started to subside and a light smile managed to form on her lips. Just the thought of Sophia was catalytic inside her.

She always enjoyed walking to the shops in the pedestrianised area, especially during holidays when Sophia joined her for their festive shopping. Maria had known many of the shopkeepers for years. A yellow jacket prominently positioned inside a new shop window caught her attention.

She looked inside the shop. The shop clerk, a young girl, was serving a young gentleman who looked lost trying to find a gift, presumably for his girlfriend.

'I have never seen this shop before. It must have opened quite recently,' she thought and went inside. She asked politely if she could have a better look at the cardigan.

She scrutinised it closely and decided she did not like it as much as she had first thought. She did, however, ask for the

price and, simultaneously, a black pair of trousers that could match it caught her eye.

She walked out of the shop, leaving behind the young gentleman lost amongst a dozen shirts.

She went past a few more shops, still examining their window displays. In the end, she realised that every stopping point was closely followed by a thought filled with Sophia's presence. *Moments of joy that turned into beautiful memories that adorned her life.*

When she returned home, the kitchen clock was at half past eleven in the morning. She left the box with the shoes on the table in the hallway. She had eventually decided that the pair of shoes was something that would please Sophia more.

A small travel bag with two or three outfits was already there, ready.

She prepared another coffee, this time without spilling it, and sat waiting for Orestes and enjoying the coffee in peace.

It was almost midday when the sound of the phone disturbed the quietness of the lounge. She jumped out of her chair. She was not expecting the phone to ring, but rather to hear the car horn. She picked it up.

'Hello Maria, it's Orestes!'

'What happened? Are you ok?' she asked, realising that he sounded breathless.

'The trip has been postponed indefinitely!'

'Why? What happened?'

'We are at the clinic! Despina is going into labour! Her waters broke and now she is already in the delivery room. I'll also have to call Sophia to let her know!'

Maria took a few minutes to realise the huge change in their schedule, brought upon them by the unexpectedly pleasant arrival. It was a boy. Orestes had announced it with so much joy when they went for their last ultrasound. And the premature arrival of the baby pleasantly overturned everything.

'I am coming over! Did you notify Despina's mother?' Maria asked anxiously.

'Yes, yes, I told her! She's coming over!' he answered and hung up the phone.

The relationship between Orestes and Maria had evolved to a very close family bond. She cared for him like a brother and was always there to support him.

Despina had a difficult birth. The baby came out with the umbilical cord wrapped around his neck. Despina narrowly escaped having a caesarean. After twelve hours of labour, the young gentleman arrived, all strained, with a colour like an eggplant and protesting loudly.

Orestes, Maria and Despina's parents almost had a heart attack from all the agony. When the nurse came out to announce the good news about both mother and baby, Orestes' knees gave way. The anxiety had dissolved him but, despite it, a permanent smile was drawn upon his lips for a long time.

CHAPTER 5
'The Wagons of Dreams'

A green meadow spread before her eyes, filled with red poppies and small white chamomile heads.

Sophia was standing high on a hill beyond the edge of the meadow. She was contemplating where to put the chamomile she intended to collect.

Out of nowhere she found herself holding a big basket like the ones gypsies sell in the neighbourhoods of the countryside. Satisfied by its size, she looked around one more time, searching for her course. She chose a road that headed towards the golden sun, which was standing majestically motionless, challenging, as if he was full of promises: 'If you manage to reach me, I will jump in your basket'. Sophia fell into the trap, mesmerised by his spell, and took the first step towards him.

Joyfully, she bent down and began to collect the cheerful blossoms that spread a heavenly smell. While crouching for a third time to collect some blossoms, she heard a noise that made her turn her head towards the sky.

'Buzzzzz…' A swarm of bees was heading threateningly towards her. At first, she froze out of fear, letting the basket fall from her hands. For a few seconds that seemed like an eternity, she searched for an escape.

Anxiety clung on her lips, and while trying to get rid of it, she eventually spat it out through a breathless cry.

She opened her eyes, startled. The time of day was visible on the ceiling. It had a strange reflection on it: one that originated from a glass surface that stood like a mirror on the

opposite building, making her realise that the day was progressing rapidly.

'Buzzz…' That creepy noise, however, was still there. Realising that she was hearing that same buzzing sound, she jerked her head from her pillow and started searching for it. She identified the sound that was coming from the chest of drawers opposite her bed. That 'sound' was getting ready to fall on the floor with a protesting blue light flashing on the screen.

'I can't believe it!' she said out loud. 'This whole bloody nightmare because of the vibration on my stupid mobile phone! Unbelievable!' she muttered annoyed, and snatched it before it had the chance to fall on the floor and break into pieces.

'Hello?' she answered wearily.

'Hi baby. It's Dad…' Orestes paused to allow her some necessary time to respond.

'Oh! Good morning. Where are you?' Sophia asked, looking at the clock. All the evening studying and sleepless nights over the merciless pages of 'Anatomy' prevented her reflexes from operating normally.

'Sophia sweetheart, we are on our way to give birth. Your brother decided to arrive earlier than we expected and he caught us by surprise! Thank God it was before we had started out with Maria making our way over to you.'

'So, our trip is postponed… You can come whenever you can,' Orestes informed her.

'It's ok, Daddy! Don't worry! I hope everything goes well with the birth. Give my kisses to everyone. I'll try to be there as soon as I can…' and the line was abruptly disconnected as the signal failed.

She put the phone on the nightstand and crawled back into bed. Her biological clock required more sleep and she duly respected that requirement.

Anyway, she no longer expected any visitors since the trips had been postponed and she had all the time in the world.

The new, chubby and rosy looking member of the family monopolised everyone's attention during the festive days of the Easter Holidays, which almost coincided with his arrival.

When Sophia first held him in her arms – a tiny little man with two big brown eyes that observed her curiously – her heart flooded with a warm thrill that she had never experienced before.

'My brother! My little brother!' she kept repeating over and over to herself. She felt so full, as if life had returned something to her that she had been deprived of several years ago.

She so badly wanted a sibling at her tender childhood age; instead, she had received bile. She was deprived of the most valuable thing a child needs: its mother.

'Look! Look, Orestes, how he is looking at Sophia!' Despina said proudly.

Sophia smiled, leaving her memory recollections aside.

'He probably realised in his subconscious that we share the same DNA!' Sophia commented profoundly.

'Dad, he has your eyes. Have you noticed? And he has Despina's smile,' she added.

She looked her father in the eyes and deep inside she saw a serenity and a joy that was remarkable. She had not seen him like this in years; for as long as she could remember; since she was a child.

A small cry of concern made his sweet face frown.

'It's dinner time,' the loving mother justified, in case he was misunderstood.

Sophia gave her back the fluffy blue blanket that hid inside the living treasure.

She placed him in the safety of his mother's arms and the little angel rewarded richly, giving her a loving smile and simultaneously bribing from her attention for the rest of his life.

Sophia spent most of her holidays in Sindos. In essence, that was her home, that is where she grew up and where she spent half of the years of her life up until then.

Her somehow adoptive mother, Maria, was always sailing in seas of happiness. She cooked all of her favourite foods, and every one of Sophia's wishes was an order to be always welcomed. Maria even prepared food packages for Sophia to take with her: two jars of strawberry jam, which was her favourite, biscuits with sesame seeds, and for Sophia's last day before departure, she made sure that the kitchen was filled with the sweet smell of her favourite donuts.

'Our home is full of life again!' she said celebrating.

'Oh come on, Auntie! Don't exaggerate! You are acting as if I have relocated to the other side of the earth! Plus, I've been back to visit, many times…'

Even though Sophia enjoyed Maria's manifestations of love, for the first time in her life, she felt a bit heavy.

Her independent life had changed her. She felt that she had grown old enough and she did not need such excesses of interest, although deep inside her she knew that many of these needs were fulfilled by Michael's loving concern.

This year's spring days were reminiscent of a very early summer to come. The high temperatures and the intense sunlight made Sophia search through their little store room for the box of summer clothes she had left here in September.

She spent many beautiful times in the 'green paradise': she always called it that. Sophia had two paradises: this green one and the blue one, the garden of her grandmother on the island. She only had a few memories from the latter, but she had promised herself to increase those as soon as possible.

Michael was almost a daily visitor. Sophia did not hide her relationship with him and had made sure to inform everyone in a simple and beautiful manner. Not that she had any reactions whatsoever because her relationship with her father and Maria was based on true feelings and events. This also gave her the freedom to avoid having to play hide and seek in such situations, which usually occurs when you are surrounded by narrow-minded people.

A key reason for Maria being possessed with a hysteria of joy was Sophia and Michael's relationship.

From the first moment she met Michael, she liked his appearance but she was most impressed by his polite behaviour and wise character. She could see the truth that Michael's straight gaze emitted when he looked at Sophia with the eyes of his heart.

Wearing her best smile, Maria placed the platter on the garden table. It was filled with musky handmade, rather than ready-made, brioche.

'The house must smell of brioche; otherwise, how will we know that we are on Easter holiday?!' Sophia always remembered these words on Holy Wednesday, when the stars in the house kitchen were fresh eggs and hot yeast porridge filled with hundreds of bubbles that burst on the surface and revealed its liveliness. The mahlepi[12], the kakoule[13] and the vanilla pods streamed in their nostrils with their intense fragrances. And when Maria baked, Sophia would take a chair and sit next to the stove, watching the brioche rise and gain that tanned golden colour, sprinkled with whole almonds that became trapped between the dough 'braids'.

Two glasses of fresh orange juice accompanied such a 'braid', which was cut into slices and stood enticingly in front of them.

'Cheers!' Maria said almost singing, revealing her good mood, and walked into the house.

'Thanks a lot,' Michael replied.

Sophia was sitting comfortably in an armchair, stroking Lucy's head with her right hand, and while observing this whole ritual, she smiled. She knew this smile: Maria's smile

[12] **Mahlepi** (Mahleb in Arabic) is an unusual Greek spice with a distinctive, fruity taste. The finely ground mahlepi powder is made from the inner kernels of fruit pits of a native Persian cherry tree. For many Greeks, the sweet smell of mahlepi always suggests the aroma of freshly-baked tsoureki, a traditional sweet bread with mahlepi baked for Greek Easter. Mahlepi is also used in holiday cakes and cookies.

[13] **Kakoule** is Greek ground cardamom.

that blossomed on her lips like roses declaring the best time of year.

'I always feel this warmth when I walk in this yard. Maria's flowers and the trees speak to me.' Then her gaze travelled onto Leda's favourite tree, and saddened: the magnolia which was reborn again as it did every spring time. 'The wooden bench,' she continued. 'Every corner holds a memory for me: sometimes it's sweet; sometimes it's bitter.'

Sophia was speaking and testifying her soul to Michael. She would open the book of her life to Michael and, day by day, he would listen and adore her even more. He wanted to hear about all the pages still unknown to him, and Sophia would offer him that generously and with love.

'I think my aunt really likes you: I feel it,' Sophia said, seeing her arriving with a second platter full of treats.

This time the platter was filled with her specialty. Of course, to tell the truth, Maria had a 'degree' in making sweets, and the velvety feel left in the mouth by the golden apricot was palatable proof of excellence.

'Yes, I felt it too. Your aunt must be a lovely person. The sweetness in her smile reminded me so much of my grandmother! She was equally sweet when she was bribing me with candies – always in secret from Mrs Rena, my mother – to steal a hug from me. I loved her very much!' he said, with a tone of nostalgia in his voice.

He travelled like lightning back to his family home, not many years ago, when he was young, in that beautiful courtyard with the stone steps which caused his poor mother great discomfort when trying to climb them.

They lived in a two-storey house with an external staircase on the upper side of town. Every time she wanted to send things upstairs, usually sweets for the children, for Michael and his brother Alkis, she would call Michael, who was the youngest, to come and get them.

'Come, my little boy. You, who has strong legs, come and take these upstairs. Come on my little sparrow! You have my blessing!'

That was the magic phrase that was not a simple proposition. It was his grandmother, the warm breeze that caressed his body when he heard her calling for him, her hugs and kisses.

He never said no to her and she always had something more to give him beyond her love, which was a given.

'Did she die a while ago?' Sophia asked, as if she had awakened Michael from a sweet dream.

'Yes, it's been a while! I must have been ten or eleven years old. She had a lot of heart problems and, in the end, her heart betrayed her.'

'I was around that age too when I lost my mother. Down there...' Sophia said, and pointed with her hand at the blossomed magnolia. Two tears that were ready to roll down her cheeks shimmered in her green eyes. She wiped them off with a paper towel that she took from the tray, avoiding continuing with the conversation. That particular memory, that last kiss, always hurt her.

The sound of the train horn that sounded from afar was their best chance to escape from the minefield of memories.

She had promised Michael to show him the notorious wagons of dreams and, of course, Lucy had to be present. She was entitled to be there since she was the moral instigator of this discovery and always the first to wait at the door.

Lucy waited very impatiently, as if complaining to Sophia, in her way, about how much her absence had cost her.

They walked down the familiar route next to the train tracks, only now it was blocked with barbed wire for security reasons. Thankfully, that project was incomplete and they managed to sneak through at a random point and reach the wagons. As Sophia sensed from all the works taking place around them, this was going to be the last time she saw them.

'God wanted to refresh my memory, my goals. That is why he brought me here at this particular moment,' she said to Michael.

They both sat at the open door of the wagon, where Sophia used to sit with Ellie. It had turned black over time, and she

showed him, with her unique ways of expressing, all the colours, all the shades that used to sometimes blacken her heart and, at other times, launch her as a rainbow into the sky. She told him about the train crash just before her exams and about the crucial decision she had made her about her future.

'Look at Lucy! She recognises every inch of this area. We've been here so many times; countless times. It was our den. Nothing ever bothered us during our walks, not even a drizzle. Only the accident's black shadow blocked 'our road'. We have not been back ever since.'

She got up, picked up a stick from the ground and tossed it away. Even though poodles are not famous for their hunting abilities, but rather for their playful nature, Lucy fetched that stick back as if it was her best find. And, of course, she waited for Sophia to throw it away again!

'From that moment, you were forming dreams about studying medicine!' Michael said. 'In such a picturesque yet tragic place, I'd say. I did hear about this unfortunate incident on TV, but I never imagined I would also hear about it from an actual witness!'

'And what do you want to specialise in?' he asked.

Sophia threw the stick away with force and, observing Lucy running behind it, she said: 'I have not decided yet. I have not yet matured. Rest assured you'll be the first to know,' and she planted a kiss on his cheek.

'Get up though. We have to go so we're not late for dinner at two o'clock. My dad will definitely be sitting on hot coals and preparing to dance as 'firewalker'!'

'I love your sense of humour! It's priceless!' Michael said laughing, and stood up.

Maria was sat in the shade of the courtyard, ready and waiting for them. She filled Lucy's plastic water bowl with fresh water, locked the courtyard door and all three of them headed to the bus stop.

Sophia, who knew her aunt well, sensed the pride she was feeling as they walked down the street. She understood her

body language inside out, from her facial expressions to that subtle smile on the edge of her lips.

Sophia was pleased for her because she deserved it. Maria had offered her love and shared a large part of her life with her.

At five to two, they were standing in front of the entrance of the apartment building. Michael accompanied them up to that point. He then made arrangements to meet up with Sophia at six and left.

Before they got here for this year's holiday and at a completely random time, Michael had expressed his desire to guide Sophia into his life 'PS' (pre-Sophia). That is how he characterised this focal point in his life's journey.

He wanted to take her there, to his own backyard: you see, they were both lucky enough to have the privilege of a courtyard and not just a balcony to play on! There on the small iron bench under the acacia, where he snuggled with all of his childish mischiefs; his large dreams; his adolescent concerns. He wanted to talk to her about those warm summer evenings when he and his friends were trying to understand the girlish antics and frills.

To disclose to her his own 'shelter'.

And Sophia wanted to keep her word on this so desirable promise she had given to him.

All the joy in its splendour was the host that answered to the name: Paul.

Beyond the fantastic tasty delights on the festive table, all other events had, once again, that same focus: Paul. Irrepressible, enthusiastic, lively, he literally monopolised everyone's interest. They did not know what to enjoy more: Despina's wonderful meal or the funny way Paul ate.

They all burst out laughing when Paul, trying to be serious, made the effort to assemble a few words to ask Despina:

'Mom, fist (first) we eat the sin (skin)?' And, of course, all he meant was the greaseproof paper that made this food taste so exquisite.

Even though the food was a delight for the adults and an adventurous discovery for the youngster, the perfect ending to

this meal could be no other than their favourite filo pastry triangles stuffed with sweet cream: Sophia's most favourite. Just like that, so that their love for her could be all-rounded, complete with their most sweet signature.

Despina received the most important congratulations of her entire life. The tasty feast conquered them all. A huge smile of satisfaction was eminent on her lips and this manifestation of her joy made Orestes doubly happy.

The rest of the group left Despina and Sophia to clear the table and they all sat down in the living room commenting on Paul's mischiefs.

The hours till six o'clock rolled sweetly and calmly with the little protagonist omnipresent every single moment.

Michael was there on time. Sophia left him with the rest of them to exchange the established wishes, and went to freshen up.

She looked at herself in the mirror. She liked to make a good impression wherever she went, let alone when she went to Michael's place.

Although a pair of jeans tended to monopolise her outfits, for today's visit she had picked out a white dress with a wide red band that contrasted wonderfully with her dark complexion. Satisfied by her reflection in the mirror, she grabbed her bag and entered the living room.

When Michael saw her, he stood up. They said goodbye to everybody and walked out the door, accompanied by Paul's murmurs of protest.

When they emerged from the building's entrance, Michael turned around and looked at her carefully.

'You look gorgeous! You will charm everyone!' he said with admiration.

'You are exaggerating as usual, Mr Psychologist!' Not that she actually believed what she responded with, but her modesty took over, even though, deep inside, she was captivated by his words.

CHAPTER 6
'A Different Kind of Tour'

Climbing up to the upper side of the town through the castles took place at the most appropriate time of day. A deep red sun was preparing to dive into the Thermaic Gulf[14] and its rays, like lively children, toyed with the castle walls and battlements with the light and the shadows. The spectacle was unique. They sat on one of the many benches placed on the uphill slope and were enjoying the view so much that they did not want to get up and leave.

Michael's house was situated in a picturesque neighbourhood on the upper side of town. The most characteristic element that caused you to be transported in time so vigorously was the cobbled streets: so narrow that even a car could barely fit.

This neighbourhood had managed to deceive the time so much that even time hesitated on whether to proceed or stop.

[14] The **Thermaic Gulf** is a gulf of the Aegean Sea located immediately south of Thessaloniki, east of Pieria and Imathia and west of Chalkidiki. It was named after the ancient town of Therma, which was situated on the northeast coast of the gulf (Therma was later renamed Thessalonica). Near Thessaloniki, the length (north-south) of the gulf is about 100 km, while its width (east-west) is about 5 km. The length of the gulf in its northern part (from its northern extent down to 'megalo emvolo' cape) is estimated to stretch 15 km, while after 'megalo emvolo' cape towards the south, its length extends a further 50 km.

The house, a renovated two-storey building, kept its traditional style with wooden verandas and a tall wall that kept the internal courtyard hidden from passers-by. It was painted in bright white and the only strongly indiscrete features were the shutters, all made from dark wood, and the grand courtyard door decorated with a bronze knocker in its centre, making it seem like an old-world mansion.

Michael put his key in the door, he opened it and they suddenly found themselves in the garden of wonders. That is how the house courtyard introduced itself to Sophia. Never in her life had she seen such an artistic place, so alive and functional that any man embraced by that environment can create, imagine and rest.

She did not know where to lay her eyes.

Under the gazebo that dominated the centre, a wooden table from Mount Athos gave its own gravity to the space. The stone well in the centre of the paved yard, with the bucket in which they gathered water, was filled with a torrent of red petunias. At the edge of the wall, under the aged acacia, an iron bench fostered all of the childhood memories.

The garden's feature was the many small and large stone statues scattered in every corner. Each was a construction of dozens of stones of all sizes and colours in a unique composition, held together by a suitable binding material. This, however, was unexpected: what Sophia anticipated was statues carved from a single solid piece of stone. All in improbable shapes with interesting meanings that showcased, in the best possible way, their creator's spirit.

'I am amazed! Now I can see why you decided to do psychology rather than anything else technological. You have had the most appropriate information and stimuli. Who else but God himself deals with all these wonderful creations?'

'These are Mrs Rena's creations. Aside from her official job as a philology professor, her informal job is this: her whole life. She gets lost for hours among her plants, the stones and the soil, and anything else that comes to her mind. And voila!'

'I admit that she gets an A plus in fine arts, in agronomy and not just that. There is perhaps more I do not know about!'

They climbed the stone steps and rang the bell. Michael, of course, could have unlocked the door with his own keys but he wanted to warn them of their arrival, which of course was perceived because the door opened the moment they knocked.

A blonde, blue-eyed, sweet lady appeared, smiling in the doorway.

'Welcome, Sophia dear, please come in. Michael has already told us so much about you… It feels like we've known each other for some time.'

Sophia was thrilled by her warmth and simplicity. Her feelings were mutual.

There was a group of people sitting in the living room discussing various current events. Eventually, Mr Theodore, a professor of mathematics at the university and Michael's father, joined them. The family had yet another member, Michael's brother Alkis, who was abroad.

He was studying information technology in London and, due to several commitments, he was not able to be with them for the holidays.

This was a family surrounded by books, filled with subjects that were diametrically opposite but which they managed to balance marvellously, and Michael was a direct example of that. He had the ability to blend the sensitivity of philology with the rationalism of mathematics with an amazing skill; and this exact ability Sophia really admired.

He acquired it over time, as he was given stimuli from both sides which he then processed and placed accordingly in his mind. Thus was shaped a gold coin with two sides, with which, depending on the facts life brought before him, he redeemed with his behaviour.

Sophia always admired his way of thinking: the various optics he used to reach a conclusion which was so amazingly close to reality. Of course, besides the field of philosophy, the branch of psychology, which was what Michael decided to

follow, was also enriched and developed remarkably by what he had received from his family environment.

They drank iced coffee accompanied by Mrs Rena's almond cookies under the gazebo with the garden lanterns, creating a sweet atmosphere in an evening drawing to a close.

Michael guided Sophia around his private areas: his room that looked more like a library than a bedroom; he took her to the edge of the garden, where he crossed the bridge of childhood into teenage life; he told her about the famous evening meetings beneath the acacia with friends who had also educated him with answers and questions; he showed her, in turn, all of the unknown pages of his life.

Sunday came to a close with the most beautiful ending. New data for both: unknown aspects of their lives that saw the light and took their place in their hearts and minds.

Happy and slightly tired, she wished Michael's parents goodnight, thanked them for their hospitality and, accompanied by Michael, descended to the city centre.

The next day was departure day.

CHAPTER 7
'Purple Lavenders'

Sophia put her suitcase down, along with the two nylon bags of food Maria had prepared for her and had diligently ensured Sophia would take with her, and put the key in the door. She unlocked and entered. The hanging wall clock that adorned the 'rat hole' (they had kept this name for the living room from the first day she and Michael entered the house together, when he was practically a stranger) showed that it was eleven o'clock. They had arrived with hardly any delays, apart from the trouble they encountered trying to find a taxi. In the end, they both settled in a taxi whose driver was a lad from Grevena[15]. Sophia was the first one to get out.

Silence reigned in the apartment. She put the keys in the lock from the inside and stroked the silver half-heart key chain now hanging from the door.

It was a present from her man for the Easter holidays. The other half he kept for himself.

'Only with you will my heart be whole,' he confessed romantically when he gave it to her in a red velvet box.

'I will always try to be by your side, baby,' she replied, giving him a sweet kiss.

[15] **Grevena** is a town and municipality in Western Macedonia, Northern Greece. It lies about 400 kilometres (249 miles) from Athens and about 180 km (112 miles) from Thessaloniki. Grevena has had access to the Egnatia Odos (motorway) since the early 2000s, which now connects Igoumenitsa with Thessaloniki and Alexandroupoli at the border with Turkey.

At the same time, Michael, who was sitting in the back seat of a taxi, was also clutching the other half of the key ring in his fingers, thinking about the dreams Sophia had confided in him during their relaxing holidays. Her goals and dreams fascinated him, but also scared him at the same time. He was walking through his life in a simpler manner and building his life measuring every single aspect of it differently from her. When, for the first time, she expressed to him her desire to acquire her medical specialism abroad, he was supportive. In truth, he was completely taken aback by her ambitions and enthusiasm. At the time, though, he had given little importance to all of that, and he even became a culprit by inflating her grandiose visions even more.

But now those dreams had begun to incarnate and were referred to for a second and third time, making them take shape and triggering alarm bells in his mind.

He felt a choke in his throat. He took a deep breath and looked out the window. As a life saver, the shiny red bonnet of a race car stopped beside him alluringly, waiting for the traffic light to change, and making his thoughts wander elsewhere. His eyes became pinned upon it. Its curves charmed him. His gaze slid sensually over those curves until the traffic light turned green, making his adrenaline pump.

With a provocative spin, the car disappeared like a tornado. His eyes were only able to watch it for a few seconds until it disappeared among the cars ahead.

He took one more deep breath. This time it was his dream that caused him to breathe deeply: his own ambitions. They were seemingly a contradiction to his calm character, but, nevertheless, they would not cease to take over inside him.

Shortly before they reached his destination, he had managed to reach a conclusion about his thoughts that worked like a tranquillizer in his body.

'Respect for our dreams!' he said, expressing his thought aloud.

'What's that, man? Did you say something?' the taxi driver asked, not having heard what Michael had said.

'No, no… I wasn't talking to you, I was talking to myself!' he said, laughing, and pointed out to the driver where he wanted him to stop.

Sophia put all her things where they belonged, in her bedroom and in the kitchen, and went straight to the bathroom. She was in urgent need of a shower after that journey.

She let the water run all over her body and she could feel her muscles relaxing. She took a deep breath and, aided by the smell of bubble bath that relaxed her, she let her imagination travel; it took her to a garden with purple lavenders.

Hidden away in a sheltered spot, among the whitewashed terraces, from where you could gaze upon where the Aegean ended! Sophia had managed to gather very few memories from Grandma's house on the island. As Sophia grew, she began to slowly sense the island's individuality; its greatness.

She was very young when they were forced to leave the island hurriedly, for reasons that were very sore.

From these very few things to remember, this place, to her, was a springboard of dreams, the sea gate to the future; she could feel it inside her. She could not have analysed it with her childhood mind, but the vibrations ran through her body from head to toe.

She sat on the bench, gazing at the sea. She spoke to the sea in words that only the heart can understand, and when her lips formed a certain smile, she felt like she was free to go; full of optimism – which she, then, certainly did not identify and name as an emotion.

'I must go back to the island as soon as possible!' she said, and turned off the tap in the shower, as if closing a data window on a computer screen.

She grabbed a white towel and wrapped it around her. A wonderful feeling of cleanliness led her to the softness of her

bed sheets. Very quickly, Morpheus[16] took her in his arms away to long journeys.

When she opened her eyes, the light of day had bid her farewell. The street lights cast their glow into the room, forming figures and shadows on the ceiling.

She got up and prepared a snack to eat.

She sat in the living room with the food tray in front of her, and while her mouth was made to eat, her mind was travelling, organising what she had to do.

'The holidays are over!' she said to herself.

'Now, back to work!' she said, and bit a chunk off the toast that was on her plate.

The days that followed were loaded. She was running around like crazy.

The university had re-opened and her visits to the secretariat to gather information had multiplied: updates for their exam period, which was scarily arriving; for upcoming courses, books, and laboratories, which were becoming increasingly demanding. All of this was exhausting every last reserve of Sophia's strength.

In the evenings, she would seek to refill her batteries, trying to come up with various relaxation methods. Going out for a drink, dinner or coffee was out of the question. Communication with Michael had become limited. They mostly spoke on the phone and no one had any other free time.

Michael had decided to attend a psychology seminar for people with disabilities and it had filled up his days. From the first moment he saw the informative poster hanging on the school bulletin board, he became really excited by the idea. It was a group of people with specific requirements in their interactions and he was interested to know the specific modes of communication with these people, especially children: something that is not easy for other people to grasp.

[16] **Morpheus** is the principal god of dreams in Greek mythology.

And as they both approached the end of their studies, the situation further complicated.

Each one was preoccupied with their personal obligations and chores, and they only allowed a minimum amount of time for themselves as far as 'fun' was concerned.

Every now and then they did manage to steal some time to go see a movie, a little more often something to eat, but nothing was ever discussed about moving away from the perimeter of the town centre, not even for an excursion, on normal days that were not included in their holidays.

Of course, autumn was not inspiring them to take a break somewhere.

Heavy rain was commonplace during the whole month of November, and that was followed by some immensely cold days that riveted them completely. Somewhere around early December, their mood began to change a little. It was probably the shops and the shop windows that were filled with Christmas decorations; the festive background music in the shops. In addition, along came the first snowfall of winter, bringing them excitement.

It was Monday morning when Sophia opened the kitchen curtain and her jaw dropped. She could not believe her eyes. These were definitely not crumbs from the apartment above but…snow! Very light snow. You could barely figure out it was snow initially, but as time passed, the Attic sky[17] was transforming into a fairy tale. She was filled with white butterflies that flew and spun from the light breeze, and which could not find an appropriate place to land. The asphalt temperature was prohibitive and, like a wicked witch, she would transform these butterflies into liquid drops, capable of extinguishing any fire except the one kindled in Sophia's heart.

[17] **Attica** is the historical region that encompasses the capital of Greece. Attica is also another word used to describe Athens, especially in Greek. With that in mind, 'Attic' and 'Athenian' are synonyms. '**Attic sky**' thus means 'Athenian sky'.

She grabbed the phone and dialled Michael's number. She could hear her phone calling while rhythmically beating her fingers on the balcony glass doors: a sign of her impatience.

Her call was answered and a sleepy voice replied, with a heavy 'hello'.

'Hi! It's me!' Sophia said. 'Have you seen what's going on outside?'

'No… what? You woke me up…'

He was not able to continue this communication with pauses because Sophia said unrestrainedly,

'So, what are we going to do for Christmas?'

Still half-asleep, Michael was finding it difficult to associate Christmas at that moment with the rude morning awakening.

'Sophia! Seriously, what did you dream about? Snowmen?' he said, unable to make sense of what she was telling him.

'No! It is real snow that is falling outside! And no, I am not asleep! I guess you are the one who has not woken up yet!' she continued, not even letting him reply.

'Ok, ok… I'll see you at twelve o'clock at the 'APPLE' cafe,' she threw at him and hung up the phone, looking at the sky, enchanted.

It continued to snow all day, but, unfortunately, they did not manage to see 'a white day!' as in the popular folk expression, meaning a natural purification of everything from the immaculate coverage of the snow.

It was approaching midday when Michael entered the 'APPLE' cafe opposite the medical school. Sophia was seated at a table on the mezzanine and was lost in a newspaper when she felt him. She raised her emerald eyes, looked at him and said, mockingly:

'Now that you have woken up, have you seen what is happening outside?!'

'Sophia, stop taking the piss and tell me what is going on inside your mind! You are probably up to something to call me that early in the morning!'

'Ok! Listen then! How would you feel if we did something completely different this Christmas? We often spend our holidays with family. This time, I suggest we go somewhere alone, just the two of us, where there is a lot of snow, and Pelio, in particular, came to my mind, that ski resort in Chania. What do you think?' she said, and hung upon his lips waiting for his opinion.

'I like your idea, but isn't it a bit too late to find a hotel? It is December already! I reckon finding a hotel at this time will be difficult, almost impossible!'

'Do not be negative about it. Luck follows those who are brave. And we shall dare. I sense that we might find something,' she said optimistically.

'I'll take care of that and I'll surprise you! But I do want you to help me with something else. The day before yesterday when I was making my way home I made a short stop at the store with the Christmas decorations. I have always loved these seasonal shops. They bring out such sweet feelings that I surprise myself. I wonder where those feelings have been hiding the rest of the time.'

Michael was looking at her, trying to understand what she was coming to. Sophia continued:

'So there, where my eyes got lost between the golden braids and the coloured lights, I think I saw your friend George. He works there!'

'Yes, as a seasonal employee for the holidays. Why do you ask?' he replied.

'You see...' she said shyly, 'I always wanted to work in such a shop. And, anyway, I have no classes during the holidays and I would also like to make a little extra money for the trip we decided to take...'

'But, that is not certain yet,' Michael interrupted her.

'For me it is,' she said decisively and continued:

'But most of all I want to live in this environment that overflows from the glow of fairy tales. Will you do me a favour and ask if they need an extra employee? In any position, I really don't care, as long as I'm in there.'

'Okay. I'll stop by on my way home and I'll ask him. If I have any good news, I will let you know immediately.'

'I'll be anxiously waiting for the reply.'

Sophia's desire materialised and she was ecstatic. And although she was standing the whole day serving clients, when she returned home late at night, she had a warm heart, as if she had sat in front of a fireplace all day, making dreams and wishes.

She worked for (literally) fifteen whole days and not one of them was unsustainable for Sophia. Each day gave her a different colour like the colourful lights that adorned the huge Christmas tree in the centre of the Christmas shop.

With so much positive energy, it was almost certain that the luck for a hotel reservation would be guaranteed. An evening excursion on the internet and a diligent check on hotel web pages and booking sites gave them a coveted double room to stay in. It came as a gift because of a last-minute cancellation. The three-day New Year holiday had already been planned.

CHAPTER 8
'Unusual Christmas Holidays'

With their suitcases full of warm clothes, they headed up to the highway. The cars had formed a huge queue waiting to go through the toll booths. Sophia chose a radio station that played Christmas music, creating the right mood and making the wait more enjoyable.

Their trip as far as Volos[18] was pleasant, although the weather was cloudy and the cold was harsh. The difficult part was getting up to Pelion.

The tyre crawlers were the first thing Michael made sure they were equipped with, as based upon the three-day weather forecast, they were certainly going to need them.

The city of Volos, lit by thousands of lights, greeted them with a festive spirit.

[18] **Volos** is a coastal port city in Thessaly, situated midway on the Greek mainland, about 326 kilometres (203 miles) north of Athens and 215 kilometres (134 miles) south of Thessaloniki. It is the capital of the Magnesia regional unit. Volos is the only outlet to the sea from Thessaly, the country's largest agricultural region.

Sophia could not get enough of the beautiful decorated courtyards of the houses as they ascended to Makrinitsa[19], the 'balcony of Pelion'.

'Have you ever been here before?' Michael asked.

'We came to Volos one summer with a group of boys, but it ended up being a horrible trip. We didn't get on, we quarrelled about useless things and we decided we'd had enough of each other halfway through our trip, so we all returned abruptly.'

'The first time I ever came here was on a day trip with our school,' Sophia said. 'We were taken up to Makrinitsa. We had bumped into several schools there since they were on the same trip. From what I remember, Makrinitsa is an amazing place. We stopped at a large opening, where you could gaze down over the whole city, the harbour up until the Pagasetic Gulf[20], as far as your eyes could see. When we were here that summer, we had come to this square that was filled with tables. You could enjoy this wonderful sight, sipping your iced coffee under the enormous tufted trees.'

[19] **Makrinitsa**, nicknamed the 'balcony of Pelion', is a village and a former community in Magnesia, Thessaly. Since the 2011 local government reform, it is part of the municipality of Volos, of which it is a municipal unit. It is situated in the northwestern part of the Pelion Mountains, 6 km northeast of Volos. One of the most characteristic traditional settlements, it is full of mansions and houses that look like hanging ornaments on the green mountain side. One of the traditional coffee houses is decorated with a fresco by the famous Greek painter Theofilos. The picturesque cobbled paths of Makrinitsa are scattered with traditional water fountains. Makrinitsa is a popular tourist destination, especially during the winter.

[20] The **Pagasetic Gulf** is a rounded gulf (max. depth 102 metres) in the Magnesia regional unit (east central Greece) that is formed by the Mount Pelion peninsula. It is connected with the Euboic Sea. The passage into the Euboic Sea is narrow and is about 4 km. Its main port is Volos.

'This season, however, from what I can adjudge from the traffic on the roads, interest seems to have shifted further up, towards the ski resort of Chania.'

The cars with skis fastened tightly on their rooftops clearly stated the travellers' purpose.

Continuing up, the landscape began to change and the snow that had previously seemed aloof slowly started to reach the main road. At that time, it was snowing, so the cars shuffled around carefully, but without using crawlers.

The night had already covered them with the magical glow of the car lights on the white snow.

'What did you say the hostel was called?' Michael asked.

'"Erato". It has the name of our love Muse[21].'

'I think we had better ask where it is,' Michael said, ignoring her comment while simultaneously searching with his eyes for some sign. Sophia was fast to stop him.

'Stop right there before the junction. I see a big sign with a lot of names.'

Michael stopped the car in such a way that its lights illuminated the sign.

'It is on the right, in five hundred metres,' Sophia identified their position happily.

'Great! Off we go!' Michael agreed, and drove back out onto the road, being careful to avoid the car becoming stuck in the snow.

They took a downhill road on the right at the junction. The night scene was strongly reminiscent of a fairy tale.

The snow was covering everything. Only the road that unwrapped like a whirling serpent gave the landscape some contrast.

[21] In Greek mythology, **Erato** is one of the Greek Muses. The name would mean 'desired' or 'lovely', if derived from the same root as Eros. Erato is the Muse of lyric poetry, especially romantic and erotic poetry. In the Orphic hymn to the Muses, it is Erato who charms the sight.

The laden trees, looking heavy from all the snow, would let a clump of snow drop every now and then when touched by the night breeze.

The lights on the house entrances and gardens painted an idyllic vista that made the area look like a fairy village.

Unlike the street, the courtyard of the guest house was covered with snow. The wheels of the car rolled softly towards the entrance.

Michael stopped the car and fetched the suitcases. He placed them on the cleared entrance landing and went to park the car at the back of the courtyard, in front of a fountain that looked like a barrel overflowing with white foam. Sophia was waiting for him by the suitcases, wrapped-up tightly in her jacket. Until Michael returned, she came unwittingly to glorify God for them managing to find this beautiful place, even at the last minute.

The guest house was stone-built, with the traditional green Pelion stone and the arches in front giving it a grand style. In the recess of such an arch, surrounded by lights, was the entrance: hidden.

They climbed the few steps and opened the glass door. A warm wave of air with the scent of cinnamon stroked their faces.

They approached the reception and gave all the necessary information to the receptionist, who welcomed them politely.

'Your room is number nineteen and it has mountain views,' the young receptionist explained. He wore a burgundy waistcoat with badges of the hotel embroidered on the left pocket of his vest.

Michael took the key in his hand and, smiling, they proceeded to the elevator, waiting for the doors to open.

Passing in front of the living room door, their eyes paused on the beautiful spectacle they saw. A stone fireplace was burning at the back of the room, painting golden hues upon a round space, competing with a two-metre fir decorated with glowing Christmas balls and coloured lights. The festive

ambience was complete with many burning tealights scattered on the tables.

There were quite a few people seated comfortably on the sofas, enjoying the warmth of the evening with a glass of wine that complemented the colours of celebration.

This first impression satisfied them. It was exactly what Sophia had dreamed of.

'Come on, Sophia, let's go drop our things and rest for a bit,' Michael urged, as he watched her becoming mesmerised by the beauty that unfolded before her.

'We will come down later', he promised, addressing her childlike enthusiasm.

They went to the first floor. Their room was at the end of the hallway.

Michael put the key into the oak door lock and opened it.

'Wow! Exquisite! Lovely room!' Sophia exclaimed, excited. She proceeded to the back of the room, searching for the window behind the huge ivory curtain that covered the entire wall. The cold air that slipped through made her shut it quickly.

She sat gracefully on the bed and patted with her palm the burgundy blanket that covered it.

'I think we will have a great time. Don't you agree?' she asked Michael, with a look full of certainty, not allowing any room for contest.

'A perfect time, my darling!' he replied.

'Let's take a quick bath to wash off the fatigue of the journey, then let's go grab something to eat because my stomach has started to protest strongly,' he said.

They chose something light for dinner, after which they went to the lounge – Sophia considered this necessary – where they enjoyed a warm coffee, sat by the fireplace, then returned to their room relatively early. They considered that they were too tired to do anything else and intended to be very active the next day.

At some random moment in the past, Sophia was adamant she would one day learn how to ski, and this was one of the

reasons for them coming to this resort. She did not initially confess this to Michael, as she wanted, by all means, to avoid any teasing, even though well-intentioned, from a keen skier. However, it was in vain; she was unable to avoid it.

And now, equipped with a red uniform, a cap, ski sticks and skis, she hovered while trying to learn the basic ski moves on the beginner's track.

Michael, who was the main cause of this persistence of hers, tried to act as her teacher at the beginning, before leaving her to practice while he headed to the slopes.

'Next time, if you're a good student, I will take you with me to the top. As for today, just learn well the basics that I showed you,' he said before becoming lost in the white landscape.

She looked at him with a feeling of jealousy as he headed towards the lift to the slopes. The cable with chairs hanging from it resembled beads on the neck of the mountain, which caught her eye. She stayed still for a while and, supported by her sticks, she imagined herself coming down the track with the dire ability of a skier. She took a deep breath, stood up and used her stubbornness to reach her fantasy.

Two hours later, exhausted from her well-known persistence and several dips in the snow, she took off her skis and retired to the rest area, beneath a huge shed.

The warm air that embraced her made the joints of the fingers numb, even though she was wearing gloves, and they decided to make friends with the colour of her nose, which was bright red.

The smell of the wonderful local recipe of peppers and sausages, the well-known spetzofai, made her look at the door with despair, hoping Michael would appear soon.

'Good God has mercy on me!' she said to herself when she saw him entering.

He approached her smiling and sat beside her.

'I am hungry like a wolf! What do you want to eat?'

He did not finish his question.

'This traditional dish that has already swept away two of my five senses, and I soon hope that my third sense is going to actually taste it!' she said, pointing with her finger at a steaming plate passing invitingly in front of her at that specific moment, carried by a girl heading to the next table.

'I get it, I get it!' Michael said, realising what she was pointing at, and he got up and headed towards the buffet.

The mountain air combined with all their sporting exertions caused them to dine with such pleasure, enjoying every last crumb of their meal.

Satisfied at all levels, they took their equipment back to the rental shop and made their way to the guesthouse.

The hotels during these Christmas holidays were packed. Everybody was seeking various ways to pleasantly spend those precious hours of rest.

For this reason, local representatives had prepared festive gatherings to satisfy everyone.

There was the usual New Year's Eve party which each hostel prepared separately in its own space and in its own way. A music event was also organised, depending on the particular night, by the local authority in the central square, and the last alternative was a special celebration for when the clocks would strike midnight, which was held in the yard of the ski resort.

Michael and Sophia opted for the last option as something special, unusual and not always feasible. Since a grand celebration was expected in the evening, something out of the ordinary, they decided to get some rest once they returned to their room, abandoning their original plans, which had included a walk in the village.

'What time do you think we should head to the resort?' Sophia asked, lazily stretching her hands, which were stiff from the morning exercise.

'Around eight should be fine, I think,' Michael replied. 'From what I've heard, several different events will be taking place and great food will be served. They will offer a buffet so we can eat at our leisure. Of course, don't expect the luxuries of a grand New Year's Eve party. Everything will be nice and

simple, unless that scares you and you've had a change of heart...' he said, provocatively stroking her cheek with the corner of the blanket.

Instead of answering, Sophia put the pillow under her head and, after feigning a few punches towards him, she replied in a serious tone, trying to keep a straight face.

'I have not. But you probably have something else on your mind. Having your own New Year's Eve party in the room and particularly on the bed!'

'I don't think that is a bad idea at all!' he said, and stood up in a hurry to avoid a pillow that Sophia was preparing to sling at him from behind.

All morning, the sky was cloudy and the weather forecasts were predicting heavy snow falls to arrive sooner rather than later. As they walked out of the hotel, white snowflakes started gently falling around them.

Dressed in warm jackets, wearing snow boots and hoods to cover their heads, they made their way to the ski resort.

Passing by various accommodation complexes, they couldn't help but peek inside at the preparations being made, like young children. Decorations hung everywhere: two lit fawns were pulling an equally bright sleigh in front of a courtyard, and a bright red Santa Claus was smiling jauntily on the terrace of a window. They did not know what to imprint in their memory.

'I want to remember everything! These are my most picturesque Christmas holidays!' she explained to Michael with ecstasy. He was playing with a small puppy in front of the entrance to a courtyard, though not for long, as the appearance of its mother, a collie, made it run towards her, cutting short its brief escape.

They could hear their boots grinding on the snow with every stride. But as they climbed higher, the laughter and voices of everyone who joined them eradicated every other sound.

As they approached the resort, which appeared to be drawn with light on the mountainside, they saw people gathering in front of a bench. They went around and were surprised to see

two girls offering lanterns and torches to those who arrived, which would be used by those involved in the celebration. They were going to light them up when the time came.

With childlike joy, they also took two lanterns. With the 'loot' in their hands and everyone else's company, they entered the great hall.

A huge fir tree decorated with red balls and golden bows welcomed them festively. A long row of tables joined together, stood as a buffet full of delicacies able to satisfy their culinary desires. On both ends, there were drinks for everyone.

With a glass of red wine and a plate full of delicacies in their hands, they wandered around eating and making jokes with the other diners. An intimate atmosphere among friends had been created. Blame the wine or perhaps the simplicity of the whole circumstance, but everyone seemed to enjoy themselves to the fullest.

Ten minutes before twelve, they all went out. Some lit the lanterns, others lit torches, and they all waited for the signal to the countdown.

'Five, four, three, two, one…' It sounded like a victory cheer as it echoed to the slope on the other side of the mountain. A river of bright stars filled the black sky. Some of those stars opened up as colourful umbrellas; others fell like silver rain; still others whistled and spun; but all lit up the entire area and the white of the snow reflected the light as if it was mirrored upon it.

'Happy New Year, baby!' Sophia wished Michael.

'Happy New Year, my darling!' he responded with a kiss.

Wishes were coming and going from lips to lips, cordial and warm against the thermometer outside that reached zero temperatures.

With their lanterns lit in their hands, they all looked like a strange caravan from a different era that had come out looking for their heart's missing star.

Some who were lucky enough managed to find it. Others awaited next year's eve, but no one gave up.

It was past three in the morning when they got back to their room, happy and a bit tipsy from the wine.

The first half day of the year they were fondly embraced by their bed. Sweet, passionate love-making was their first gift of the season to each other, until a sensual smile drew upon their lips, revealing their happiness.

Late in the afternoon they decided to abandon their nest. They got dressed and went to the dining room. Almost everyone there was still having breakfast rather than lunch. This reduced the embarrassment of the moment. The coffee stimulated them enough, arming them with the mood for a stroll around.

It had snowed for almost the whole night, but today, on the first day of the New Year, a bright sun appeared proudly in the sky.

His rays spread out over the snowy rooftops and began to shimmer from the crushed flakes that had converted into crystal drops. Tufts of snow began to abandon the tree branches, causing a splash and shaking them upward on the release of their weight.

'The weather is looking better,' Michael said.

'It will facilitate our return trip tomorrow,' he added.

'I say we go to St. John's church first. In the winter the sea has a wild beauty that excites me! Just like this snowball... Catch!' Sophia said, forming a snowball with her hands which successfully struck him.

She caught him on his throat. A little bit of snow slid prying into his jacket. This was enough cause for the most painless 'white war', where the only victims were their wet clothes.

'With all this snow around, I can't even lift a white flag! You won't be able to see it! I surrender!' Michael said tenderly to Sophia, and embraced her by the waist.

'I surrender in your arms, your Majesty!' he whispered in her ear, stroking it with his hot breath.

Sophia let the snow drop off her hands, then lifted her arms, hugged him and gave him a passionate kiss.

The meeting point of two great powers always causes awe. This is the best word to describe it: 'Awe'. This word, with its one syllable, is the only one that can describe that feeling of spectacular amazement.

Enormous grey rocks were erected at the edge of the vast sea. They looked like giants, whose resistance to the waves hurled them into the air, like a white cloud bursting forth with such force that it drags everything in its path.

A natural magnetism came from inside them and triggered the young couple's desire to approach closer.

They climbed down the slippery green rocks very carefully.

They approached just close enough to avoid getting soaked from the waves bursting powerfully on the rocks, forming a huge umbrella as they retreated. The power of nature, its grandeur, the wildness and the awareness of humility for their existence, translated into a catalytic purification of feelings.

'Sometimes I regret that such moments are so few, like now: I feel within me the wisdom of God. We people forget so easily that in fractions of a second you can be overthrown and, almost always, we are unprepared for it, lost in our vanity.'

'Why do you say that?' Michael asked Sophia.

'The first thing that you feel when you see the battle between nature's elements, when you are so close to them and you feel the risk, is fear. It is much later that our human, healthy thoughts arrive. This is exactly what is missing from the technological, sometimes fake lifestyle we lead. Usually, while we do experience such physical battles in our everyday life, in different events, and often with dramatic results, we let them pass us and never let them touch us. We put our dark glasses on and pretend not to watch! We do not listen to that little voice inside us that warns how dangerously near all these are and how, at any time, they can become ours, sticking tragically upon our skin.'

'That is why they find us criminally unprepared and have a heavy impact, first and foremost towards our own self,' Sophia explained.

'But for you to feel the attraction and to find yourself here, it means that you have within you, even in a vestigial form, this quest towards humility, supported and fed by your contact with nature, and that leads to life-saving thoughts. Isn't that right or am I wrong?' Michael asked her.

'The truth is that I try not to let humility sleep in me; "in peace". I don't think I am doing a very good job though. You see there are around us so many events still "asleep" that are making my life difficult.'

'Think,' she said to Michael, emphasising the words, 'that Saint John the Theologian, whose name bears the particular place where we are, wanted to retrieve from the hearts of the people writing the Apocalypse, that inspirational book which I think is the most important after the Bible, this exact feeling of humility.'

'I agree with what you are saying. These are difficult times for the human race. We must strive to see the truth, which often is "right under our nose",' Michael said to Sophia.

She remained silent for a while. You could see in her eyes that she was travelling in her mind. After a while, she looked at him and said:

'I have promised you, though, as I've also promised myself, that I owe both of us a pilgrimage visit to this holy place that this futuristic book talks about.'

'Even though I was young and did not understand much, this place was pulling me like a magnet when we lived on the island. My mother took me there often, but most of the time it was Grandma Sophia who took me there. Perhaps that is why it keeps twirling in my head!'

'That is where I will take you! At that place, where the human condition is eliminated against time by His divine intervention and His grace that emerges!'

They left the imposing rocks and went to the tranquillity of the coast.

Sophia leaned over and out of the millions of stones lying by the sea, she picked up a round white stone.

Their return included stops in small green villages that adorn the entire mountain of Pelion.

In the afternoon, they visited Kala Nera[22]. Overlooking the sea and with a glass of ouzo in their hands, they enjoyed their delicious appetizers, prepared for them with great care by Mrs Efstathia, the owner and cook of a picturesque tavern on the edge of a small creek.

The 'loot' of their tour, except for the innocent theft from the beach of Saint John, was a small pot with a green azalea, loaded with small buds. Raised in yards and gardens, Sophia could not help but nourish her great love for flowers.

She looked after the azalea as if it was a little baby, and waited anxiously for spring time when it would reciprocate that love by revealing her beauty.

And spring came. One morning in May, as Sophia was sprinkling the azalea leaves with cool water, she saw the first timid bud trying to open its fuchsia petals. It was like a chick that emerges from its egg, slowly breaking the shell.

Sophia always counted her flowers as if they were precious to her. Sophia counted thirty beautiful little flowers that whole month until, in the end, she could not even distinguish a single green leaf. Everything had been covered by the beauty of life, regeneration, flowering, maturity: it is an unfinished life cycle without death. Sophia, usually, tended to refrain from referring to him – Death – but she was well aware of his existence.

[22] **Kala Nera** (meaning 'good waters') is a village in the municipal unit of Milies, Magnesia, Greece. It is situated in the western part of the mountainous Pelion peninsula, on the Pagasetic Gulf coast. It is 3 km southwest of Milies, 5 km southeast of Agios Georgios Nileias and 17 km southeast of Volos.

CHAPTER 9
'A Double-edged Knife'

The small azalea grew, year after year, and every spring it made sure to reward Sophia with its presence. It had now grown to be a respected shrub and, of course, it was unique. It was not just a plant. Sophia spoke to it, she caressed it and even played melodious music for it to listen to. For Sophia, it was a living creature. It was as if it understood her, but it could not talk to her, or rather it did in its own special language.

She had put the azalea in a prominent place, in front of the window, where it never got too sunny, and she was proud of it. Of course, she had also learned all its characteristics from a suitable book on how to groom and take care of it.

The 'older' the azalea got, the closer Sophia approached the end of her degree, and the more she tried to avoid death – not with its literal, mortal meaning, but the metaphorical one referring to situations and events in life – the closer Sophia felt it coming: without any proof, or even evidence, only some vague aches and tightness she felt in her stomach, which prepared her for and reminded her of some unpleasant situations from the past.

All these years, Michael and Sophia's lives were sometimes flowing hastily and, at other times, rather slowly, depending on their feelings through various glitches, and in direct conflict with their goals. The battle was tough and the standards set by Sophia were very high. Through time, the nuggets of her desire to specialise in oncology grew, forming inside her a decisive and clear shape. She was now certain. It

was what she would pursue in every way her human strengths would allow. Once she was set upon that decision within her, she started programming all the necessary movements to make it happen.

She started looking online and seeking her professor's opinion on the most appropriate medical centres where she could develop the specialisation she wanted. She had several suggestions and options that she could pursue, always aiming for the best. Her very final decision took her a while to make, and the price she had to pay for it still tormented her mentally.

A twinge in her stomach recalled and clarified the problem for her, which had now begun to take shape and form, becoming visible.

'So this is what has triggered my instinct and sent these signals to my body,' she wondered.

'This is the metaphorical death of a relationship and the shift to some other level: a more distant one…'

She was left staring at the white colour of the wall, letting her mind run: undisturbed.

She knew she had to do what was best, and the best in her opinion was a scholarship at a medical centre in America.

America was a double-edged knife for her: a key crossing point for her life-changing course.

The two sides of herself were fighting each other, with her, as a whole, being their victim. She knew she had to choose. She knew that whatever she left behind would hurt her.

'Michael's absence will really affect me! He is part of my life and I have to find a place to "put" him, a place to keep him in my heart so that at least it won't hurt too much! But again, I cannot deny myself and my life's dream. Without it I will be incomplete and then I will hurt even more.'

'I hope "my" Michael understands that. I am not saying that it is easy… I don't know… I really don't…' she said aloud to herself in a state of despair.

'Oh please God, I hope he understands me!' she said and put her hands on her head. She closed her eyes and wished for them to find ways of understanding.

'He must! At the end of the day, he has studied psychology! What the heck? We'll figure it out,' she said decisively, opening her eyes. Through them, a glimmer of hope flashed.

Pressured by her thoughts, she chose to find a way to let go by exhausting her body in a walk, which would prevent her from thinking anymore.

She grabbed her purse and walked out of her flat. At first, she almost ran, though she did not know where to go. She just walked until her footsteps led her to a grove and a sign made her heart beat loudly.

'It's a sign from God. I will not back down! I will make it!'

She proceeded to where the signpost led her.

Lost among a cluster of ancient pine trees, she saw a small church in which barely five people could fit. Above the iron entrance was a marble plaque with golden letters: 'SAINT JOHN, a kind donation by the Meletiou family in remembrance of their beloved daughter Sophia.'

She found the coincidence in the name fascinating.

'God is telling me something! I have to understand it! Why have I arrived here?' Thoughts were running through her mind with lightning speed.

She turned the doorknob and the door opened. She walked hesitantly inside. It looked like a large iconostasis. She made the cross sign and looked around to see if there were any candles, but found nothing.

Her eyes wandered over the icons. She stopped at one that spoke to her heart. At the bottom of it, with Byzantine writing, it read: 'Saint John'.

Time stopped. She did not even realise how long she stood there upright, her eyes fixed on Saint John's icon. A warm wave of air stroked her face and brought her back to reality. A peace prevailed within her, like some divine intervention: salvation that was catalytic.

'Thank you, God!' she said, and walked out of the church with the sweetest expression now blossomed upon her face.

'We must find the strength and the courage to tell him, to prepare him for what is to come,' she thought.

Michael knew that Sophia would, at some point, move away from him, but only briefly, he thought, until she completed her specialisation. His mind could not even grasp the turn of events that was about to take place. He'd rather not even think about it, because he was aware of Sophia's wishes, he had heard them, but he considered them somewhat vague and perhaps a bit unrealistic. But see how those wishes were now approaching dangerously…

'For some reason, I am having a horrible day. Everything is going wrong since this morning. Anything that could set me back has happened! Why?' Sophia wondered while closing the window.

The air that suddenly started blowing was torturously making the shutter bang, and it was getting on her nerves.

Michael and Sophia had organised to have dinner together at her place at about nine. Sophia looked at the clock on the wall for the tenth time. Its minute hand had lost its soft circular movement and had started to behave like a rusty ray, struggling to move.

'We will have dinner with poison for dessert!' she thought, and despair almost overtook her, but she did not allow herself to enter that state of mind. Instead, she was overwhelmed by stubbornness.

'No! I have to tell him and I will!'

At quarter past nine, the doorbell rang. She gave the dinner table one last cursory glance and then went to the door.

Michael appeared smiling with a bottle of wine in his hands. He offered it to her along with a warm kiss.

'What are you going to spoil me with again today?' he asked, sniffing around ostentatiously with his nose and trying to guess what the odours he could smell were hiding.

'Sit at the table and you will find out!' Sophia said.

'Whatever it is, it smells wonderful!' he said, pulling out a chair to sit upon.

'Open the wine and I will bring the rest…'

A platter of beef rolls topped with white sauce and potatoes for garnish was the excellent food she had prepared. They enjoyed it with wine that accompanied the dinner just like a perfect companion complements his mate.

'Excellent! I give you ten out of ten!' he said, leaving the fork on his plate, obviously pleased.

'You are very kind, sir! Thank you very much.'

'Let's make one last toast. In what you really desire, to achieve and to enjoy, and do not let anything spoil that!' Michael said, prophetically.

The words after a glass of wine come easily from the lips, but sometimes they are difficult for the ears to receive.

Sophia got caught up in his last sentence and tried, with artificial simplicity, to naturally and at last convey to him her decisions.

Even though she looked comfortable, her heart reached her mouth when she had to blurt out the word 'America'.

She realised that it was so much more difficult to tell him than she had imagined or wanted to believe.

Her words created a grotesque situation. After a few minutes of silence, only the tunes on the digital disc remained unaffected. Michael, with all the calmness in the world, which he recruited from the 'composure warehouse' within him, wanted the fine details of the considerations which had led her to this decision.

He was so calm that Sophia was concerned at first. But that flicker on the edge of his lips, for someone who knew him as well as she did, gave this moment its real dimension.

If she could open his soul, she would see a landscape that was swept by a wild storm at the moment the raging sea slams upon the rocks: just like the rocky beach of Saint John. That is how her words had slammed inside of him, lifting all the sadness into the air and making it swirl with unrestrained speed.

But we are talking about Michael. When he was in pain he would turn into a sphinx. He did not allow anything to come out, at least to those who did not know him.

It took some time for him to accept Sophia's decision. At first, he discussed nothing about the issue and their conversation always steered another way. Sophia did not try, by any means, to bring that discussion back to the surface. She left her decision to mature inside him and waited for time – her assistant – to do its job.

In fact, Michael was hard up against himself. He knew what the right words were. He knew the right advice he should give someone who is a psychologist's patient, but now he had the most difficult patient right in front of him: his heart. Any reasonable advice would, at first, fall on deaf ears. He had a very deaf patient on his hands who did not understand a thing, but with his insistence, on the one hand, and his unbearable pain on the other, he had to somehow put things into perspective and strike a balance. After lamenting this upcoming loss, his soul softened and that is exactly where his love shone. He always wanted the best for Sophia and wanted to see her happy.

He never told her what a difficult time he went through trying to accept this. He did not want to fill her with inhibiting guilt for what she intended to do. He wanted her to be clean of any guilty feelings and undefiled by any bitterness. And eventually he managed to discuss the topic again, which, in itself, had so many parameters to find solutions for that eventually raising that topic again was indeed helpful to Sophia.

He was the only – truly close to her – person who could support her, not so much on the practical problems she faced, but in the crucial decisions she had to make.

She evaluated his opinions, his judgments and, almost always, she would also hear his objections or doubts, and this was such a big task for her. She could not, by any means, make any serious mistakes and misperceptions.

The first and most decisive next step for her was the scholarship. She fought to secure that scholarship with everything she had. It was difficult. During the time of the exam period, she walked in a world where she recognised nothing but medical terms. Thank God Michael was there to keep the

balance in their everyday lives, and he did not let her become lost.

After a difficult month, the most difficult of her entire life to date in terms of studying and fighting against her agony to succeed, Sophia managed to attain the desired grades and was finally able to hold in her hands the much sought-after passport for America: a scholarship.

The morning she was alerted by John, the head of the student union, that their grades had come out, she was unable to deal with it alone. She grabbed the phone and dialled her precious assistant's number.

'Michael, help! I cannot go alone. I can't feel my legs and my eyes refuse to see!'

'What happened sweetheart? Where do you have to go? What do you want to see? Calm down and tell me!' he said sweetly.

'Our grades have come out and I cannot face this by myself. Please come with me, I need support...' she said, as anxiety started dancing on her breath.

'That's why I am here silly! I'll be there as soon as possible. Get ready! Although I have no doubt that you have succeeded. You studied so hard! I say you've got that scholarship in the bag!'

'I don't know. I don't know! If we see it with our own eyes, I mean your eyes, because I can't bear to look, only then will I believe it... Come on! Hurry up!' she said, addressing the situation with a wave of stress that overcame her.

When they approached the posted grades, she hid behind him, hugged his waist, leaned her head on his back and said:

'Now that I am supporting myself on you, tell me! Slowly and clearly, so that my ears hear the truth and not what they want to hear!'

He read each of her awarded grades one by one, and her hands started loosening on his waist. When he read the very last one, she let go.

'Wait a minute, I'll be right back!' she said.

He looked at her, wondering.

She walked away from him in a direction that was not crowded. From afar he saw her stopping in front of a wall as if she had forgotten something and was trying to remember. He did not understand.

Sophia, just as at the beginning of her university career, considered it obvious to first inform her mother, even if only in a conceptual way, because she truly believed that she could always listen to her. More so now, she wanted her to be the first to hear about her success. It did not matter that Michael was the first person to find out as she considered them to be one.

She turned around smiling, with her hands up in the air, cheering.

'We made it baby! We did it!' she said, hugging him.

Clearly emotional, Michael looked at her green eyes, which radiated joy.

'Well done my girl. You deserved it and you conquered it fairly!' he told her proudly.

Sophia, of course, felt the need to confide in him the cause of her short sudden 'disappearance' and how it was important for her.

Michael smiled without saying a word.

At last, the road lay open in front of her, except that it was going to be a very lonely road. This was not what she wanted, but it was also not something that would stop her. She had already made her choice.

'I have to call my father and Maria, to tell them the good and the bad news. They do not know much. I kind of mentioned the possibility of going abroad, but I did not tell them about America. I will tell them when I go home. I now have something else to do that I had promised us!' she said with a burst of vigour.

'I'm going to book our ticket for the ferry. Patmos is waiting for us!'

'Excellent idea! We will celebrate as we should!' he said, looking visibly excited, though a little voice inside him, a sharp

needle, pricked his heart with the words: 'This is going to be our last summer vacation together!'

Michael changed the subject, wanting to move away from what was chasing him.

'So what are your plans about your specialisation? Have you given Mr Kaliris any clues? I think that will be helpful.'

'The only certain thing is that he can assist and I am sure he gladly will,' Sophia replied to him confidently.

From the early years of her studies, Sophia was an outstanding student. Her goal was so defined and her love for this profession was so eminent that the combination of those two always gave her the lead as far as her grades were concerned. Her first reward from her professor, Mr Kaliris, was the position of assistant. Mr Kaliris was 'a Man with a capital M': that is how Sophia referred to him.

'I will never forget his first words in the auditorium,' she said to Michael.

'The first day I had chosen to sit somewhere in the auditorium's middle rows. Soon after, the professor entered. You know, with the typical aura of a university professor: with gold glasses and a black leather bag in his hand. He reminded me of our math teacher in high school, until he started talking. Then, everything changed. After welcoming us and wishing us a good academic year, he gave us some helpful advice on courses, workshops and other miscellaneous stuff. At the end of this advisory speech, he concluded with these startling words: "Never forget that firstly we need to be human beings and then doctors. Any patient we have in front of us needs to feel that. That is the difference that makes this profession more than just a profession!" That's why I said to you earlier that if there is anything he can do to help, he will do so generously,' Sophia explained.

And she was absolutely right.

Mr Kaliris offered her the chance to shadow him occasionally as his assistant, making sure Sophia covered, every now and then, the position of a rural doctor a short

distance from Athens. This enabled her to come and go without having to change her place of residence and without losing out on necessary contacts.

'So, we still have a year ahead of us to be together,' Michael said happily, having at the back of his mind the long journey, which, in the depth of his soul, seemed like his biggest enemy.

'Hopefully! But let's not consider it as the end of the world. Anyway, we will spend some of the holidays together, a few summers perhaps, and also with the internet bringing us close it will almost be like we are still together,' she said, trying to shorten the distance across the Atlantic.

'Well said! "Almost",' Michael replied, stressing that 'almost' verbally.

'But it is your choice and I must respect it. Moreover, I think I have already proved that I respect it,' he said to her, trying to soothe his earlier ironic comment.

'You are the best! The one and only!' Sophia said with emphasis, and some feelings of guilt overcame her, for a very short time, as she felt that she was taking advantage of him. She immediately nudged those thoughts aside though, pushing them forcibly to the back of her mind, intact.

Towards the end of July, Sophia kept her promise.

CHAPTER 10
'The Island of the Apocalypse'

'Neptune' was a large ferry that visited the harbours of many islands, serving people's summer getaways.

That was the ferry in which she chose to travel to Patmos with Michael; the name inspired her. At eleven o'clock exactly, they were in the harbour ready for boarding the ferry. The crowd waited in front of them and some people had already begun to board.

They climbed the stairs up to the first deck. They had not booked a cabin as they were travelling during daytime and the trip was too beautiful to spend in a cage. They put their things on a bench on one side of the deck and leaned on the railing to watch the crowd that continued to board. Any type of contact Sophia had with ships and the sea caused her mixed feelings, but this time she chose to keep close to her only the beautiful feelings.

The ship was carrying several trucks, transporting goods intended for the islands. Every time a big truck was boarding the ferry, it would swing gently like a seesaw, and it seemed like the ferry was entertained and happy like a child.

Michael was holding Sophia by the waist and staring at her discreetly, trying to store in his mind and soul as many beautiful moments as he could. At twelve o'clock, the anchor ropes were released from their iron hooks and the ferry lifted anchor. The engines began to push it slowly forward. At slow speed, they exited the port of Piraeus and the ship set sail towards the east.

They went past the coast of Attica. In the background, the temple of Apollo on the Cape of Sounio[23] was distinguishable: imperious remnants of a glorious era.

'The temple has another grandeur when viewed from the sea,' Sophia said.

'Imagine how magnificent it would have seemed in those ancient times, with the ships passing by in front of it, and certainly not like the one we are travelling in,' Michael replied.

Soon the temple columns were two long scars in the sea.

Michael and Sophia left the railing and sat in their seats.

'What I enjoy most about travelling by ship is the wonderful island songs that sound from the loudspeakers. Just like at this moment: those songs tie beautifully with the blue colour of the sea!' Sophia said. 'People go up and down arriving at harbours, and people on the islands yearn for the arrival of ships. From what my dad used to say, life on the islands is difficult, especially in winter. In summer, with all those visitors, they are at least much busier. When, however, the temperatures start to drop and the winds start blowing over

[23] **Cape Sounion** is a promontory located 69 kilometres (43 miles) south-southeast of Athens, at the southernmost tip of the Attica peninsula in Greece. It is noted as the site of ruins of an ancient Greek temple of Poseidon, the god of the sea in classical mythology. The remains are perched on the headland, surrounded on three sides by the sea. The ruins bear the deeply engraved name of the English Romantic poet Lord Byron (1788–1824). The site is a popular day-excursion for tourists from Athens, with sunset over the Aegean Sea, as viewed from the ruins, a sought-after spectacle.

the Aegean, Aeolus[24] is partying and islanders say their prayers!'

'How long has it been since you last visited the island?' Michael asked.

'The last time I was there,' Sophia made a short pause and continued, 'it was the funeral of my Grandmother Sophia, and I was with Dad, before entering university. Her death really scared me. It was really difficult for me! Two of my favourite people passed away and left me almost at the same time. That's why, all these years, I avoided visiting the island. All the memories I had from it were filled with pain that came alive like a ghost back then and, even now, haunts me still.'

'Did you let the house during the summer?'

'We used to rent it out to a retired Austrian couple for several years. They worshipped the island, but Frau Matina (that's what they used to call Mrs Hefner) died last year and Mr Marcus, her husband, returned to Austria to be close to his son. Mr Marcus was too old to live by himself.'

'And now? What are you planning to do with it?'

'I will probably rent it out again. It is the only legacy my mother and my grandmother have left me and I will try to keep

[24] **Aeolus**, a name shared by three mythical characters, was the ruler of the winds in Greek mythology. These three personages are often difficult to tell apart, and even the ancient mythographers appear to have been perplexed about which Aeolus was which. Briefly, the first Aeolus was a son of Hellen and eponymous founder of the Aeolian race; the second was a son of Poseidon, who led a colony to islands in the Tyrrhenian Sea; and the third Aeolus was a son of Hippotes, who is mentioned in *Odyssey* Book 10 as Keeper of the Winds. The latter gave Odysseus a tightly closed bag full of the captured winds, so he could easily sail home to Ithaca on the gentle West Wind. However, his men thought it was filled with riches, so they opened it, unleashing a hurricane, which is why their journey home was extended. All three men named Aeolus appear to be connected genealogically, although the precise relationships, especially regarding the second and third Aeolus, are often ambiguous.

it in good condition as it has great sentimental value for me. The only way we can do this is to have someone to care for it because I…' Sophia stopped and shook her head, knowing that the future ahead of her held no regular visits to the island, except as a tourist; rarely.

'You never know! You might come to stay here forever someday as a grandmother with white hair and a walking stick in your hand!' Michael said and laughed, fetching a book out of his bag.

'Yes… Maybe…' Sophia whispered and lowered her eyes. Her mind sank into a blank thought, as if in an empty room with white walls, with no windows and no door, only light, a lot of light.

Sophia was so annoyed by that white, as if blinded. She unconsciously closed her eyes and, when she reopened them, she realised that her eyes were looking at the floor, not her mind.

The unattractive iron deck benches were coated in a dark blue oil paint. Their surface was so uneven that they looked to have been caught in a sandstorm during painting, with all the sand having stuck to the fresh oil paint. They were secured to the floor with two large iron screws. Just where a small recess had been formed from the excess paint, something caught her attention. As if awakened, she said to Michael:

'What is that?' and she leaned over to see better.

She sat on the bench like she was riding a horse and she leaned forward, stretching her body. What she saw was at such a distance that her eyes could see it, but her hands could not reach it. She stood up and leaned forward even more, holding out her left hand in a posture reminiscent of the famous painting by Michelangelo, in that amazing display of the perfectly stretched laxity of the index.

'Come on. A little bit more!' she said to herself, and grabbed it with two fingers. She brought it close, taking a deep breath, and she started scrutinising it with her right index finger.

'What is it?' Michael asked, and leaned towards her, clenching his eyes to see better.

It was a sea-blue stone shaped like a drop caught on top of a golden palm. It moved towards Sophia's left hand. She let it roll to the right, then to the left, shaking her hand. In every move, small glittering flashes were surrounding it. Sophia scrutinised it with her eyes.

'It is very beautiful! Look at it!' she said to Michael, and held out her hand for him to see.

He caught her hand in his and brought his eyes closer.

'It looks like a small lake in the plateau of your hand. Like the beautiful blue sky on a sunny day,' he said, revealing his imagination.

'I wonder who could have lost it?' Sophia asked.

'Whoever lost it was unlucky!' Michael assessed, shaking his head and leaning back. He stretched his legs forward and was lost in his book again.

Sophia was still looking at it, smiling.

'This is my lucky charm! I am lucky to have seen it over there, where it was hidden. It was trapped in the recess created by an air bubble bursting in the blue oil paint. Its golden buckle shined and that is how it caught my eye,' she said, rather talking to herself because Michael did not show any reaction.

Sophia cleaned the dust off it with a little water, and it appeared to be even more glamorous. Sophia's gaze sank into its crystal waters and the freshness brought a shiver to the spine.

Sophia took her bag from beside her, placed it in front of her and proceeded to make a 'nest' in the fabric. She carefully placed the charm in it. She unbuckled the necklace she was wearing, with the gold cross that Maria had given to her, and threaded the chain through the charm. She lifted it up into the sunlight and admired it.

Wearing it around her neck, she suddenly felt enriched with a trickle of power, equal to a drop from the sea.

A young couple approached them. The girl asked if the seats next them were free. Michael replied affirmatively, so the couple put their things on the floor under the bench and sat down.

They were about the same age as Sophia and Michael.

The girl had long blonde hair tied with a rubber hairband on the back of her head. Small blonde tufts escaped from her tied hair and waved around her face like crazy. The sea breeze did not leave anything in its place. She wore a pair of jean shorts that were worn out like an old mat. On her white shirt, a few shimmering beads formed letters spelling the word 'Paros'[25].

The boy had a very dark complexion and short hair: ideal for summer. He was wearing designer clothes and shoes, showcasing the appropriate 'life-style' for the season, and was also partially concealing some attitude behind designer sunglasses.

'They seem like an ambiguous couple!' Michael whispered to Sophia.

Sophia looked at the girl's blouse.

'Do you like Paros?' Sophia asked the girl, smiling.

'Oh! Yes. It is outstanding! That is, of course, if you want to have a lively holiday. It is a cosmopolitan island, it has great nightlife and you will have many sleepless nights!' she replied cheerfully.

'Is that where you are going?' Michael asked the young guy.

'No, no…' he answered slowly, with a serious tone.

'We are heading to another destination. We are going to Patmos. It is quieter, more picturesque…'

[25] **Paros** is a Greek island in the central Aegean Sea. One of the Cyclades island group, it lies to the west of Naxos, from which it is separated by a channel about 8 kilometres (5 miles) wide. It lies approximately 100 miles (161 kilometres) south-east of Piraeus. The Municipality of Paros includes numerous uninhabited offshore islets totalling 196,308 square kilometres (75,795 sq. mi) of land. Its nearest neighbour is the municipality of Antiparos, which lies to its southwest. Historically, Paros was known for its fine white marble, which gave rise to the term 'Parian' to describe marble orchina of similar qualities. Today, abandoned marble quarries and mines can be found on the island, but Paros is primarily known as a popular tourist spot.

'I am Marios by the way,' he introduced himself, considering that the introductions were long overdue, 'and this is Antigone,' he said, pointing at the young lady.

Michael and Sophia also introduced themselves.

'We are also going to Patmos,' Michael said casually, in contrast to Marios' stiff manner.

'It is Sophia's place of origin, so we decided to go for a few days to escape the city and to relax.'

Antigone tried to tuck behind her ear a lock of hair that was waving like a curtain in front of her face. She did not succeed, however, and just left it there to flap around. Undisturbed, she posed her question to Sophia.

'We have never been to the island, this is our first time, but we've heard that it is quieter than others.'

'Indeed. It is a special place. Usually visitors go for religious reasons and to combine that with their holidays. It has beautiful beaches,' Sophia replied.

'But if peace and quiet are what you are looking for, I believe you will definitely be satisfied,' Michael added, looking at Marios, who listened silently.

They wished them happy holidays and Michael picked up his book again, looking for the bookmark.

Sophia sat as comfortably as she could and was engulfed in a magical contemplation of the sea.

Their two travelling companions chose – quite oddly, Michael thought – to play backgammon.

'This game does not suit his character,' Michael thought, acting as a psychologist. It seemed contradictory to his previous presentation.

Antigone took a black cardigan from the bag lying on her legs and spread it out onto the wooden planks of the bench.

From an elegant bag, Marios retrieved a narrow light blue box. He opened it and carefully placed it over Antigone's jacket.

The white and blue circular magnetic checkers appeared as Marios opened the box, and they looked as if glued together in this strange work of art.

Antigone separated each checker, one by one, and placed them in their starting positions.

Marios grabbed the dice. With a militant cry and an aggressive smile, he said to Antigone:

'Get ready to die! Right now!'

Michael was stunned. He could not believe what had just left Marios' mouth. He did suspect that Marios was hiding something under that mask of pretentiousness, but he certainly did not expect it to be revealed that fast. Michael hid a smile, shaking his head at the same time Antigone gave Marios an appropriate response:

'It will not be as easy as you think!'

The ship sailed calmly towards its destination. The Aegean Sea flooded Sophia's vision, as if some magic hand had thrown a bucket full of blue paint onto the floor, forming streams running off in every direction, showering anything they found in their path.

Two of those paint drops slipped through the doors of her eyes and ran powerfully through the winding pathways of her brain. The red of the blood mixed with the blue from the sea. She almost felt that salty taste on the tip of her tongue.

Thousands of small droplets, the full sea squeezed, flooding across the surface of her forehead, into the cavities of her eyes; they were balancing on her eyelashes and, in the end, they rolled over her red lips, trying to open the door of her castle; trying to convince its queen to offer them hospitality.

The sweet notes of a traditional island song brought her back to the sea's surface. A zither welcomed her with the tremble of its strings and the white foam of the sea embraced her, bringing her back to the present. She sat up in her seat and stretched up her arms, as if she had just awakened from a magical dream.

Not far away, on the horizon, the first port appeared. A frantic motion engulfed the ferry. Passengers that were going to disembark were crowding all the exits.

On the bridge, the captain was preparing to manoeuvre the ferry for disembarkation, and the boatswains, with thick ropes in their hands, were ready to throw them to the pier to tie the ship ashore.

Such contradictory situations all crammed on the same route; on the one hand, the carefree holiday spirit, and on the other, the sweat of labour: both travellers in the same moment in time, who almost never travel alone.

A raucous noise prevailed over the unfolding mayhem. The thick iron chains that were holding the anchors descended slowly, aiming for the seabed. A loud splash was heard and the anchors disappeared before their eyes. The ramp was released and anxious for contact with the concrete pier. Their meeting proved tough.

People and cars poured onto the ramp. Horns, voices and engines revving, trying to climb up the ramp, completed the intensity of the moment.

A port official with a white nautical outfit was trying to arrange the vehicle and crowd exit. He was waving his hands and supporting them with the sound of a whistle in his mouth, giving instructions.

At the pier, hotel owners were fishing for customers. Others expecting customers were loudly calling out the guest's names for the newly arrived to hear. The captain was carefully observing these events from above.

Like a tap that dries out and with a last drop, a red truck headed towards the exit. The person in the white outfit turned to face the opposite direction, looking at the queue of cars waiting patiently for their own incarceration in the basement of the ship, and the whole process began again in reverse.

A small ripple was caused on the sea's surface every time a big truck descended to hide in the ship's bowels, and a flock of seagulls was watching every movement of the water carefully for signs of lunch.

Passengers leaning on the deck railings were discussing among themselves the events taking place with the rapid speed of a relay race.

After about half an hour, the last 'athlete' arrived in a small white truck, bearing the sign 'Sakis' Candy' on its side.

And before the small truck was lost among the others deep inside the ship, the dark-haired man, with the whistle hanging against his chest, beckoned with his hand for the hatch to be raised.

He was still standing on it when grey ropes began pulling it upwards.

The group of casual friends, so recently formed, kept an input and output record of how many people entered and exited the ship, commenting and laughing all this time.

'Let's go to the bow to see the departure!' Michael cried with obvious interest, leaving the others behind him to follow.

The entrance to the bottom, where the anchor ropes, chains for the anchors and other necessary tools were gathered, was closed to the public. But you could see the big iron bobbins on which thick chains would coil up, making the two anchors of the ship look like dangling earrings. The anchor ropes were wrapped around, forming a thick brown pipe.

Everybody was running and executing commands. Sophia rested her jaw on her palms and fixed her elbows on the railing. She watched carefully, trying to understand the whole process, when an airy slap hit her on the cheek. Like a shadow bolting from the blue, she saw a brown snake twitching like crazy in the air. It went a few centimetres past her left cheek. Her instantaneous reaction was to spring backwards with bewilderment. She turned and looked at the others who were standing a few steps further back, and the terror was evident in her eyes.

Michael ran like a bullet towards her. He grabbed her by the arm and asked:

'Are you ok baby?'

'I was slapped in the face by something brown, but I don't know what it was!' she said, and put her hand to her cheek.

'Have a look. Has it gone red?' she asked.

'Just a bit. Thank God! Baby you were very lucky! You have no idea what could have happened to you!' he told her, still pale from what he had seen.

'Are you okay Sophia? Are you hurt?' they all asked her, touching her gently on the shoulder. Antigone and Marios were visibly agitated too.

'Are you going to tell me what actually happened? I only saw a brown shadow!' she said and looked at Michael.

'It was rope, Sophia, a cut rope that could have cut your head off like a knife!' Michael told her, and terror was born in his eyes by the mere mention of it. He held her tightly in his arms, trembling at the thought that he could lose her.

His eyes welled up with tears, but he kept his temper and just tightened his arms around her. She was here; beside him.

'Thank you, God!' It was like a prayer inside him.

His breath returned to its normal rhythm. His temples finally loosened and his wrists too.

But before they could recover, thinking of what could have happened, a strange stillness of the boat and an even more peculiar commotion at the bow brought everyone together towards the front. The crowd had already gathered when they arrived and all they could hear, as they could not see, were exclamations of sadness.

'Poor child!'

'I wonder what happened to him?'

From listening to people's words here and there, they reached a conclusion.

'A ship worker was hit on the head. From what I understand, a cut rope hit him on the head while the ship was trying to keep still,' Marios said, and added, 'Sophia you were lucky today. The piece that got detached passed right in front of your face and then fell into the sea.'

Sophia listened to him dumbfounded. Only then did she realise the danger that had flown right past her.

Seeing an opening in the crowd, Marios ran to the rails for a clearer view.

Michael observed him all this time, from right after the incident, and it was like he was seeing a completely different person. A thought came to his head and he said it aloud to himself: 'Oh, these damn facts of life that gather all the things we cannot gather in our character!'

He followed the girls as they jammed in next to Mario, just in case they managed to see more.

The disruption was manifestly evident. Many men in and out of uniforms were crouching over a relatively young man who was lying on the iron floor. A red stream of blood was running from his nose. Someone, probably a doctor, was trying to assess the situation by examining him. The remaining workers, obviously shocked, had gathered in a corner and watched anxiously. The man who examined him stood up and passed his hand over his forehead, trying to reach a conclusion. He pulled his cell phone out of the pocket in his trousers and spoke to someone.

After that he leaned over the young man again, holding his hand.

'He is taking his pulse…' Sophia whispered to Michael.

They tried to fashion an improvised sunshade to protect the man from the hot rays of the midday sun. They did not dare to move him at all: not even one millimetre. They simply sprinkled his face with water every now and then.

Soon the sound of the ambulance siren tore the air, declaring the emergency of the situation.

The ambulance stopped in front of the ramp that had to be lowered again – no one knew exactly when that had happened – and two paramedics were lost in the bowels of the ship. Soon they appeared again with a stretcher in their hands. For a while, no one could say who was a sailor and who a nurse. They all looked the same in that moment with their white uniforms.

They moved very quickly, placing the man carefully on the stretcher, immobilising his neck with a collar and tying him down with straps.

'The man has probably suffered some traumatic brain injury!' Sophia stated.

'The blow was indeed strong. Think of what you felt from the shock wave when that thing went past you!' Michael replied.

The ambulance left, screaming for first aid.

The ship, on the contrary, departed to continue its course very quietly.

With mixed feelings in their souls, they returned to their seats. Marios and Antigone went to the bar to bring coffees. They needed something to stimulate their nervous systems. Michael hugged Sophia lovingly; she rammed her body into his arms and leaned her head onto his chest, feeling safe with him. They remained in this tender embrace for some time, talking with the warmth of their bodies, with the gentle touch of their hands.

At the other end of the corridor Antigone and Marios reappeared, holding a paper tray containing four plastic cups with different coloured straws in each.

'The order has arrived! The coffee with the red straw and extra sugar for Sophia! Michael, the one with the green straw is yours. Marios, you have the purple one. And, of course, the one that is left is mine. Everything okay?' Antigone asked, like a good hostess, while trying once again to settle that blonde curtain of hair that was still bothering her.

With a coffee in their hands and a discussion on current films, the atmosphere lifted.

Little by little, smiles started to regain their lost positions. Sophia's emerald eyes found their lustre, once again and Michael... Michael was just happy that he had her there with him, safe and secure.

The horn of the ship sounded three times: an infallible sign that they had reached a harbour. The sound reverberated on the mountain behind which the sun was now preparing to hide in the west, and, echoing, it scattered upon the golden beaches.

Sophia got up and stood in front of the railing.

Her hungry gaze stopped when she saw the Monastery of St. John the Theologian, which rose up on the mountain, proud

of its history. A shiver went through her like thunder in her body.

A thousand memories started knocking on her mind's door.

'Not now, not now!' she advised herself.

Antigone, holding a map in her hands and trying to make sense of it, approached Sophia.

'The Chora is the one facing up the mountain?' she asked.

She put her thoughts aside and replied to Antigone like an experienced local.

'Yes. And in the middle, where the high walls are... can you see them?' Sophia pointed, stretching her hand, '...is the monastery of St. John. Much lower, where the trees are, is the Holy Cave of the Apocalypse. You should definitely go. Whoever comes to Patmos and does not visit this holy place goes home feeling empty inside.'

'Girls, let's go! We will discuss the rest later,' Michael said, and threw the empty coffee cups in the bin.

Quite a few people disembarked the ferry at the port of Skala, but most continued to Rhodes[26].

The ship departed immediately. It was already facing delays because of the accident.

Skala was a quiet place. Some taverns adorned the waterfront, offering great food to the island visitors.

[26] **Rhodes** is the largest of the Dodecanese islands in terms of land area and also the island group's historical capital. Administratively, the island forms a separate municipality within the Rhodes regional unit, which is part of the South Aegean region. The principal town of the island and seat of the municipality is Rhodes. The city of Rhodes had 50,636 inhabitants in 2011. It is located northeast of Crete, southeast of Athens and just off the Anatolian coast of Turkey. Rhodes' nickname is '*The Island of the Knights*', named after the Knights of Saint John of Jerusalem, who once conquered the land. Historically, Rhodes was famous worldwide for the Colossus of Rhodes, one of the Seven Wonders of the Ancient World. The Medieval Old Town of the City of Rhodes has been declared a World Heritage Site. Today, it is one of the most popular tourist destinations in Europe.

'A quiet night,' Marios said in pain, placing his designer suitcase down on the concrete wharf.

'What now?' he asked, looking at the rest of the group.

'Shall we all jump in a taxi and go to Chora?' Antigone asked, looking at Michael and Sophia, who was searching with her eyes for all of her old memories.

The waterfront edge was painted as a glowing curve. From a distance, the shop lights were glimmering in the darkness that had caught up with them. They glittered so much that, as they reflected in the waters, they looked like a diamond necklace, under the strong headlights of a luxurious shop display.

Sweet music echoed from afar. Sophia looked at Michael pleading, and using a good excuse, she said:

'Shall we grab something to eat before we head up?' She asked this while looking at Antigone and Marios, waiting for their opinion.

With her hands in her pockets and bouncing around to ease her excitement Antigone agreed by nodding her head. She was jumping around like a kangaroo to the edge of the sea and back again, on the road to the taxi station where they had stopped to decide what they were going to do.

There were only a few people wandering around. Most had gone by taxi or been picked up by their families, who had been waiting for them to arrive.

A grandfather with white hair and a walking stick in his hand was sitting on a chair beside the door of a small shop, like a kiosk. He was staring at Antigone, behind his thick glasses. Her blonde hair drew everyone's attention, whether young or old. She probably reminded him of something and brought back memories. He had taken the look of a seated traveller whose eyes see something whilst the mind sees something else.

Eventually, everyone agreed to eat something and then ascend by taxi to Chora.

Sophia had no idea what condition they were going to find the house in, but she had discussed it with Michael and they were fine risking it on their first evening. Any potential problems would be dealt with the next day.

Antigone and Marios had no problem as they had booked a room to stay in Chora.

'Well! Time to leave,' Michael said, 'or else I'm sensing we will be having a very original holiday on the pier!'

'Antigone! Enough with your evening gymnastics! Grab your things and let's go!' Marios cried in an authoritative style, jokingly of course.

Antigone stopped abruptly, shook her hair back and, with an ironic childish tone, she picked up her backpack and said, 'Yes Sir!' returning the joke.

With relatively few bags in their hands, they walked along the beach, looking for a restaurant that would attract their interest. Each restaurant was beautiful in its own way, and as they had no opinion about the quality of the food, they were left to judge only by external presentation.

'There! There! There! In the courtyard with the basil trees at the seafront!' Sophia exclaimed, pointing with her hand. 'What do you think?'

Her enthusiasm convinced everyone.

A picturesque tavern stood in a relatively small space under a white tent. It could hardly accommodate ten tables. The very first table was almost on the beach. All around the courtyard, small pots painted white were placed, loaded with huge royal basil trees.

The fragrance spreading in the air, pampered by a north sea breeze, was magnificent. An old lantern from the past enclosed an electric light from the present above each table. Traditional music accompanied the whole scene, as if it was coming through the slow waves of the sea.

They chose a table at the front, very close to the 'blue queen' of the region. The girls chose the sea view and the boys got what remained.

The matted chairs welcomed them. The long branches of a vine tree, woven around the steel construction of the canopy, were dangling lazily in the mild sea breeze.

The lights on the boats that were fishing in the sea resembled a garland of lights that constantly changed shape.

And further away, almost dipped into the sea, a new moon made its appearance, sending a pale beam of light slipping uncertainly upon the beach.

'The perfect romantic evening!' Sophia expressed with admiration. She was about to rest her back on Michael's chest and get lost in his arms, but she sat up again as she saw a blond boy, with long hair gathered at the back of his head, approaching their table. He wore baggy checked shorts and a white t-shirt.

Nothing in his appearance but the paper tablecloth hanging over his arm made him look like the waiter, and that tablecloth is what guided Sophia's thinking. While laying the cloth on the table and fixing it in place with special clips, he introduced himself to them.

He was Italian and he was called Raffaello.

He came to Patmos for holidays a few years back and he had stayed on the island permanently ever since.

The way he spoke Greek professed his foreign origin. He noted their order to take back to Captain Manolis, which is what the boss, and sometimes the cook, was called, depending on his mood, and Raffaello disappeared into the depths of the restaurant.

Until their starters arrived, and because of Raffaello's situation, a debate upon voluntary and involuntary migration was ignited around the table.

Marios, with the attitude of ten cardinals, bragged about how he was a frequent visitor and aware of the Aegean Islands. He began to count instances identical or similar to that of Raffaello.

'Don't you remember, Antigone?!' – Marios wanted her confirmation as well – 'last year, in Paros! That guy in the bar! I cannot remember his name. He was from England, on holiday, and had also become a permanent resident.'

'For three years and only in the winter, for three months, he would go up to London to see his family.'

'And he had no intention of going back to London in the near future.'

He took a breath and continued. The others preferred to let him speak.

'In Crete, as well, three years ago, and specifically in Rethymno, where we were renting with Antigone – incidentally that was the first summer we spent together – we met René.'

'I believe you remember him Antigone!' he turned and looked at her.

Antigone, as if awakened from wandering around her own little world by hearing her and René's names, gave him a condescending response.

'Yes, yes, René! With a huge tattoo on his back: an eagle with open wings! That tattoo made a very strong impression on me…'

And even if Antigone wanted to continue what she was saying, Marios was unstoppable. He interrupted her before she had managed to conclude her sentence.

'So René had gone to Crete on holiday. He was from Lyon, a Frenchman. After touring almost the whole of Crete for a whole month, he ended up in Rethymno. He found a job, as an employee at a large hotel complex, and was very satisfied. He also met a Cretan girl and he was fully ready to become a permanent resident of the island…'

Fortunately, the arrival of Raffaello saved them from hearing about Marios' other experiences and forced him to stop abruptly.

Magically, the table filled with dishes. Their hunger brought 'silence'. Only clinking glasses and forks declared their presence.

About a quarter of an hour later, the pleasure of eating and drinking made their eyes meet again in a nirvana of pleasure.

Timidly the debate restarted.

Michael believed that, after eating, their spirits would have been calmed, but he was wrong.

Antigone and Marios were colleagues in a private company, i.e. employees. Marios, who monopolised the conversation, complained about his low salary; his requirements and his whining soon become too much.

Michael and Sophia were irritated by his greed, until Michael could not bear listening to him any longer and decided to put him in his place.

'You are right, Marios! There is nothing we can say! We were studying all these years and maintained by our families, while occasionally working part-time for some extra money, maybe to enjoy a few days on holiday. You have visited every island you can think of and you are complaining on top of all of that!'

Seeing that the tone of their discussion was getting out of hand, Sophia intervened as politely as she could.

'Guys, I think it's time we made a move. We are all tired and it's starting to become evident!'

They all got up, slightly sulking, and headed to the taxi station.

CHAPTER 11
'Bittersweet Memories'

When they arrived at Chora, Marios and Antigone were the first to get out of the cab. This was the last time the two couples saw each other. Not that they intended to meet again, but the events that followed did not turn out as they had planned.

'Please could you drop us off here,' Sophia said to the taxi driver.

The taxi stopped in front of a narrow street, designed only for pedestrians or two-wheelers.

With their luggage in hand – as it was impossible for them to pull their luggage on its wheels over the pebbled surface – they walked a short distance.

Sophia had started to become really emotional. Thousands of messages rushed back like a tornado in her mind.

'Not now, not now!' she said to herself again.

She put the key into the keyhole of the blue wooden door and opened it. She searched for the light switch on her right. A pale light from the dusty glass lamp flooded the space. They walked in and placed their bags next to the walnut hanger.

Everything, or almost everything, was as she remembered: Grandma's carved settee from Skyros Island[27] that she adored

[27] **Skyros** is an island in Greece, the southernmost of the Sporades, an archipelago in the Aegean Sea. At 209 square kilometres (81 sq. mi) it is the largest of the Sporades, and has a population of about 3,000 (in 2011). It is part of the regional unit of Euboea. The Hellenic Air Force has a major base on Skyros, because of the island's strategic location in the middle of the Aegean.

as a child, which Sophia was also going to inherit, the buffet with the mirror hanging off the beaks of two hand-carved seagulls on the upper edges of the wooden frame…

She entered the bedroom. An iron double bed with a snow-white mosquito net, hanging from the ceiling like a crown, was the dominant feature of the room.

'Mrs Matina must have added the mosquito net. Grandma did not have these here before,' Sophia said, consulting her inventory of memories.

But Mrs Matina's major interventions had been in the kitchen and bathroom, Sophia gathered as she wandered past. The era that prevailed in these two rooms, unlike the bedroom and the living room that were stuck in the past, was clearly the present era. Not a single electrical device from those that simplify our lives was missing. The 'magic' in the bathroom and terrace they would have to discover later, with the first light of day.

'At first sight, things look fine,' Sophia remarked, 'apart from the dust having a party everywhere that will continue for only one more night. Can we endure it just for tonight?' she asked Michael, and her eyelids were overcome by drowsiness.

'I have a suggestion,' he said smiling.

'Let's imagine that we are forced to spend the night at the train station, waiting for a delayed service, and we have to sleep with our clothes on, just not on a bench of course,' Michael said, looking meaningfully at the comfortable double bed, 'but rather much more comfortably, and let's imagine that we have arrived well-rested early in the morning. Isn't that a better thought?'

'You're right, and by noon we will have put everything in order,' Sophia said optimistically.

'I am really incapable of doing anything else tonight. I am dead tired,' Sophia justified, and pulled the white protective cover off the bed.

Sleep took over them quickly and it felt like self-preservation to their bodies.

Around seven a.m., Sophia opened her eyes unwittingly. A big blue sea filled her entire view.

'Where am I?' she wondered for a few seconds.

She closed her eyes and reopened them. Absorbed in the deep blue, the realisation came. Something fluttered inside her and she jumped out of bed.

'Michael, wake up! Wake up and see your dream come alive!' Sophia said, nudging him softly. He opened his eyes for a moment, laughed and turned his back to her, going back to sleep.

Sophia left him there and got up. She combed her long hair with her fingers and pulled it back.

Opening the flimsy curtain, she stepped out into the 'Blue Heaven'. Barefoot, as she did when she was little, she walked in those same childhood footprints and sat at the same spot on the terrace, with one knee bent, around which she clasped her hands. She leaned her chin on her knee and set herself free.

As expected, her memories struck again, knocking at her mind's door for the third time. This time, however, she welcomed them wholeheartedly and let the sweet emotions of her heart take over.

So many years had gone by, years filled with new memories, yet nothing had changed that childhood fluttering in her heart. Sophia looked at the blue door of the future and this was the exact same sea, just as she remembered it: then and now. This feeling that swelled and gushed inside of her like a storm was the same: then and now. She took two deep breaths and the familiar smell brought a coveted smile to her face, the same now as it did then.

Only now, she felt closer: closer to the future that her fate had intended.

She released her hands and freed her knee.

She lay down on the wide bench and let the sky caress her. Seagulls were flying high, embroidering laces in the air.

Spontaneously, a single word came to her lips.

'Mom, mom!'

Memories flooded her mind like heavy rain. She ached as each large drop crashed down onto her naked body from the force of the storm. She became trapped. She almost drowned at times, but in the end, as the rain cleanses everything in its path, so too was her soul cleansed; it started shining like well-polished silver; like a mirror in which you can see your reflection clearly.

The complete immobility that overtook her strengthened her senses.

She felt his presence behind her. She turned her head to look back and saw Michael's face, upside down.

'Baby, you got up!' she said and gave him a warm kiss on the lips.

She stood upright and looked into his eyes.

'This is the gift I promised you, all dressed in a blue wrapper! Inside it hides all the dreams, desires and fantasies. I give it to you with all my heart. Take it!' Sophia said, pointing at the vastness of the sea that was revealed in all its splendour, from the royal throne of Grandmother Sophia's courtyard.

'My gift, sweetheart, is you! Your existence, your breath, your touch, your kiss,' he whispered and took her in his arms.

This moment was etched in their hearts forever; in all subsequent difficult years that followed. It was God's gift to them and it prevented them from drowning in life's waves. It was the beacon that always showed them how to keep away from life's reefs.

The horn of the ship entering the port of Skala brought them back to reality. Sophia stretched her arms up high, as she did every morning when she awoke, and she looked at Michael energetically.

'I will take care of the cleaning and you can take care of the shopping,' she said. 'You will find the shops further down from where the taxi dropped us off yesterday. Buy all the essentials: milk, cheese, fruit and whatever else you think we will need.'

'Oh! Do go to the bakery as well, and apart from bread, buy a few cookies for breakfast.'

'That's fair!' Michael told her as he was walking backwards, off to perform his part of the deal.

Once he left, Sophia – acting like a good housewife – gathered her hair with a clip and disappeared into the house with all the necessary 'tools'.

For the next two hours, spiders and cockroaches were subjected to unceasing alarm. Their forts were being mercilessly attacked and, unfortunately for them, this particular war was won by their sworn enemies: a broom, a mop and a pound of detergent ammunition that had been left there by Mrs Matina.

Sophia was sweating profusely after this 'battle', and the summer heat was reaching its highest temperatures for the day. Sophia put her hands on her waist and moved around the house for inspection.

All the forts were under full guard control and they sparkled with cleanliness.

'Let's also await approval by the other "inspector" who will be arriving any minute now!' She had not completed her thought when Michael (the other inspector!) appeared at the door asking for help. His hands were full of nylon bags with groceries.

'Did you get supplies to see us through a possible war that could last thirty years?' Sophia asked, taking a few bags from him to lighten him.

'Sophia, don't make fun of me please! I see that you're in a really good mood. Maybe we should live here forever then,' he said, and placed some things on the kitchen table.

By the time the coffee maker jug was full (Mrs Matina had also added that), they had managed to put all the food in place.

'A hot cup of coffee is the best compensation! Go take a seat in the "Blue Heaven"' – she could not call it a courtyard as it seemed like a very poor expression – 'and I will get the coffee,' Sophia said, while searching for a tray in the kitchen cabinet.

On hearing the word 'blue' come spontaneously out of her mouth, Sophia's mind instantly travelled to another paradise

with different colours: green, purple, red, yellow; Maria's courtyard was filled with colours, in contrast to the one here, where white, blue and a little grey were dominant.

While she was thinking, she filled up their cups with coffee. She then placed them on the tray with the milk, sugar and a plate filled with the cookies that Michael had bought.

'If we did stay here, we would, of course, add a splash of colour!' Sophia thought as she came out of the kitchen.

She put the tray on the table and they both rushed to grab some cookies, the heavenly smell provoking their taste buds, dangerously – poor cookies...

They enjoyed a wonderful breakfast in an equally wonderful place. Sophia brought the cup of coffee to her lips and took a generous sip. As she was placing the cup back onto its saucer, a breaking sound was heard and a clay pot that fell from the sky landed a little away from them, in front of the kitchen door.

It smashed, spreading brown clay pieces.

A red geranium rolled to her feet, leaving a line of dirt in its path.

Sophia was scared to death but kept her sense of humour.

'You see! The sky is raining colours for our yard,' she said, and looked up to see where this heavenly gift had come from.

A blonde head appeared on the adjoining balcony, looking down.

'A thousand apologies for the inconvenience. I hope no one was hurt! I am really, really sorry, but this kitten is very mischievous. A thousand apologies...' the young girl said, and seemed rather upset.

'Can I please come down and pick it up?' the girl asked them politely, and clearly feeling guilty.

The 'kitten', which turned out to be a handsome male cat, was the cause for Michael and Sophia to meet Kelly.

She had a doll-like face with warm brown eyes, and her cropped hair above her forehead adorned her face cutely. She showed up at the door with a broom and a shovel in her hands.

The innocence of her youth – she was only nineteen years old – radiated in her eyes.

Not that it was difficult for Sophia to clean the 'mess' up herself, but she enjoyed this unorthodox acquaintance.

Kelly swept the dirt and broken pot pieces, put them all in a bag and, looking at some pots crammed into a corner in the yard, said hesitantly:

'Would you like to put this geranium in one of these pots?'

'I'm sure we will do something about that. Would you like to join us for a cup of coffee?' Michael asked.

'Not only did I disrupt you, but you are also offering me a cup of coffee?' Kelly asked, lowering her eyes full of guilt. 'We've only been here a couple of days and this cat has settled himself on our balcony and won't leave! My friend Tatiana, who is on holidays with me' – Kelly clarified – 'says that the cat has fallen in love with her and that is why he won't leave our side.'

'Come on… There is no need for you to apologise. We needed a little colour in our yard! It has "arrived" in a rather weird manner, but it is welcome,' Sophia said, filling up a cup with fragrant coffee for Kelly.

A white dove landed gracefully on the concrete terrace, interrupting their conversation. It took a few steps, looking at the small group of friends who turned their heads to observe it.

Breaking a piece off a cookie that he had brought from the bakery earlier, Michael rubbed it between his fingers and threw some of the crumbs to the dove.

With its tail bouncing up and down at every bite, it ate some crumbs and took off happily.

Kelly drank the last sip of her coffee and stood up. She thanked them politely, took the broom and shovel, and performing a funny twirl she left smiling.

Sophia turned the white cloth armchair around to face the sea, spread her legs on the mantel and took the cup of coffee in her hand.

'Michael, I suggest this afternoon should contain a large dose of relaxation. I did not sleep very well last night… Let's also put the dishes that have gathered in the dishwasher… Have I persuaded you?' Sophia asked, looking into his eyes and lowering the sunglasses she wore a bit ostentatiously.

'You have convinced me, not that I needed much convincing. But I think I prefer the bed to the armchair. Have a nice rest,' he wished her and went inside.

Sophia stayed there alone, gazing at the sea. Down in the harbour, a luxury cruise ship was preparing to dock. With a slight movement, sideways like a crab, the ship brought its padded 'belly' to the side. The ship's control tower, with both ends extended outwards, looked like a hammerhead shark, helping the captain to check the sides of the ship.

The tourists had gathered on the side deck ready for disembarkation. A ladder was thrown over the side of the ship. The crowd began to descend. They looked like coloured ants that were following their leader from afar. Five coaches, in an emphatic red colour, waited to begin their scheduled tours.

Sophia stretched in her armchair, trying to see the departure of the red 'caravan'. She nearly fell off her chair in her effort to see: leaning her body way too much to one side, she suddenly heard a creepy creaking. The armchair was balancing dangerously on one side, imposing Sophia's full weight on the two blackened stilts that were worn out from time. She suddenly sprang to her feet, letting the armchair burst down like a ripe watermelon.

'The heat has probably struck me on the head!' she thought. She shook the white armchair cloth to clean it off and placed it back into position. She collected the tray with a slightly dazed and sleepy manner.

She put it on the kitchen counter as softly as she could.

The distance from the kitchen to the bedroom was not more than five or six metres, but, at this time, it seemed most enormous to her.

She dived face down on the white bed sheets, nudging Michael's body a little: he had spread out on the bed, possessing a royal share.

Sophia embraced the pillow with Grandma's white embroidery and gently placed her cheek on it, enjoying the scent of lavender. Her mind did not manage to consolidate the feeling of pleasure, as the feeling abandoned her violently, like a seed that we spit out when eating a cherry with gluttony: not kindly by hand, but spat out impolitely onto the soil.

Purple dreams flooded her mind's world.

She was walking barefoot on the edge of the shore. Her footprints were leaving their mark on the wet sand. She could see them but they were not her own: they were too big to be her footprints. She continued to walk, but the sea pulled out a wave that suddenly reached her feet, foaming angrily. But it was not sea foam. It was soap foam that felt sticky on her legs and disgusted her.

That white slime suddenly became green. She could not avoid it. She would take a step here and there, looking to find a clean place and instead she found herself walking on dead fish that were blackened and rotten!

'Aaaaaaah!' Sophia cried.

Her cry came out like a squeak from her lips.

She sat on the bed, grabbing her head in her hands.

Her palms were filled with sweat that flowed to the tip of her hair.

'What a miserable nap I had! What a horrible dream that was!' Questions with no answers swirled in her mind.

She turned towards Michael. He was sleeping like a baby. The only thing awake was the vein on his neck. She fixed her eyes on that vein, counting the beats, and it worked: it was stress-relieving for her inside, but it was not catalytic.

Something inside her yelled: 'Thank God Michael did not wake up', and of course she told him nothing about the dream.

A small thorn found an opening and pinned itself into her chest.

She leaned back on her pillow, but it no longer had the same feeling, the same smell. With her index finger, she was pushing on her thumb in a single movement, as if she was trying to pull that little thorn out from her heart. It was a motion expressed voicelessly, with her hands. The rest of her body was still. It was just fingers that functioned as pistons moving back and forth.

Sophia's eyes were fixed to the ceiling; looking nowhere.

She soon fell asleep again. The tension had exhausted her.

Her eyelids were flickering restlessly. Vague contractions would make her beautiful face burst into strange grimaces.

A hand travelled gently on her cheek, expressing, in one touch, all the love of its rightful owner.

A slight movement on the edge of her lips replied to the owner's hand that the message had reached the recipient. She opened her eyes and looked at him. She was hearing the sweetest words a man can say, but those arrived not from the lips but from two brown suns that illuminated and warmed her soul.

Michael leaned over and kissed her sweetly. They exchanged the most beautiful words, without a word, without a single exclamation.

The sun had been hiding away for a while now. A wonderful stillness was conquering the evening. The night had started to lie on the island, leaving the stars and the moon to be her assistants in the sky.

Sophia left Michael in the kitchen to wash a few fruits, and she walked into the bathroom.

She tried to wash away with water the thoughts that were swirling in her mind. It was difficult; very difficult. But she imposed on herself. She really did not want to understand her intuition. It was no joke. Something was awaiting her and Michael around the corner and it certainly wasn't going to be something good. She knew deep inside that if she told Michael

about this feeling, they would both have to start pretending: physically present but brain absent, in their own theatre play. She decided to fight this intuition alone.

'Maybe it does not mean anything,' Sophia comforted herself. She wrapped her body in a white towel, and with a positive, comforting feeling towards herself, she went to the courtyard.

A warm breath sweetened her heart. The glow of a candle on the old round table, the dish of fruit beside it, two glasses of wine and the figure of her beloved man under the moonlight would captivate even the most hard-to-get woman. She paused at the door. She gave her mind the necessary time to record what she was seeing, down to the last detail.

She sat beside him silently, then grabbed a juicy peach and brought it to her mouth. The flavour and aroma dominated the moment.

'Mmmm… it's delicious!' she commented, and praised Michael for his excellent choice.

He smiled, but did not say anything.

'Are you ok? I detect a little melancholy or am I just imagining things?' Sophia remarked.

'The truth is I feel a bit strange, but I don't know why,' Michael replied, dragging his words.

'You are sensing what is coming… but what is it exactly?' she said breathlessly to herself.

'I suggest we let the crickets have the last word tonight because they have begun to sing loudly in concert and I don't think they will let us have a conversation,' Sophia said listening to the nightly chorus, and finding the most appropriate excuse to avoid a discussion which could lead her to a painful confession.

The evening started pretty calmly, and no one and nothing seemed capable of disturbing them. A light breath of wind, perfumed with the scent of an evening primrose stolen in its path from the garden, was seductively married to the aroma of wine.

The harmony of those two senses almost approached a perfection that drags with it something from all three other senses.

And as the pendulum moved from one end to the other, this perfection startled Sophia. What secrets would be revealed at the other end? How painful would those secrets be and for whom? Obsessive thoughts took over and, like a sponge, they started erasing every beautiful thing written on that blackboard at that specific time.

Sophia's smile, like a bird in a cage, escaped from her lips, smothered by the executioner of her thoughts. The shadows of the night made the bird's escape invisible. Only the moon witnessed this sadness. A star faded, falling like a tear from the sky, and then everything quietened down. And then nothing; void.

The night that passed reduced the intensity of Sophia's mental dyspnoea. The new day brought with it a cool breeze, a breath of life from the deep blue sea.

The quiet waves of sleep were agitated by the tweets of a group of birds, arguing cheerfully over the ebony feathers of a swallow.

'Get up sleepyhead! If we stay in today as well, I suggest we better find a decent pension fund to invest in!' Sophia murmured, pulling the bed sheets off Michael.

And with a distorted voice, as if heard through a loudspeaker, she began to speak:

'Ladies and gentlemen, today we have planned a tour for you of the sacred cave of the Apocalypse. Wear the appropriate psychology and be ready...' Sophia's voice, now became imperative, '...in half an hour!'

CHAPTER 12
'The Holy Cave'

The taxi was parked in a shaded part of the road. The driver was leaning on the bonnet of the car, enjoying juice from a carton.

He stood up as he saw them approaching. He said good morning and asked:

'So where are we going?'

'We would like to head down towards the Holy Cave,' Sophia replied with modest respect.

The car started slowly. The drive through the narrow streets of Chora was taken carefully. In some areas, the streets were paved with pebbles: the durable remnants of a bygone era. In other areas, they were paved with cement: the interference of the new era. In some places, the passage was rather narrow, and coming face to face with another car resulted in a major problem.

Passing in front of the imposing walls of the monastery of St. John, Sophia leaned her head towards the car window. Seeing all this, she told Michael:

'I suggest we visit the monastery on our way back. From what I know, there are many relics, icons and original manuscripts we can see.'

Before Michael was able to answer – he was literally halted with his mouth open – the taxi driver spoke for the first time and asked:

'Where are you guys from?'

And this is normally how the conversation commences in a taxi in Greece, especially in most outskirts across the country, though it happens more rarely in the large cities. It's partly the Greek hospitality and partly the unbelievable curiosity of a Greek person to know everything, and the usual question is: 'where are you from?'

Dimitri was a native, born and bred in Chora. He had been a taxi driver for many years.

'I have seen many, many things doing this job!' he said, taking pride in his knowledge.

'I have driven people from all around the world: Americans, Germans, British, many, many different people,' he said proudly.

'And from your home town, Thessaloniki, many visit the island!'

'It is the sacred cave that draws people here who want to go and pray. But many come here from mere curiosity. God has blessed our island and we can make good wages. Life for the islanders is difficult. Tourism saves us somehow, but unfortunately it does also change us as people.'

'Well said Dimitri, you're right,' Michael agreed when Dimitri stopped his monologue. He had not even taken a breath during that 'speech'. Michael, however was mistaken thinking Dimitri was going to stop talking. He was in the mood for a chat.

'Money, kids,' Dimitri continued, 'is a double-edged sword, my grandfather used to say. It will cut the bread, but it will also kill people.'

Sophia was not really listening to the conversation as the beautiful route had been stirring memories for her. When they arrived the previous night, everything was dark and they could not see much, almost nothing. The fatigue and darkness were prevailing.

Somewhere halfway through the journey, the taxi indicated and turned right, then started ascending a hill, travelling among the olive trees.

The car went a little further and stopped at a large opening that served as a parking space.

Sophia saw the buses that were parked outside the Holy Cave and, concluding that it would be really crowded inside, they instructed Dimitri to pick them up in a couple of hours.

The taxi did a U-turn and left. The bus drivers were all sitting in the shadow of a big, old olive tree.

A wooden table and two benches hosted them while they waited for their guests to finish their tour.

A group of tourists, probably French, Michael and Sophia gathered from the dialect they were speaking, were just walking up with their guide.

They all gathered on a landing, trying to catch their breath from the climb.

The way the stairs were painted with white lime was reminiscent of the holy ladder to Heaven. Anyone, no matter what their faith, could discover paradise in this holy place.

Michael and Sophia descended slowly, enjoying the natural landscape around them. They took their time as they knew there would be a long queue of people waiting to enter the cave.

On both their left and right, the tree branches were bowing from the weight of their fruit. Some of them seemed to more devout and were almost touching the earth. The sanctity of this place seemed to affect everything around in a special way.

When they arrived in the courtyard of the Holy Cave, they realised how crowded it was.

They found a bench under the shade of a tree and sat down. The view was amazing. Like a painted carpet, the port of Skala with its fishing boats and the beautiful beach, from the cape to the sandy beaches of Kumana, spread out before them.

The island was one of the very few green islands in the Aegean.

Picturesque boats would come and go in the harbour, making day trips to nearby beaches and islands.

Michael and Sophia did not even realise that the time had passed. When they turned their heads, nearly everyone was gone.

'Get up Sophia, let's go,' Michael said and pulled her by the hand. She shook her skirt and they started advancing together.

They paused in front of the cave entrance. Its very peculiar construction prodded their interest. A huge piece of grey rock stood imposingly over their heads.

Lower, near the base of the rock, a piece of the wall was connected to the earth. In this part of the wall, there was a door and two small windows. A small whitewashed chapel, like the ones found everywhere on the Greek islands, was presented before them.

They entered through the door, feeling an instinctive respect for this sacred site. Straight ahead of them, Saint John was portrayed in a large Byzantine icon, framed by an image of God and surrounded by various other saints of the Church.

A chandelier with a lit candle was smouldering in front of the icon of Christ, and several other oil lamps were hanging from the rock in front of each icon.

For security reasons, no one was allowed to light candles in the cave. They looked around, scrutinising everything that caught their eye. Half of this holy place was built normally as a chapel. The other half was a sacred mountainous area: a cave in the rock.

This was the brave entry point of the Holy Spirit. It had left a sign of its divine power on the hard rock, ripping it into three pieces, just like its Trinitarian subsistence. Sophia observed the course of the crack that ran from west to east.

On the left side, an extended golden rope forbade people from coming closer. Behind it, carved by time on the rock, was St. John's headrest, and on the right, a little higher, a dent where the old man leaned over and placed his hands when praying.

'These images have always lived in my memories as a child, from when Grandma Sophia first brought me here,' Sophia said to Michael in a quiet voice.

Michael had turned his attention to a sign describing what they were looking at. An almost flat surface on the rock served

as a table for St. John's companion, Prochoros, to capture on paper the Word of the Lord, from the mouth of the Saint.

«Γράψον ουν α είδες, α είσι και α μέλλει γενέσθαι».
'Write therefore what you saw, what is happening and what is to come' (Revelation chap. I, verse. 19).

They carried on silently, as if they did not want to verbalise any of the golden words that were recorded in their hearts. A deep breath sealed those words in their souls.

Sophia looked around her and realised that she had lost sense of space and time. Her eyes met Michael's. She grabbed him by the hand and they started walking up with a strange tranquillity that had taken over.

Outside the Holy Cave, Dimitri was waiting for them in the parking lot, as they had agreed, to take them back to town.

On the way back, words were scarce, as if some force was protecting the meaning and purpose of this visit.

Dimitri dropped them off outside the high walls of the monastery, wished them 'good luck' and took a couple that was waiting for a taxi.

The main reason for this trip was achieved with this visit. Michael and Sophia toured the holy areas and were impressed with the simplicity and cleanliness. They were speechless to see some very old sacred manuscripts and relics, preserved for two thousand years by the venerable abbots of the monastery.

When they finally walked out of the monastery, Sophia wondered out loud:

'Do you think Father Harry, the priest who welcomed us to the sacred cave earlier, was right?'

'What do you mean by that?' Michael asked with curiosity.

'That anyone who visits the sacred cave does not come here by chance.'

'I do not know how to respond to that, but I know that I feel something that I cannot identify,' Michael said, with a look on his face as if he was trying to capture something that had escaped.

He made a motion with his hand as if to brush away something that bothered him, and they both marched towards the centre of town.

'After unburdening our soul of this debt, all the beaches are ours!' Sophia said in a refreshed mood.

As they approached the town centre, it became more crowded with people. The streets were filled with small shops that spread out their goods to facilitate purchases by visitors, who in the end, of course, had problems deciding what to choose. There were so many souvenirs and gifts: small – large, expensive – cheap, serious – funny; an absolute temptation for the eyes and the wallet. This was the other face of the island.

Sophia instinctively avoided the space that kept guarded in the air all the childhood memories of her mother's shop. She was not yet sure of her readiness for this type of venture.

Sophia and Michael stopped at a shop and let their gaze wander over the beautiful objects, searching to find something that would impress them.

Sophia looked at some hanging lanterns with coloured stained glass. She was especially taken by the charm of a tiny little Gospel in golden colour, bearing a picture of St. John on the inside. A rosary made from amber shone in the rays of the sun as she was examining it with her fingers. She looked at Michael.

'Would you like it if I bought you a gift?' Sophia asked.

'I would prefer the other one over there, next to it. The one with the eye of the tiger. Your gaze gets lost in the golden waters of its stones. Yes, I would love that one!' he told her, fascinated.

Eventually, after some time, they decided to get the gold rosary for Michael, while Sophia chose the small Gospel for herself.

Excited and cheerful like little children who have just received their presents, they left the shop embraced. A sense of hunger made them start looking for a suitable place to appease their appetites.

Their steps led them to the little tavern of Apostolis: – 'the philosopher' (as his friends used to call him). Apostolis was a tall, skinny, blue-eyed guy who far from resembled a tavern owner.

'When he opens his mouth to speak, everyone pays attention!' a sympathetic looking customer said from a nearby table.

'He is a great kid!' another customer added.

'I say, drop the flattery! You know I don't get on with it,' said Apostolis, while spreading a white tablecloth with meticulousness on their table.

'From just the way he moves, you can understand what kind of a man is standing in front of you,' Michael said to Sophia when Apostolis had walked away.

'Yes, Mr Psychologist. I agree with you,' she replied.

It was much later, way after their meal, that Apostolis sat for a while at Sophia and Michael's table to meet with his new friends.

'Those who come to my tavern also become my friends,' he told them proudly.

And so, as the conversation started to flow, Apostolis told them about his life.

He had lived in Germany for years. They used to call him Apo there. He was working at a pharmaceutical company.

'It was tedious work with endless hours of standing and thousands of chemicals scattered around,' he said, and you could see in his eyes and his expression that he did not want to remember those days, however it was brought up in the discussion.

After a failed marriage to a German girl, Apostolis decided to leave everything behind and come back 'home': that is what most Greek immigrants called it.

'I opened this tavern and saw "the light of God",' he said, and life was radiating within him.

The setbacks he experienced had forced him to deal with life in such a way that he had to look deeper and at every single angle of things. He had to become a philosopher, hence his

nickname. He always looked at things, of course, with a good sense of humour. Everybody loved him. The shop was never empty. He even had a table near the kitchen that was always laid out, ready to welcome good friends and offer them a glass of wine to drink in 'good health'[28].

Sophia and Michael were delighted and promised to come back. A promise which they did not get to keep, at least in the near future.

[28] Drinking to '**good health**' is the Greek version of 'Cheers!'

CHAPTER 13
'The Dream Takes *Flesh and Bones'*

It was after three in the morning when Michael's mobile cut the stillness of the night like a knife. The screen light lit up the ceiling like a sheet of lightning. It was time for the nightmare of the previous night to become an implacable wild reality.

Michael emerged forcefully from the bliss of his dreams. With his eyes closed, he stretched out his hand and searched for his mobile.

With the first sense of touch, he realised that he had not grabbed it properly. With the second, he caught it and brought it to his ear.

'Yes, who is this?' was the first and last calm question.

A stuffy female voice spoke, short of breath.

'Hello, Michael, can you hear me?' his mother asked.

'Yes, who, er… yes,' he asked, but then understood instantly. He sprang out of bed. His mother did not reply for a second time to his question.

'Hi Mom. Yes. What happened? Why are you calling in the middle of the night?' Michael drowned his mother in questions while his heart started jumping out of his chest.

'Your father, Son, is in hospital. About an hour ago, he felt a bit unwell and lost consciousness. I called an ambulance and they transferred him to Papageorgiou Hospital. The doctor said he had a stroke. My darling…' and her sobbing began to get louder, 'please, come as fast as you can… your brother is away…' (she was talking and crying) '…your aunt is with me… but please… come…' and her voice stopped.

'Mom?' Michael said. A strangled noise was heard on the other end of the phone from Michael's mother, who was crying and trying to restrain her lips.

Her words seemed like a hammer to the head that expelled all of the blood to his legs, as if it had all gathered down there, making them become as heavy as rocks.

Sophia, who was watching his reactions all this time, realised that what she feared had come faster than she had imagined. She stretched out her hand and touched his shoulder.

Michael jumped up for a moment. He had not realised that Sophia had woken up and was sitting next to him, listening to the phone call.

'Mom, I will get there as fast as I can, don't worry. Everything will be fine.' He really imperceptibly believed it. 'I will also call Alkis to come over. Please don't be upset,' he reiterated.

Alkis, his brother, now lived in London permanently. He had found a good job in a large computer company, and had opted to work there for some time.

He hung up and let the phone drop next to him. These moments of silence seemed like an eternity to Sophia.

She did, however, give him all the time he needed to realise what had just happened before she started asking questions. Michael, like thunder, stopped Sophia in her tracks. He turned and looked at her with an anguish hiding behind his tough-looking eyes. They just entangled their fingers tightly, as if they were trying to encourage one another.

'My father, Sophia...' and he took a deep breath, '...had a stroke. He is in hospital and I need to get there as quickly as possible. From what I understood and what my mother said, he is in intensive care.'

'I'm so sorry, baby. I really hope everything goes well,' Sophia said with all her compassion. 'I know Mr Theodore will get through this. He is a strong man and he loves life,' Sophia encouraged him, putting her hand on his back.

'So tomorrow, in a few hours, you will be leaving on the ferry to go to Rhodes, and then continue from there with a flight

to Thessaloniki. Go sweetie. Mrs Rena should not have to face this all alone. Give her all my sympathy. I wish you all the best.'

It was dawn when they called for a taxi. Sophia escorted Michael to the port of Scala, then jumped in the same taxi to come back home, just as the ship had started to sail.

'I'll stay for a few days, to make arrangements with the estate agent, and then I will go back to Athens. Please call me once you get there and if you have any news at all…' Sophia had said to Michael as he climbed aboard the ship, loaded with his thoughts.

The days that followed were difficult for everyone, but most of all for Michael, as expected. Mr Theodore was stable at first. Their anguish was unspeakable. Mrs Rena's mental health was approaching the limits of endurance. Michael and Alkis tried to keep their cool as much as possible. Finally, God mercifully eased everyone's struggle as, on day four, Mr Theodore's health showed some improvement. Day by day, his condition improved.

'This phone call has made my day, Michael! I am so happy to hear such good news. My greetings to all and especially to your father, and give him my 'Get Well' wishes!' Sophia said, and hung up the phone, extremely happy.

So many days of anguish had pinched her nerves. She got up from the armchair in the living room, which had been hosting her and her worries all these days, and went into the kitchen.

She felt reborn. She turned on the coffee maker and grabbed the phone again. She felt the need to listen to the voice of her own father, to hear his news, to appease her momentary insecurities.

When she hung up, she felt that everything was restored to its normal rhythms. Her good mood, which had been long gone all these days, returned, and she decided to scrape and clean her small apartment. She had to get it minimally clean, so she did not spend much time tidying up. Once she finished, she conducted her usual inspection. The clothes were in the closet,

the scattered glasses found their place in the dishwasher, and the floors were sparkling. She preferred to walk barefoot on the cool grey stone of the floor. She poured some coffee into a cup and went out to the yard that once again looked like the 'blue paradise'. She sat back in her chair and began staring at the iron round table in front of her.

She remembered that, at the time her grandmother was still alive, that iron table stood crumbling and wronged in a corner of the yard, holding on its back, just like Atlas[29], a few flower pots. The last owner of that table, though, decided to do something more: she nursed it, coated it with black paint and gave it a prominent position in the centre of the courtyard.

''*How to convert a useless object into a functional object*': this could easily become the title of an article in a magazine dedicated to home décor, etc.,' Sophia thought, revealing her good mood.

Her thoughts were interrupted by a voice that was calling her. She turned her head and saw Kelly. During these days that Sophia was home alone, those two had met only two or three times to chat. But today Kelly and the girls were leaving and they shouted to tell Sophia their 'goodbyes'.

'I am probably leaving tomorrow too, to go back to Athens. I almost finished with my obligations here,' Sophia told Kelly.

'I was really pleased to meet you all and I wish you all the best,' Sophia added.

The same morning, Sophia had paid the estate agent a visit and had given him all the necessary information about the house. She was already expecting a couple who wanted to see the house in the afternoon. From tomorrow, though, she would have to leave the key with the estate agency, and they would

[29] In Greek mythology, **Atlas** was the primordial Titan who held up the sky. He was the son of the Titan Iapetus and the Oceanid Asia or Clymene. According to the ancient poet Hesiod, Atlas stood at the ends of the Earth towards the west.

have to take over from there if a deal was not closed today with the new tenants.

She could not and did not have time to wait any longer. She had obligations back in Athens that could not wait anymore. The horn of a tour boat pleasantly attracted her attention. She let herself go in the magic of the cruising boat and became a bit melancholic.

'What a pity I did not get chance for a single boat trip to the surrounding islands with Michael!'

She frowned a bit, but then thought of the worst that could have happened. This gloomy feeling left her very quickly.

For the rest of the afternoon, she finished with all her other obligations and prepared her suitcase.

The tenants she was expecting did not show up in the end, so the matter would now have to be resumed by the estate agent. Her only task was to leave the keys at the agency in the morning before leaving.

She had a quick look around the house to make sure she had not forgotten anything.

Over on the living room table, she saw the two boxes containing their commemorative gifts. She put those in the suitcase along with all her other things. Before putting them away, she paused. She opened the smaller of the two and took out the little gold Gospel. She opened it. On seeing the picture of St. John, a thought crossed her mind.

'It seems like this trip was indeed intended for a single particular visit!'

She closed the Gospel slowly and placed it back in its little box. Picking up both the little boxes, she placed them in the suitcase amongst her clothes. She remembered to leave out only what she was going to wear tomorrow during her return trip.

She closed the top of the suitcase without pulling the zipper and left it in a corner of the bedroom.

She took a quick shower and went to bed. Sleep came quickly, and it was deep and dreamless.

CHAPTER 14
'Everything is Going Well'

Somewhere, seven hundred miles further north, the night progressed very differently.

Michael took his coffee in his hands and went out into the canteen yard. In the evenings, the hospital was not very crowded. The tables outside were almost empty. Michael chose a bench on the left of the chapel entrance. He sat at one end and placed his cup on the wooden surface beside him.

On the other side, a stray dog sat jauntily in front of the bench. It was a cross between a German Shepherd and some hunting dog.

Michael's need for company led him to this particular bench, but he did not calculate well. He looked at the dog. He had the colours of a wolf and the characteristics of a hound. And, of course, he was not alone. There was a whole gang scattered around. The dog raised his head and looked at Michael's hands: there was nothing there for him to eat, so he ostentatiously ignored Michael, leaning his head down with a bored look.

Michael took his coffee in his hands and tried to arrange his thoughts. Those past few days, with all the events taking place, he had not had any time to organise his mind. He would throw all the scattered events into the lobby of his brain and wait for an appropriate moment to tidy up. This was the most appropriate.

Mr Theodore had managed to escape the danger and this was the most important positive fact. For his father, the hours

in intensive care were the worst. It was as if Mr Theodore was balancing on a tightrope, with the risk of disappearing into a void and without a safety net below to catch him. What he was attempting was a great achievement. He had not chosen to do this. He was forced to do it. It was a one-way street: you move forward or you die.

As for the spectators of this feat, anxiety overflowed from their souls. Mrs Rena paid the price mentally and physically. She was the first Michael forced to somehow go home to get some rest.

Alkis took their mother home and Michael stayed at his father's side.

A move of his canine friend, with whom he shared the bench, brought him back to reality. A remaining piece of toast that had fallen from someone nearby made the dog get up cheerfully from his position in search of it.

Michael stood up too. He went up to the room and glanced at his favourite patient. He slept quietly.

'This Golgotha[30] is slowly coming to an end,' Michael thought, and allowed his thought to philosophise.

'Life is full of ups and downs. The weight of each person's "cross" differs every time. That cross is attached to the body. You cannot leave it anywhere, nor share it; all you can do is to have the strength to lift it up. That is your salvation. What makes you stand up and what helps you not to crawl in the dirt. Carrying that cross to the top and back down again. To endure! To endure!' Michael said, and repeated it again and again.

[30] **Calvary**, also **Golgotha**, was according to the Gospels a site immediately outside Jerusalem's walls where Jesus was crucified. It is also an expression in Greek for someone enduring a hard time.

CHAPTER 15
'A Difficult Return Trip'

A sweet melody began to spread in the quiet room until it reached Sophia's ears. She let it play. She really liked it. She had chosen a gentle rhythmic beat from the last dance show she saw – 'The Lord of the Dance' – and had set it as the alarm tone on her mobile phone.

The second time the alarm went off, she stood up. She sent an imaginary thought of love to Michael and left the room in its silence.

In half an hour, she was ready: she had called a taxi and she did not want it to have to wait for her. With a red scarf on her head, to hold back her rich hair, and her favourite pair of jeans, she stood at the door, holding the house key in her hand.

'Who knows when I'll be back, and how; under what circumstances!' she thought. That 'how' made her wonder.

'Why did I say that?' she thought, without being able to give an answer to her question.

She shook her head with a look of ignorance, pulled the door closed behind her and locked it, placing the key in the pocket of her trousers. She picked up her suitcase and, after checking the ticket in the bag hanging off her shoulder, she descended to the spot where she always used to wait for the taxi driver.

Despite her desire to be the one waiting for him, he was there first. She greeted him cheerfully.

'We are going to Skala, I imagine?' he asked, taking the suitcase.

'Yes, but first let's please make a short stop at the estate agency because I need to drop something off,' and she showed him the agency's business card bearing the address.

'I will not be long. It will only take me a minute to drop off the key and then we can go,' she said and disappeared, walking down towards a courtyard filled with fuchsia bougainvilleas.

She came back quickly, as promised.

'Let's drive to the port now. And I hope the ship is not caught up in any delays,' she said, reclining in the cosy lounge of the car.

The road had a gentle slope among the trees on the way to the port of Skala. At the junction adjacent to the sacred cave, she turned her head. With a thought, she managed to imaginarily touch her palm on St. John's prayer point.

She felt the coolness of the rock on her fingers. Instinctively, she hid her fingers in her palm as she did not want to lose that feeling. She closed her eyes and focused on the coolness that caressed her hand.

They encountered some morning traffic in the port of Skala. Cars with travellers, trucks with goods, refrigerator trucks transporting fish: all ready, lined up one behind another awaiting the main means of transport with the rest of the world.

Drivers, some half asleep on the wheel, usually truck drivers, others strolling down the port, impatient, making circles around their cars, and others so mad with joy that even if the ship arrived tomorrow they would not care: these people especially enjoyed everything that was happening around them.

Sophia sat on her suitcase and, facing the sea, let her gaze wander as it followed some seagulls flying.

Those seagulls held a key role in the performance of the ship's arrival, as they were simultaneously its escorts and observers.

The sun was shimmering on the light blue water and dispersed like blue glitter all around. However, the heavy smell from the rotting stagnant seaweed on the edge of the wharf spoiled that golden embroidered 'painting'. The dissonance of

this whole image was saved by a gauzy net, spread on the cement pier by two young fishermen.

The beauty of this living painting wiped away everything ugly and threw it literally outside the field of the mind.

On the horizon, the sound of a thunderous horn indicated the arrival of their means of transport. Soon, everyone was going to bow in joy before it.

Sophia's return trip ended up being a meditation journey. For the first half hour, everything was mayhem until all the newly boarded passengers had settled. Eventually, everyone found something to occupy themselves with and pleasantly pass their time of travel.

Sophia chose a relatively solitary spot inside the lounge area. She put her suitcase beside her and sat back in an armchair beside a window in a shady part of the ship. The view of the sea always calmed her down. She pulled a book from her bag and left it on the table in front of her.

A stocky man wearing black reading glasses was sitting in an armchair nearby. He indistinguishably sat up, trying curiously to read the title on Sophia's book, but did not succeed. Unfortunately for him, the book was upside down, so he abandoned his efforts and turned his attention elsewhere.

Sophia took the book in her hands and turned her body towards the window, annoyed by his gesture. She did not open it. She just put it on her legs and let her gaze become lost in the foaming waves.

When the ship started sailing into deep waters, the ride was not very gentle. Coming face to face with Aeolus, the Lord of the Winds, the ship had no choice but to face him. The confrontation was rough and shaky; unpleasant. Everyone on board tried to sit, as balancing is not an easy feat when the ship is rolling and pitching because of the waves.

Many started feeling nauseous and asked for nylon bags: the disgusting aftermath of being sea sick. The most proactive passengers had already swallowed the appropriate pills to combat sea sickness. From a position of power, they now

looked with pity at all the yellowed faces wearing that aversion before vomiting that wandered threateningly.

'I don't think I can read,' Sophia said to herself in a last-ditch effort to open the book.

She closed the book reluctantly and left it beside her with the title now visible. She did it on purpose, as a reaction towards the rude passenger who looked ghastly from nausea and did not want to look at anything now! He had his eyes closed and was struggling between his curiosity and the nausea.

Anything that could have fallen off a table was stowed away in no time. Waiters literally running around picked up any glasses, cups, plates – they succeeded wonderfully in balancing everything, their experience evident – and secured them behind the lounge bar. They also secured garbage bins, and all other small items displayed on the wooden counter disappeared. Within minutes, the bar that was earlier full of queuing people pulled down its safety shutters in a nanosecond, and everyone ran off as if being chased.

A man, possibly a non-commissioned officer swaggering in his white outfit, wandered in style around the lounge. Hanging on to things every now and then to maintain his balance, he was ordering passengers not to leave their seats to avoid any accidents.

A gentleman in his forties wearing white floral shorts and flip flops – advertising, unkindly, the claws on his feet – and with an omniscient demeanour, prominently addressed his wife, who was sitting beside him.

'We are experiencing bad weather, we are experiencing bad weather!' He said it twice, not for his wife to fully comprehend the information but for everyone else around. She did not even listen to what he said as she was loaded with two babies in her arms, probably twins judging by their similarity. She was equipped with all the necessary emergency kits – bottles, pacifiers, hats and toys – and was trying to keep them quiet. She turned and looked at him with an air of despair which did not last long, as a tiny hand pulled on her chin demandingly, fighting for her attention.

'I am talking to you!' a squeaky little voice told her, and the little rascal was demanding her to look at him.

The whole situation was evolving dramatically. A foul stench started to spread in the lounge. The bad weather had riveted everyone to their seats. Sophia was trying to maintain her self-control, but it was in vain. She admonished herself for overestimating her strengths.

As if passing between the Clashing Rocks[31], Sophia arrived sweating at the toilet. She could no longer afford to act civilly. As a last resort, she had to use a suppository that she found at the bottom of the bag – what good fortune – as a lifeline to appease the nausea that was dangerously taking over her.

She splashed some water on her face, but was startled by her appearance in the mirror. She left the toilet in a rush, as it had become the most important area of the ship for the past hour.

Despite the difficulty of moving around, she considered it necessary to urgently get out for some fresh air. By supporting her body on whatever she bumped into, and caught in the course of a drunken person, she managed to reach the outer corridor. The wind grabbed her by the face. Her hair, even though she was wearing the scarf, poured out like a torrent in front of her. She had no choice but to let it lash her face because her hands had undertaken the important mission: to keep her upright. She merely turned her body towards the wind in an effort to rid her face of her hair and clear her view.

Her stomach was a horrible mess.

[31] The **Symplegades** or **Clashing Rocks**, also known as the **Cyanean Rocks**, were, according to Greek mythology, a pair of rocks at the Bosphorus that clashed together randomly. They were defeated by Jason and the Argonauts, who would have been lost and killed by the rocks except for Phineus' advice. Jason let a dove fly between the rocks; it lost only its tail feathers. The Argonauts rowed mightily to get through and lost only part of the stern ornament. After that, the Symplegades stopped moving permanently.

'I need somewhere to sit,' she said, and holding on to the iron handrail, she found a bench.

Those who had come prepared had the benefit of finding fun in the whole situation, and enjoyed watching the waves 'play' violently, angrily banging on the keel of the ship.

Sophia felt jealous.

'I had to act quicker when I realised what was going to happen. Now, I am stuck here…' she said and took a deep breath, wanting to help the drug take effect faster.

As she let her gaze run over the white foamy waves, something caught her attention: a curved motion and colour opposite to the white she was seeing.

'Oh! Oh! Am I really seeing…' in the next few seconds she confirmed in joy, '…dolphins!' she cried triumphantly and tried to get up, unfortunately forgetting that she was standing on shaky ground.

Losing her balance the moment the ship was surfing on a high wave, she found herself falling over on the wet iron deck.

She muttered something angrily to herself, but got up quickly and searched desperately with her eyes, wishing to see the dolphins again.

'There, there!' she said, and this time fixed her hands firmly on the iron pipe handrail.

The joy and beauty of life were born into those raging waves. Sophia admired the dolphins' wonderful movements, their grace, playing with the waves, and their companionship with their courageous iron co-traveller.

And as suddenly as they appeared from the depths of the palace of Neptune[32], that's how suddenly they dived back, searching for the mermaid sister of Alexander the Great in the deep blue sea.

[32] **Neptune** was the god of freshwater and the sea in Roman religion. He is the counterpart of the Greek god Poseidon. In the Greek-influenced tradition, Neptune was the brother of Jupiter and Pluto; the brothers presided over the realms of Heaven, the earthly world, and the Underworld.

A sudden dive of the ship reminded her of the fluttering in her chest, just like the time she rode in the small colourful boats of the roller coaster when she was a child.

That fluttering was an auspicious sign that the nausea was slowly abandoning her, and she could now comfortably enjoy watching the ship 'playing' with the waves; unfortunately, that feeling did not last long. The wind stopped blowing sharply, as if the ship had emerged from the boundaries of an airy corridor.

A sweet breeze now caressed Sophia's cheeks, wheedling her and apologising for the inconvenience it caused. She returned to her seat to check on her things. With all that was happening, she had completely forgotten about them.

In the passenger lounge, total chaos still prevailed. Drowned by that chaos, she carefully surveyed her suitcase. The stocky gentleman was – putting it leniently – in a terrible state. This omniscient man had handed his 'weapon of knowledge' to the couch this time, sleeping in a funny manner with his mouth open, admiring the ceiling.

Sophia was overcome by a muffled laugh and went back out again. She was timidly followed by others, as if just awakened from hibernation, counting the victims of this peculiar war against their insides.

Sophia looked at her trousers, which were dirty after that clumsy fall on the deck.

'These trousers were also a victim of the storm,' she thought, and watching other passengers trying to regroup, she was consoled.

The coast of the Saronic Gulf, painted in dark green colours, began to appear faintly on the horizon. As the ship was approaching, small things began to acquire volume and their colours began to vary.

The Gulf's entrance was always flanked by the columns of the temple of Sounion. The number of ships increased significantly: commercial ships, passenger ships and cruise ships clearly demonstrated that they were approaching the port of Piraeus. All the passengers began to prepare for

disembarkation, seemingly with much haste, as they were worn out from the hassle of the trip.

A speedboat cruised past at very close proximity, heading gracefully to its destination.

The boat occupying the position at which Sophia's ship would dock had just lifted its anchors in preparation for a long trip.

The binding process of the ship and the quay was routine for the seafarers, and it was executed very quickly.

People poured out into the marina, heading to different destinations.

Sophia jumped into a taxi with three other people. Each passenger would be dropped off at a different point of a rather long drive. After such a gruelling trip, however, everyone wanted to reach home as quickly as possible, so they have to compromise on some extra kilometres, rather than waiting for the next taxi not knowing when it might appear.

The traffic on the streets was that usual desperate kind found in megacities. Traffic jams, horns and endless fuss.

In some strange way, Sophia felt really comfortable: like a fish *in* water. As if she had returned from another planet. The events surrounding Michael's father, the visit to the sacred cave and, lastly, the morose trip back had taken her far away from what she knew. Faced again with what was familiar and intimate gave her an illusory sense of security.

Her brain processor was translating from its own lexicon: traffic chaos – *translation: all good, what happens every day*; air pollution – *translation: the same familiar smell of the city*; lit shops – *translation: everything rolls smoothly, powered by consumption.*

She searched for her purse in her bag, took out ten euros and paid her share.

She dragged her suitcase to the entrance of the apartment complex, muttering irritably because the driver had forced her to walk a few extra metres as he did not want to lose a potential customer.

'Damn it! Next time I will certainly not jump in a taxi with other people. Somehow, the taxi driver is the one that is ultimately served, rather than his clients,' she said, more angry with herself for being impatient.

She was still mumbling when she entered her flat. She left her suitcase in the hall and literally threw all of the clothes she was wearing onto the floor. They were carrying on them all the nausea, dust and discomfort of the ship.

A tight and shapely body slipped under the cascading water in the shower. She let the cool slide down her sun-kissed skin.

'Finally! The "pig" has become human again,' she said in self-sarcasm.

A sigh of relief escaped her lips, dragging with it towards the drain that entire sense of dirt that was on her.

'My bathroom today will become a spa,' she said to herself firmly.

She opened a bathroom cabinet and took out an unopened body cream with coconut scent. She had bought that cream some time ago, along with some other things, just because she liked its aroma. She considered that now was the most appropriate time to use it.

She took it and went into her bedroom. She squeezed a respectable amount into one palm, then shared the cream onto her other palm too.

She had only just started rubbing the cream into her left leg when the phone rang.

'Interruption! What a great 'melody'!' she said censoring the moment and putting all the cream on her body, forming two white mountains over her thighs. With a funny monkey walk, she approached the dresser and took the phone from her bag.

She heard a familiar voice on the other end of the phone.

'Hello baby! Are you home? How was your trip?' Michael asked with obvious interest.

'Yes. I arrived about half an hour ago, exhausted, filthy and strained from trying to settle,' she replied. 'As for the trip, it was horrible but I'll tell you all about it when I see you,' Sophia added in a brisk tone.

'Ok. Ok. Get some rest. I will probably be back after tomorrow. My father will stay in hospital for another week. Alkis will stay with Mrs Rena' – often Michael referred to his mother with her first name, benevolently – 'Mr Theodore's health is very good, but they need to keep an eye on him for a little bit longer. He will go through some final check-ups and then be discharged. I'll let you know if anything changes.'

'Fine, Michael darling. I'm looking forward to seeing you. Kisses!'

'And kisses from me too. Bye,' Michael replied and hung up.

Sophia went back to the bed with the same monkey walk, picked up the cream and added some more of it into her hands. After that, like a good witch, she made the white mountains on her thighs disappear, turning them into thousands of tiny grains of hydration that released a wonderful aroma around her.

Pleased with herself, she brushed her lush hair, which she had already dried, and headed to her bed.

Passing through the hallway, she had a fateful meeting with her suitcase. She looked at and spoke to it as if talking to a friend.

'I will see you tomorrow.'

And, at last, Sophia spread herself sensually on her cool bed sheets.

CHAPTER 16
'Internal Worries of a Young Doctor'

Michael's return marked the beginning of a quite active period: completely different and also full of enthusiasm.

Sophia had to enrol at the hospital where she was going to undergo her practice, like any young graduate doctor.

Michael was seeking a space to house his office.

With much joy, Sophia promised him that she would offer her full assistance in setting up. He, in return, did not have to promise her anything, as he had already offered his help for some time now in other matters.

So, in parallel, they supported each other with their respective needs.

Ten days into the month of September, on a Wednesday morning, they headed in a great mood up the highway towards Thessaloniki.

It was a day of exploring. Sophia had unbridled curiosity to see the place where she was going to start working, which would be hosting her for an entire year.

The morning traffic was a little troubling, but not sufficiently vexing to harm their morale, at least not today. The workforce of the country was on its way to work at this time.

The areas to their right and left were filled with factories, and it immediately gave the air of industrial production. As they drove further, the huge volumes of factories, with their chimneys sending messages to the sky, began to dwindle.

In front of the gate of a chemical plant, a huge red banner was hanging, hiding the name. Sophia's attention was caught by the black painted skulls.

'I guess, in this case, the environmentalists' protest against the pollution has obviously rattled those responsible,' Sophia said to Michael, judging by what she saw.

Under the written material protest, people from the environmental organisation, dressed in black clothes, were trying to inform the workers, talking to them and giving them leaflets concerning safety in the workplace.

'It seems that the ecologists have succeeded in convincing them. See?!' and Sophia pointed with her hand. 'Most are standing outside beside them and won't go to work!'

Michael looked at where Sophia was pointing, focusing on the tall building standing imposingly on the right side of a large courtyard. He shook his head and commented:

'Some, of course, behind the huge impermeable windows of their offices, will be provoked by this red rag like bulls are, but I suppose they're so constrained that they can't let their anger be expressed. They can only monitor like cheap spies, at least for now...' Michael said, and continued analysing his opinion.

'The dirty games of apparently legitimate agreements are conducted under the table, with their own unwritten laws and rules, able to remove thousands of lives without any fear or a pinch of hesitation!'

'Fear! Hesitation!' Sophia repeated, as if she had heard something strange, then voiced her opinion on the issue.

'These concepts belong to an unknown vocabulary at the level of financial transactions, and you know very well that capital considers everything unknown as hostile. A monstrous equation applies: unrecognisable = dangerous.'

'At spring time, some headlines about dangerous chemical leaks in the papers had caught my eye. The report referred to them as: 'Unsigned Complaints'. And how do you sign them?! When each signature comes in equal dose with a life, namely that of the person signing.'

'These are just scattered words to attract the attention of journalists and the world, and offer minimal hope against those in power who make the wrong moves on the chess board,' Sophia said, distraught.

The slight cloudiness of the city thickened on higher ground. A breeze would pick Sophia up like a 'smoked cotton ball' and carry her over the concrete complex of the city. Trapped between the tall buildings, she would wander around, playing through the labyrinths of the large city avenues for a while, and then get lost at sea.

Sometimes she was unfortunate playing this game. She would fall onto the warm enemy: the superheated cement that eradicated her. Initially turned into transparent thick drops, she ultimately formed a greyish mud at the low level of the sidewalk, dragging with it the black powder of fumed buildings.

'What a mirthless transformation,' Sophia concluded, abandoning her imagination.

The large green highway signs appeared, informing of the approaching intersection.

Michael indicated and took the first exit. He drove across the overpass and continued into a narrow street. The harvested grain fields resembled hedgehogs that had been bleached by the sun. On the side of the road, the green ribbon of weeds offered a breath of life and balanced the life cycle.

A long straight, like a lover of nature, permeated the land, dividing it into two pieces, and somewhere at the end, like hanging jewellery, the first houses appeared.

They went past a small bridge and entered the main street.

Most houses were small and detached. Only towards the centre of town did they see some two-storey buildings, which stood out from the rest because of their stature.

The community clinic was housed in a restored building next to the City Hall.

Michael looked at the inscription above the entrance.

'This is it, Sophia. What do you think?' he asked.

'It looks ok, I'd say, at least from the outside. However, the village is very beautiful,' she said looking across the lush, well-maintained, small park, with the impressive fountain in its centre welcoming them into the square as official guests.

They parked the car right in front of the building.

Michael thought he saw the well-preserved entrance door open.

Sophia took her bag and got out of the car. Her appearance did not resemble that of a doctor. Dressed in jeans and sneakers, someone would more likely mistake her for a student.

She proceeded down a narrow hallway lined with big white tiles, then walked under a natural green arch formed by a rosebush full of twigs. A few round remnants of the flowers that had already fully bloomed appeared here and there. However, some pink rebels, going against their time, were not giving up as they insisted on proudly opening their red petals.

Michael stroked one with his fingers and then followed Sophia. She stood at the entrance and knocked on the door. A lady appeared with a broom in her hand and a smile on her lips.

'The doctor is not here. Hopefully he'll be here tomorrow...' she said, assuming Sophia was a patient, and continued with her work.

Sophia hesitated a little. This was the first time she would introduce herself by profession first, and then by name.

'I'm the new doctor. My name is Sophia Galanos,' she stated, smiling.

Mrs Helen, the cleaning lady at the surgery, proved to be a gentle woman, who expressed her joy with a warm welcome. Sophia glanced at the examination room and the rest of the space around it. In the few square metres of the whitewashed waiting room, there were a few leather chairs and a table in the middle. That was the extent of furniture. On the glass table, some leaflets on healthy eating and a small vase with plastic flowers offset the strict simplicity of the room. She turned and looked at Michael. He had folded his arms over his chest and was smiling, waiting for Sophia to take it all in.

'I admire you, my girl. I admire you!' he said wholeheartedly. Sophia thanked him with a warm look.

They went out looking for Mrs Helen, who was sweeping some dry twigs in the courtyard. They asked her for some information about the village that interested Sophia, along with all the bus routes. Sophia was going to use the bus from now on, starting from the very next day.

They bid Mrs Helen farewell and wandered around the village for a while as tourists, before heading back.

The first drops of rain began to fall, touching the windscreen of the car and slipping down its smooth surface, forming dozens of little streams.

As they approached Athens, the little streams swelled into rivers. When they arrived home, it was pouring down with rain. By the time they reached the entrance, they were soaked. Their feet were swimming around in their sneakers.

Their trousers, from their knees down, were dripping water, as if they had just taken a walk in the sea, fully dressed. Their footprints formed small ponds on the marble entrance. At each step, a slippery squeak was heard.

They opened the door of the house, went inside and stood opposite each other.

A flame sprang through their wet clothes. Without a word, they started to undress, throwing their clothes on the floor, leaving the eyes to speak, sparkling. A soggy mound of clothes formed in front of them. They stretched their hands to overcome the imaginary barrier. They touched their fingers together one at a time, conscientiously, slowly, and let their touch trigger sparks in their eyes. Their gaze was set ablaze, and it transformed into a golden flame of love that started to swirl in the bottomless vortex of love.

Early the next day, while waiting at the bus stop, Sophia felt like it was her first day at school.

Dressed more formally, she wanted to make a good first impression. She felt that a black pair of trousers and a burgundy jacket in her wardrobe were the most appropriate choices.

A sunny start to the day sealed a positive course for the rest of it.

'Even the weather is in a good mood today!' Sophia thought, and looked to the east as the sun peeked between two tall buildings.

The bus ride was short and pleasant, giving her no time for stressful thoughts. The bus stopped at the square almost right in front of the clinic. While descending the steps of the bus, she saw that the clinic door was open.

'Mrs Helen has arrived before me,' Sophia thought guiltily as she hastily crossed the road.

From the entrance of the courtyard, she could clearly see the waiting area of the clinic.

The four people waiting for the doctor was the cause for Sophia to almost trip over, which she avoided with dignity only at the last moment. She was not particularly sensitive, but it was her first day and she was feeling a bit stressed. That feeling did not last long once she donned her white medical gown. From that moment on, she was walking out to the waiting room as 'The Doctor'. Of course, this uneasy feeling did not abandon her straight away, at the beginning of her career. She struggled quite a lot to overcome the vulnerability of a young doctor.

The first few days as students, when they began to visit hospitals for courses and practical work, there were several people, including Sophia, who saw patients with a troubled emotional view. Her evenings were filled with thoughts of worry for Mr Mimis, suffering from heart failure, whom she had seen in the morning, or Mrs Mary who had a serious respiratory problem. She would arrive at home carrying in her mind and soul all the problems of those whom she examined as a doctor.

Until she eventually collapsed. She could no longer sleep well and all her strengths had begun to abandon her. She inevitably came face to face with herself.

Thank God Michael was always there for her; her saviour. He anxiously watched, day by day, Sophia drowning.

Although he had warned her, his lovely girlfriend was a little stubborn, as he used to tell her many times, and she did not listen to him, until one night she had a hysterical crisis.

For five whole hours, she cried her eyes out due to the pressure she had created for herself. Her eyes were swollen from crying. In the end, when she grew exhausted, Michael spoke to her as a psychologist: 'And now that you've defused all the tension and acquired fish eyes, come sit down and let's discuss it. I think you are in the right place to see things clearly!'

That was the last time she pushed herself to that breaking point. She understood that, in this manner, it was impossible for her to help another human being since she could not even help herself.

'You have to look at things differently, Sophia. A patient is in pain and only has his own problem to deal with. You cannot identify with the problems of ten or twenty different people. It is impracticable and impossible for any person to do that,' Michael advised her.

She lowered her head, realising how right he was and that, this time, she had to listen to him.

This was the last time her extreme sensitivity led her down the wrong path.

She greeted, smiling, the people waiting and entered the examination room. She left her things on her office chair. Mrs Helen had welcomed her in the most beautiful way. She had put on her desk a vase of roses, the last crop of the season, that made her feel cheerful simply with their presence.

She put on her white gown, left her stethoscope on her desk and called the first patient in. By the end of September, this morning procedure had become a daily routine.

CHAPTER 17
'The New Office'

Orestes felt very proud of his daughter. All of his sacrifices were rewarded with feelings of joy from Sophia. Like a good father, he always supported and cared for her. So now, once again, in anticipation of her needs, Orestes decided to surprise Sophia with a present.

They were ready to leave. Sophia closed the living room window as it had started getting chillier lately.

The appointment to see an apartment, which Michael would transform into an office for work, was at six o'clock. They were not very tight on time, which allowed them sufficient comfort in what they had to do.

Sophia was applying a little pink lipstick when her handbag began to vibrate and shine like a lamp with hidden lighting.

Aided by the glow, she found her mobile phone relatively quickly in her bag, which had become a small shop filled with women's accessories. She looked at the caller-id.

'It's my dad! I really hope we are not late!' Sophia told Michael as she answered the call.

'Hello Dad! How are you?' she asked with interest.

'We are fine, darling. Everything is fine. I just called to see how… our young doctor is doing! Is everything ok?'

'Perfect! Amazing actually! When my patients see me coming, they rush to leave!' Sophia said, with her weird sense of humour.

'Sophia! Stop saying things like that to your dad!' Michael cried out from the kitchen. Sometimes her extreme way of expressing herself irritated him.

'If you are in the mood for jokes, I gather everything is going well,' Orestes said, and continued, moving on to the main subject of conversation.

'Now tell me, when are you planning to visit?'

'I am not sure exactly when, Daddy. We're a bit pressed for time trying to find a space for Michael's office...' Sophia responded. She looked at Michael, who was looking at his watch.

'I understand but... what about your present for getting your degree? I wanted to surprise you but you spoiled it! Who will bring your present down to Athens? I really cannot bring it down there myself...' Orestes said, and left Sophia speechless.

A silence filled with many dots gave Sophia the necessary time to analyse his words, but she wanted to make sure that she understood well.

'Dad! What surprise are you talking about? What do you mean?' Sophia asked, supposedly clueless.

'Your own car, Sophia my darling! I wanted it to be a surprise, but, unfortunately, I had to tell you over the phone. So, when are you able to come over to pick it up?' Sophia's response was explosive.

She thanked him a thousand times, almost leaping out of her seat from joy, and promised him that she and Michael would go visit at the weekend.

Michael, who had not heard Sophia's conversation with Orestes, was looking at her like a fool.

'But... we have plans on Sunday...' he said, trying to understand what had just happened.

Sophia put the phone down and rushed over, hugging him.

'The most essential gift came at the right time,' she said, and continued kissing him.

'We will go to pick it up at the weekend,' Sophia said decisively.

'Pick up what? And from where?' Michael asked, looking for clarification on what he still remained unaware of.

With a big smile, Sophia answered all his queries.

'The day after tomorrow, on Saturday, you and me, if you want to of course' – she said all this in a supposedly serious manner – 'will drive up to Thessaloniki to pick up the most necessary and useful gift that my father has ever given me, just at the time when I most need it. A new car!' she said, full of enthusiasm.

'Well done Orestes!' Michael said in admiration.

'It is as if he is telepathically reading my thoughts,' Sophia added.

'Recently, a few delayed bus routes have forced me to think strongly about this and "puff", like magic my wish has come true.'

'What I love about my father is that he cares and realises what he believes I need before I even mention it to him. When, for example, I recently announced to him my trip to America, he searched for and found a cousin who lives in New York. He has already prepared the man to expect me at some point and he will help me in my first steps there. I love him so much, Michael!' Sophia said, excited.

'He is a gem, Sophia. I agree with you. But let's go because otherwise we will stand another man up and we have a meeting,' Michael said, looking at the time again.

'Yes, yes, you're right,' Sophia told him, feeling guilty, and made her way to the car where Michael was already waiting and had even opened the door for her.

Michael found parking on the right side of the road under an orange tree. This particular stretch of road was full of trees filled with oranges. In a paradoxical, but explainable way, the oranges only hung from the middle of the trees upwards. On the lower branches, where passers-by could reach, there was not a single orange.

Sophia enjoyed what she saw, but said with her familiar caustic humour:

'What a pity! They left none for us! In this neighbourhood, no one should get ill. It's so full of vitamin C…'

As she was looking up, she did not notice a black cat that came flying in haste out of a dumpster. The cat nearly fell into Sophia's arms. Frightened, Sophia took a step back and cried out acutely. Michael, who had seen her, laughed at her reaction.

Sophia took a deep breath to recover from the fright and followed Michael. He was ahead, searching for the flat number at the entrances of the apartment buildings.

He stopped in front of a glass entrance with a bronze front door in the centre.

'What an impressive entrance. Do you think the rent is expensive?' Sophia asked, and looked at Michael.

'If we go up, we'll find out,' he replied, looking at the list of names alongside the entry phone.

He rang the bell for the name he was given over the phone.

The heavy door, with the characteristic sound it makes when opening, released from the lock and opened with a slight jerk. The elevator was on the ground floor.

They jumped in and pressed to go up to the fifth floor. Once the ascent concluded, they stepped out into the corridor. One of the four oak doors was half open. They pushed it open shyly and went inside the empty apartment. The room was filled with the last sun rays of the day. It looked huge unfurnished. Its only ornament was the deep red marble floors.

Mr Anastasiou appeared and they had to abandon their observation to turn their attention to him. He proved to be a very nice and easy-going person. His main concern was to keep the apartment in good condition. Anyway, that was evident from the excellent preservation of the place by the previous tenants.

Michael was very pleased with everything. In addition, the blue bathroom tiles with sea shells in the centre gave a tranquil note to the place, which was ideal for the space's intended purpose.

His only wish now was for the rent not to exceed his financial capabilities.

And, like a miracle, his wish came true. He was beyond pleased. He shook hands with Mr Anastasiou and they both agreed with satisfaction. They both signed the contract and the agent handed over the keys to Michael. He wished them all the best in Michael's new work venture and left, leaving Sophia and Michael to make plans on decorations.

They complemented each other in their ideas as far as furniture, colours and tables were concerned. After two hours of exchanging proposals, they decided upon a mix of options that they perceived would have a wonderful effect.

The next day, Michael started looking for the things they had decided to buy. He was first going to find everything in the shops, then he and Sophia would go to buy everything together, after they had decided on the final things.

At the weekend, they travelled, as promised, to Thessaloniki to officially receive Sophia's gift from Orestes. A red car was waiting, all polished, in a car park near her parents' house, and adrenaline rushed to her veins. Orestes had parked it there for safety reasons and because he did not want Sophia to pick it up dirty, but the rainy autumn weather ignored his desires.

Sophia, deeply touched, thanked him in the sweetest way. She gave him a huge warm hug, embellished with two sonorous kisses that made Orestes twice as happy.

He did wonder whether Sophia would like the characteristics of the car, but now he was absolutely certain that his choice was the right one.

The hours available for Michael and Sophia to see their loved ones were hopelessly limited.

Sophia thought it necessary, albeit briefly, to visit Michael's parents' house. He wanted to see his father after the troubles he had experienced with his health. Mr Theodore seemed pretty rundown, and some extra wrinkles had been added onto Mrs Rena's face after all the suffering and agony of those difficult past days.

As for Aunt Maria, travelling to Thessaloniki without visiting the 'green paradise' was unheard of, only this time the 'green paradise' was more bicoloured.

Yellow hues were spreading everywhere, showing, in their own characteristic way, how time flows ceaselessly.

On the return journey, Michael and Sophia shared the drive, so they arrived quite rested in Athens. They were even in the mood to prepare a schedule for the fast-approaching week.

Sophia arranged for all her evenings free of clinical duties to be entirely devoted to helping Michael set up his office.

Collecting everything they had chosen to buy took a whole week. The last piece was a wooden hanger for coats. They discovered it in an antique shop in Plaka. It was made from ebony and, at the top, three carved lion heads adorned the black wood.

'It looks very impressive,' Sophia expressed as soon as she saw it. 'Those lion heads declare a sense of power, like the one those people who come to your office will seek,' she added as they left the shop, having arranged the delivery day.

On Friday morning, Michael was stranded in his new office, waiting for the things they had purchased to be delivered. They had arranged with everyone to deliver on that day, giving them the whole weekend to put everything in place with no rush.

Sophia made her way straight to Michael's office after finishing at the clinic. Moving around now with the car was very comfortable. She only lost valuable time when trying to find parking. Unfortunately, everyone in the city without the good fortune of their own parking space had the same problem. She had also brought from home a bag with some casual clothes, loose trousers and a cotton shirt, that would turn her into a proper housewife in a second.

When she arrived outside the office door, the hallway was full of cartons, polystyrene and nylon bags. She walked in just as Michael was unpacking the wooden coat hanger.

She kissed him quickly and took the casual clothes out of the bag she was holding. In a minute, she was ready for work.

They unpacked everything and spread it out in the middle of the spacious room that would later serve as a waiting area.

For some time, they relaxed, sipping on an iced frappe coffee Michael had foresightedly bought from the neighbourhood coffee shop.

They had not finished drinking their coffee when proposals on where to place things started flooding from both sides. They would isolate each item and, after four or five suggestions, they would conclude upon the most appropriate suggestion. However, it was not always unanimous. They did have some sharp disagreements, where their tone of voice rose, but, in the end, they would somehow find a middle ground and their ammunition – reasons for confrontation – would cease.

After a two-day bloodless war for the conquest of the office fortress – with a couch, two black leather armchairs, and two paintings by Tsoklis with fantastic marine themes – they reached the end on that Sunday afternoon, with capitulations and signatures on both sides.

Exhausted and sweaty, they sat down to enjoy their creation.

'It looks amazing!' Sophia said.

'Perfect!' Michael added as a postscript.

Finishing in peace was celebrated with a thank-you kiss to the main assistant of the project, who now also acted as decorator.

Winter was passing with a fertile and peaceful daily routine.

Sophia devoted her mornings to the clinic and some afternoons to her work in the University, alongside Professor Kaliri. She attended some amplifying English courses that she considered necessary, especially on medical terminology.

Michael opened his office doors and proved that the profession he had chosen really suited him. His customers multiplied day by day, giving him great pleasure as the reward for his efforts.

CHAPTER 18
'The White Envelope'

Seasons changed and they did not get any wiser. The hourglass of time continued to count down, regardless of whether they saw it or did not want to, ensconced in a life that ran smoothly.

And while summer is the time when clouds do not usually visit the clear blue sky, fearing the brightness and heat of the summer sun, for Sophia and Michael, the seasons were reversed. This summer was just strange. Full colourless and hazy days, as if they lived in another hemisphere, where the winter chill makes people dress up to their ears.

From the day the envelope arrived in the mailbox, change came rapidly.

It was Saturday morning. The July sun, in its closest contact with the earth, foreshadowed a very warm day.

With their bags over their shoulders heading for a swim, they called the elevator to go to the ground floor. They felt hopelessly impatient for a swim in the cool sea.

The coolness that prevailed in the hallway made them take an instant breath of cool air before walking out into the 'furnace' of the road.

Sophia's eyes fell unwittingly onto the metal mailboxes. The white colour of an envelope in the slot of the box grabbed her attention. She opened the mailbox and took the envelope in her hands. The stamps on the top right and the address on the left clearly stated where it came from.

Michael saw that the stamps came from across the Atlantic and realised its origin as he gazed from the side. He felt a tightness in his stomach, but did not show it.

Sophia did not open it or even look at it more carefully: she only said, with a feigned neutral tone of voice:

'It's from America.'

She placed the envelope in a side pocket of the bag she was holding, which was decorated with dolphins, and put the bag over her shoulder, trying to put to the back of her mind all the exponential thoughts that had begun to overcome her.

She tried to regain her pre-envelope mood, but her effort was futile. For the whole past year, Michael and Sophia had done quite well, but they now had to confront, face to face, the truth that approached them as an impetuous torrent. Throughout their walk down the beach, a white mine had nested in their minds. Cute words of supposed comfort were unable to neutralise the numbness, and the length of the wick that was going to start the fire seemed to make them more anxious.

When they returned home that afternoon, they did read the white 'mine', which revealed that the date of the 'explosion' was set as September 20th.

In the entire letter, a number and a word alone conveyed everything that needed to be said.

That was the date on which Sophia had to appear at the New York Medical Centre to begin practice in her intended specialism as a doctor.

The countdown had begun.

This August was nothing like any previous Augusts. Filled with liabilities and preparations for the transatlantic voyage, it left Sophia and Michael with no time for trips to the sea. In addition, the mood was definitely not there either.

The paperwork was quite a difficult part of the preparation. Paperwork for the passport, certificates for the visa, air tickets and many other small details made Sophia run around at a crazy pace.

And in all this, her martyr assistant was Michael.

'I am doing everything in my power to send her far away from me! I'm crazy. I am crazy!' he said to himself, over and over again, as he waited patiently in the queue at different public service offices for a stamp or a signature on Sophia's papers. But he knew, deep inside him, that this was the right thing to do. No one had the right to stop her: only God or Sophia herself.

Sophia had already started counting the days until her departure. In her place at the clinic, a new replacement doctor would arrive from Ioannina. She had met him when he came to 'trace' the region as Sophia had done about a year ago. Sophia conveyed to him her best impressions about the people in the area, their hospitality and her compassion towards Mrs Helen. On her last day in the clinic, Mrs Helen bid Sophia farewell in the same sweet way she had greeted her when she first arrived: with a bouquet of red roses. Sophia was so deeply moved by the gesture. She took the bouquet with her and made it last a whole week in the vase by changing the water every day, trying to preserve them for as long as possible.

However, someone else was particularly upset by Sophia's departure.

Costas. From the first moment they had met at the infirmary, he showed a warm interest in Sophia. Whenever he brought the prescriptions for Sophia to stamp, he would not take his eyes off her. As the only pharmacist in the village, his visits to the clinic were almost daily: to get prescriptions stamped or collect a supply of medicines, and always with a smile on his face.

Sophia realised very quickly what was happening but gave him no room to hope. Besides, a meeting with Michael one afternoon, when he came to pick her up from the clinic, put things firmly in place. Despite that, always of course within the limits of civility, Costas' feelings towards Sophia never ceased. He never embarrassed her or made her feel awkward, and the only impulsive conversation they ever had was the one on Sophia's last day, when he had to say goodbye.

'I will really miss you, Sophia,' he said, and a sadness spread in his eyes.

Sophia felt very uncomfortable. She left, taking with her some of Costas' unhappiness. However, her own acute problems made her totally banish any thoughts of him very quickly.

She gave the apartment owner enough notice that she was to leave the warm 'rat hole', which had hosted her lovingly all these years. She only had a few things to collect anyhow, as that was all she had arrived with. The new roommate, who had replaced Lena when she left, kept most of Sophia's little gadgets, apart from one, which she really wanted Michael to have.

'I want you to keep this and think of me when you look at it,' Sophia told Michael the day she brought over to his place the tufted azalea.

'But what if something happens to it at some point? Should I stop thinking of you?' Michael asked, teasing her.

'I neither said nor meant that. While it lives, it will be something to remind you of me!' she explained to him, a bit embarrassed.

'Much will remind me of you, Sophia, my darling!' Michael replied, of course referring to the obvious.

Only clothes, shoes, her personal stuff, photos of loved ones and biographical documents were the items which filled her suitcases. All the memories were arranged in a box of her mind and locked away tightly. She paid off all her bills, as she never liked to leave things pending, and handed the key to her now former roommate.

She was going to stay at Michael's place for the last few days before her departure.

Her father decided to take back her car, to do with what he considered best.

Three days before her departure, she drove the car up to Thessaloniki with Michael, where she said her goodbyes to the

whole family. Those family moments were touching and awkward. Contradictory feelings alternated in the souls of everybody. The joy of Sophia's progress conflicted with their sadness, because she had to leave them and be gone for a long time. The only person excited, in his own childhood world, was Paul. He had already prepared a wish-list of games for Sophia to bring him back from Disneyland at the first opportunity.

Orestes gave her a piece of paper recording John's address and phone number: he was Orestes' beloved cousin and had emigrated many years ago.

''John the Greek'. That is what they call him in America,' he said. 'Call him when you arrive and he will come and pick you up. I have informed him about your arrival time and, from what he has told me, he lives pretty close to the airport where you're landing.'

'Daddy, thank you so much. It will be immeasurably easier for me to have someone I know in a city I'm completely unfamiliar with,' Sophia said, already starting to feel heavy. Some difficult goodbyes were approaching.

Two paternal tears appeared in Orestes' eyes while his daughter hugged him.

'Take care, my darling!' he said protectively in her ear as he held her in his arms.

'I will, don't worry! I will call you soon as soon as I get there,' Sophia said, reassuring him.

The next two stops were the usual.

With much affection for Sophia, Michael's parents gave her their best wishes for her future.

Only at Maria's house would a few melodramatic scenes unfold.

'Oh baby! You are going too far! Sweetheart!' There were no words to express Maria's pain. Her words bathed in the tears that ran from her eyes. This separation was too heavy for Maria. She felt like she lost Sophia from her arms; her embrace.

'Don't be upset, Auntie. I will be back soon to come and see you,' Sophia comforted her, knowing, deep inside, the impossibility of keeping that promise.

Lucy did not leave her side for one minute. She was not wagging her tail and she was not cheerful: she only stood by her, looking at her with her small black eyes and a sorrowful tone, as if she knew it was the last time she would see her friend.

Six months later, when Sophia was already in New York, she was told by Orestes of Lucy's tragic end. In one of her little getaways from the 'green paradise', she found herself under the wheels of a truck, meeting the fate that took her on the long-awaited journey. During the first few days after hearing the tragic news, Sophia was inconsolable. Lucy was constantly on her mind. She would recall all the beautiful moments they had spent together, but also the painful ones, when Lucy would try to console Sophia in any way possible. Sophia remembered her dedication and longing when she would reach for her leash, hold it in her hand and wave it defiantly in front of her shouting: 'Come on Lucy, let's go for a walk!'

Every white dog Sophia encountered on the road would constantly remind her of Lucy. It took her some time to overcome her melancholy.

Their return by train was utterly silent. They had chosen the express train as they wanted to quickly get back to Athens. Their remaining time available was measured. On the last day before her departure, Sophia dedicated the entire day to Michael. She wanted to leave him after creating some sweet memories. No one could have known how events would evolve and what the future reserved.

For the whole morning, Sophia and Michael wandered around the places they had walked together before, to corners where they had slowly begun creating this wonderful bond, so much deeper than a simple affair. They were bonded by strong emotions, above the ordinary: friendship, companionship and love in its broadest form, and they carved a relationship that no distance could squander.

Intense feelings emerged during a tender moment of the afternoon, which found them hugging on the couch in the living

room of Michael's house; a wonderful melody adorned the moments which, like beads of a chaplet without a safety pin at the top, fell silently onto the floor and ran to hide in every little corner.

Sophia stretched out her arms and stroked his hair.

'I remember the first day that I met you on the train, when you were wearing that red baseball cap, hiding your lovely hair,' she said nostalgically.

'I was obsessed with hats that summer! I owned at least ten of them. But do you also remember how many earrings were hanging off your ears? I did wonder how you managed to fit them all on!' he teased her, with a time-delay that also indicated a moment of self-wonder.

'I think that, at that age, it seems we do take things to the extreme – marginally – taking into account, of course, each person's limits,' Sophia concluded. 'Although our own were just for laughs! Don't you think?' she said jokingly.

'We had our own style. To some others, it may seem conservative, but people decide for themselves what their limits are,' Michael said, supporting her view on this.

'I do not think we've ever been conservative, neither then nor now. Also, conservatism is a very general concept and I'll prove it to you right now.'

Sophia paused for a moment to rectify the coherence of her thought, and relieve her left hand that was going numb under Michael's arm.

'All these years we have created a relationship that is not based on sexual attraction alone. We grew up together in the early steps in life, we fought together, we got angry together, we rejoiced together and we became lovers together. Do you agree so far?' she asked.

'I agree,' Michael replied, trying to follow her reasoning.

'And now I will ask you something and I want you to answer me directly. Do you think that if you erase the status 'lovers', that alone has the ability to delete all previous statuses?'

232

'Of course not, I think a relationship should result in two people being lovers, rather than that being its basis,' Michael replied.

'For this exact reason – because we agree – I want to let you know that whatever is our erotic course, because people do have "needs", I think everything else that we've created with much angst will not change, no matter what the distance. And with this reasoning, I presumably prove to you that we're far from being conservative. We simply had and still have our own perception of life's notions.'

Michael clearly understood that Sophia was officially giving him freedom. He considered it a distant issue now, still holding her in his arms, but he did not fail to appreciate her rationale.

As he held her gently, her long hair caressed his left hand as she laid her head onto him. He looked at her from the side.

Her eyelids opened and closed like sleepless guards of the green treasure of her eyes.

He gently touched her lips with his index finger and caressed them all the way around, in a very slow-moving circle. Everything he saw on her he wanted to record in his memory as vividly as he could: in that pink box where he kept all his precious moments; his life-saving moments. Every time he lost optimism or hope, he ran like a frightened child into his mother's lap, and as a 'big' child, he found this comforting hug there! There, once he opened the melodic pink box with the treasures of his soul, well-kept and inaccessible to anyone else.

While his mind was processing his thoughts, his eyes became pinned on the edge of the curtain. A cool breeze was peeking through the ajar balcony door, and the curtain was waving like velvet. This exact same feeling, this feather-like movement, he was feeling in his heart, and it made it difficult for him to breathe. A sharp, deep breath broke the organic apnoea that had possessed him, bringing him back to reality.

Sophia slept sweetly on the hand of his heart.

'I wonder when I will ever feel the warmth of her breath on me again?' Michael pondered. He closed his eyes and sealed them tight. He did not want anything to escape: this was his most valuable collection.

The plane was scheduled to depart at six forty-five a.m. Destination: Gatwick, Britain, with a connecting flight to New York. Sophia would have preferred a direct flight from Athens to New York, but unfortunately there was no direct flight on the day she had to leave, so she settled for this alternative.

Michael and Sophia had set the alarms on their mobiles to wake them from a sleep that never really came. At fifteen minutes past three, a soft melody filled the room: an utter mismatch with their psychology.

They both got up silently and readied themselves to leave. Sophia's eyes were slightly swollen, confessing some secret evening tears that had escaped on Michael's arm. She looked at her face in the bathroom mirror. The lamp set in a decorative glass flower directed its light forcibly onto her. She stepped back a little, instinctively, in self-protection. A sombre shadow was wandering in her eyes.

Being separated from Michael would be much more difficult than she had imagined, Sophia reflected, as she sat on the armchair in the living room, surrounded by familiar belongings that gave her security.

She turned and looked at the shelf in front of the mirror. The silver bottle of fragrance with the elegant black cap was urging her to open it. She deeply inhaled the bitter notes of the fragrance.

'Michael in a bottle!' she said aloud.

She took a round cotton pad, normally used for cleansing her face, and sprayed it a couple of times. She then placed it carefully on top of the fragrance bottle.

She washed and cleansed her face with cool water. Applying a little makeup helped to slightly lift her mood. She left her hair loose on her shoulders, to be used as a front if she needed to cover her face: like instant salvation, as the emotional

management seemed difficult. She took the cotton pad with her as she vacated the bathroom, giving her place to the owner of the house.

She entered the kitchen and turned on the coffee maker. Opening a kitchen drawer under the microwave, she pulled out a small nylon bag from a stack of various sizes. She opened the bag and placed inside it the soft white carrier of lovely smelling memories. Retrieving the purse from her bag, she put the small nylon bag behind Michael's photo.

She turned back and filled two mugs with steaming coffee.

'I made some coffee!' she cried.

She took a sip from her no-sugar, no-milk coffee – just as she always drank it – and began to dress. Although the weather was hot in Athens and she dressed lightly, she also took a denim jacket as a precaution that she would hold in her hands.

Michael entered the kitchen, looking serious, and sat down beside her at the table. He hastily drank his coffee.

'Are you ready?' he asked Sophia, who was making sure she had all the papers she needed.

'Yes. Let's go,' she said languidly, and stood up.

When they emerged from the apartment building's entrance, the shadows of night covered the shadows of their souls. The silence of the night-time city made their footsteps and the sound of their rolling suitcases resemble a strange chorus on the paved sidewalk. They loaded the suitcases into Michael's car and departed. They drove up Kifissias Avenue to take the exit towards Attiki Odos, heading to Eleftherios Venizelos Airport.

Sophia was trying to suck in with her eyes everything she saw en route. She did not know when she would see Athens again. The years that she had spent living here were very important, and she had created some really valuable moments for the rest of her life.

At the Attiki Odos junction, the vehicle traffic started to grow heavier. They paid the toll and calculated the remaining duration of their journey: they were going to arrive on time.

The radio played soft, melodic songs that spoke directly to their souls.

And suddenly the voice of another guy called Michael, Michael Chadjigiannis[33], flooded the air with its sensuality.

'Please come back, I beg you, with much pain. My heart only beats for you, please don't delay, don't delay!'

Without taking his eyes off the road, Michael said to Sophia, with much sweetness,

'The words of this song I dedicate to you with all my love.'

Sophia stretched out her hand and stroked his cheek to thank him. She did not say a word; only a melancholic smile appeared on her lips.

The airport lights could be seen from afar, illuminating the whole area with white and orange hues. They arrived very quickly. Time was running out. Sophia tried to halt it, even for a second, but realised very quickly that her efforts were futile.

There were quite a few cars in the car park. This was the time that the city was waking up, but, for the airport, there was never night or day, especially during the summer months.

The glass elevator took them up to departures. They headed towards the departure check-in.

On the large electronic board, Flight 709 to Gatwick was flashing. At the number eight check-in desk, a queue of people snaking between the blue dividing ribbons had already formed. They stood in line to check in and drop off Sophia's baggage. It took them over half an hour to reach the front. The clerk checked Sophia's ticket.

'Window or aisle?' the clerk asked, looking at her.

'Window,' Sophia replied, choosing her seat number.

The clerk handed Sophia her ticket and boarding pass, repeated her seat number, and weighed her suitcases, gracing them with the adhesive travel bracelet.

[33] **Michael Chadjigiannis** is a popular Greek singer.

'Are you ready?' the clerk asked Sophia with a formal smile.

'You are departing from gate three,' she informed her, and turned her eyes to next person waiting in line.

Sophia took her ticket and boarding pass and walked off with Michael at her side. Further down the corridor, gate three was already lit up. The hourglass counting down their time was dropping its last few grains, forming a mountain of life's cramped moments at its base. Her heart jumped, making her breath stumble, unable to follow the rhythm. She looked around her with despair.

On the right, Sophia saw the entrance to the toilets, and a few metres away, a tall green Benjamin Fig was adorning a clay pot with ancient meanders. Sophia took Michael's hand and pulled him towards it. She leaned back against the wall, in an artificial hideout created by the plant. She put her hands on Michael's shoulders, plunged her heart's eyes into his eyes and said:

'Sweetheart, don't ever forget that you're the most important person in my life, whatever happens…' While saying these last words, she embraced his face in her hands; in holding it, she was attempting to ensure that every single word she uttered would reach its destination.

'I love you sweetheart!' she whispered, touching her lips to Michael's.

Michael responded with fervour, and gathered in his heart all the loving waves that reached his heart and soul.

'I will never forget that baby! I love you. I love you,' he said, covering her face with kisses everywhere.

Tears did not pour. All the tears had fallen the night before, during their very personal moments. They had both promised not to lose control of their emotions.

And they both kept that promise, despite leaning dangerously on their limits.

Walking just a few metres further down the corridor, Michael embraced Sophia by the waist, giving her some final

tips and imparting his desires. 'I want you to take care of yourself! Please call me when you arrive, and whenever you feel the need to talk to me, at any time, do not hesitate to call me.'

He gave her another kiss and let her walk softly away towards passport control. He let her go like a paper boat released at the edge of the shore: an uncertain undercurrent tugs it gently as you see it moving away from you, and you are filled with divided feelings of joy and sadness.

That is how Michael was standing there, staring at Sophia. When he could no longer see her, and only then, did he release the security door of his eyes, allowing a tear to run, overflowing from the 'glass' of loss. Much later, he understood that she was irreplaceable.

CHAPTER 19
'Flying with the *Monster*'

Sophia progressed through the grey magnetic arch for body scanning and, recovering her personal things from the conveyor belt, she followed the passengers walking in front.

She felt a huge void inside her. She was trying to manage it, but it acquired a voice and was mocking her with a hysterical laugh.

'You are on your own! You are on your own!' that voice shouted at her, again and again. Panic set in and, like two huge hands, it gripped her throat and started choking her.

She was walking, but her legs were following a red jacket she saw in front of her, mechanically. Inside her mind, she was waving her arms, desperately trying to reach the surface of the intense sadness that was pulling her down.

She was saved by her instinct for self-preservation, which hit her instantly when, entering the aircraft, she caught her right foot in the gap between the tunnel extension and the plane.

She nearly fell flat on the mobile ramp. Reaching frantically to each side seeking a means of support, her hand slipped and she found herself on her knees on the floor. A stewardess ran towards her and asked, with much interest, if she was ok.

'Yes, yes, don't worry, my foot got caught,' Sophia explained, feeling ashamed of herself.

'What a violent salvation, but how necessary!' she thought later when seated by the window, as requested.

Not that her internal anguish was eliminated, but at least it had been somewhat restricted.

She looked around at the other passengers: some were chatting or laughing, whilst others looked a bit dour, perhaps trying to control their own fears. She was somewhat consoled and glanced out of the window. Men in blue uniforms were coming and going under the plane, near its tyres.

Sophia heard the stewardess' sweet voice again, this time inside the plane.

'Are you okay? Are you settled? Do you need anything?'

'Everything is ok, thank you,' Sophia answered as, little by little, she felt more relaxed.

With a slight movement, the plane detached from the building, like a puppy breaking from his mother's nipple. A small truck pulled the plane away from its parking spot and started wheeling it to the runway.

In the east, the sun decided to make its formal appearance. In front of and above the seats, the words 'fasten seat belt' started flashing imposingly.

The noise from the housing of the engines signalled that they were ready for take-off. The sense of liberation from the earth's gravity was catalytic for Sophia. She felt the exact same release from the weights that had been drowning her all this time. She had left everything behind and decided to start a new life, and she had to follow it without any further delays.

It was her first experience of flying, and the feeling of taking off from the ground had flooded her with a strange heartbeat, until the plane levelled-off on reaching its desired altitude, heading towards the north. Sophia looked down at the beloved city that she left behind: she had never seen it from so high up. The sight of it seduced her. The lighthouse of civilisation, the Acropolis, made her shiver with emotion. The endless blue that stretched around, embroidering the city with earthly lace, looked like a jewel that embedded itself in her mind. And one golden sun oversaw this whole beautiful scene while climbing fast into the sky.

The time that was devouring distances took almost everything away from her eyes, leaving only the golden ball to warm her heart.

She tried to sit in a more comfortable position and pulled a book from her bag – she always carried a book with her – to pass her time during the two-hour trip.

Still holding the book in her hands, the smell of coffee distracted her pleasantly.

Breakfast on the plane was something she had not experienced before. She knew well, however, that this would become a mere habit for her in the future.

A piece of cake and some croissants, all packed in transparent plastic packages, accompanied the coffee that acted as a sedative for Sophia.

The young gentleman sitting alongside helped Sophia open the table in front of her. Sophia thanked him, explaining, somewhat embarrassed, that this was the first time she had ever travelled by air. He smiled and said:

'There is a first time for all of us. Besides, I probably owe this to someone who helped me the first time I got on a plane, many years ago, of course.'

'I now travel so frequently that this is all routine for me. Where are you heading to, if you don't mind me asking?' he enquired, putting a small piece of chocolate croissant in his mouth.

'I am going to New York. I have just completed my degree in medicine and I'm off to New York to commence my specialty.'

'Specialty! In what exactly?' the man asked, looking for clarification.

'Oncology,' Sophia replied, also explaining some further details. At the end, she asked him, with interest, the purpose of his own journey.

'I've been sent on a business trip by the company I work for. I am a sales representative for a multinational clothing company, and airports have become my second home. It has become quite tedious for me now, I would say, because in the

beginning I really liked it. It seems I am getting older,' he said, laughing in self-sarcasm.

Sophia listened and, while he was speaking, she observed him. He was a charming man in his forties – most likely a bachelor – with a nice stature and elegantly dressed, but she found that something was missing: she could not grasp what exactly and she did not give it much attention.

Her coffee in the plastic cup was almost finished when he urged her to look down outside the window.

Sophia leaned her head towards the window.

'What are those black holes in the milk?' she asked in amazement. The man laughed at her humour and responded accordingly.

'Those black holes are called lakes and the milk is the snowy mountains of the Alps, as seen from above. We are flying over Switzerland.'

'Fantastic scenery!' Sophia muttered in surprise.

'I have never seen anything like that!' she said looking down, enchanted.

'We're halfway there. In about an hour, we will land at Gatwick Airport and there we will catch our connecting flight to New York. I never usually travel at such short notice, but something went wrong and I had to leave urgently!' he explained.

The man looked at Sophia's jacket, which was folded beside her, and said: 'From what I can see' – and he pointed at the jacket – 'you are prepared for London weather!'

'On overseas trips, you often depart from a city in summer, but where you're heading, you are faced with winter, usually in the north, and then you come back to what you started with. You know, since New York is located on the same geographical parallel to Athens, it has approximately the same weather, so you will not feel the climate change. Everything else there is very different, of course. It is the country of individualism, hidden well behind the charities that do fundraising all over the world, without us ever knowing in whose pocket that money

ends up. You will experience it too…' he said, and passed his tray to the stewardess who was passing by collecting them.

Sophia listened, but did not speak. She was like a sponge, collecting information drops, avidly.

Her eyes stopped on Andreas' hands.

'Andreas Ligaras,' he introduced himself at the beginning of their acquaintance. His hands reminded her of Michael: he was still 'Her Michael'. She wondered where was he now? What was he doing? The most common questions someone can ask themselves when away from their beloved.

She was lost in her questions when a sudden pressure change during the flight made her unwittingly emit a cry of horror: 'Aaaaaaaah!'

Like birds, all of her questions flew away.

She froze with eyes full of anguish. She instinctively looked at Andreas, who had fallen asleep, so she looked around at all the other passengers. She did not see anyone sharing her concern. Making some logical associations in her mind, she casually leaned back in her seat.

'If no one is worried, this is probably normal,' she concluded.

The plane began a slow downward course, descending the stairs of an invisible sky.

'We have probably started our descent,' Sophia thought.

Inhospitable grey clouds greeted them with their usual drizzle. The British countryside was paved with green carpets, and some farmhouses scattered here and there were trying to balance this hazy landscape.

With many jerks and through rain that had now become heavier, hitting the plane's windows with force, they landed somewhat clumsily at the airport.

This was her first travel experience and, straight after they exited the plane, it led her to where even the king goes alone.

Andreas was very helpful and she felt lucky. He waited outside for her in the long corridor, talking on his cell phone. He turned his back and spoke intently.

'Something went wrong with his programme!' Sophia thought, and waited silently behind him.

He exchanged a few insults with his interlocutor and lowered the phone away from his ear. He turned around so abruptly that Sophia sprang back. Two deep grooves on his forehead expressed his tension.

'Is it serious?' Sophia asked cautiously.

'Serious for my job,' Andreas said in a nervous tone.

'An order that should arrive in New York before me has been delayed. That means I have to wait a whole week for it to arrive, so I must also cancel another appointment I have in Munich,' Andreas explained, his mind working overtime.

Sophia noticed the stress that overwhelmed him. She could hear it in his words and see it in the contractions of his face and the movements of his hands, which were moving in circles accompanying his words.

'And there is no solution? Perhaps a change in the appointment? I certainly don't know anything about your job, but I'm wondering, maybe there's an alternative?' Sophia suggested, giving some advice and trying to measure her tone.

'The appointment can be changed, but any deferred appointment costs money when you are trying to negotiate,' he said, and continued, deciding that nothing could be done.

'The competition is that rough...' Andreas stopped talking and became lost in his thoughts for a while: in negative ones, as the darkness in his eyes confessed.

'Come on, let's go to the waiting room at the gate. We have a couple of hours ahead of us,' Andreas said, with an icy tone in his voice, and without even looking at Sophia, he began walking towards the end of the corridor.

Sophia arranged the bag on her shoulder and almost began running behind him.

'Thank God I do not have any suitcases with me,' she said to herself.

She watched Andreas as she walked behind him. His intensity was also chasing after him. His stylish suit suddenly seemed uninviting and cheap. She had never experienced

chasing life like this so intensely. She felt sorry seeing him like this and a thought rang in her head.

'The price of success is unbearable!'

However, she really did not know what her own life was worth yet.

Through a big door, they entered a maze of stairs. The ongoing technical work in this area was in full swing.

'This damn airport will never finish with the patchwork...' Andreas swore through his teeth.

Sophia did not say a word. She was in a difficult position.

They passed under the erected scaffolding and arrived at a grey steel door. The door opened inwards and, beyond, it looked like they had visually changed planet. That is exactly what Sophia thought when faced with what she saw.

A huge circular lounge hosted an incredible crowd.

She stood there for a moment, lost, but very quickly sought the ivory back of her escort that directed her to the left.

Andreas made a stop at the duty-free shops.

Sophia did not see what he bought as she was fixated on the perfume bottles.

'Shall we have another coffee?' Andreas asked.

Sophia was puzzled by the calm manner of his question, and at first thought he was another fellow Greek traveller, speaking to a friend or family member.

'So, are you coming?' he asked again.

'Yes, yes. Let's go,' Sophia replied affirmatively, feeling unburdened of all the previous stress he had unintentionally transferred onto her.

'He has probably accepted the work hitch,' Sophia thought, and followed him like a puppy.

This huge space was laid out on two levels. They wandered past the small shops spread circularly on the ground floor, and took the escalator to the first level. While ascending on the escalator, Sophia lifted her eyes to the ceiling. A beautiful glass dome allowed the limited light of the rainy day to sneak in.

At this level, most of the stores' sole purpose was to fulfil travellers' nutritional needs.

Andreas picked a café table right next to the circular railing, and, like a noble knight, he teasingly offered her the seat with the best view.

'From what I understand, you like sitting by a window with a view, so we will offer you a balcony with a view.'

Sophia found it quite funny but not enough to justify the inexplicable nervous laughter she burst into. She took advantage of the chance to push all that laughter out of her; to release all the accumulated pressure that had begun to hover over her, giving her a light headache.

She avoided Andreas with amazing dexterity, letting him wonder as she pulled herself back together, overcoming the crisis of laughter that had jolted her stomach.

Once she stopped laughing, she realised it had been a long time since she was so entertained. The final days before the trip were burdened with much emotion, pressure and running around. She was now sitting here with a man she barely knew, in a place she had never been before, on her way to a country unknown to her, but to such a well-known destination: the only thing that could help her overcome her insecurities.

While Andreas was regarding the snack menu on the table, finding what they could order to accompany their coffee, Sophia almost dislocated her neck, neglecting her usual tactfulness, in observing a classical type of Englishman drinking tea at the next table. Had she been at home and not in a public place, her jaw would have slowly dropped while watching the Englishman's ritual movements, so perfectly attentive to the last detail: from the way he held the teaspoon to put sugar in his cup, the soft circular stirring of his tea, the spoon's silent 'return' to the white porcelain saucer, and his delicate movements when touching the cup to his lips.

Realising what had caught her attention, which was borderline indiscreet, Andreas said to Sophia, smiling:

'Don't forget that we're in England and there are many traditional types of people,' he informed her, 'who enjoy lots

of different customs, but their habits in how they enjoy their tea will never change!'

'I admit that I'm surprised. Maybe it's the speed of time that has lured us to follow its pace in a big part of our daily lives. I'm telling you that, in a few years, such pleasures will belong to revolutionary movements,' Sophia expressed, as if she was a futurist.

A nippy waiter approached to take their order at an amazing pace: completely counterrevolutionary.

They both ordered coffee, violating the tradition of the country that would host them for the next couple of hours. However, what they duly honoured were two wonderful bowls of chocolate pudding.

They ordered a second cup of coffee – both of them were fanatical coffee lovers – as that one cup seemed way too little to accompany the various issues they discussed while waiting for their flight.

Hanging from the ceiling, a large traditional clock – not electrical – reminded them that it was nearly time to undergo another inspection, before boarding the huge jumbo jet that would take them to the faraway continent.

They gathered their things when a voice from the airport's loudspeakers informed the flight's passengers that the gate was now open for boarding. They arose in good spirits, knowing that their journey was now entering its final straight.

Sophia turned to Andreas just as he was deactivating his phone – it had rung several times while they were waiting, and Andreas had also made quite a few calls of his own – and very honestly said:

'Anyway, thank you very much for your help. Things would have been quite difficult for me, it being my first time on a plane and in a different country. Also, you are great company...' Sophia paused for a moment and raised her eyebrows mockingly '... when you are not pissed off, of course, and when you have spare time away from your phone!'

'You should have seen yourself when we arrived! You were like a bull in a china shop!'

'You haven't seen me at my worst! That was nothing for me! At times, I can't even put up with myself!' he confessed as they were descending to the ground floor.

The departure gates were crazily crowded.

Men, women and children were sprawling in a huge queue. Holding their transit cards Andreas and Sophia stood in one of the rows, stocked with considerable patience.

Shortly before reaching the front, where the charming hostess stood carrying out passport checks, Andreas wished Sophia a safe trip.

'Sophia, in this "beast"' – that is what Andreas called the jumbo jet, considering it the most representative characterisation – 'we will not have the chance to sit together. Try to spend the hours of flying pleasantly, as there are many of them and they pass painfully... especially the last ones.' Just the thought of the really long flight made his face warp as if eating lemon peel.

Sophia laughed, watching his reaction, which she considered a little excessive.

'Don't you laugh!' he said meaningfully, and continued:

'I'm really curious to see what you'll do in the final two hours of the trip... when you've already watched two movies, heard music that could last you a week... OK, maybe you'll also get a couple of hours' sleep, while your legs are desperately asking you for help, asking you to move them, so they're no longer numb from their suffocating stillness.'

'Come on, Andreas! I think you're exaggerating?!' Sophia admonished him, bringing to mind his own strong reactions that she had experienced over these past few hours in his company.

'Oh!... And the most important thing!' Andreas said, relentlessly supporting his view.

'There is something more important than that?' Sophia asked jokingly.

'Come on, just tell me...'

'Today, for the first time in your life, you will have the privilege to enjoy the east twice and, in between, the west, at very unusual times!'

Sophia looked at him in amazement.

'The first sunrise we saw in Athens while we were taking off. We will see the sunset over the Atlantic Ocean during the flight, and we'll experience the second sunrise in New York!'

'Are you serious?' Sophia asked. 'I had never thought of that!'

'Absolutely! Unless you fall asleep!' he replied like an expert.

His words were nailed in her mind.

They had already reached the entrance of the aircraft and she still had his words in her ears.

Their paths separated after entering, as she went to the right and he to the left. The unrest that prevailed from overcrowding did not last long as everyone gradually settled in their seats. When everything had calmed down and Sophia was able to look around and survey the distance, she realised why Andreas said that the "beast" was huge! She was travelling economy class, unlike Andreas, who had the privilege of travelling business class. But this upset her less than the fact she was not sat by the window.

Sophia arranged her few belongings and inspected all the recreational privileges offered by flying on a jumbo jet.

Visibly more relaxed and knowledgeable, she put the headphones into her ears to enjoy the music channel.

The lonely journey, amidst one hundred and eighty passengers, gave her chance to briefly go back in time.

A love melody made her whisper impulsively, 'Michael darling…'

A phrase she used quite often in the early days, especially in difficult times. A warm feeling started spreading across her body, and it remained her companion throughout the trip.

When the numbness in her legs began to bother her intensely, she realised they had already spent four hours flying.

'I guess Andreas was right…' she told herself, '…and I really thought he was exaggerating! We also have another four hours to go. Ouch!' she groaned.

After a while, she could not bear the numbness any longer, so she stood up and walked to the toilet at the rear of the aircraft. 'At least this is a way to walk around for a bit. Maybe the blood that has stagnated through my veins will start flowing again!' she said, sensing a thousand bites on her legs.

The last two hours seemed very difficult indeed.

She managed some sleep, but woke suddenly as she sensed her stomach travelling up her body. The cause was an abrupt descent of the aircraft. She was shaken for a few minutes, but the pilot's decision to fly the plane at a lower altitude proved salutary.

Sophia worried for a moment, but recalling her previous such experience, she managed to control her thoughts.

Nevertheless, she caught herself unwittingly squeezing the plastic bag, containing various useful items for the trip, which the stewardess had given her when they boarded the plane. While clutching onto it tightly, she noticed inside it a red tint that attracted her attention. She opened it and a soft fluffy item dropped into her hands. Sophia's surprise was great when she realised it was a pair of socks so she could rest her feet from wearing shoes.

'If I wasn't wearing my own socks, they would be really useful,' she said smiling, and put the socks back in their place.

The announcement from the sound system came as a balm to her body. They were approaching New York. In about ten minutes, they were going to land at LaGuardia Airport.

'Finally! I will get the chance to unfold!' Sophia exclaimed, without any regard for the people sitting next to her. 'Anyway, they don't seem to know any Greek!' she concluded with some doubt.

She collected her things with pleasure, putting the headphones in place and closing the tray-table in front of her. She was ready.

The touchdown on the ground was imperceptible, if not perfect.

The weather in New York, even though it was dawn when they arrived, was reported by the captain as sunny and warm.

It seemed so strange to take off as it was dawning in Athens and arrive at dawn in New York.

'Perfect! From Athens to New York. In no time! As if I was teleported through a dream.'

AMERICA

CHAPTER 1
'Tick-tock, Tick-tock: The Big Question'

The jumbo jet approached a gate at the huge airport. It leaned its 'ribs' gently against the folded entrance protruding from the main building, and its door opened. Smiling flight attendants were trying to help passengers to disembark, without, of course, forgetting to thank them for choosing this particular airline for their travel. Anyway, this was the policy for all airline companies.

Sophia looked around, just in case she saw Andreas, but the flow of the crowd quickly swept her out and away.

Passing through a shady tunnel, they all ended up in the vast arrivals hall. Three bright signs directed them to the exits. She picked a line and waited to go through passport and special visa control. Regular questions included: 'What is the purpose of your trip? How long are you planning to stay? Where are you going to be staying?' Sophia thought: 'Very contradictory measures for the country of freedom!' Especially after the events of September 11, security measures were leniently strict!

The dark-skinned employee handed back Sophia's visa and gave her a suspicious look that really irritated her.

She blamed her handbag for everything and proceeded to baggage claim.

As she walked along the conveyor belt to pick up her suitcases, she was observing all the other passengers around.

She was surprised by the physical features of some of the people going by: people from all parts of this multifarious world. But what impressed more than anything was how the Arab people were dressed.

A black cloud went past her, leaving her speechless.

'Tick-tock, tick-tock.'

She looked behind her, but no one was very close by. She was definitely not mistaken. That was the sound of heels on the marble floor! She turned to look in front of her and only then did she realise, after a closer look, that the 'black cloud' was wearing heels that were well hidden, though the sound was not.

'I cannot believe what I'm seeing!' she said to herself.

'They look like black ghosts in heels!' she said again, and was overcome by a nervous laugh. She put her hand over her lips to hide it discreetly. Fortunately, she was far enough away from others and no one noticed her spontaneous reaction.

As everyone stood around the conveyor belt, waiting for their suitcases to appear from the entry point, what came to Sophia's mind was the train of terror in the amusement park. Every now and then, that conveyor belt entrance opened its huge mouth, waving its plastic teeth and spitting out one suitcase at a time.

Her interest was suddenly redirected back to the women in black who passed her earlier.

You could only see their eyes: black, shiny, but etched with a touch of fear in every meeting with other eyes.

You couldn't distinguish their age easily. Only during some careless movements could you see that, beneath the black burqa, there were women hiding, dressed in haute couture clothes and jewellery worth a million on their hands. The mind would involuntarily enter a state of confusion. It is difficult for a woman that has grown up in the West to understand this kind of mindset.

Absorbed by the spectacle that caught her attention, she did not see the iron mouth spit out her suitcases onto the conveyor belt. She only noticed them when they had already passed in front of her. Sophia was looking at them like she had just

missed the train, as they completed the entire circle before approaching again. This time she was waiting for them. She lifted them off the conveyor belt and, passing through the crowd amassed behind her, she searched for the exit signs.

Shortly before exiting through the big glass sliding doors, she decided to call John, as her father had instructed her. She sat in a chair and put her suitcases next to her. Noticing some weird looking guys wandering around, she recognised the need to be especially careful.

She pulled her phone from her bag and looked at it. It was a last-minute buy from a mobile phone shop near Michael's home. The salesman had explained to her that it needed to be multi-frequency to make calls to Europe, and Sophia had several phone calls to make. First and foremost, she needed to call her father's cousin, John, who was undoubtedly expecting her arrival.

Searching through her contact list, the name 'John' appeared in English. Sophia pressed the call button and waited for the call waiting sound from the recipient's line.

'Hello?' a female voice answered in English.

'Can I speak to Mr John, please?' Sophia asked in fluent English.

'Just a minute please. Let me get him for you,' her interlocutor asked politely.

Soon a heavy male voice replied.

'Hello…?'

Sophia swallowed her tongue. She was surprised as she had not expected that he would answer in Greek.

'Hello…?' John said again in the same tone.

'Good morning… It's Sophia, Orestes' daughter.'

He spoke very slowly, giving Sophia time to understand what he was saying.

'Oh! Sophia! You have arrived! Welcome darling!' John welcomed her cordially over the phone.

'I'm really sorry I am not at the airport…' and chewing his words a bit, he continued, 'I can't pick you up unfortunately…

Would it be ok if you took a taxi?' he asked, and waited for Sophia's response.

'Yes, of course,' Sophia said cheerlessly.

Anyway, there was nothing she could do about it.

'Something very urgent has come up… I will see you when you get here. You'll be ok, right?'

He sounded a bit worried.

'Sure. Don't worry, Uncle. Can I call you "Uncle"?' Sophia asked.

'Of course… my pleasure! I'll be waiting for you…' he replied, and put the phone down without saying anything else.

Sophia took a deep breath. She really did not expect such a welcome, but ok. 'Something serious has probably happened,' she thought.

'Michael sweetie, we are having a rough start!' Sophia whispered, but did not let her mind wander away. She strongly felt the insecurity of the place and did not wish to make such a trip.

She felt a hand on her shoulder that made her jump involuntarily from her seat, throwing up her right hand.

'Calm down sweetness, don't get upset! Is something wrong with you?' Andreas asked with interest.

'Phew…' Sophia exhaled.

'You scared me Andreas…'

'Sorry I hit you…' Sophia justified.

'It's okay. Are you okay?' he asked again, seeing that she was somewhat perplexed.

'I'm fine. I… was expecting my uncle to come pick me up, but something came up and I have to take a taxi. I just got off the phone to him before you found me. But why are you still here?'

'Don't tell me. I know. A phone call is to blame…' she said and saw him smile.

'Well, this is what we're going to do. Because I also need to get a taxi, we can leave together and we can drop you off

anywhere you want. Of course, I hope it is also convenient for me and we don't have to go out of my way completely.'

'Where does your uncle live?' Andreas asked.

Sophia opened her bag, took out a piece of paper and read him the address.

'Aha! You have left Greece to find yourself back in a smaller version of Greece here in New York. I'm sure you know that many Greeks live in Astoria!' Andreas told her emphatically.

'Yes, I've heard, and from what my father has told me, Uncle John... "John the Greek", that's what they call him here, has a small shop and sells traditional Greek dishes, including gyros and souvlaki.'

'Oh! Great! I will pop in one evening to try his delicacies.'

'Get up, though, and let's make a move because we are running late. We'll drop you off at Astoria, then continue to Manhattan,' Andreas said hastily and looked at his watch.

'I'm so lucky in my misfortune! Thank you very much, Andreas. I want to reciprocate sometime,' Sophia said, while arranging her jacket and a small suitcase on top of the large ones, forming two small towers.

Having less stuff to carry, Andreas volunteered to help her to the taxi.

They took a taxi from among the many waiting in front of the main exit. Andreas gave the taxi driver John's address and explained that, after their first stop, they would continue to the final stop at his 42nd Street hotel in Broadway.

As the taxi entered the great boulevard, Sophia asked Andreas:

'So how long are you planning to stay in New York?'

'The way things have developed...' and he remained sceptical for a while.

'I believe you remember that phone call at Gatwick Airport!' Andreas turned and looked at her meaningfully.

'I'm not sure what will happen. I have to go to the company offices and see what our next moves are, but from what I

foresee, I will definitely have to stay for at least a couple of weeks.'

'What are you planning to do?' he asked Sophia.

'Certainly, the first thing I must do is go and register my position at the hospital, and of course figure out where I'm going to stay. They're the initial basic issues I have to deal with. Of course, for the first few days, I will stay at Uncle John's house, until I make arrangements for everything.'

The taxi driver, puzzled to hear a language unknown to him, kept peeking at Sophia and Andreas in the back using his mirror. In the end, he could not resist and asked politely:

'Where are you guys from?'

'We have just arrived from Greece,' Andreas replied in English.

On hearing the word 'Greece', he looked as if a lightbulb had flashed above his head.

'Ah! Yes! The Olympics!' the taxi driver replied excitedly.

'It's great that everyone knows us just because of the Olympics rather than anything else!' Andreas commented smiling and looking at Sophia. 'Although I think there was another reason for him asking the question!' Andreas added shaking his head.

'What do you mean?' Sophia asked with curiosity.

'After the terrorist attacks that took place, there is a general mistrust, especially towards dark-skinned people like ourselves.'

'Did you notice that the minute he found out our origin, he stopped giving us weird looks? He wanted to make sure we do not have bad predispositions. Sometimes people overcome by their fear operate like horses with blinkers.'

'But one thing is certain,' Sophia said. 'All taxi drivers globally are so bloody curious!'

After a relatively short ride, they entered the Greek neighbourhood. Anyone would so describe it seeing all the Greek shops]amassed on either side of the road.

The taxi turned right at the traffic light of the main road and drove down a much smaller street. The two-storey wooden houses revealed that this area was occupied by the country's workforce. A group of children arguing on the sidewalk caught Sophia's attention and it made her smile.

The car cut its speed and started sliding gently along the one-way street.

'Ultimately, all the children in the world are the same. Do you agree?' Sophia asked Andreas.

'They are Sophia… however, some are more privileged than others. Especially here! In the land of extremes.'

'You'll see that the kids here are so spoiled that they're looking for the meaning of life in all the wrong places and in the wrong ways. On the contrary, children to whom life has been cruel are not even seeking the meaning of life, even from a very tender age, but they can feel it in their own skin, whether white, black or yellow…'

'I think I agree with what you're saying, but I think we're all responsible for what is happening,' Sophia said.

'But the most grotesque thing is this,' Andreas added, and started talking like a completely different person.

'In underdeveloped countries in Africa, as we call them because we are civilised and they are not' – Andreas' ironic tone was very sharp – 'children lack basic things their bodies need, such as food and hospitalisation. As for spiritual education… we'd better not talk about that.'

'On the other side of the world, in developed countries, most children, not all of course, I need to stress this, are offered those privileges. Imagine that! We've got to the point where we call these elementary needs "privileges"! And the quid pro quo is just insidious: the innocence of their childhood soul.'

'They find thousands of fraudulent means to drain a child's soul from its childhood, and when those kids grow up they end up being well-fed bodies, empty of vision, of faith and of hope that someday they will rise out of the doldrums of nothingness. In front of them, they see a dead end that they no longer recognise.'

'Andreas, I'm amazed. I never expected that a man with your career orientation could find time to look deeper into less obvious meanings!'

'Appearances are often deceptive, Sophia,' Andreas replied, just as the taxi stopped beside a large blue sign with white lettering that read 'Ocean' in English.

'Here we are!' Sophia exclaimed, and grabbed her jacket and handbag.

She turned to Andreas and, with a grateful manner, said:

'Let me say "thank you" once again, but it is not enough... Life is short... I'm sure I will find a way to repay you!'

Sophia opened the taxi door and jumped out.

While the driver lifted her suitcases out of the trunk, Sophia leaned in at the taxi window for a final few words.

'If you do find some time and... you're in the mood, you have my phone number. I would like to take you out for a coffee somewhere. Of course, you would have to be the one to take us somewhere because I don't even know where I am! Good luck sorting everything out at work.'

'I'll try Sophia. I'll try!' Andreas replied, but his mind was already wandering elsewhere.

Sophia understood and said nothing more.

She stood on the sidewalk and looked at the taxi as it drove away.

Turning her gaze, she looked at the blue sign above the large windows of the restaurant. Everything was closed. She looked further up at the windows of the house. Two white curtains adorned the windows, reminding her of all the beautiful moments in life she had left behind.

She decided to ring the doorbell next to the restaurant entrance. She pressed the button and waited.

Soon the door opened. A rosy-looking grey-haired man with a black moustache, which looked odd, opened the door.

'Are you... Uncle John?' Sophia asked shyly.

'Welcome! Welcome!' he replied, and hugged her.

'Come in...' He helped her with her suitcase and closed the door behind him.

They climbed the wooden staircase in the large hallway, which probably also served as a warehouse for the restaurant.

The hallway was full of stacked crates containing soft drinks and beers. As she was walking up the stairs, Sophia observed a small door that apparently led to the shop.

They entered a spacious living room with beautiful sofas and lots of photos. Sophia put down the suitcase she was carrying and stood there feeling a little cautious. Extreme silence prevailed in that place. Sophia felt somewhat uncomfortable.

'Take a seat darling! Shall I get you a drink?' Uncle John said, trying to make her feel comfortable, though the words came out of his lips with great difficulty. Sophia perceived this, but she sat on the couch and did not ask anything.

John disappeared into the kitchen for a while. This gave Sophia time to become accustomed to the warm, homely environment around her.

She was ready to ask about Aunt Hope, but Uncle John's phone rang so she said nothing. She heard him speaking softly and, from the tone of his voice, she realised that something serious must have happened.

When Uncle John returned to the living room with a glass in his hand, he had transformed into a ghastly ghost; only the small veins on his cheeks had kept their colour.

Sophia became upset. She saw him struggling to try and behave normally, but it was impossible.

'Uncle... You're not looking well. Has something happened?' Sophia asked, worried.

He looked ready to cry.

'Things should not have turned out this way…' Uncle John muttered to himself.

'Uncle!' Sophia said sweetly. 'Please tell me what's going on?'

'We have a serious problem, Sophia, with Aris, my son. At this very moment, he's in intensive care, fighting for his life,' he told her, and two tears appeared in his wrinkled eyes.

'Why? What happened?' Sophia whispered.

Taking a deep breath, he explained to her exactly what had happened in the restaurant the previous night. He still could not believe what he had seen with his own two eyes.

He spoke about the incident as if it concerned some stranger.

'A row broke out over nothing between two massive drunken guys. They were Puerto Ricans. Words were exchanged, and Aris just tried to kick them out of the restaurant.'

'He is a strong lad...' Uncle John continued and a sigh reached his lips, 'but these treacherous bastar...' he said, clenching his fists, 'each took a knife and stabbed my child hard in the stomach...'

He started crying. Sophia hugged him.

'Come on, Uncle. Please don't worry... he will get through it. Did you not say that he's a strong lad...' Sophia comforted him, knowing nothing about the severity of the situation, but, at this time, doing the best that she could.

Uncle John wiped his eyes and continued:

'The phone call was from Mrs Hope, your aunt. She is with him in hospital.' As he spoke, he sounded like he was chewing stones.

'Which hospital is he in?' Sophia asked.

'In Manhattan Medical Center,' he replied.

Sophia was baffled.

'I can't believe it! That's where I will develop my medical specialty,' she muttered. 'My first contact with my future has been stained with blood.'

John was not even listening to Sophia. He seemed lost in his thoughts. She left him like that for a while: lost in his own world. Eventually, she asked timidly:

'So what do we do now?'

As if awakened suddenly, Uncle John replied:

'I need to go to the hospital. Please stay here and get some rest. Let me show you your room: it's the one next to Aris' room,' he said, and stood up nervously.

Sophia was uncompromising.

'I'm not going to discuss this further. I am coming to the hospital with you,' she said decisively.

'I will get some rest later. Let me just call my father to let him know that I have arrived safely.'

Sophia made two phone calls: one to Orestes and one to Michael. Without saying much, she told them she had arrived safely and would call them later.

She carried her things to the room Uncle John showed her, changed her shirt and quickly returned to the living room.

'Uncle, I'm ready. We can go,' she said, and followed him out.

CHAPTER 2
'Tragic Coincidences'

A few metres away from the restaurant, a white van was parked, waiting. They jumped in and silently began their journey to the hospital.

They went over Queensboro Bridge, crossing the East River, turned onto Second Avenue and headed for the New York Medical Center.

An endless complex of buildings sprawled alongside FDR Drive on the banks of the East River, which flowed slowly towards the Atlantic.

When they entered the hospital, Sophia did not know whether to be happy, from a doctor's perspective, to see the place where she was going to work, or sad about the tragic situation that faced her.

Her sensitive soul decided to rejoice later. Yet though her logic reminded her of the crisis they were facing, her voracious eyes soaked up whatever she saw as she walked by: from the parking area, to the huge lobby and spotless hallways leading to the intensive care unit.

The visitors' waiting room was austere and cold, as it is in every hospital. There were several people waiting to hear news about their loved ones. In their faces, you could clearly see anguish.

In one seat, a woman was twisting mechanically with a tissue in her hand. Her eyes were swollen and bloodshot, leaving no room for any misinterpretation of her tragic situation.

Uncle John approached her and put his hand on her shoulder. She turned to him with a look of despair: that stalemate stare of a mother; the one that speaks and shouts: 'There is nothing I can do to save my child.'

Uncle John sat next to her and she leaned her head on his shoulder, weeping softly.

Sophia froze and stood there watching, like a statue.

She was still looking at the end of the corridor, puzzled, when a cool hand touched her arm.

Mrs Hope, who was meeting Sophia for the first time, just like Uncle John had earlier, fought long and hard trying to articulate a few sweet words to her. She retreated to the muteness of her own Golgotha very quickly, with eyes riveted on the door of the intensive care unit.

Every time the ICU door opened, she would jump up, thirsty for some promising news.

Sophia tried to ask one of the doctors as they emerged, but quickly realised that the emergency button had been activated in one of the rooms, so she dropped back.

She did not say anything to her uncle and auntie about the emergency button, not wanting to load them with even more anguish on top of what had already nested in their souls.

Aris was fighting his own difficult battle.

'I'm sorry, Auntie, that I cannot do anything to help at the moment. I promise that when I come to the hospital tomorrow morning, I will do everything in my power to find out more.' These were the only words of comfort she could offer. No further words left her mouth.

All three of them sat there, looking at the door and at the other people around them who were also in the same predicament. Only one couple let a hopeful sparkle shine with some good news regarding their loved one, who was struggling on the field of life.

The fatigue of Sophia's journey started hanging off her eyelids. She fell asleep without realising.

'Sophia! Sophia. Wake up,' Uncle John said softly.

Sophia opened her eyes. It did not take her long to realise where she was. She stood up quickly, pulling her hair back with her hands in a gesture that looked like she was washing her face with fresh air.

'Let's go home for you to get some rest. I will be back later...' Uncle John said to Sophia, and then asked Mrs Hope if there was anything she needed from home. She replied in the negative and followed them with her eyes as they walked down the long corridor.

It was almost midnight when Uncle John left the house to go back to the hospital. He gave Sophia some guidelines so she could feel comfortable at home, and warned her strongly:

'Sophia. Do not open the door for anyone. Did you get that? If the doorbell rings, let it ring, do not answer the door for anyone. We have no idea how those thugs could react!'

He wished her goodnight and left.

Sophia was so scared that she locked all the doors behind her. And her fear was ready to grow stronger, were it not for the fact she felt desperately sleepy.

She did not even have time to account for the day's events. In one day, so many things had happened that no one could apply any logic to them; no one's mind could apprehend it.

Only one word, like prayer, came out of her lips and caused her eyelids to close:

'Michael!'

Sleep came over deeply, dreamless, like a huge time gap.

The sound of the telephone ringing woke her up violently. She ran to the phone, looking for the caller identification, as her uncle had informed her. She reassured him that everything at home was fine and asked him if they have had any positive news.

'Nothing yet...we are still waiting,' he answered sadly.

'I will get ready and make my way over. I'll take a taxi. In an hour at most, I'll be there,' Sophia said and hung up.

She took a quick shower and got dressed. She searched her suitcases for something formal to wear: in the end, she chose a black skirt and a light blue shirt.

Leaving the living room, her eyes fell onto a family photo. Uncle John, Aunt Hope and Aris were sitting side by side at the restaurant's front desk, which was decorated with two small flags each on either side: one Greek and one American.

'Aris is a good-looking kid,' Sophia thought when she saw him in the picture. 'He looks like an ancient Greek God.'

'We must be the same age,' she remarked as she held the photograph closer in its silver frame.

He had a dark complexion with somewhat long hair and, paradoxically, he had blue eyes.

'Those eyes he got from Aunt Hope,' Sophia said, remembering her aunt's bloodshot, watery blue eyes yesterday at the hospital.

She put the photo back into its place and picked up her bag. Glancing at the paperwork she had to file at the hospital today, she put it back into her handbag and walked down the stairs.

She double-locked the door as Uncle John had instructed her and headed to the main road to find a taxi.

She found one relatively quickly. She gave the address to the driver and sat back to enjoy the route. She had completely ignored it yesterday with all that tension. The new surroundings monopolised her thoughts. Only when they stopped at the main entrance of the hospital did she decide to put these thoughts aside.

Initially, she thought she should first check on her uncle and aunt, but then changed her mind.

'No, I should state my position first and see if I can gather any information about Aris that's more up to date.'

She went to the hospital secretariat and asked for Professor Davis.

She was told to go to the door at the end of the corridor with blue stripes on the floor. She knocked on the door and waited for an answer. A serious voice replied.

'Come in.'

Sophia entered. The man seated behind the desk certainly did not fit the voice Sophia had just heard!

A short, very sweet man welcomed Sophia to his department and wished her a good start in the admittedly difficult specialty she had chosen to follow.

'As of today, you are part of our hospital staff, and I would like you to become my right-hand wo-man! From what I have seen in your résumé, you come here with excellent recommendations and I would like you to achieve more,' he said.

Sophia felt proud hearing his kind words and promised to always do her best.

Professor Davis gave Sophia a mini induction in her obligations and introduced her to all the doctors in the department. She was really surprised by the simplicity of such an important man, which persuaded her to take the opportunity to raise the issue of Aris.

Sophia knew, of course, that it was a long shot, as the department of oncology was not related to the surgical department, but she gambled on a reference to a well-known doctor in intensive care.

And miraculously it worked!

'Ask for Dr Belmont,' Professor Davis said.

'Tell her that I am sending you and she will cater for whatever you need to know.'

Sophia thanked him and asked permission to go and find out about her cousin.

'I have the feeling we'll have some good developments today,' Sophia said cheerfully.

'This day seemed like a good day from early this morning,' she said to herself while knocking on Doctor Belmont's door.

Dr Belmont's stern appearance made Sophia's enthusiasm curb a little. But the whole situation was unlocked with a magic key named 'Professor Davis'.

Once Dr Belmont heard his name – Sophia could see Dr Belmont's appreciation for Professor Davis – she was willing to give her whatever information she wanted.

Sophia's earlier premonition was true.

Aris was now out of danger.

'The knife missed the liver by millimetres, so it did not cause any irreparable damage to vital organs,' Dr Belmont informed Sophia.

'The critical 24-hour observation stage has passed successfully. If his condition remains stable tomorrow, he will be taken to a normal room outside the ICU.'

This was the most wonderful news she could have heard from the doctor's mouth. A smile officially bloomed on her own lips.

She could now be happy from the bottom of her heart, without anything obscuring the extraordinary journey of her future, which was unfolding in front of her.

Sophia thanked Dr Belmont with a smile and ran to announce the good news to Uncle John and Aunt Hope.

The elevator stopped gently on the ICU floor.

Sophia stepped out of the elevator and turned left down the corridor, as instructed. She passed the ICU secretariat and entered the waiting room.

Two souls, feeling immense anxiety, were seated on the hard blue chairs of the hospital, holding hands. Sophia empathised when she saw them from afar. She was so happy to be able to announce the good news that, walking towards them, she felt as if her legs had grown wings.

Uncle John saw her first. He stood up.

'Sophia, did you get here ok, darling?' he asked with interest, despite his emotional pain. His sensitivity really touched Sophia.

'Uncle, let me…' and with glowing eyes she emitted words of 'resurrection'.

'Aris is no longer at risk, Uncle! He is doing very well!'

Uncle John could not even open his mouth to express his joy and Aunt Hope seized upon whatever words were flying

from Sophia's mouth. Realising she had been informed about Aris' situation, Aunt Hope rushed over and embraced Sophia, imploring her to speak.

'Tell us please, what did you find out? What did the doctors say?'

With a calm and joyful voice, Sophia announced all the latest information she had been given by Dr Belmont.

Their joy was so great that the tiny amount of courage left inside them was not enough to express it.

They fell into each other's arms, thanking God for protecting their only child.

Sophia could now enter the ICU to see Aris, with the privileges of moving around freely given by her medical status.

She wore a sterile green robe, a hat on her head, plastic bags that covered her shoes and a white mask on her face.

The protection measures in this area were followed by all, without exception.

She told the ICU head, responsible for the unit, the patient's name. Properly applying the rules, she asked Sophia a multitude of questions. Sophia concluded she had to use the two 'key' names at her disposal.

Immediately, a gentle hand and a polite voice directed her, showing her Aris' bed at the far end of a wing.

Sophia approached.

Aris was still in an induced coma, intubated with thousands of tubes and cables connected to the monitor, keeping a constant check on the state of his health. Sophia looked at the readings on the machines. She did not see anything worrying.

A smiling, fat, blonde lady, who bore the title 'Head of Department', soon approached.

'The "passports" I've used,' – meaning Professor Davis and Dr Belmont – 'are doing a great job!' Sophia thought.

'He is doing very well! I heard the doctors say this morning that they will try to bring him out of the induced coma this afternoon,' she said, showing her interest. Perhaps she was paying her dues by offering this information, or maybe she was

earning credit for the future. Sophia did not know, but what interested her now was Aris and his condition; nothing else.

The department head gave Sophia another smile and turned her huge butt around to go to the next bed, where she inserted a syringe full of medicine into the hanging bottle of serum.

Sophia looked at Aris. A sweet tranquillity spread on his troubled face. The artificial 'sleep' was giving his body vital time to cope with the shock and the difficulty of the surgical procedure he had been forced to undergo.

She patted his hand, whispering:

'Hi Cousin! Nice to meet you, even under these circumstances.'

Sophia always believed that a part of the subconscious hears words that it sometimes recalls. She was betting on that belief and generously offered Aris her sympathy.

Before leaving, she took off all the plastic garments she had been required to wear before entering the ICU, scrunched them into a green ball and threw them into the assigned bin. She took her bag and walked out, thanking the 'blonde mountain' who was looking at her whilst seated at her desk.

Two pairs of eyes waited anxiously for Sophia to make a happy exit. Once they saw her, they both approached.

'He is fine. He is sleeping,' Sophia responded to the barrage of 'speechless' questions.

'In the evening, during visiting hours, he will be able to talk to you. Now, go get some rest, there is really no reason for you to be here. Come back during visiting hours and don't worry. I'll come back to check up on him!'

Sophia said just enough to send them home somewhat less anxious, as much as possible of course, then made her way back to her department, emotionally full from how things had evolved.

That evening, after Sophia had returned from the hospital, she sat in her room, happy with the way things had finally turned out, and came to the decision to stay at Uncle John's

house. She also made all the calls that were pending from the day before.

First of all, she phoned her father.

Orestes was, on the one hand, really happy that his daughter seemed so satisfied with starting work at the hospital and, on the other hand, very sympathetic to Uncle John's grief for his misfortune – thank God, a reversible situation – that came about so suddenly. He asked Sophia to convey his greetings and his 'get better soon' wishes to his beloved cousin, almost ignoring Sophia's good news. Under different circumstances Orestes would have bombarded Sophia with questions on every little detail.

'Fortunately, he doesn't,' Sophia thought, as she did not have much time available today.

Before she travelled to America, Orestes had given her some information about his cousin.

'We grew up together,' he had informed her. 'We were very close. We even got into trouble together. When we turned eighteen, someone told Uncle John about America and how he should move there, and he decided to leave, wanting to make a better life for himself. Since then, he has never been back. He would, every now and then, keep in touch, telling us his news over the phone. This was the only way we communicated. Uncle John felt that, this way, he was still tied to his roots. He met his wife, Hope, in America. One time, years ago, he sent a photograph of the two of them, when they first opened their restaurant. I felt I was looking at a different person in that picture!'

Sophia remembered her father's words.

'There is a peculiar type of loving between two men!' Sophia thought.

Only this could explain Orestes becoming so emotional when he heard of Uncle John's problem.

Sophia also made sure to inform her father of her uncle's cordial hospitality at such a difficult time.

Sophia and Orestes put the phone down happy, before which Sophia did not forget to send greetings and kisses to Despina and Paul.

'And now, it's time for the most difficult and painful phone call,' Sophia said, biting her lip and looking through her mobile's contact list at the entries that began with the letter M: 'MY SWEETHEART'. That was the tender word she had used to save Michael's phone number on her sim card.

Michael's 'Yes?' sounded like Sophia was getting an answer to her own question. But he was her life; her everyday life; her feelings, regardless of the fact they were separated by an ocean.

'Hi baby; my darling, how are you?'

She filled the call with the tender exclamations she needed to tell him and needed his ears to hear: it was an illusion of his presence beside her.

'I miss you darling. I miss you. I feel so uncomfortable over here on my own!' Michael was quiet for a few seconds and then, to be saved from the 'tsunami' rushing towards him, he changed the subject.

'Anyway, tell me, what's going on? I was really worried after your first phone call... which was not a phone call. It sounded like an ultimatum,' Michael probed.

Sophia recounted, with the fewest words possible, the bad situation she was faced with just as she arrived, which fortunately had evolved positively. For most of their call, though, Sophia discussed her dream that was taking shape and form. Although it was too early to be sure, everything seemed promising and it filled her with satisfaction.

Michael, who knew all of Sophia's expressions, realised from her tone of voice that she was perfectly happy.

'I'm so glad, my darling, that everything has turned out as you expected! And don't forget that I'm always here for you!' They went on to discuss different things about Sophia's trip and her first impressions.

Neither of them wanted to hang up, but time was relentlessly cruel upon their pockets.

'I will speak to you soon. I love you,' Sophia said, nudging her optimism to rise to the surface.

'Kisses, sweetheart. I love you too!' Michael reciprocated and put the phone down.

Aris spent ten days in hospital. Uncle John and Aunt Hope visited him regularly every day. When Aris was no longer in intensive care, they decided to reopen the restaurant. Sophia was willing to help them out. She felt that she was a small part of the family. Life had started to return to its previous rhythms. Of course, not exactly the same rhythms as before, but the change that came with Sophia's presence in the house and after Aris returned home made Aunt Hope really thankful, as she admitted later, when she had finally calmed down.

Sophia was more than happy with her place of work. She became acquainted very quickly, met new people and started to feel comfortable with the city she now called home. Of course, everything she did was in moderation because her time was limited.

The scholarship grant offered her significant financial comfort and she was able to save some extra money for personal expenses. Uncle John was adamant.

'You'll stay with us! There is an empty room in the house and you can use it!'

Also, there was no way he would allow Sophia to pay rent. He once became very angry when Sophia alluded to paying him rent, which made her realise that Uncle John was never ever going to accept a dime from her.

Aris regained his strength and returned to working at the restaurant, preparing the meat. The restaurant regained its old glory and its normal rhythms, and Sophia could not believe how

busy it was. She felt like she was standing outside a restaurant in Omonoia Square[34].

When the restaurant was especially busy and the customer numbers exceeded expectations, Sophia would go down and help. She believed it was the least she could offer the people who embraced her with such love and interest.

On many afternoons in the early days, when she had finished working at the hospital for the day, she enjoyed taking a map of the city, planning a route around the districts and travelling around by various modes. She learned to wander around comfortably, considering the little time she had lived there. Sometimes, on Sunday mornings, when the restaurant was closed, she arranged road trips with Aris and they drove to more distant destinations.

In this way, she experienced places she had only heard of or seen in a movie. Aris had been raised in this huge city and had, therefore, become her personal guide. He took her to the legendary Brooklyn Bridge, the African-American Harlem, and of course, first and foremost, to the trademark of America, the Statue of Liberty and Ellis Island, which hosts the immigration museum. Aris also took Sophia to many different places beyond the lights and glamour.

A colourful river flooded Sophia's life painting, and, using her fingertips, she started mixing colours, drawing calm, dynamic, extreme and, tentatively, some romantic themes. Her work fulfilled her; she was beautifully fulfilled. Only her relationship was placed in a storage box with 'Michael' written on top.

[34] **Omonoia Square** is a central square in Athens. It marks the northern corner of the downtown area defined by the city plans of the 19th Century, and is one of the city's principal traffic hubs. It is served by Omonoia train station. Omonoia Square is one of the oldest squares in the city of Athens and an important shopping centre. It is located at the centre of the city, at the intersection of six main streets: Panepistimiou, Stadiou, Athinas, Peiraios, Agiou Konstantinou and 3rd Septemvriou.

She met several people, mostly the Greeks whom she encountered at Uncle John's restaurant. She also pursued some short-term relationships, but her soul's 'jug' always remained empty, and then she would turn it upside down and refocus on work, which was the only thing that satisfied her from every aspect.

She kept in touch with Michael, and although they did not speak very often, at least it was regular. She would find out about his job, which was developing very well. Every now and then, Sophia would ask him about his relationships, trying to joke around, but had not gathered from his words that he had something serious. Somewhere inside her, the fact that Michael did not have a serious relationship made her rejoice, but she tried not to show it as she considered this very selfish on her part.

Sophia's job was running swimmingly. Professor Davis was extremely satisfied with her and had started promoting her to higher positions. Sophia's relations with other colleagues were also mostly evolving at a healthy competitive level. With hard work, she was steadily ascending the steps towards her objectives. She also rarely took days off, and when she did, she would, in any case, devote them to her work, watching various seminars to improve even further. She had already started to see how it would be at the top, and enjoyed being praised and respected by some very important doctors in her specialty.

This time, however, the three-day holiday Sophia requested had a very specific purpose and destination.

Thinking of her little brother and the planned visit to Greece for the Easter holidays, she immediately accepted Aris and his girlfriend Barbara's proposal to join them on a magical trip to Disney World.

The trip was planned and every little detail was taken care of by Aris. He booked the airline return tickets to Orlando, reserved two rooms in a hotel, choosing from among the many that serve the needs of the area's tourists, and everything was ready for Thursday morning; for them to enjoy a beautiful

journey into the realm of childhood imagination. Sophia had not used her suitcase since arriving in New York. She only realised when she placed it on her bed and started filling it with her personal things. She sat beside her case and allowed her mind to briefly travel back, many miles away, beneath another sky that is bluer, that is sweeter, that mirrors the entire beauty of the islands of her country: her home. She sighed melancholically and continued packing her suitcase.

At exactly nine o'clock they were making their way to the John F. Kennedy International Airport. They were going to leave Aris' car at a guarded car park and pick it up on Sunday evening upon their return.

Even though all three of them were in their thirties, this trip made them regress many, many years.

Barbara, a stunning blonde with an American style, was the soul of the party. She managed to create the merry atmosphere of a childhood trip with her endless humour.

'It seems the destination of our trip has begun to affect our behaviour,' Aris said in an effort to restrain himself. He was ready to dive into the dream, where the girls were already splashing around ahead, playing games with their rolling suitcases.

The airport lounge where the domestic flights were checking in was packed, and no wonder. Most passengers for the flight to Orlando were reminiscing about previous carefree times, shifting their mood from the formality of the present time, recalling all the necessary characteristics, mischief and laughter that brought tears to their eyes.

'At least our travelling companions will empathise with us,' Sophia said, which somewhat confessed, in a way, the experience that comes with age.

Inside the aircraft, the passengers created an incredible pandemonium. In vain, the stewardesses gave instructions on the seating positions. They took some time to pacify the high spirits and restore some order.

Thankfully, the flight was short, and so could endure so much accumulated vitality. The LED 'fasten seat belt' sign was flashing for the landing before they were offered an orange juice, accompanied by the very traditional American snack: potato chips!

The weather was incredibly hot for the season. In recent days, the ascendance of warm air currents from the Gulf of Mexico to the mainland gave it a taste of summer.

'If the good weather lasts for the whole weekend, we'll be very fortunate,' Aris said, putting the jacket he had been wearing into his backpack.

When Barbara spotted Aris taking off his jacket, she also removed her own jacket, ostentatiously revealing a red backless shirt.

'I warned you about the weather, sir... but you kept calling me a "stupid blonde"!' Barbara said, finding an opportunity to scold him for something that seemed to bother her, even though Aris had meant it as a joke.

The taxi they took from the airport dropped them right in front of their hotel entrance.

Aris looked at it from the outside. He was not impressed by this first impression.

'Let's go in and, if we don't like it, we'll look for something better,' Aris said to the girls, who frowned.

The receptionist who welcomed them was quite helpful. They took the plastic key-cards and proceeded to the elevator, going on a fast acoustic journey through Germany, Japan and Arabia simultaneously.

'It reminds me of Babel!' Sophia observed, laughing.

The elevator stopped on the seventh floor. They had requested their rooms to be adjacent. The corridor was lined with a cheap old carpet that was torn in several places, with openings that looked like huge mouths, revealing underneath another carpet worse than the one on top.

Barbara twisted her mouth in disgust, adding to the negativity.

'If the rooms look like this carpet, I do not want to go in!'

Aris, also seeing Sophia's disappointment, felt accountable. He merely whispered,

'Let's see…'

The far better sight of the rooms was like salvation, reminding them strongly of a successful facelift. New carpets were laid on the floor, clean curtains were hanging at the windows and a flowery wallpaper gave the room a breath of regeneration.

Sophia approached the window and opened the curtain. The rooms overlooked a courtyard. Below, in the distance, there was a 'hole' filled with water: the so-called sample of a pool that they could see from above.

Sophia turned away from the depressing sight and headed to the bathroom. Barbara followed her. She leaned over Sophia's shoulder to glean her personal opinion. She turned and looked at Sophia, only a breath away from her, looking for disapproval.

'I think we can make it work, what do you think? At least it's clean.'

'Fortunately, we will only use the beds to sleep in and the bathroom, as we will be out almost all of the day,' Sophia replied.

Aris breathed a sigh of relief seeing that the women had accepted – at least – the limitations of the current situation. With a suddenly blooming enthusiasm, having avoided a new-hotel search, he approached the girls with a pompous style, causing them to look back at him surprised.

'The only upsetting and sad thing is that, unfortunately, we won't have the pleasure of experiencing the coolness and spaciousness of an ideal Olympic-size pool: what a shame… shame…' he said in a serious tone, waving his hands around like a parliamentarian.

Sophia and Barbara began to whistle, taking the piss out of him for saying such stupid things.

'Fine, fine. You have convinced me. I will stop!'

They decided to rest for an hour and Sophia retired to her room, leaving them to share the imaginary riches of the royal suite.

Outside the hotel, a minibus was waiting to transport clients to the surrounding parks.

Many people were already waiting at the bus stop. Aris, Sophia and Barbara were the last to board and they marched along the narrow aisle. Thankful that some seats were unoccupied at the very back of the bus, they jammed in next to each other.

As the bus proceeded down its usual route, the three of them tried to reach a joint decision on where to begin the tour.

This proved a bit tricky, but, in the end, they agreed to visit the Epcot Center first, making the Disney World Magic Kingdom park their next trip, for which they would have a whole day at their disposal.

When they got off the minibus at the huge parking area specifically allocated for tourist coaches, they could not believe their eyes. Appearing before them was a moving sea of people heading for the entrance. They stood at the very back of one of the dozens of queues, armed with abundant patience, in order to buy tickets. While they waited in the queue, which was moving at the pace of a turtle, Aris informed the girls about the park's exhibits.

'I don't think we'll be able to see all the attractions, so I think we should decide which one we want to see!' he told them.

'I would like to see the Mexico and Canada exhibits,' Barbara stated, waving a brochure.

'I suggest we decide as we go along. If something draws our attention, let's go check it out. I don't have any particular preference in mind,' Sophia proposed.

Aris agreed with Sophia, which pissed Barbara off, but she forgot about it very quickly.

A beautiful water dance, accompanied by exciting background music at a huge fountain, was a sight that did not go unnoticed by anyone, least of all Barbara. It sounded like a drum orchestra that always stood out, with its bustle, from all the other instruments.

Next to this audio-visual fiction, a tall silver sphere dominated with its imposing presence.

They walked up a narrow metal ramp and through a small dark tunnel, which led them into a starry night sky on an icy winter evening.

Their space trip began in a 'boat', inside this huge dome with thousands of stars shining above their heads, following the progression of culture from its birth through to the present day.

Bewitched by the Hollywood spectacle, they were left both stunned and extremely proud when the first figures of the explanatory video projected onto the artificial sky were none other than those at the forefront of science worldwide: Aristotle, Pythagoras, Socrates, and Hippocrates. 'I really don't know who to recall first!' Sophia wondered proudly.

The video that followed was equally wonderful, reminding them of all the important breakthroughs: from the discovery of electricity to the conquest of outer space.

When they emerged, Barbara looked as if she had just awakened from a beautiful dream. Her serene smile puzzled both Aris and Sophia, who were not accustomed to such reactions from her. Barbara's reaction professed an inner quest that was perhaps unprecedented.

They walked silently up the stairs to the artificial lake. Located around it were themed pavilions dedicated to different countries of the world. At the wooden pier, many people awaited the arrival of a small that would take them to the other side: it was a picturesque alternative way to access the pavilions and it seemed to fascinate a lot of people.

When Barbara saw the boat approaching, she went back to her good old self.

'Let's go on the boat!' she purred in Aris' ear while hugging him.

'Shall we fulfil her wish?' Aris asked Sophia.

'Yes, I agree with Barbara, it'll be quicker by boat than on foot,' Sophia replied and jumped aboard.

It was really dark when, worn out from walking to the main square near the entrance, they decided to grab something to eat before heading back to their hotel.

They bought a sausage sandwich and sat at one of the many tables scattered on the grass around the lake.

There were a lot of people around and, as time passed, even more gathered. All had turned their attention towards the centre of the lake. It was obvious that everyone expected the spectacle of the evening. Aris looked at the girls, who also sat there watching, waiting for the firework show to commence.

Very soon, all the lights were dimmed, also luring the crowd to quieten down.

A magical picture of colours and shapes emerged from the centre of the lake, transforming it into a flaming volcano.

Celestial electronic music, well-synchronised with the movement of the light, spun like a couple dancing on top of the shiny surface, mirroring the thousands of small explosions flashing with different intensity and in different directions.

At each peak of light that ascended into the sky, opening up like a fan with infinite colours, a long exclamation of admiration was heard.

'It's like a fairy tale!' Barbara cried towards Sophia, who was also lost as she gazed upwards, enchanted.

Sophia nodded her head in confirmation.

'I could watch this every night,' she said, without pulling her eyes away from the peaceful aerial war playing out above their heads.

Sophia enjoyed the firework show, with her heart and soul, twice more over the next two nights, first in Disney World Magic Kingdom, accompanied by the parade of fairy-tale heroes, and second in the Universal Studios theme park.

Sophia did not forget the main reason for going on this trip, despite the fairy tale magic that made her travel far, far away, and not always on journeys that evoked nice feelings.

Loaded with sweatshirts of cartoon heroes, hats, keyrings and anything commemorative, she imagined that she would really excite little Paul.

'The kid expressly stated that a visit missing out the clan of the cartoons is not a real visit!' Sophia justified, trying to excuse herself for the number of bags she burdened them with on their return home.

'It would be best if he was here to see everything up close for himself!' Sophia said, sensing that what she had bought him was nothing compared to the actual live experience.

'Well, when he grows up a bit, you can bring him here!' Barbara told Sophia, wanting to make her feel hopeful.

'Yes, you're right,' Sophia replied, but somewhere deep inside, a negative emotion was blocking the road ahead.

Sophia's innate kindness led her to wholeheartedly thank Aris and Barbara many times for inviting her on this wonderful and unique journey into the magical world of a kid's life, and not just a kid's life: far more.

CHAPTER 3
'Inconceivable Whisper'

They returned to New York on a Sunday afternoon. Sophia had the whole evening ahead of her to rest, as they came back exhausted from walking. On Monday morning, she bounced back to her normal rhythms.

She cheerfully entered the staff-only room, where doctors left their things, and put on her doctor's robe. She placed her clothes in the staff locker, locked it and walked out, heading to the doctors' office.

Passing by Professor Davis' office, she saw the door slightly open. She paused. The door was rarely open, so she looked inside shyly. She saw him sitting at his desk, holding his head in both hands, in a worrying condition. Sophia knocked on the door to make her presence known.

'Good morning,' she said reluctantly. He raised his head and looked at her. Sophia saw pain in his tired eyes.

'Are you ok?' she mumbled with a slow voice, and walked towards his desk.

He picked up two pieces of paper in his hands and held them in a strange way... as if they were burning!

'I have just had some very unpleasant news!' he said and stopped abruptly.

At first, Sophia hesitated. She had now known him for several months and they had a very close relationship, but only work-related. On a personal level, they had not exchanged

much information, apart from a few facts about each other's lives.

In the end, though, she overcame her hesitation.

'I hope I'm not being too presumptuous… may I ask if it's about you?'

At first, Professor Davis met her question with silence. He was quite closed as a character, but the pain he was feeling forced him to surpass any abeyance and to express to Sophia the tragic position he was in.

'I do not know how to handle this, Sophie,' using the name he used to call her when they were alone. He stopped speaking again.

'What exactly? I don't understand,' Sophia probed with keen interest.

'I have been a doctor for forty years now. I have found myself among thousands of cases of people suffering from cancer and now…' he stopped to take a breath, but continued quickly, just in case he succumbed again to reticence.

'My beloved wife…' he spoke keeping his eyes lowered to the floor, as if his words were hanging heavy on his eyelids.

'Sophie, she has cancer… It's in the final stage… and I don't know how to tell her!' he told her, devastated.

Sophia felt like a thunderbolt had struck her. She really did not expect to hear something like this.

'If it was stage one, we could have fought it… but now…!' Professor Davis said, and climbed down every step of frustration.

Even though Sophia was shocked by Professor Davis' devastation, she found the logic inside her to confront him, pulling him out of the deep well of despair into which he had fallen. She later wondered to herself how she had managed to do that.

'I will repeat the words that I noted when a great and dynamic physician addressed a patient in exactly the same situation as your wife.'

'And I quote: "Do not let illness knock you out. Your faith is half the cure. The other half we'll take care of!"'

He raised his eyes and looked at her. Sophia continued, giving even greater intensity to her words, which began to act as a medicine against the faint-heartedness that had overtaken him.

'With these wonderful encouraging words, you managed to convince Mrs Matthew, I even remember her name, to throw away the sad mantle of abandonment and fight for life.'

'I'm sure you remember very well the result of this mental effort!' Sophia stressed.

'Mrs Matthew managed the impossible and defeated cancer, earning herself several more years of precious moments with her family.'

Like the wand of a good fairy, Sophia's words touched and transformed the quiet man whom she knew very well. Behind his very superficial calm exterior, the gears of militancy began to shift. The glow in his eyes betrayed his intentions. The movements of his eyeballs, which had started a crazy dance with his thoughts, were driven by the magical aura of hope.

'Thank God!' Sophia told herself, and walked away discreetly, leaving him to organise frontal attacks against the visible enemy.

She closed the office door behind her gently before, completely imprudently and without warning, she opened another door, releasing all the voracious thoughts that had accumulated having found an opportunity to sneak in, demanding her attention while she was talking to Professor Davis.

'If my tutor, with all his experience, has stumbled, what would I have done? Me?' Sophia wondered, supporting her back against the corridor wall.

Sophia had never had to pose this question to herself, until today.

Talking with her colleagues, she had discussed, many times, the possibility of someone getting infected, for example, from a surgical knife that they held in their hands daily, but all these views were so distant, as if they concerned her patients, rather than herself. It was the first time Sophia felt the breath of

fear so close to her, but, even now, it remained at a safe distance.

There was always an incomprehensible whisper inside her, from the day her mother died, of the possibility that it could also happen to her. The real reason she decided to pursue this specialty was none other than a face-to-face confrontation with 'him', armed with all the weapons of knowledge and the militancy of a fighter.

But still the day of final reckoning had not yet arrived.

CHAPTER 4
'The Blonde Angel'

The date for her trip back to Greece was approaching, and as the days went by, Sophia's yearning grew. She knew that spending a few days in Greece would be dwarfed by the size of her desires. Only a week's time divided between Michael and Orestes, the two most important men in her life: she did not yet consider young Paul to be a man.

In the afternoon, one day before her departure and having just finished with work, she ascended to Broadway to take a walk among the city's shops. She wanted to buy a few gifts for everyone: she did not want to go to Greece with the empty hands she had at the moment, except for Paul's orders.

Sophia chose a souvenir shop. It was crowded. New York City always had guests from all over the world, but when Sophia heard her mother tongue, it really delighted her.

Just like today. As Sophia entered the shop, a small girl around twelve years old was dragging her mother to show her something she had chosen.

'Come on mommy, I want to show you something... It's very nice... you'll see!' the little girl said, struggling to convince her mother to buy it for her.

Sophia proceeded further into the shop, smiling as she began to search around for suitable gifts.

For some time, Sophia twirled along the shop's aisles, filled with thousands of beautiful objects arrayed enticingly over the shelves.

Her eyes stopped on a wonderful miniature depicting the Statue of Liberty. On its white marble base, it had a super-chic little clock, over which the female figure, holding in her hands the torch and the text of independence, stood proudly. She chose this gift for Despina, hoping she would like it. Her next gift choice was particularly demanding.

The flashes of translucent crystal, which reflected light onto the window, enchanted her. The Empire State Building, the tallest skyscraper in Manhattan, stood in front of her, adorned by a strange, colourful, peacock-like tail created by the refraction of light. There was no way she was not buying this for Michael. Sophia found it amazing. She was so captivated that she did not even wonder whether Michael would like it: she considered this a certainty.

Completely satisfied, Sophia proceeded to the third gift, which seemed to trouble her. In the end, she decided on an opal jewel in the shape of a big apple, New York's trademark. When opening it in the middle, lifting the upper half, a sweet melody sounded.

'Aunt Maria will love this!' Sophia said, and gave it to a saleswoman to wrap for her.

Sophia also bought caps with the New York City initials embroidered with golden thread for the three males in the family.

Happy and with her shopping bags in hand, she walked out.

She had spent a whole hour in the shop without even realising.

She felt so happy, as if she was holding treasures in her hands, and it was the least she could offer them.

Near the Town Hall, she was lured by an Italian coffee shop and went inside. She chose a table near the glass window and sat down. She ordered an espresso with a piece of apple pie and sat comfortably on the chair, surveying all the people passing by outside. What had struck her from the first day she set foot in this city was the diversity of cultures. She looked at the gentleman passing by in front of her at that moment, with his

long black coat and the bushy curls that surrounded his face and protruded from beneath his tall black hat.

'He's either a stockbroker on Wall Street or a diamond trader!' Sophia thought, putting a bet on her second choice and drinking a generous sip of the steaming coffee she had just been served.

Steam rose from the cup, painting designs and thoughts that made Sophia travel far away. Her latest telephone conversations with Michael had acquired a different air. She felt he was a bit distant, a bit puzzled, and that had created confusion inside her. Secretly, she believed that her short trip home would be determinative.

She looked at her watch. It was almost nine. She got up, picked up the paper bags from the adjacent chair and walked out. The street was still full of people doing their shopping and gazing at the glamorous shop windows. She crossed the road at the pedestrian crossing and headed towards the metro.

As she was approaching home, she could see, from afar, the lights of Uncle John's restaurant – the 'Ocean' – twinkling like summer rays sparkling on the sea.

Many customers were waiting in front of the serving counter.

When she got closer, she could see Uncle John, who was waving his hand at her.

She approached him, eager to hear what he wanted to tell her. The noise from the electric knife, cutting the meat into pieces, prevented Sophia from understanding what Uncle John was saying to her. She asked him again, louder,

'What's the matter?'

'Sophia, can you please help?' Uncle John begged. She had never seen him like that before, so she felt that something serious must be happening.

'Of course, I'll be down in five minutes,' Sophia reassured him. She also searched with her eyes for Aunt Hope, but she was nowhere to be seen. She looked back at her Uncle's face. Drops of sweat were forming little streams on his temples.

Aris was next door, preparing orders and filling up the pita breads with colourful vegetables. He also fixed Sophia with a pleading look that cried for help.

Without losing any more time, Sophia went up to the house to drop off the purchases she was holding in her hands. When she opened the front door and entered the living room, there was a strange silence. She expected Aunt Hope to be in the kitchen, as usual, doing chores to aid the guys in the restaurant below. Sophia was really confused.

'Aunt Hope...' she cried, heading to the kitchen. A slow voice, which was not what she expected to hear, responded.

Entering the kitchen, Sophia saw her aunt sitting at the table with a glass of orange juice in front of her.

'Aunt Hope! Are you okay?' she asked worriedly.

'I felt a bit dizzy and your uncle hurried me away from the restaurant. I think my blood pressure must have dropped. We had a lot of customers downstairs... but now I feel better and I think I'll make my way down again,' Aunt Hope replied, and made to get up.

'That is out of the question. I'll go and help,' Sophia replied with an adamant tone to her voice.

'You should sit and rest!'

And as an expert on the matter, she gave her a mini check-up.

'Your blood pressure seems fine. Make sure you get some rest...' Sophia said after measuring her blood pressure with the machine.

Sophia left Aunt Hope sitting at the kitchen table and went to her room to change clothes. In less than ten minutes, she was behind the restaurant counter cutting fresh vegetables. Uncle John was always demanding of the quality he offered his customers, which is why the reputation of 'John the Greek' far exceeded the boundaries of the neighbourhood.

It was late and Sophia was about to abandon her post when, in the mirror in front of her, she saw a distant but familiar face. She turned her head back to get a better look.

'Yes, I'm not mistaken… it is Andreas,' Sophia thought. It was Andreas, indeed. Her memory was not deceiving her. The man who had helped her the first time she travelled to New York. He did not recognise her, which was understandable as she was wearing a white hat and a long apron. 'My hat and apron may be white, but they are white for my other job too,' Sophia thought as she approached Aris.

Sophia was preparing two sandwiches when she spoke loudly enough to draw Andreas' attention.

'These are on me because I've owed them to this gentleman for a long time!'

Andreas and Aris both looked at Sophia with curiosity. The time it takes the mind to retrieve images and thoughts from the depths of its memory gives the face a lost look.

Andreas wore that lost expression as he tried to remember. Aris, of course, did not understand what was going on, so he looked at Sophia and then at Andreas, waving his hands over the French fries.

The awkwardness was finally dissolved by the bright light that flashed in Andreas' mind.

'Sophia!' he stammered, with an intense look of surprise.

'These are on me. It's a small token of my appreciation, to thank you for being so willing to help me in my first air travel,' Sophia explained. greeting him with a warm handshake, then walking out from behind the counter to stand beside him.

'I confess that since the day I dropped you off across the street, I haven't been back here, and today I've come over completely randomly. I never imagined that I'd find you wearing these work clothes. I see you've changed a lot. I wouldn't have recognised you if you hadn't spoken to me. And your hair! If I remember correctly, you had a torrent of hair on your shoulders, and now it's hidden under the chef hat,' Andreas said, analysing the differences.

'You, on the other hand, haven't changed at all,' Sophia stated.

'You look exactly the same as the first time I met you. Where have you locked him away so that he hasn't had any effect on you?' Sophia said, smilingly referring to 'time'.

Andreas burst out laughing at Sophia's consequential remark.

They talked for a while, each updating the other on their progress, before they cordially said 'goodbye', allowing 'fate' to plan their next meeting, if there was going to be one.

Sophia hung her apron and hat on the shop's rack, and passing through door into the corridor, she went up the stairs.

Aunt Hope was sleeping. The sweet tranquillity of home functioned as a sedative for her.

'A quick shower and straight to bed,' Sophia said to herself.

'Tomorrow is the last day at work and I have to clear up several loose ends.'

But a single case was travelling around her mind, looking for the right words: words that could be understood by the little brain of a ten-year-old child.

All these years, Sophia realised that her relationship with her patients exceeded, in many cases, the standard patient–doctor dynamic. This was exactly the case here.

The hurt she was feeling was immeasurable. She hurt first as a human being and second as a doctor, because she had exhausted all possible options to save little Zanou's life. She thought of his bright gaze when she first saw him six months ago, and of his blond curly hair. It was as if an angel had appeared, and now… Sophia kept seeing that 'angel' in front of her without his curls, feeling discomfort in his little body from all the chemotherapies… When she looked at him, the only thing that kept shining in his large, honey eyes was his childhood innocence.

Sophia had to explain to him the reason for her trip. She wanted her little friend to understand; he wanted to understand.

She twisted and turned in bed for some time.

She eventually fell asleep thinking of Zanou, and awoke the next morning with him still in her thoughts.

She opened the curtain of her bedroom window, which overlooked a depressed inner courtyard at the back.

In a corner, a pile of broken chairs composed a strange, sad creature.

A cloudy grey sky accompanied an equally miserable landscape.

'It looks like it's going to be a tough day,' Sophia said, and closed the curtain, feeling low-spirited.

She arrived at the hospital a little late. The traffic was hopeless today.

With heavy slow steps, she entered through the staff door. Being on duty today was itself a mountain-like obstacle. A lot of people were wandering the hospital corridors, and Sophia was carrying a heavy load with an angelic face in her soul.

'Later. Not now,' she said to herself, bringing to mind the sweet face.

She carried out everything else mechanically: informing the doctors' office, visiting the wards to check up on patients, emergency calls: everything that was her daily routine; her life.

Noon was approaching. Around this time, she usually had a lunch break, but, today, nothing was going down into her stomach. She left the doctors' office and headed for room 305. Her mind was running, so the distance seemed as nothing.

She gently turned the door handle and walked into the room, putting on her best smile. Zanou looked at her with two huge suns on his face, and held out his hand in response to her smile.

Despite all the tubes that restricted his movements, he pulled Sophia close and hugged her gently, weakly, with as much strength as he had left. Any strength he had was abandoning him slowly, with an irrevocable steady pace. His mother, seated in an armchair in the room, sat there looking at them. She had waited impatiently for Sophia's daily visit. She knew that Zanou had a soft spot for Sophia, and he showed it with the joy that overflowed in him when he saw her.

Zanou's mother's psychical pain was unbearable. She of course, always hoped for a miracle, but the powerful painkillers her baby was taking would pierce her heart and eradicate a part of it every day.

Sophia sat beside him and asked him, with interest, about the book he was reading. She then told him a true story about a hero of her own from when she was a child:

A figure carved in wood, with a hump on his back and huge bare feet. The poor guy was always hungry and his belly was never full. Zanou was thrilled with his beloved friend's hero.

Sophia decided that now was the right time to mention she was going to be absent for a few days. Zanou did not like what he heard at all. His little face frowned.

'I promise you, when I return, I will bring with me a figure of my hero, and we will play with him,' Sophia reassured, and began to explain, showing him with her hands, how to make a puppet come alive and give it movement, speech and life. Zanou, as a child, would travel far away hearing Sophia's words, and he would craft stories. The smile on his face bloomed again.

Keeping Sophia's promise as a pledge, Zanou gave her, in return, his friendly permission to make this long journey, which would bring with it the hero of his beloved friend.

He stretched out both his hands and hugged her.

'You promise that you will come back quickly?' Zanou asked with a flicker of doubt in his eyes.

'I promise you, my darling, that although it will be a long journey, I will be back very quickly, like lightning, for you… and I will not come back alone… agreed?' Sophia said with a wink, sealing a sly mutual agreement between them.

'But now I have to leave you. I need to see some patients before I leave…'

Sophia got up from Zanou's bed and said goodbye to his mother, who thanked Sophia and wished her a good trip.

With the door knob in her hand, she turned and looked at him. His eyes were nailed on her.

'You will wait for me! Okay?' Sophia said emphatically.

Zanou did not say a word. He only nodded his head in agreement, giving her a final laugh.

Sophia left the room smiling, but just as she closed the door behind her, that smile disappeared, as if she had left it by Zanou's side, to accompany him during the days she was going to be away.

An evil thought endeavoured to stagnate in Sophia's already weak mind, but she renounced it, attributing it to her mental tension.

In the last hour, she briefed her colleagues on patients who were under her supervision, gave the necessary information and instructions, and left, trying to leave most of her concern for them behind: Zanou occupied a major part of that concern.

Coming out of the hospital, she noticed that the morning clouds had flown away, and a sleepy sun had descended a slippery slope towards the sunset.

She chose to take a taxi to travel home. She felt very pressured, plus she had to get ready for the trip.

The drive by the river somewhat relaxed her.

She was observing the boats sailing sweetly in the calm waters, and imagined herself among the tourists admiring the view of the city. Paradoxically, there was no traffic on the road and they arrived at Queensboro Bridge very quickly. They then turned right for Astoria.

Aunt Hope was getting ready to make her way down to the restaurant when Sophia walked into the living room.

'I have ironed the clothes you gave me and left them on your bed,' she said to Sophia, after wishing her a good evening. Then she walked out, holding the crisp white aprons for the restaurant in her left hand.

Sophia took off her shoes and placed them in front of the shoe cabinet, then walked barefoot up to her room.

With her hands on her waist, she stood in the middle of the room, pondering how she could find room to squeeze all the things she wanted to take into her suitcase.

'The gifts should be placed between the clothes, so that they don't break,' she thought, marching towards the closet.

Clothes were soon flying from the wardrobe to the bed. Deciding what to take with her took little time compared with arranging everything properly to fit inside the suitcase.

Before the clock struck midnight, she was all packed. Calm and relaxed, she sat down to enjoy a beer in front of the TV when the door opened and Aunt Hope walked in.

She left some things in the kitchen and returned to the living room. Relaxing into a chair, she stretched out her legs on a footstool. She suffered from phlebitis and it was really bothering her lately.

'Aunt, you should definitely do something about your feet. By ignoring them, your veins will end up looking like trees; most likely, ancient looking trees,' Sophia commented, surveying her swollen calves.

Aunt Sophia grimaced in pain and agreed with Sophia by nodding her head.

They exchanged a few words on the events of the day and about the upcoming trip.

'I would love to be able to visit my home, someday,' Aunt Hope expressed plaintively, '…but working at the restaurant does not allow for anything!'

Aunt Hope was born in the picturesque city of Macedonia, Kastoria[35]. She migrated to America with her brothers, who now lived in other states, and then, just like Uncle John, she never returned home. The nostalgia she felt, when she got time to think, would keep her up all night, until the next morning, when she re-entered the battle of life.

Sometimes, when she was very disappointed, she would become macabre: 'I will never go home! Neither horizontally

[35] **Kastoria** is a city in northern Greece in the region of West Macedonia. It is situated on a promontory on the western shore of Lake Orestiada, in a valley surrounded by limestone mountains. The town is known for its many Byzantine churches, Ottoman-era domestic architecture, fur clothing industry and trout.

nor vertically!' But this, too, she would forget about very quickly.

She rubbed her tired legs for a while and stood up.

Sophia went downstairs to say goodbye to her uncle and cousin. Aris offered to take her to the airport, but Sophia was adamant: she did not want anything to spoil their schedule, forcing her uncle undertake all the shopping for the restaurant alone.

They all gave Sophia their greetings and wished her a safe trip. On her way up, she also wished 'goodnight' to Aunt Hope, who was washing dishes over the sink.

A yellow taxi stopped in front of the house at nine a.m. Uncle John and Aris had left several hours ago. Aunt Hope helped Sophia take her things downstairs, kissed her and stood outside the door until the taxi disappeared from her view.

CHAPTER 5
'A Short Trip Back'

'What a beautiful day. Nothing like yesterday,' Sophia thought joyfully, and her mind had already begun to fly away.

She took a direct flight to Athens. She had decided to spend her first few days with Michael. But Sophia decided to book a hotel room. She did not want to burden him. She did not even know if he lived alone. Sophia was travelling in muddy waters as far as Michael was concerned. She, of course, said nothing to Michael about where she was going to stay, telling him only the exact day she would arrive in Athens.

It was the Monday morning of Easter Week, which was commencing in preparation for the big religious holiday.

Athens was all festive, waiting for people to do their usual Easter shopping: candles, eggs, pastries and, of course, the traditional lamb for lunch on Easter Sunday.

Michael awoke with an expectant feeling of joy and, humming, he prepared his coffee. For the past few days, he had arranged for Mrs Maria, the house-cleaner, to pop by.

'I want you to make it shine! I'm expecting a VIP,' was the mandate he had given.

Holding the coffee in his hand, Michael walked around checking everything like a cleaning inspector.

He was pleased and surprised with himself.

'I still love her so much! As if she never left!' Michael said out loud.

He had arranged not to work this week. He wanted to dedicate it to Sophia and was planning to go with her to Thessaloniki, to be with her on Easter Saturday: the night before Christ's resurrection.

He called the airport to find out the arrival time of the flight from New York. He had not said anything to Sophia about picking her up: he wanted to surprise her.

He had told Katia that he was expecting his best friend to arrive and that he would not be able to see her during the Easter holidays because he would not be in Athens. Katia was Michael's current 'strange' relationship. They had a completely open relationship, with no commitment to anything, and Michael was certainly not committed to her either! As with all the other girls he had been out with over the years.

None of them was ever able to fill Sophia's shoes because they were never actually empty.

Michael got dressed and went out to buy some food to fill up the fridge, along with the necessity of red roses: Sophia's favourite. He had plenty of time until the evening to have everything sorted out.

The huge aircraft was preparing to land at Eleftherios Venizelos airport. It descended very slowly, aligning itself with the runway, until its wheels firmly touched down on the asphalt. The braking sound was loud, but then the aircraft approached the main building gently, ready to unload its precious 'cargo'.

To Sophia, this journey seemed very short compared to her previous experience of the last trip. It was possibly the direct flight, and also her dreams of returning, which found her with her suitcase in hand, a smile pinned to her lips and a heart pounding like a well-tuned clock.

She was not in a hurry, so she was sucking in through her eyes everything she had missed about Greece: the air, familiar faces and even some familiar sounds; but there was one sound more familiar than all of them.

'Sophia, my darling!'

Her reflexes reacted faster than her brain. She turned her head and searched with her eyes for where the words that made

her heart dance had come from. She saw him smiling behind her.

'My dark-haired angel.' That was the first inner voice she heard when she saw him. Sophia then released herself to the tears of joy rolling down from her eyes, and became lost in his arms. The last time she had felt this way was when their lives changed paths. Now, in his arms, Sophia realised the magnitude of her love, which time had kept intact.

'Michael. Sweetheart,' Sophia whispered tenderly.

She did not want to release him from her arms. A shadow of doubt, however, made her reluctantly pull away. For a moment, she regretted letting herself loose. The intimacies in his life may have changed, her logic told her, but her heart was grasping reality as it was, the same way she was grasping reality with her hearing.

'My sweetheart, I missed you so much! I missed you! I missed you!' Michael's words sounded like a song to her ears.

He did not need to say anything else to her. His sweet kisses were what spoke to her, his warm embrace eliminating any doubts Sophia had.

Michael and Sophia headed to the car parking holding each other in their arms.

Words were too poor to describe the divine feelings that flooded their hearts. It felt like they had both regained a lost part of themselves.

Michael put her suitcase in the boot of the car while Sophia sat in the passenger seat. Her eyes caressed the little blue dolphin hanging from the car mirror, so reminiscent of the moments of joy they had shared.

Michael sat down in the driver's seat. He kept looking at Sophia again and again, and he could not get enough. He imprisoned her in his arms yet again, then, after a while, reluctantly let her go, putting on his seat belt.

On the way to Michael's house, Sophia had to cancel the hotel reservation. He was adamant in responding to any of Sophia's formal objections. In truth, deep inside, Sophia

wanted to stay with him, but was waiting for Michael to make the determining decision.

From exchanging their first words, Sophia and Michael realised that they had to close many loopholes created by their well-intentioned separation, at least on the key issues in their lives. Life's thread had to reach the present and become so well-tied to it that any subsequent compulsory separation could not be withstood.

It was a situation that deeply hurt both of them, but they knew it was something they could not back away from, at least at this specific moment in time. Their souls kept alternating between joy and sorrow.

Sophia was talking, laughing, observing and caressing him.

She felt so happy, like the twenty-year-old girl she once was, and she remembered when they met for the very first time.

'I could never have imagined how much I would actually miss all of this: the roads we are driving along, the familiar places, our favourite spots!' Sophia said, overwhelmed by the feelings welling up inside her on the way to Michael's house.

Michael parked the car and they got out. They walked up to the flat entrance, with Sophia observing all the known and unknown details.

'Oops! Here come the first changes!' she said when she saw the new entrance door.

'Yes, yes, what a huge change!' Michael replied with humour, and they both walked into the elevator.

The reception Michael had reserved for Sophia, by transforming the house into a red flower garden, left her in no doubt about his innermost feelings.

Like a torrent, their love overtook every part of their bodies. Sophia proved the love she felt for him with her actions, with all the strength she had in her soul, with all the warmth of her embrace, and with all of the passion in her kiss.

They never once mentioned the 'crutches' in their lives during the time of their emotional disability, being away from each other. Those 'crutches' were concealed, like mutual

survival secrets for their relationship, which seemed to be shining all ahead of them.

Unfortunately, they both soon realised that the days they could spend together were painfully few, but even within this very short time, the flower of their love managed to grow new green leaves, promising much for their future.

Twenty-four hours were enough to prove to both of them that, essentially, nothing had really changed; only the practice of everyday life presented a big obstacle.

In their own time, they found the parameters and solutions to resolve any issues they had, to clarify any doubts, and to enjoy their reborn love. Looking at them, one would presume they had not been apart for a single day, but that, exactly, was their big test: the stress test of this so-important bond between them.

But Sophia and Michael fought for their relationship with mutual concessions and understandings, and won deservedly. They had found the right balance and that was the most important thing.

Sophia told Michael about the events on her first flight to New York, the early days marked by the tragic incident involving Aris, which fortunately had a happy ending, her everyday routine, her joy for the course her career was taking, and the sore points she was carrying within her, in as much detail as she could remember. She also told Michael about her little friend, Zanou. It was the only occasion, during all the time Sophia was talking, that her green eyes eclipsed with melancholy and bitterness.

Michael listened to her with regard. It was the same regard with which he listened to tales from his grandmother's lips many years ago; the only difference now was that the tales came to life and required his active involvement.

He also described to Sophia, in his own way, the evolution of his work. Michael seemed visibly pleased and proud about it. He also told her about his frequent trips to Thessaloniki and, ultimately, how often he also visited the 'green paradise',

which now, in the absence of Maria, had become more like a jungle, leaving Sophia very surprised.

Orestes constantly called Sophia while she was in Athens. The whole family was eager to see her, especially the little one. He was sitting on hot coals from the moment he learned his sister was accompanied by 'imaginary bodyguards' of great skills, of which he would be the final recipient.

'I promised them! Friday morning, I will go and see them!' Sophia said to Michael, informing him of her time frames.

'I must be there, otherwise I can see all of them setting up camp in your living room!'

'We'll be there Friday around noon,' Michael said understandingly, touching with his thumb the smooth crystal surface of the miniature Empire State Building, placed in a privileged position upon the main table of the living room, surrounded by useful personal objects.

'Did you go up this skyscraper?' Michael asked, leaving his finger resting on top of the Empire State miniature.

Sophia answered in the negative, adding:

'I went to several attractions, including the Statue of Liberty and the Guggenheim Museum on Broadway, but I did not go to the Empire State Building. I don't know why. Maybe it was not the right time. Did we not say that everything happens for a reason? Everything comes at the right time, regardless of whether we understand it or not.'

Michael moved the crystal miniature into a position he considered much better for it. As a gift from Sophia, he was trying to find the most suitable place for it, moving it to one location, then repositioning it elsewhere. He placed it under a lamp, examining its visual angle carefully, and then turned and asked Sophia:

'Shall we take a walk in our own attraction? Our favourite one!'

'You mean Plaka?' Sophia asked, and her eyes sparkled like emeralds.

'Yes. I've missed taking walks with you so much!' Michael said plaintively.

'With pleasure! I'll go get ready,' Sophia replied, and stood up.

About half an hour later, they were walking down the road, hand in hand, heading towards one of the most beautiful places in Athens.

The picturesque market of Plaka welcomed them with a festive spirit. The shop windows were decorated with all the colours of spring, the main colour being red. Traditionally, Easter eggs in Greece are dyed red, symbolising the blood of Christ. In the shop window decorations, however, there were eggs dyed in every colour imaginable. Those eggs were decorated with beads, feathers, and drawings; they had ribbons tied around them and they were hanging from dry tree branches, from which a new green life was ready to emerge, symbolising the rebirth of nature.

And chickens... so many chickens! Some small, some large with their little chicks; hens and cockerels.

The kids were going crazy in front of them, watching them move and shake their wings as if they were alive.

Michael and Sophia walked into one of the many shops and bought a green basket of coloured eggs for Despina.

'Let's buy something that is Easter-appropriate!' Sophia said, and paused.

'Why don't we get one more for Mrs Rena as well? What do you think? Your mother will really like that, don't you agree?' and without waiting for Michael's special consent, Sophia asked the shop assistant to wrap another basket.

With two red festive bags in their hands, Michael and Sophia continued to walk amongst the flowing crowd, laughing and enjoying the beautiful atmosphere.

The road to Thessaloniki was familiar and beloved for both of them. It was marked with many memories, triggered by signals at various points.

A place that Sophia especially adored was the Valley of Tempe[36]. She did not even have to ask Michael to make a stop. He had already planned it himself.

'I want to reexperience the dynamic, psychic waves this place offers me,' Sophia told him enchanted as they drove along the narrow, snaky road, which was almost perched on the side of the mountain, just above and parallel to the river.

Nature was thriving on both sides of the road. A sign informed visitors of the presence of the small chapel of Saint Paraskevi[37].

They left the car in a recess of the mountain, which had been created as a parking area, and descended the stairs of the underpass to cross to the opposite side. A few steps further led them to the small market of various folk art offerings. Further down, a narrow path led to the large suspension bridge.

The waters of the Peneus River flowed swiftly towards the sea. Large whitewashed stones were obstructing its path, creating small frothy waterfalls.

[36] The **Vale of Tempe** is a gorge in the Tempi municipality of northern Thessaly, located between Olympus to the north and Ossa to the south. The valley is 10 kilometres long and as narrow as 25 metres in places, with cliffs nearly 500 metres high; through it flows the Pineios River on its way to the Aegean Sea. In ancient times, it was celebrated by Greek poets as a favourite haunt of Apollo and the Muses. On the right bank of the Pineios sat a temple to Apollo, near which the laurels used to crown the victorious in the Pythian Games were gathered.

[37] **Saint Paraskevi** of Rome is venerated as a Christian martyr of the 2nd Century. According to Christian tradition, she was born in Rome around 140 AD to Christian parents. According to tradition, the emperor attempted to force her to denounce her faith, and even offered to marry her. Paraskevi refused, and was tortured by a steel helmet lined with nails being placed on her head. Paraskevi endured this torture and her endurance caused many to convert to Christianity.

Huge trees, cordial friends of nature itself, reverently closed their branches over the crystal-clear waters, as a token of gratitude to Him for their magnificent existence.

It was such a tiny, narrow strip of land between the two tall mountains, and yet was full of movement, sound and colour.

A bridge suspended by two thick cables connected the two banks of the river.

Sophia walked ahead of Michael. At every step, she could feel the bridge wobble.

'Shall we stop for a bit?' Sophia asked Michael when they reached the middle of the bridge. He agreed with her and rested his hands on the iron guardrails, watching the giant water snake passing beneath their feet.

Sophia looked first at the water reflections below; then her gaze slowly ascended the steep cliffs, stopping at the bizarre caves carved into the mountain, before disappearing into the sky, glorifying the Creator for this sight.

This was the magic moment Sophia was always seeking at this place: living proof of the saying, 'Everything was created in His wisdom'.

The raging water was carrying many different objects, creating strange combinations at the river's edges where the natural obstacles amassed. A relatively large trunk, 'stolen' from an old tree, found strong resistance from a large rock and stopped. A plastic red ribbon, brought to it by a magic hand, tangled itself artistically amongst the dead branches, creating a beautiful composition against the background of that idyllic place.

'Shall we go visit the holy spring?' Sophia asked suddenly.

'It's up to you what we do with our time, baby, not me!' Michael replied, and put his hand on her shoulder while moving ahead.

They descended from the bridge into a courtyard whitewashed with lime, emphasising the purity of the space.

A small chapel had been built under the towering cliffs, and right next to it, a small alcove formed a portal into the bowels of the Earth. The whitewashed concrete tunnel led deep

underground. As they walked down the tunnel, its height shrank, forcing them, towards the end, to walk almost stooped, in an imposed worship stance.

'Sophia, be careful, it's very slippery!' Michael said when they reached the holy spring, which was blessed by the Saint.

Sophia leaned over and placed a burning candle in the sand-filled container, next to the small pond formed between the rocks. Everyone that believed in this place and the holiness of the water gave it divine grace.

Michael leaned over with difficulty and touched the clear water. With his wet hand, he touched Sophia's hand. A sweet warmth flooded their hearts.

They let that warmth travel to every part of their body, helping them with their silence.

They walked out bowed, in the same way they had entered.

'I don't know if it's the religiosity of Easter or my sensitivity, but I feel like I'm walking on feathers lately,' Sophia said to Michael, grasping his hand.

Once back in the car, Sophia took off the white knitted cardigan she was wearing, folded it and put it on the back seat. The temperature, as noon was approaching, was reminiscent of summer. Michael, watching Sophia remove her cardigan, asked her before entering the car:

'You want to drive?'

'No, no. I prefer to enjoy the beautiful drive. Really, I have missed all these little details en route that I'd never even noticed before.'

Near Platamonas, they stopped to refuel at a petrol station. While the young employee was filling up the car, Sophia was preparing in her mind a small deviation she wanted them to make during the drive.

She informed Michael of her wish just as they left the petrol station, before entering the highway.

Michael cheerfully assented. He was always fascinated by this small but beautiful piece of nature, where the mountain met the sea, and where yesterday met today. They drove down the street towards the beach of Platamonas. The picturesque little

ports were already hosting their first summer guests. The road was uphill and narrow, continuing along a green path, with the sea to their right stretching as calm as it can be, just below the old railway line that once provided scenic trips to passengers. The future stole those train trips and led them into the depths of the mountain, in a huge tunnel under the immensely heavy foundations of the majestic castle of Agios Panteleimonas: a vivid recollection of another very distant era.

They went past a deep ravine filled with old trees and, climbing up a long ascent, found themselves back on the highway.

'The vivid scenery ends here. In one hour, we are going to arrive in Thessaloniki,' Michael said, as if making a travel announcement.

Sophia replaced her sunglasses and leaned her head back, with the trace of a smile on her lips.

Easter Friday is a day of sadness for Christians throughout the world; it is a day of mourning. But in one neighbourhood of the city, resurrection came early.

United, the whole family welcomed Michael and Sophia at the door with hugs and kisses. Orestes' arms closed around Sophia, and his paternal feelings overflowed. Despina rejoiced discreetly beside them, leaving father and daughter to express their love.

As for young Paul, he did not detach himself from Sophia for one minute, until Sophia fulfilled the promise she had given him before leaving. Satisfied and with the precious gifts in his hands, Paul finally disappeared into his room, leaving the rest of the family to hear of the most important moments flowing in Sophia's life during her long absence in America.

Despina thanked Sophia for the gifts she had brought them, and offered her own gifts to Sophia with much joy.

Michael sat with them for a while, telling them his news and delightedly listening to theirs. He was somewhat like a family member and a very likable one. Every now and then, he would come to Thessaloniki to see his parents, and would pass

310

by Orestes' house to say good morning. And he was always welcome.

Michael got up to leave, but Orestes' felt he was leaving rather soon.

'My parents are waiting for me, impatiently. I haven't seen them in a long time…'

'How is your father?' Orestes asked Michael with interest.

'Better. He takes his medicine, he's careful about what he eats… what a man of his age should do anyway to avoid or reduce any health problems.'

Orestes nodded, smiling slyly in hiding some guilt regarding the issue of diet. But Despina caught that guilt mid-air and, with a nod of her eyes, informed Orestes that he could not hide from her.

Sophia accompanied Michael to the front door. He paused.

'I was hoping we could spend the evening of Easter Saturday together. What do you think?' he asked.

'I should discuss it with Dad first!'

'Hold on, let me tell my parents first, as I don't know how my father will be feeling. Then I can call you to confirm.'

'Where do you suggest we go?' Sophia asked.

'I was thinking of the monastery in the Upper Town, just above my house,' Michael replied. 'Many people go there on Saturday evening… it's very beautiful!'

'Okay, I'll wait for you to call,' Sophia said cheerfully, and reciprocated his kiss as he went out the door.

Sophia returned to the living room and sat down with her father. They discussed several issues about her new life, her Uncle John, and Aris' ordeal. She conveyed Uncle John's cordial greetings to her father and his promise that they would visit them sometime. Orestes listened to Sophia carefully as Despina, with a white apron tied around her waist, walked endlessly up and down the room preparing all the traditional Easter dishes.

'Only Maria could not be here,' Orestes said with sadness to Sophia, who looked at him in amazement.

'Why? Where is she?'

'I expected us to all be together for Easter,' Sophia said, and disappointment spread across her face.

'You know that, for several years now, she has lived in Ioannina with her cousin. Since her little dog was killed, she decided she couldn't live alone anymore.'

'The truth is that she was meant to come to see you, but, fifteen days ago, Maria's cousin was hospitalised, and you know Maria.... She could not, in her heart, leave her cousin alone during the Easter days. Call her, she will be very happy to hear from you!'

'I will certainly contact her. My sweet Maria... it's such a shame she couldn't come,' Sophia said, knowing how golden her 'foster' mom's soul was.

'But I agree with her decision. It's not easy to get over the death of an animal, especially one that's been living with you for years. I lived with Maria and Lucy for much less time, and when you called and told me about Lucy, it took me about a week to realise what had happened. So imagine how difficult it must have been for my poor aunt!' Sophia added, visibly upset.

'I brought her a small gift. I'll leave it here with you, and you can give it to her when she comes to visit,' Sophia informed Orestes.

The moment they decided to call it a night and get some rest, the phone rang. It was Michael.

'Sophia, is everything ok for this evening? Please do ask Orestes as well,' he informed her.

'Hold on, don't hang up, let me ask,' she said.

Orestes and Despina unanimously agreed with his proposal. The meeting time was set for eleven in the evening, in front of the monastery gate.

Dressed in their best outfits and with candles in their hands, Sophia's and Michael's families met for the first time, in front of the large wooden door. Many people had gathered. They proceeded into the churchyard, where most people were

standing around, with access into the monastery nearly impossible.

The city below shone in the spring night. With much reverence and patience, they waited to be near the holy light, once the priest had uttered: 'Come and receive the light'. The 'light' flowed out into the darkness and poured forth powerfully outside the church, like a bright river. They all lit their candles and the glow spread to their faces, preparing their hearts for the most important event of the Easter days.

The church bells started ringing joyously at the sound of: 'Christ is Risen!'

Kisses of love flew from everyone's lips, aimed at the hearts of others.

Some kisses reached their destination and gave light, whilst others were fake and were lost in the dark.

Paul took a red egg from his pocket and, adopting his pugnacious style, he yelled:

'Come on Michael, let's crack our eggs!'

Michael lost the 'egg fight' and so did Sophia, but Paul was beaten by Mrs Rena, who broke his egg and left him visibly dissatisfied.

'You can't always win, my boy!' Orestes said to him sweetly.

'You beat the most important people,' Orestes said pointing at Sophia and Michael, who were laughing at Paul's antics.

Michael's parents stayed until the end of the mass service, waiting for the Eucharist. The rest of them, with the little 'bug' that was doing their head in, decided to head home, with their minds on the traditional kidney soup that would tastefully complete the Easter days' festivities.

Monday morning arrived far too quickly for all of them: for those who had to leave and for those left behind. Leaving Thessaloniki created moments, especially for Sophia, that she did not like at all, and the hardest part was yet to come.

At dawn on Tuesday, Sophia and Michael were at the airport. While Sophia was waiting at check-in, she turned around for a fateful – as it proved much later – conversation with Michael.

'I have a strange feeling…' Michael looked at her carefully. 'While I have many things planned ahead, something inside me, and I don't know what, tells me,' – Sophia now emphasised her words – 'that I will be back sooner than I anticipate.'

'Maybe, baby…' Michael said, and continued smiling.

'You know what wise people say? When we make plans, God sees them from above and laughs! Perhaps God is laughing right now and you're just sensing some distant notes of laughter.'

'You think?' Sophia wondered, finding what Michael said both serious and funny at the same time. She took back the ticket that the employee held out to her, presented with the clichéd, 'have a good trip'.

Another difficult separation was becoming evident in the bustling airport.

'The next time I come,' Sophia said seriously, 'I promise I will buy a one-way ticket to Athens.'

Michael smiled and hugged her as she continued to speak.

'I had a wonderful time with you; I only have such a good time with you.'

'I love you sweetheart. I'll try to be back as soon as I can!' Sophia said to Michael with all her heart.

'I'll be here and I'll be waiting for you, as always!'

Michael had long realised that he could not get away from this love. Whatever he did to distance himself from it, he failed miserably, until he made a decision.

In matters of the heart, his heart had been locked and the key annihilated.

His head was bowed and his hands filled his jacket pockets when, as he approached his car, he heard the loud noise of an aircraft taking off. He turned his head and saw the plane ascending into the dark sky. Only the flashing lights declared

its most silent presence. He walked to the car and made his way
back, all alone.

CHAPTER 6
'Clarifying the Soul'

Sophia found the long trip back useful this time. It gave her all the time she wanted, to think, to plan, to decide, and make some choices. It had now settled inside her that Michael was a person closely tied to her life.

If, during their first separation, she had experienced doubts about him and about herself, now she knew well, she could feel it, that Michael would be her companion for the rest of her life. This crucial decision overturned several of her original life plans.

When, during the course of her career, she began to rise and her objectives approached higher levels, she had decided to stay in New York even after she completed her specialisation.

However, the few days she spent back in Greece created a major upset in her life.

Her heart now rebelled and destroyed all her plans. And with such a rebel against her, she had no choice but to come to terms with it. She would complete her specialty and then go back to Greece. She was going to find a job in a hospital in Athens. She knew that, with all the papers she had in hand, she would easily have the privilege of choice.

Her internal war had now started to cool down. All the necessary negotiations were completed, bringing peace to the two camps in Sophia's soul. The retreats she had to make were not easy: to sacrifice her life's dreams in exchange for the very life she envisioned next to Michael.

With a winning smile, she got off the plane.

Everything looked so different on this rainy morning. The sunshine in her soul made her smile, even when a hurried motorist drove the wheels of his car through a puddle of dirty water, projecting it all over her.

Sophia surveyed the mess and started laughing. It was the best opportunity to defuse the joy she felt at the decisions she had made.

Her other family, the one in New York, welcomed her with much joy. They considered her a means of contact with their homeland. When they hugged her, they seemed to cling tightly to try to smell the Aegean air and scent of basil on her.

They all sat in the living room, sharing a bowl of popcorn and savouring the best imaginary film to be played in their lives in recent years. The title was: 'A family of immigrants dream of their sky-blue home'.

When their endless questions dried up, the popcorn bowl had been emptied and the film came to an end, almost accompanied by tears.

John whined at Hope.

'What do you think? Will we be able to go to Greece this summer?'

Mrs Hope had heard that particular proposal so many times that, in the end, she stopped counting. She did not reply to him. She had stopped responding to that question when she realised that her husband was hanging onto this 'dream'.

Inside her, she had classified going back to Greece as something too distant to be realistic.

So, returning to the present, Mrs Hope stood up silently from the couch and the group scattered, with everyone returning to work.

Sophia went to her room and opened her suitcase. She singled out the gifts that her father had sent for his cousins and, along with her own personal gifts to them, she gave everything to Aunt Hope.

She arranged all of her things and put everything in its place, separating out her laundry, which she threw into the hamper in the bathroom.

Sophia placed the little aquamarine crystal dolphin next to her on the nightstand. It was Michael's gift. Within it was captured all the blue of the Aegean Sea.

Sophia looked at the dolphin's head. Even though it was lifeless, a smile beamed under its nose and caressed her soul.

Before closing her eyes, she rested her fingers on it and let herself travel with it in her dreams, crossing over to the other side of the Atlantic, with the desire to meet the one who gave it to her.

She found herself cheerful in the morning. Even though every day brought the same regular routine, today, even that had changed colours.

Sophia still carried within her the Aegean breeze and, like a magic wand, it transformed everything around her.

Only at the hospital entrance did the wand break, and the magic was lost. In truth, she was very thick-skinned to be able to change with just a pleasant feeling.

She walked up to the clinic, said 'hello' to the head of the secretariat, and headed to the special area where doctors changed their clothes and put on their medical gowns. She opened the room with her own private key and went inside. She donned her white uniform, put on some plastic galoshes, and hung her stethoscope around her neck. She took a small package out of her handbag and, smiling, she walked out.

Sophia proceeded to the doctors' office for an update.

The first thing she had in mind was her little friend Zanou. Holding his gift lovingly in her hands, she imagined the smile of joy when he saw her.

All the days that she was away, she thought of him many times. One occasion was on the morning they went to the market in Plaka. There, in a small shop with antiques, tucked

away in a basement reminiscent of different times, she managed to find a puppet figure of the beloved joker Karagiozis[38].

Carved from wood and hand-painted with bright, warm colours, with his characteristic hump and nose like an eggplant, it made her burst into laughter when she held him in her hands.

She shook his auxiliary chopsticks and made his hands and feet move, reviving her own memories.

'I'm getting ready for a long journey, my friend!' Sophia said to Michael, distorting her voice to resemble the puppet she was animating with her hands.

Michael understood for whom this gift was intended.

Sophia asked the shop assistant to wrap the puppet well because its journey would be long.

Holding the puppet wrapped in white paper, Sophia opened the door to the doctors' office and went inside. Most of her colleagues were already there, chatting to each other. They greeted Sophia politely, and a couple of them asked, with curiosity, how her holiday had been and what Greece was like during the spring season. Sophia replied cheerfully, and her eyes searched for Claire: the young doctor she had left in her place. Claire, a short Asian girl, knew first-hand of Zanou's problem. Claire had been working alongside Sophia ever since Zanou was placed in their care, which was the main reason Sophia left her in charge, especially as far as her young patient was concerned. Claire was up to date with all the details and the ugly turn that young Zanou's health had taken.

Sophia spotted her at a desk in the back, buried in a stack of patient test results. It was impossible for her to imagine trying to buy time before being forced to drop the bomb that would burn Sophia's hands.

Sophia approached her smiling, and touched her on the shoulder.

[38] **Karagiozis**, or **Karaghiozis**, is a shadow puppet and fictional character of Greek folklore, originating in the Turkish shadow play Karagöz and Hacivat. He is the main character of the tales narrated in the Turkish and Greek shadow-puppet theatre.

'Claire, tell me what happened while I was gone, and, first of all, tell me how Zanou is doing?'

Claire continued searching through the papers without raising her eyes, as if she had not heard her.

A shiver overtook Sophia's body, as she subtly sensed that something was wrong.

'Claire, I'm talking to you! Tell me how the little one is?' Sophia asked again with urgency, grabbing Claire's arm.

Sophia did not need the confirmation of words. The answer was given to her with a single turn of Claire's head, forcing her to look Sophia in the eye.

Sophia's smile fluttered away like a bird being hunted. Two jet-black eyes, full of sadness, were looking back at her, and two tears appeared timidly, becoming tangled with some quiet words:

'He's gone, Sophie, he's gone…'

Claire's whispers sounded like thunder in Sophia's ears, so strong that it almost threw her onto the adjacent chair.

'Why, why…' Sophia muttered, and bitter tears rolled onto her lips. She did not want to understand, to accept, what she had just heard.

'I didn't get here in time… I told him to wait for me…' She was speaking incoherent words, leaning on the desk with Claire next to her, trying to support her.

Sophia knew that Zanou was going to 'leave' at some point, but not so fast; not now. She found herself completely unprepared for this.

'When did it… finish?' Sophia stammered with a trembling voice.

'Two days ago… He went, sweetly in his sleep, smiling like an angel. His mother was devastated, with eyes like rivers. She told me that, on that last day, Zanou was looking for you constantly.'

Sophia could not bear this; she felt like she was drowning.

'Only for my mother… have I hurt so much, Claire, and for a small pet that I lived with for several years. Zanou had a

special place in my heart. I thought of him as my little brother, you know they're almost the same age… well… they were…'

She saw the white wrapping paper containing Zanou's present that she had unconsciously left on the desk.

She could not digest that he had left without her seeing him; without him holding, in his little hands, the gift she had promised him.

She saw it now, wrapped in front of her, and could not find any reason for its existence. She left it wrapped like that, in the paper; sleeping forever, just like Zanou when he fell asleep.

Her emotions were in a bad mess. She drank a double coffee and began talking to herself. 'Pick yourself up,' she said to herself, 'a doctor is not allowed to fall, she should continue, your patients need you,' she said to herself again and again.

It took Sophia an hour to decide that she had to get up.

She put the puppet in the bottom drawer of her desk and lost herself in the hospital corridors, trying to escape the one-way street her mind was wandering down.

Before leaving for home, she went back to her desk and retrieved the puppet. Sophia put it reverently into her purse. She knew inside her that she wanted a few days to mourn this tragic loss in her own way.

On the way back, a thousand thoughts were running through her mind, her eyes and her imagination.

And amongst all the moments of joy and sorrow that she remembered, she searched for the best place to put the present that would remind her of Zanou forever.

Eventually she found the right place: she was going to put it on the nightstand, alongside the blue dolphin. Two small objects to remind her of her two great loves: very different from one another, but both strong.

She placed the puppet upright in the centre of the nightstand, in honour of the little angel who had opened his wings and flown into the starry sky, occupying a position from where he would shine forever.

Sophia's next move was to grab the phone and ask Michael for psychological support. She spilled all of her pain and shared it with him, resting on him with her mind.

And Michael, in the same way, hugged and comforted her by sending his love from across the world.

Sophia hung up the phone and stretched her numb body out on the bed. Her eyes were nailed to the ceiling and her mind was a void. But when the tiredness and tension of the entire day, like a strong breeze, closed the shutters of her eyes, a perfectly round sun, with two huge honey eyes, opened Sophia's eyes forcefully.

Another two attempts to close her eyes were crowned with utter failure. It was impossible for Sophia to escape the painful vision persisting each time she tried to close her eyelids.

She stood up decisively. She took off the nightgown she was wearing and put on some overalls. She made her way to the kitchen. At the door, she stopped and looked around her.

'I need to find something to do,' Sophia said out loud.

She reached down and pulled out the detergents from the cupboard under the sink. 'Work is the best medicine,' she said, and began taking out all the items from the first cabinet in front of her.

When Aunt Hope entered the kitchen, she looked at her and her mouth dropped wide open.

'What's wrong?' she asked Sophia, searching with her eyes to locate the damage that had forced her to pull out all the items.

'Nothing more than a cleaning treatment,' Sophia said, and succinctly explained to her aunt what was happening, conscientiously avoiding diving into the previous stressful situation.

When Sophia finished with the cleaning, she was so physically exhausted that she could not even think. She fell into a deep, colourless sleep.

The next few days were difficult. Every time she went past Zanou's room, her thoughts would bring him back into her mind.

Only when the door opened again and another patient had been moved into that room did Zanou's intense presence start to fade away, and Sophia began to slowly return to a calm everyday life.

CHAPTER 7
'An Unwanted Presence'

Even though, seemingly, everything was calm, with Sophia's job going as planned, her relationship with Michael holding its own balance and the good times she was having with her 'new family', a heavy grey cloud settled firmly over her life. At first, she did not realise it was there because she was gazing at the horizon. She was looking at the boats sailing up and down the large river, riding small waves until the bright sun, caressing them with his golden hands, disappeared.

A grey shadow spread just below, right there, towards her right armpit.

The boats turned around and made their way to the harbour to set anchor. From nowhere: 'We are going to have bad weather' was heard.

Sophia closed the shower tap, wrapped herself in a towel and quickly went to her room.

She closed the door behind her and wiped away the water still running from her hair with the towel. She threw it on the bed and stood in front of the mirror. She began searching herself inch by inch, looking and looking.

She was hoping to search for something and not find it, but she did, as if she had caught a mouse by its tail.

Her heart began pounding. She searched again and again, and each time there was a perfectly round ball, the size of a walnut, hidden in the underside of her right breast.

One hundred percent certain of the unwanted presence, she began searching on the left as well, just in case she located

another suspect ball. That investigation, thankfully, proved fruitless.

She returned to investigate the uninvited visitor. She fumbled as best she could. That 'thing' could also be seen with the naked eye. She searched for other signs of it by inspecting her nipples thoroughly, but found nothing to suggest it had company. She searched even further below, fumbling her lymph nodes from the outside where her fingers could feel. She found nothing tangible, except the existence of a small mass on the right side of her breast, which became pinned like an arrow in the centre of her mind: right in the lock of her mental room with the nameplate on the door, written on which, with a child's letters, was 'Mom'.

She opened that door wide and entered with momentum, raising clouds of dust, searching through her memories of that time that brought pain to her soul and now… her body.

She slipped on a cotton dress she found hanging roughly from a hanger, and searched for her phone. She looked inside her purse and found her phone somewhere at the bottom of her bag, under various brochures on new drugs. Taking it in her hands, she sat on the bed. She searched through her call history and Michael's number topped the list. She pressed the button to make a call, but cancelled it immediately.

Just the fact that her mind ran to him gave her the momentary calm she needed to think more carefully.

'No,' she said with intensity, 'I want to be certain first,' and she forcibly set her phone down on the nightstand next to the blue dolphin, which had made friends with the funny hunchbacked and always hungry little man.

The night was strange. She could not sleep or relax. In the morning, she found herself dozing off. A noise outside made her jump out of bed, like a spring, and she looked at the time on the clock. It was quite early to get up, but Sophia concluded there was no way she was going to sleep as she was really upset.

She went into the kitchen and turned on the coffee machine, which started whinnying calmly. She tried to be as quiet as possible with her movements so as not to wake up the others.

She wanted to be left alone. This was no time for questions. She closed the kitchen door and sat down at the table, thoughtful.

'It seems that my inherited genes have unwantedly appeared in time for our appointment. And she was about my own age when the first signs appeared.'

The factory of her mind started working overtime with all of its reserves.

She filled a cup with black coffee and continued to stir her memories.

A ferocious cat fight was taking place in the backyard, clearly audible through the half-open kitchen window. Sophia looked back at the time. A magnetic clock was stuck on the refrigerator door. She got up from her chair, left the cup in the dishwasher, and went to her room to get ready.

Her face was a mess. She put a little makeup on to cover the signs of her insomnia, without much success. She made a grimace of indifference, took her purse from the chair in the room, and went to the front door. Absolute silence reigned in the house. Working during evening hours in the restaurant forced the others to wake up after her departure almost every day, except on supply days when the men of the house had to leave at dawn.

She closed the front door behind her softly and descended the stairs. The taxi she had called was already waiting in the street.

She jumped in and languidly replied to the 'where are we going?' question. After that, Sophia did not re-open her mouth until it was time to pay. She really did not realise how or when they arrived. She was almost angry that they had arrived at her destination so fast and that she had allowed her thoughts, even though the destination was not the appropriate place, to provide answers to some of her questions.

She entered the hospital, almost running, but as she approached the changing room, her pace became slow as if pulled back by an invisible hook.

The same shrinking feeling she felt in her soul now was what she had experienced before, on that sad morning a few

weeks ago. Like a comet, Zanou's face came into her mind and disappeared.

Sophia quickly put on her medical robe and went to the doctors' office. No one had arrived yet. She grabbed a bunch of referral forms and completed them for herself. Ripping them from the pad, she took them in her hands. She opened the door and went out into the hallway, heading to the department of radiology where mammograms were conducted.

The next necessary visit would be to the microbiological laboratory.

Almost half of her morning she dedicated to the most important patient in her life: herself. Her emotions were like a minefield; she felt that she could go neither forward nor backwards. Until the diagnosis was complete and she had seen the radiographs with her own eyes, she hovered in an anti-gravitational field, unable to communicate properly with her surroundings.

Sophia's whole concentration was pinned on the grey shadows she now held in her hands. She tried to keep her self-control.

'There's not one, not two, but three intruders. Who invited them? Who asked them to come over? I don't want them… I don't want them…' Sophia said in a frenzy of anger, sitting on a chair lined with invisible nails.

The conversion of her initial shock into an unbelievable anger tormented her.

She mounted the x-rays on the bright screen and examined them carefully, strategically preparing for a war against three lumps, two of which were far too subtle to feel when she had first searched. Her imagination could see those two lumps laughing sarcastically, and as she heard their soundless laughter, she grew even more angry.

She grabbed the x-rays violently and rushed to find Professor Davis.

Blood tests that indicate tumours take a few days to give results, but regardless of what seemed to be, surgery was scheduled for next week.

That was the Professor's decision, when Sophia knocked on his office door and entered in a rampage to show him the mammogram negatives.

Professor Davis' interest in Sophie, as he used to call her, was almost paternal. It was the right time to reciprocate the mental support she had once generously offered him.

He saw Sophia's vague anxiety, which was playing hide and seek behind her angry look.

'Sophie, we will not give up! That is what you advised me once and you were absolutely right. Besides, we have so many means to fight this, girl!' Professor Davis said calmly. 'We will take it out and we shall see how we should proceed,' he said, directly feeling the positive impact of his words on Sophia. Her face calmed down for the moment, and the grooves on her forehead eased.

However, transitions in Sophia's psychology succeeded each other. After being overcome with anger, she began to behave like a doctor. She spoke calmly, explaining the data, highlighting what was promising and on her side, but failing to mention the possibility for something to go wrong.

Sophia listened carefully to her inner voice. Sometimes this voice was calm, at other times it was reactionary and angry, and sometimes it had the power to knock her down.

That evening, she called Michael. His voice and his words dynamically filled her soul.

'Whatever you do, I'll be there beside you, and I'll be holding your hand,' Michael promised before putting the phone down.

Sophia did not need to hear more, as if she was no longer interested in the outcome, and as if she knew it from the beginning.

'Everything will be fine now Michael is coming over!'

His arrival and presence had a catalytic effect on her.

Even when the haematological results came back, showing controversial data, Sophia faced them with incredible composure.

At home, everyone was cautious. They were not saying much, but they always had something good to say.

As for Sophia's family in Greece... she did not say anything to them, as she did not want to put her father through such a familiar and painful process.

'Later, if necessary, I will tell him... not now!' Sophia explicitly said to Michael.

He respected her decision and did not mention a thing.

Two days before surgery, Michael landed at J.F.K. Airport, into the arms of his beloved.

Sophia borrowed Aris' car and drove to pick up Michael from the airport. When she saw his figure go through passport control and come towards her, her soul fluttered.

She ran to him and disappeared into his already open arms. Words of love, sweet and tender, were flying loosely around them, like butterflies in an enchanting erotic dance.

'We have more than twenty-four hours at our disposal. I will take you to as many places I can', Sophia said to Michael on their way to the house. 'I want to walk with you and see everything through your eyes!'

Michael looked at her tenderly. He was embracing her in his arms, but holding her soul tightly.

'Shouldn't we first arrange a hotel for me to stay in?' Michael asked.

'Drop it. That subject is not up for discussion,' Sophia replied without any explanations, and continued with what she was saying.

'Do you remember when I was in Athens and you asked if I'd gone up the Empire State Building, the tallest skyscraper whose miniature I brought you, which you then walked around with in your living room for about a week?'

'Yes, I remember,' Michael replied curiously.

'Did you eventually find the best place to put it?' Sophia asked, laughing.

'Is that the real and only reason for asking that question?' Michael answered, with a question to the question.

'Of course not. I only said it as a joke. I just wanted to remind you of my words when I responded to your question. Remember what I told you? "Maybe it was not the right time".'

'Yes, I remember,' Michael said, trying to understand Sophia's reasoning.

'I was waiting for you, so we could go up there together. This is the right time. To look down at life together, from the highest point of this Babelian city.'

'With honour, joy and pleasure, but I don't want you to get tired because of me, my darling.'

'I won't get tired… anyway, everything is OK and ready. There is only one thing I am not allowed to do: to drink alcohol.'

'I'll remember that and you will repay me later,' Michael said cheerfully, and laughed.

'But first I'll take you home so you can drop your things off and meet my family here: my uncle and aunt, and my cousin Aris, who was kind enough to lend us his car as a favour.'

They arrived at home and found the family relaxing, just before it was time to open the restaurant. When Sophia opened the door, they were all sitting in the living room chatting. The minute Aunt Hope saw them, she got up to greet them.

Their cordial hospitality impressed Michael. He was pleased Sophia was lucky enough to be living with such warm and hospitable people.

As for the hotel, it was just as Sophia had told him!

'It's not up for discussion.' Uncle John was adamant, as usual.

Michael thanked them in advance, feeling obliged.

Michael and Sophia took advantage of every minute available to them. All morning, they wandered around the city; they ascended to the top of the building they had discussed so many times; Sophia even took Michael to see the hospital where she spent more than half of each day working. She talked to him about her thoughts and wonders. She always needed his

opinion, his view, and, especially now, she needed it even more.

They returned home relatively early. Michael did not want Sophia to get tired for any reason.

The fact everyone was working at that time was the best gift God had given them during those difficult times, even though Sophia tried to downgrade the price that had to be paid.

They hadn't been with each other for so long, in each other's arms, melting with their hot breath the frost that had inevitably formed through the time and distance apart.

Sophia fell asleep on his chest, letting Michael's heart lull her sweetly with the beats of life.

He was happy just to feel her soft breath caress him.

Breakfast found them hand in hand, walking down the hospital corridor, heading to the single room in which Sophia was going to stay for some days. Professor Davis would perform the surgery himself. All necessary tests had been done and everything was ready.

Sophia put on her surgery clothes and cap, and waited on her bed with Michael; her Archangel by her side, she waited for the doctors to come and get her.

'For the first time, I'm on the other side of what I'm used to,' she said, while the nurse administered some premedication. At the same time, a hospital porter walked into the room.

'My dear, everything will be fine. I'll be here and I will wait,' Michael said, and kissed Sophia as she was taken away for surgery.

She smiled, squeezed his hand hard, having held it for such a long time, and then left. The hospital porter rolled the bed down the long corridor, and they soon disappeared from his eyes.

The two whole hours of waiting seemed like centuries to Michael. He did not stop walking up and down the corridor looking at his watch. The agony obscured his face until he saw the carriage carrying his precious approaching.

Sophia had a faint smile on her lips: a smile that was between sleep and waking. The effect of the anaesthesia was still visible.

He let her recover and sat next to her, holding her hand and looking at her, whispering softly.

'I miss you my baby, I miss you very much.'

The first few hours after surgery were quite difficult, but Sophia overcame them with tolerable painkillers that were administered to her and, most importantly, with Michael by her side.

Her recovery was going well. Professor Davis was quite pleased. In a few days, Sophia could go home. Michael spent all day every day beside her. Endless discussions, about events that had taken place and plans for the future, made Sophia forget the pain she felt, which lessened every day.

In the afternoon of the first day after Sophia's surgery, someone knocked on the room door. Sophia and Michael turned to see the invasion of a huge bouquet of flowers with a 'tail': Uncle John, Aunt Hope and, at its end, Aris and Barbara.

Sophia was touched by their interest, especially that of Aris, who was there every afternoon while Sophia remained in the hospital.

'I owe you, cousin. How can I forget what you did for me?' Aris said when, on the third day, Sophia affectionately asked him not come to see her every day, knowing, of course, that he had to go straight to work afterwards.

Michael, who knew all the facts from Sophia, commented favourably on the family's behaviour.

When Sophia got out of the hospital, as a patient, of course, she barely felt any discomfort, except for some tension in certain movements of her hand, reminding her of the fact she had just undergone surgery.

The fifteen days' leave she was granted was the best thing that could have happened to her, if, of course, Michael could stay in New York. But it was impossible. He only managed to steal another week, pushing back many of his obligations at work.

But Sophia did not complain: she was so happy that they got to spend those days together, even in these difficult times.

Michael left New York seemingly calm. Sophia seemed to be doing fine for now. He could not, however, get the pending biopsy out of his mind.

'You will let me know over the phone when you get your results,' Michael almost ordered Sophia, who confirmed by nodding her head, on their way to the airport.

Aris offered to drive them there, knowing that Sophia was not allowed to drive yet. They gratefully accepted his offer. They sat in the backseat embraced and took advantage of every last second they had together.

Sophia and Aris accompanied Michael to the Departures entrance, and then returned home.

When Sophia called Michael the next day to find out if everything was okay, she was upset by some unpleasant mishaps Michael had suffered at the airport before boarding his flight.

'I had a huge problem,' Michael said. 'I almost missed the flight. From what I understand, it was because I have the same surname as someone undesirable to the security authorities. I had so much trouble trying to convince them of who I was. In the end, although I managed to leave, they black-listed my visa, adding me to their suspect list!'

Sophia listened to Michael astounded. She had heard of many such events happening at the country's airports, but did not expect that Michael would experience something like that. In any case, the light colour of his skin prevented many suspicions about his origin.

Sophia was not particularly concerned at the time she listened to Michael's story, as she had almost planned her own return anyway, sooner rather than later. However, things were to turn out differently from her forecasts.

The day Sophia returned to work after her recovery period, she was cheerful. She had become almost chronically bored by

the compulsory rest. Her days were refilled with all that she loved, the things that helped her not to think about her recent unpleasant adventure. She joined, once again, the functional group that gave life, that donated days to human dignity, and helped, with whatever means available, the resistance against the carnivorous beast's pain.

And Sophia almost succeeded. Occupying her time with her patients' problems was the best medicine for her.

CHAPTER 8
'The Final Countdown'

She was sitting in the doctors' office comparing two x-rays she held in her hands when Claire walked in. She walked towards Sophia and left five folders in front of her.

'When you finish, can you have a look at them?' she asked, waiting for Sophia's reply.

'Okay Claire. I'm done,' she said, and put the black and white slides in a white envelope that was in front of her.

'I will have a look at them right now. Is it something urgent?' she asked.

'The first one on top is urgent. I would definitely like your opinion,' Claire said, and went out of the office.

Sophia picked up the large folder from the top of the pile and began skimming through the test results inside it.

She really did not like the results of the enclosed CT scan. Sophia frowned. She gathered all the paperwork and x-rays, and put them back inside the folder.

She was ready to look at the second folder when the internal phone line rang. Doctor Parker picked up the phone and answered. Sophia saw him move his head understandingly, listening to the person speaking on the other end.

Sophia did not pay any further attention and opened the thick folder, laying out various papers. She took a red pen and was writing her observations on some of them when she heard her name.

'Sophie, the Professor needs you. He's asked for you to go to his office,' Doctor Parker said to Sophia.

'That is who you were talking to?' Sophia asked.

'Yes, he was asking how Thomas' chemotherapy went.'

'Did he tell you what he wants?' Sophia asked again, and pegged her pen on the examinations she was reviewing.

'No, he just asked me to tell you that he needs you.'

'Okay Pete. Thank you,' Sophia said, and re-gathered all the paperwork.

She left the folder on top of the others, separating out the ones she had seen, and stood up.

She walked out and headed to the office of the head of the department.

When she arrived at his door, she knocked and waited for his reply, which never came. Professor Davis opened the door himself and beckoned her to come in.

Sophia did not like this. He had never done this before.

Then, and only then, did the specific date of this day go through her mind like a bullet. All around her screamed that the biopsy results she was expecting were not going to be encouraging at all. And, first of all, the behaviour of the man in front of her said it all.

It did not take much for Sophia to understand the heavy burden he was carrying on his back, identical to the one she had seen when he confided in her his wife's problem.

His steps up to his desk were heavy, like a hundred-year-old man's.

Sophia felt sorry for him, beyond her own problem. She saw him as a father. To make things easier for him, she said with a supposedly comfortable voice:

'I know what the results are.'

He raised his eyes and looked at her over his glasses: he was short-sighted. He was smart enough to recognise Sophia's bluff.

'They came straight to me. I asked for them...' Professor Davis said, forcing her to succumb. She looked at him with green pools in her eyes.

'The air around us has confessed the results to my intuition's inner ear. So, are the results positive...?' Sophia asked.

The 'Yes' that came out of his mouth was barely heard.

Sophia's voice, on the other hand, sounded very loud and incredibly tough.

'And now, what's next? When?'

'You know better than anyone what needs to be done and when,' Professor Davis said, looking Sophia in the eye over the silver glasses hanging on the edge of his nose.

'The sooner the better, Sophie. The sooner the better!'

From that moment onwards, Sophia's inside clock turned with a 'click' into an unknown area of her emotions, which was alternating inside her with unimaginable speed.

She had started a personal chess game: against herself. Sometimes the white pawns were ahead in the game; at other times, the black ones.

And when the white pawns were ahead in the game, Sophia's life was taking different dimensions around her, different colours. She saw things happening next to her, in front of her, which long ago would go unnoticed. Now they made sense; they had entity; they had value. Sophia understood that this insight she had made all the difference: it was the harvest of positive values, the essence of the bad events that swarmed her life and brought a single word to her dry lips:

'Why... why...?'

A question that Sophia – the human being – could not answer. Sophia – the doctor – could give a thousand answers, but this game of chess belonged only to the first version of her.

She had to bear this alone all the way to the end, and she could win or lose. She did not allow anyone else to be involved in this 'game'. It was her battle at the end of the day. She did not even mention it to Michael. Sophia did not want him to become crazy over this. Michael was trapped without a visa; it would be agonising for him and for her to cause him to suffer unwittingly.

337

She was not sure whether she was doing the right thing, but she knowingly chose this course of action.

At home, of course, she could not hide it.

The upcoming surgery and chemotherapy that followed could not pass unnoticed by the people near to her.

Day after day, she began to get used to her two selves. But the hardest, the most painful thing for her, was the moment she had to contact Michael.

'Now I have to forget everything, nothing is happening, everything is good. I must think about the time I'll be going back to him,' Sophia said to herself, deflecting her pain before picking up the phone to speak to him.

She had already gotten a taste of how he felt when she had to tell him the first lie about the biopsy results.

But her love gave her the strength to keep him from knowing until the end.

There were moments when Sophia found herself at the bottom of a black sea, unable to find a way up to the surface.

In these difficult times, she had just one salvation: the power that her prayers gave her.

She would take from her bag the little gold Gospel she had purchased at the prophetic island of Patmos (she always kept it with her), hold it tight between her palms, and let her faith raise her to the surface, to the light, to the air, to life. And the more often she held it in her hands, the more often she felt inside her that the scales were starting to lean towards the white pawn camp.

She could not express this feeling in words. She could only taste it; experience it.

The surgery was undertaken very quickly. Every second that passed had significant weight. The removal of her internal genitalia was a painful process. Sophia knew this very well. She had handled dozens of those cases in the past and now it was her own body. The pain, at first, was only physical, but slowly,

as it faded away, it turned into a psychological hyena ready to devour her.

Sophia endured the most difficult times in the place that, in recent years, had given her the most beautiful moments in her life. Even though her heart now told her it was time she abandoned this place, she could not ignore all the pleasures she took from seeing patients being cured, even if that came with time limits, and making dreams for their lives.

The three people in her 'second' family did not leave her to go through this alone: not for a single day. They were the only ones who knew, and had committed to their promise not to say anything to Orestes and Michael without Sophia's consent.

When the physical pain began wearing off and Sophia started recovering, thousands of thoughts crammed into her mind.

'I must find a way to keep them in check. I have to arrange them in my head. I have to... find a suitable place for them, otherwise I will lose this game,' Sophia said to herself with the acumen that characterised her.

'One by one. I will catch them all. One by one,' she said stubbornly.

The first, and most important one, concerned her very existence.

The realisation that she had to coexist with a ticking bomb hidden inside her, and be ready at any time in life to deal with it, just in case it ever decided to re-activate, was initially the most difficult problem in her life.

There was no space inside her that she could find to corner this bomb. Sophia would leave it outside her mind's door, but as it was woven into her mind; it continued to disrupt anything that tried to come and go. It took Sophia some time to figure out she had to diminish the bomb's size, so that she could pass it through the door. She threw away many useless fears that had piled up inside her, and at last found a place, not at the very front of her mind, but further in, towards the back, though somewhere that it could always be seen.

The black king on the chess board had to accept a 'checkmate' move from the white pawn winner. He abandoned the game a loser…

This was the most important victory of Sophia's life, in her own life.

She never liked this uninvited guest. She was forced to cohabit with him, and he, as a gift for the concession Sophia allowed him, gave her a pair of magical glasses, with the ability to transform everything ugly into something beautiful; everything evil into something good; every simple thing into something great.

Perhaps this same gift is invaluable to the course of humanity on this planet, and that is why it is received by people who give a big part of their own lives to others; give their pain, their bodies, and their tears.

Sophia was discovering inside her a whole new way of thinking that offered her unprecedented pleasures.

'I cannot be mad! Yet I'm living unexplained moments of happiness for a reasonable man, or better to a man who hasn't tasted this bitter substance,' Sophia concluded with a smile.

The second thought, which not only hurt her so deeply but also affected her partner, was that she would never be able to be a mother. She was never going to fulfil her feminine nature, and although this directly affected her, it also indirectly concerned Michael. She would never have the pleasure to feel inside her that magical fluttering of life that every woman feels around the fifth month of her pregnancy.

'And Michael? I will never be able to have his baby, our baby…' Sophia said with sadness, and a tear rolled from her eyes.

'Oh God, how am I going to tell him?' Sophia wondered while in tears.

She was more concerned about Michael, rather than herself.

She left this unsolved in the lobby of her mind. She would find some way to mention it to him, along with all the other

stuff, when she returned, which did not appear to be that far away.

Forty full days (Sophia was counting them one by one) did the rough seas last in Sophia's life and soul.

She fought this battle with tooth and nail, and with her faith in God as her tireless assistant, Sophia was able to emerge victorious.

Little by little, serenity and calm emerged back into her everyday life. The palette of Sophia's life was refilled with colours. She wiped the black and grey off her hands and plunged them with passion into the red, the green, the blue!

'I have really missed you baby,' were Sophia's last words to Michael during last night's phone call.

Sophia awoke the next day with fervour in her heart and a pink smile spread across her lips.

CHAPTER 9
'Goodbye'

Sunday morning dawned. Sophia awoke with so much sweetness in her heart; it had been a while. She stretched her hand to the bedside table and stroked her sea-blue companion, sending imaginary love to the one who gave it to her. She got out of bed, but changed her mind quickly and lay back down, lazily reeling the acrylic blanket around her neck, enjoying its softness.

She could hear Uncle John and Aunt Hope talking in the kitchen, and the ticklish smell that reached her nose betrayed that coffee and toast were triumphantly sitting on the table at this time.

'Aris will still be sleeping,' Sophia thought, and continued snuggling with her blanket in bed.

When she decided to get up, it was already ten o'clock. She put on her slippers and headed to the kitchen. She looked at the coffee maker, which was still on. There was plenty of coffee in the jug. Two clean cups waited for Sophia and Aris on the kitchen table, along with a small plate of toast covered with aluminium foil.

'My sweet Aunt Hope always takes care of us!' Sophia said lovingly, and filled a cup with the steaming coffee.

As she was biting a mouthful of toast, Aris appeared, almost half-asleep.

Something that sounded like a 'good morning' was heard through his lips, as he walked drunkenly, heading towards the steaming liquid alarm.

He filled his cup and sat opposite her. With his eyes closed, he drank his first sips. Sophia was enjoying Aris' clumsy movements. When Aris started drinking the second cup of coffee, he opened his eyes and looked at her.

'What are you doing today, my precious emerald?' Aris asked.

That was what Aris used to call Sophia when he was in a good mood, and today seemed like it was his day.

'I don't really have anything to do. I think I will, little by little, begin to gather my things. I should empty the room from which I once evicted you!' Sophia said, teasing him.

A crumb of bread landed in her empty cup, having travelled on a curved trajectory as Mars was responding to her.

'Stop taking the piss, Sophia! It's too early for that! The truth is that we've got used to having you around for so long! I think our lives will change now that you're leaving. Something will be missing... regardless of the fact nobody is saying anything...' Aris said plaintively.

'It is, therefore, time you visited Greece! You never know. You might like it more than here. And, anyhow, you haven't closely experienced your homeland. You haven't lived there, and all that I convey to you is very little compared to the reality,' Sophia challenged Aris, in a good mood.

'I promise that I will come. I don't know when though,' Aris announced.

Sophia smiled.

'Why did you ask me if I have something to do today?'

'Shall we take a last walk to the statue? To get a little sea breeze through our hair! We won't be late...' Aris suggested.

Most Sunday mornings, Aris and Sophia made this trip, for a coffee or just for a walk. Sophia had established that Sunday walk. It was her contact with the sea that filled her soul with peace. In the end, Aris was also captivated.

'I see the gene of a seaman has awoken within you cousin!' Sophia said the first time he suggested they should go on that walk himself.

They both put on some tracksuit bottoms and trainers; then, with their cell phones in hand, they descended the stairs.

Uncle John and Aunt Hope had gone down to the restaurant a while ago now for the morning chores. They were cleaning the kitchen utensils when they saw Aris and Sophia walking through the inside door. They looked at them, wondering, and then looked at each other.

'Should they not still be sleeping?' Uncle John and Aunt Hope asked each other with their eyes.

'Where are you going?' Aunt Hope cried.

'For a walk. We'll be back in about an hour and a half,' Aris replied, and hastily grabbed the car keys from a bowl hidden behind the restaurant counter.

'I will go by Pepe's too!' Aris shouted at Aunt Hope on his way out.

Aunt Hope watched them walking away with their youth clearly present in their every move. She sighed.

From the day they were informed of Sophia's decision to leave, they had not discussed it at all together. They avoided the subject thoroughly. But today Aunt Hope could not bear it any longer.

'John!' she yelled.

He turned and looked at her as if hearing his name for the first ever time. He was used to hearing his name being called in English, as all the customers addressed him.

'You know I can't even remember the last time you called me that? I had forgotten myself,' Uncle John said, noting his remark.

'John,' Aunt Hope said again, softly, 'it will really affect me a lot when Sophia leaves. She is like my daughter. I remember like it was yesterday when she came and found us in the hospital: those difficult days for us.'

John listened and did not recognise his wife. He had never seen her so moved, except over Aris. But he, himself, felt the same.

'It will affect me too, Hope dear, but perhaps her not being here can be the main reason for us to finally make that coveted trip to Greece in the summer,' he said with his well-known optimism.

This time, however, Hope felt that his words had a different kind of weight. She saw it in his wet eyes, in his plaintive, nostalgic gaze, which was hiding behind his words.

Aris found a place to park when a car on the right side of the road left its spot, and he almost celebrated.

'We are lucky today I see,' Sophia said as she opened the door to get out of the car. She closed the door softly behind her. Until Aris approached, her gaze fell upon the golden, three-dimensional sphere depicting a planet.

It stood symbolically in the centre of the huge paved area in front of the United Nations building.

Just beside it, accompanying the artistic creation, there stood a representation of a long-barrelled revolver. Its muzzle was tied in a knot, preventing, in this practical way, any criminal use. It really puzzled Sophia.

'So many real wars on planet Earth...' she thought, frustrated, raising her eyes to the massive complex of buildings.

'Where are your thoughts wandering?' Aris asked.

'Very large buildings for very inconsequential jobs!' Sophia commented negatively, walking with Aris just beside her.

'We won't be late getting to Pepe's. Luckily, we found a parking spot next to his warehouse, so we'll be done rather quickly,' Aris said, justifying the forced detour they had had to make en route to their destination.

'I don't mind. I only hope you're equally lucky with the parking near Battery Park so we don't waste much time walking.'

And it was, indeed, a favourable day. After half an hour, a free parking spot for the car appeared, living proof that everything was in their favour.

In front of them, the evergreen park stretched along the lowest point of Manhattan, waving goodbye to guests venturing to the small island housing the Statue of Liberty.

Sophia and Aris walked beneath the tall trees, observing the little squirrels that scurried up and down them. They were so accustomed to the presence of people and did not hesitate to eat from their hands, despite the fact that signs on the trees forbade the public to feed them.

There were quite a lot of people at the dock, forming a long queue to board a ferry that would take them across.

They bought tickets and joined the queue, behind a Chinese couple. Right behind them, a group of Africans gathered.

Sophia looked at Aris and whispered in his ear, laughing:

'Now we're ready to be in a poster for the U.N.'

They were almost the last to board the ferry. They climbed to the upper deck and stood by the railing. The route was very short and they preferred to enjoy the morning breeze of the sea, watching the tall buildings of Manhattan from a better perspective. The huge windows of the skyscrapers shimmered in the sun, mirroring the white feather clouds, like an extension to the sky.

In the distance, the top of the Empire State stood distinguished: the tallest skyscraper following the terrorist attacks on the twin towers.

A voice from the speakers announced their arrival. They descended the staircase and, within a few minutes, Aris and Sophia were strolling on the wide walkway around the huge statue, on the few square metres of land. When they arrived at the front, the magnificent form of a lady, holding in one hand the text of America's Independence and in the other a lighted torch, appeared before them. Sophia turned to Aris and made a proposal, which did not please him at all.

'Can you withstand the pain and suffering of climbing 354 stairs for a unique view?'

'Can we not enjoy the view from a civilised height?' Aris complained.

'I'm not in suitable shape for a morning hike high into the depths of the lady's interior!' Aris refused Sophia's proposal politely, suggesting an alternative way to enjoy the view, at least from a certain height.

'OK, fine. Fine. Let's try this as you wish,' Sophia said, and walked towards the huge elevators.

'Another queue!' Sophia said, disappointed and puffing. They managed to get up to the third level.

'This is certainly faster than going on foot!' Aris said with satisfaction, walking out onto a large balcony.

'This is my last visit here,' Sophia said, admiring the breathtaking views of the city.

Aris looked at her, unhappy to hear these words.

'And I owe you a big thank you for all your help and support. It has been really valuable during my time here,' Sophia said to Aris sympathetically.

'When you come to Greece, I promise to repay you for your hospitality.'

'I will come, Sophia, I will come…' Aris answered, and deliberately changed the subject, suggesting they should make their way to the outdoor snack bar: a small shop inside with an endless exterior. The tables were spread over most of the square metres of this island. It offered visitors fast food, and not the best. Aris and Sophia both settled on a hamburger to appease their hunger. They put them on a tray, accompanied by the county's international drink, and ventured outside to find a shady table under a tree.

'The first attraction everyone visits must be this one, judging by the number of people we see every time we come here,' Sophia said, biting a piece of her burger and forming a grimace of disapproval.

Aris was so hungry that he did not hear most of Sophia's words. The food travelled in milliseconds from his mouth to his stomach.

On Sophia's third bite, Aris was already on his way to get another burger. While Aris waited in another queue, Sophia

stretched out her legs and sat as comfortably as she could, thinking of the days she had left, which were numbered.

She was happy to be going back, but also upset at the same time, for different reasons, of course.

When she first came here, she had so many dreams and plans. Many of them came true, but some changed course and others remained only dreams; others still were realised, without ever having been dreams or plans.

There was also a small thorn that had pinned itself in her mind since the morning, when she had stood naked in front of the bathroom mirror, looking at her breasts. Unconsciously, she had lifted her hands up and touched them. The replenishment of silicone implants restored her feminine confidence a little. It was a bittersweet experience that she had handled quite well, but which also induced wonder that ate away at her.

'How will it be, now, during our most-intimate moments? How will Michael react to it?' All these 'hows' were spinning around in her head, without receiving an immediate answer.

It was the last thing in her mind, of course, after the loss of her maternity, but it was real.

A flock of white seagulls landed on the edge of the wharf, picking over visitors' leftovers.

'What a beautiful day. It feels like summer!' Sophia thought, tossing a small piece of bread to her white friends, who become bolder and approached her.

Aris appeared, taking a big bite off the hamburger he was holding.

He sat comfortably beside her and muttered something with his mouth full of food, but Sophia did not understand what he said. She asked him, but with a flick of his hand, he made Sophia understand that he preferred to continue with his food, rather than repeat himself.

A ferry approached the dock and unloaded a large consignment of new visitors down its ramp.

Sophia looked at Aris. A smile of satisfaction appeared on his face.

'What do you say? Shall we head back?' Sophia asked him, and pointed at the people climbing aboard the ferry heading back to the city.

'Why not?' Aris replied, and got up heavily, moving his hand to his stomach, which was in the process of some intensive work.

On the way back, they chose to sit on two seats on the open deck, allowing the sun to caress them with its warm rays. The last few days before Sophia's journey home were passing very quickly. Perhaps Sophia's many obligations at work, the bureaucracy that, in reality, exists everywhere, made her arrive home extremely tired.

Today was Sophia's farewell day at the hospital.

There were some colleagues who rejoiced at her departure: such a remarkable place she was abandoning! Others worried that they were losing a valuable partner. Two people, however, were even more upset because they were losing a friend. Claire could not believe her ears when Sophia first told her of her decision to leave. Especially after the adventure involving Sophia's health, Claire had been so emotionally tied with her that, until now, she stubbornly refused to accept that Sophia was leaving. Claire said goodbye with tears in her eyes and promised she would do whatever possible to honour Sophia's invitation to summer vacations in Greece.

Claire had heard so much from Sophia about tours in the blue waters of the Aegean; the infinite beauty of the islands had really captivated her.

The separation was equally difficult for Sophia.

The first person who always sought her gaze when entering the doctors' office was Claire. And, today, Claire was going to be the last, except for someone else very important to Sophia, who was waiting for her in his office at this moment.

Sophia collected all of her personal items in a bag and left the office, throwing one last look at the space and capturing it

in her remarkable memories. She walked down the corridor, even though her legs were not really obeying her.

She stopped outside the very familiar door and looked at the nameplate with golden letters. The nameplate had many titles written on it, but only one was of interest to Sophia at this time: the name 'Ch. Davis'. That said it all.

She took a deep breath, knocked on the door and entered.

He was sitting at his desk. As usual, Professor Davis was lost in stacks of medical examination results and patient files. He raised his eyes and looked at Sophia severely. 'I never expected you to leave Sophie!' he said with a sad tone in his voice.

Sophia did not answer. She sat down in the leather armchair in front of his desk. She leaned over and put the bag she was holding beside her on the floor.

'I thought you were going to replace me at some point. You're one of the very few people I know with the knowledge I would want my replacement to have,' he continued with the same strict tone.

Sophia looked at him with a puzzled smile. Out of habit, she brushed her fingers through her hair (which was short now due to the chemotherapy), then rested her hand on Professor Davis' desk, stroking a crystal ball that held down a stack of papers. She looked him in the eye and replied:

'You know it was a difficult decision. But this is my decision.' Sophia stopped for a while, giving Professor Davis the necessary time he needed, and hoping he would understand.

'Especially with the last ordeal I went through, it has been confirmed to me, beyond doubt, that this decision is the right one, at least for my life.'

'Sophie!' he said, and took his glasses off. He left them in front of him on the desk and drank a sip from the glass positioned next to them.

'Would you like something to drink?' he asked her, dropping for a while what he had started telling her.

She gladly agreed. Her mouth felt like the desert. She drank a refreshing sip and put the glass next to her on the desk. She

looked at him with her green eyes. Despite all of the suffering, she was still a very charming woman.

'Sophie!' Professor Davis said again, clearing his throat.

'As your professor, I will tell you the same exact words as before. It's really stupid of you to leave your position. You know that, in a few months, they will be looking for my replacement! And you will not be here!' he said chidingly.

'This position belongs to you on merit. You have worked for many years, as very few of your colleagues have done. But since you want it your way, so be it!' Professor Davis said with a sigh. Sophia lowered her eyes and started looking at the carpet designs, sensing there was nothing else to say to him.

After this, though, Sophia's strict judge performed a one-eighty.

'Sophie,' he said again in a sweet voice.

Sophia lifted her eyes to ensure that the same person was still talking to her.

'Like your father, though, because I could be your father, I am telling you – good for you! You know I see you as my daughter and, therefore, I would like to say to you once more – good for you!'

While he was talking, Sophia felt his words like a cool breeze in her heart.

'Live your life, girl, like you want to, enjoy it. With so many years here, you have understood that nothing of what we really want should be ignored, or it will come back and retaliate in a very painful way!'

A smile blossomed on Sophia's lips. The opinion of this man was so important to her! She realised it clearly now, that his words gave confirmation of her correct choice.

'I want you to always be clear with yourself. Do not deceive yourself. What you aim and wish for, I hope you see it happen. Always search in the setbacks of life. Somewhere, there is a hidden pearl that repays the pain.'

Giving Sophia some final advice, Professor Davis stretched out his hand and opened the top drawer of his desk. He put his hand inside the drawer and brought out a little blue box.

'This is a small souvenir to remind you of my final words of advice,' he said, and placed it in front of her.

Sophia was baffled. She did not expect such a move on his part. Moved by this gesture, she took the box in her hands and thanked him.

He asked her to open it.

She lifted the lid and sensed the softness of the velvet on her fingers. The box's contents tangibly revealed the feelings of a man who had stood by her and helped her as few people had done in the recent years of her life.

As if at the bottom of the ocean, embraced in the deep blue velvet, a sweet, white, perfectly round pearl rested. The glow of its iridescence raised a hot tornado from the depths of her soul.

Professor Davis got up from behind his desk and approached her.

Out of instinctive respect, Sophia stood up from her own chair, holding the open box reverently in her hands.

'I hope this will always remind you of my words!' he said, and touched Sophia's shoulder to express his friendly sentiments.

Sophia, with evident joy and the spontaneity of her youth, said her goodbye by giving him a tender kiss on the cheek. He smiled and heartily wished her a good trip.

Sophia put the small box in her bag and looked back to see him before leaving. That was the last time she ever saw him.

She walked towards the exit of the hospital with very slow steps. At each step, she would gather life moments that she had not, for so long, felt the need to catch. Now she would grasp even the tiniest detail, utilising it as valuable material in the land of memory.

When she was further away, she turned and looked back.

She took an imaginary picture of what she saw and recorded it among the favourites in her mind.

Sat comfortably on the living room sofa with a glass of water in her hand, Sophia was sorting out any last outstanding issues.

That morning, she had gone to the airline offices and bought the much sought-after ticket: a one-way flight to Athens.

She held it in her hands.

'New York to Athens,' Sophia read. 'That sounds so good!' she said smiling, and continued to look at it as if admiring a work of art.

Sophia's admiration was interrupted by Aunt Hope dynamically entering the house with a bottle in her hand. She disappeared into the kitchen. Sophia looked at her in amazement. Before she could open her mouth to ask questions, the door reopened.

First, her uncle walked out. He was holding a round box in his hands with a bow on top. Sophia's surprise was increased as Aris followed with last, but not least, Barbara behind him, holding a pink purse decorated with white ribbons.

Even though Sophia well-understood that this small, unexpected party they had prepared was for her, she asked casually, with her usual sense of humour:

'Is it anyone's birthday today? Did I forget?'

'Someone's birthday? Wrong! Someone is celebrating… someone who decided to change hemisphere without asking us. Not that we had a say of course!' Aris said, and continued,

'Nevertheless, we love that someone very much!' He approached Sophia and, near her ear, he added: 'We love her so much, in fact, that we wanted to say goodbye this way.'

While Aris was making his speech (he always loved to orate), Aunt Hope brought five crystal glasses and the bottle of champagne, which she had earlier tried to camouflage with a towel to take it unnoticed into the kitchen.

She placed the tray on the table with a dose of formality. Aris, while finishing his monologue, took the bottle from the tray and with a professional-like 'pop', he opened the champagne and decanted it into the glasses.

Each one of them made their own toast.

Sophia, visibly moved, was accepting their wishes for a good trip, for everything to go well, and for good luck in her life: all filled with their love. Of course, she had not forgotten them either. When she went to get her ticket in the city centre, she made sure to buy a small gift for everyone that was symbolic to each of their interests.

Aunt Hope untied the bow from the box that Uncle John was holding and presented, with pride, a white cake. On top, with red glaze, a wish was written in Greek: 'Always be well'.

Aunt Hope cut a piece for everyone and offered them on small porcelain saucers, which had been waiting next to the box.

The time went by so beautifully, with all of them looking back and commenting on moments of the past, that Uncle John completely lost track of time.

'John, get up, we need to open the restaurant!' Aunt Hope said, revealing with her actions, in contrast to her words, that she, herself, was somewhat refusing to obey her mandate. Aunt Hope got up reluctantly and picked up some plates from the table.

'Auntie, leave them. I will pick them up!' Sophia said.

'Thank you all for the wonderful celebration. And I expect to see all of you in Greece!' Sophia said, and looked her uncle in the eye.

'I will miss you all so much!' Sophia whispered with a choked voice, and hugged Uncle John.

'You have no idea how much we will miss you. We might all be playing it cool, but, come tomorrow, things will start getting difficult,' Uncle John responded.

And tomorrow came in seconds. So it seemed to everyone. Sophia did not want anyone to accompany her to the airport.

'I don't think I'll be able to handle it, Uncle. No! I will take a taxi, as if it's an ordinary day. Don't get mad, please!' Sophia purred, trying to convince him.

'Well, well, let me at least order the taxi for you!' Uncle John said, and went to get the phone.

Mental and physical fatigue was eminent in his heavy walk. Heavy. Just like the years on his back.

Fortunately, the taxi arrived soon.

The final farewells were done very quickly, the way a well-sharpened knife cuts: it is afterwards that you notice the pain, when you see the blood pouring from the wound.

CHAPTER 10
'Yearning the Return'

On the other side of the Atlantic, the same events were about to take place. Another celebration was set to honour Sophia, with the only difference that, here, only joy and impatience prevailed pending her arrival.

Orestes, with Despina and Paul, had arrived early morning in Athens. They went straight to the hotel they had booked and called Michael on the phone.

Michael… was sailing in seas of happiness and ignorance.

Knowing nothing about his loved one's ordeal that followed his departure from New York, he made many plans for their future family. He was holding these plans well-kept in his heart, waiting anxiously for Sophia to come, to reveal to her the treasure of his thoughts.

He had prepared everything himself: flowers, sweets and drinks! He could have done so much more for her, he confessed to himself, while arranging a 'hug' of roses in his room at their house! Sophia had promised him that they would live together the last time they spoke.

'Okay baby. We'll live together from now on. Together; forever!' were Sophia's exact words.

At eleven o'clock on the dot, Michael was outside the hotel Orestes had chosen for the night. Michael alerted Orestes and the family that he had arrived at the front desk, and they all came down. They had a full hour ahead of them before the arrival of Flight 609 from New York.

All Sophia knew was that her father was in Athens for a job, and she expected to see him, but did not suspect the pre-planned conspiracy around her.

At thirty minutes past twelve, and without delays, the huge jumbo jet touched down on Greek soil. Sophia's eyes could not get enough of the light blue: the Greek light blue that was flooded with nostalgia.

She quickly disembarked and headed to the luggage collection area.

When she saw them all gathered together, as if posing for a photo, she could not believe her eyes. She ran and hugged them. The joy was unspeakable. All human expressions were not enough to convey her real feelings.

She looked at Michael.

'You are the instigator of this, magnificent host?' Sophia asked, and was lost in his arms.

'Welcome my darling!' Michael whispered, putting his hand on Sophia's cropped hair as his lips approached hers. He was calm, and certain that she was going to stay this time.

Sophia had just walked through the door of paradise. Life was granting her its most beautiful side. Sophia lived her every moment completely, and was taking advantage of every precious second in a good mood, and mainly with love.

The first one to make the most apt remark was Paul, just as he was sneaking demandingly between her arms.

'Why did you cut your hair?' he asked in amazement.

'You don't like me like this?'

'I like you... but I liked you more before!' he confessed with his childhood innocence.

The festive atmosphere lasted until late that night.

There was so much Sophia wanted to know, and she had so many things to say, except one. She decided to say nothing about the problem with her health to Orestes. If something twisted along the way and the situation forced it, then and only then would she reveal it to him. For now, she just wanted to see

him happy. And, anyway, there was nothing she could do about it.

But, as far as Michael was concerned, she had no choice but to tell him. She had to tell him. She wanted to share it with him. Every time that thought passed through Sophia's mind, a faint cloudy sky would quickly fly before her eyes.

But Sophia hastily evicted that thought when she saw Michael's eyes tracing her own. Neither the time nor the place was appropriate for confessions.

It was past ten in the evening when Sophia's family bid them goodnight. They were travelling back to Thessaloniki the next morning.

With happiness having taken front seat on Orestes' face, he kissed Sophia on the cheeks. He was always proud of Sophia's choices and always supported her, even though, sometimes, he did not agree with her.

When the door closed behind their visitors, Michael turned towards her, and with a sly yearning in his eyes, he gently put his hand on Sophia's waist. He pulled her into his arms and, bowing down to her throat, he whispered a sweet threat: 'And now it's just the two of us, baby!'

Sophia was a bit afraid of this moment. She did not know how she was going to react and, subsequently, how Michael would react. There were still moments when she remembered, with goosebumps, the nightmarish absolute flatness where her breasts once stood, before the prosthetic plastic surgery restored her female confidence.

When she was in hospital during those difficult days, this issue really troubled her. She knew that, theoretically and practically, it was not going to be different but, understandably, she felt agony about that first contact.

When Michael put his hand on Sophia's chest, he felt a momentary stillness and realised the different feel to the touch of something he knew so well.

But the magic of love, like a hurricane, blew away everything in its path. It was the catalyst in their souls and in their bodies. When the beautiful flower of love opened, Michael and Sophia enjoyed its beauty, got drunk on its scent, and shuddered from its touch.

Sophia was not afraid anymore. All her self-wondering was washed away by a huge wave of love and passion.

When she opened her eyes in the morning, a red rose, a breath away from her face, was resting on the pillow.

She stroked it with her eyes at first, then sank into its soft velvet, in its harmonic curves.

She took it in her hand and touched it to her lips, giving it a kiss, before putting it back gently where she had found it.

A light breeze was making the white curtain wave and playing games with the light. From the end of the corridor, a ticklish smell of coffee came, able to draw Sophia from the bed. She followed the scent and found herself, surprised, in front of the most beautiful breakfast table.

Although Michael was used to creating such surprises, as a lover of a good and well-laid kitchen table, he had surpassed himself this time.

'I admit you deserve a round of applause. While I was gone, have you, by any chance, got another degree about which I wasn't informed?' Sophia asked, giving him a kiss and sitting down to enjoy the breakfast of love, in her new life beside him.

The ringing phone violently interrupted this gentle start to the day. Life was demanding her rights. Michael answered the phone and confirmed one of his scheduled appointments. He came back and sat down again beside her.

He put a croissant into his mouth and, while chewing it, he asked:

'What do you suggest we do on our first weekend? Do you have any desires?'

Michael looked at Sophia and waited for her response. She remained thoughtful and silent for a few minutes. She then raised her head, and with a calm but decisive tone, she expressed her wish.

'I would like to make a trip to Patmos.'

Michael was surprised. He did not expect that.

'Is there any particular reason?' he asked, detecting clarity in her desire.

'There are two reasons why I want to go…' Sophia paused, and then continued, 'but I want to reveal both to you when we're there,' and to lighten the conversation, she completed cutely:

'Besides, it's the Island of the Apocalypse, is it not?'

Michael smiled.

'Done! Beautiful. After my appointment, I will go get the tickets. Let's just hope the seafarers aren't on strike again. The last two weekends, many ferry routes have been cancelled,' he said to her informatively.

'I hope we're not unlucky, because if we have to get on a later ferry, we won't have the house available to us. Dad has informed me that, next weekend, the new tenants arrive for this season, so we will have to find somewhere else to stay.'

Michael walked away from the table in a good mood, and left his cup on the kitchen counter.

'How are you thinking of spending your morning?' he asked Sophia with interest.

'I'm thinking of making a trip to the mall. I need to buy some clothes and some other necessities for the house. I don't think you'd like me to wear your slippers all the time!' Sophia said, ostentatiously raising her foot that was lost in a huge male slipper.

With a dynamic, smooth motion, Michael caught her leg and leaned towards her.

'I'd give them to you happily, but they don't match your eyes, baby!' Michael teased her, giving her a kiss before leaving to get ready, while whistling a cheery tune.

Sophia was still sitting with her second cup of coffee, noting down her shopping, when Michael appeared at the door.

Dressed in blue trousers and a light blue shirt, he was very charming. She looked at him with admiration.

'I like you very much, you know?' Sophia said smiling, and stood up to embrace him.

'And I like you too baby. I'm crazy for you! But I have to leave, I'm already late…' Michael said, looking at his watch.

He gently released her from his arms and walked out, closing the door behind him.

Sophia heard the elevator stopping on their floor, and turned to the shopping list again, noting a few more items.

She looked at the list one last time, ensuring she had not forgotten anything. She folded the piece of paper and stood up. Leaving the list next to her bag, she approached the library to put on some music from the digital discs. She chose a joyous melody that filled the living room with colourful notes.

She let her eyes wander over the objects in the library, keeping company the fleet of books arrayed along its shelves.

Most of those objects were familiar: souvenirs from various trips, gifts that they had given to each other, and, on one side, she saw a round white stone next to her picture.

'Ah!' emerged from her lips, and she reached out her hand to pick it up.

She took the stone out from its position and replaced it with another object, so that the line of books it supported would not fall.

When she had ensured that the books would remain upright, she turned around and sat on the couch. She held the white stone in both hands and felt its smooth, cool surface on her fingers.

A date written by her with a permanent marker pen took her back several years.

Like scenes from a movie, memories unfolded. Happy moments, white moments, unsympathetic moments. Her eyes turned to her photo. She was sat on a huge rock with a frothy wave behind her, taller than she was, as if it was trying to swallow her.

'It swallowed me and spat me back out again!' Sophia commented aloud, reflecting the pain she went through. Stress overwhelmed her soul.

'I need to talk to Michael,' she thought. Her words turned abruptly back to the present, violently evicting the morning serenity. She put her memories back in place and started getting ready for the market.

Sophia wore comfortable trousers, a sleeveless shirt – which the summer weather required – and a pair of flat shoes, ideal for walking.

She put the shopping list in her trouser pocket and went out.

She felt strange at first. Yesterday, she was in New York; today, she was in Athens. Normally she would need some time to acclimatise, but the so-familiar representations, the people, the Greek dialect, created very quickly the impression that she had never left.

Sophia took the tram to Syntagma Square. She descended towards the metro station, observing all the changes around her. There were moments when she felt like a visitor in her own town: in the town where she had lived a large part of her life, but she overcame those moments really quickly.

In Stadiou Street, she decided she had to start looking for the things she needed to get. She went in and out of shops, looking at the display windows, trying on clothes and shoes, and checking her notes every now and then. While trying on a black and white polka dot dress, Sophia looked at herself in the mirror. Like an epiphany, the idea of change came to her.

The way her short hair looked really disappointed Sophia.

For years, ever since she could remember herself, rich, wavy hair had adorned her face. She would tie it up with ribbons or, at other times, let it caress her shoulders. Now, she felt that something was missing.

'I must do something about this soon!' Sophia told herself, looking at her head instead of the dress she was trying on.

She paid in cash and, with another bag in her hands, she left the store. She walked to the nearest kiosk and asked politely for the yellow pages, containing information about different types of stores. She turned the pages and stopped when she saw the word 'HAIRDRESSER'.

She searched for something nearby to the street she stood in. Taking a pen from her bag, she wrote their addresses on the back of the piece of paper containing her shopping list. She thanked the young man in the kiosk, returned the yellow tome, and left.

She looked at the first address and walked towards it.

She found it easily: it was only two blocks from her location. Sophia opened the glass door set into a large window and went inside.

At first glance, she was disappointed: it was crowded. She headed towards the centre. Behind a desk, a girl with striking red hair and a fake smile asked her what she would like to do.

But when Sophia heard the waiting time, she jumped into the air.

'Three hours?!' Sophia cried, surprised, and some heads turned towards her. Lowering the tone of her voice, and with a similar smile, she replied,

'I'm sorry, I can't wait that long! Bye!' she said, and walked out.

She stopped further down the street, resting her bags on the edge of a large flower pot, which was loaded with colourful petunias, and took the piece of paper from her pocket.

She looked at the second address and muttered,

'Let's hope we have better luck in the next salon.'

She gripped the handles of the paper bags in her left hand and continued to the new address.

She turned into a narrow street, perpendicular to Stadiou Street, and looked for number 20. The shops on the building's ground floor had nothing to do with what she was seeking.

Sophia approached the entrance, looking at a plethora of nameplates. She identified the one she was looking for right at the bottom.

'COIFFURES IRO', mezzanine.

The front door was open. Sophia climbed the few steps and rang the bell.

A blonde girl in her twenties welcomed her as she walked in. Before Sophia even started to talk, she looked around,

calculating the approximate waiting time. Fortunately, the salon was not too busy. Two chubby ladies were waiting in the salon lounge, each holding a magazine in their hands. Another two ladies were sitting on chairs in front of the huge mirror, receiving the necessary care from the salon staff.

'Hey girl, what would you like to do?' the blonde head asked her while munching on something.

Sophia was about to answer when an emphatic hair tone attracted her attention. She looked at the girl with the orange mane, who was combing the hair of a lady in front of the mirror. She scrutinised the image she was seeing and the face hidden behind this hair, which was sending familiar images to her mind.

As her eyes met with the eyes in the mirror, a cry was heard that sounded like an echo.

'Sophia!' the girl exclaimed and came towards her, letting a tuft of the hair she was combing fall into the face of its female owner. Sophia took a better look.

'Sophia darling! Where did your rich hair go, my girl?' she joked while hugging her.

Sophia recognised her, but did not manage to say much, other than to murmur her name. Sophia was overwhelmed with a torrent of questions. Iro was plainly questioning her.

When Iro stopped to catch her breath, Sophia was given the opportunity to say her few words; that was it, since Iro was irrepressible as always. Nobody in the salon managed to say a word.

Sophia certainly had no wish to tell Iro the cause of having to cut her rich, long hair; she only asked her if she could change the colour.

'Whatever my old classmate wants!' Iro said.

'Only, can you wait for a bit so I can finish with this lady?' and she continued to wave her hands as she combed her hair.

'Of course!' Sophia replied, understanding that Iro would be done relatively quickly, and sat on a chair.

While Iro worked, she was making several suggestions, always according to her own taste.

'What colour would you prefer, Sophia darling? I think an acajou would really suit you! It will make you look very impressive!'

Sophia thought of getting up and leaving, but she did not abandon her original decision.

'Iro, I don't think I'm cut out for such extreme experiments. A light blonde would be the greatest excess I would dare, at least for now,' Sophia said, looking at her dark-headed complexion in the mirror.

'Whatever you like, girlfriend,' Iro said heartily.

Iro brought over the sample colour book and Sophia chose a shade reminiscent of flower honey.

When they were finished, the result Sophia saw satisfied her. Suddenly, she saw another Sophia before her. She wondered how a simple hair colour change could also change her image so much. She never belonged to the list of regular customers of such salons.

She thanked Iro, promising her that she would come back, and walked away satisfied.

Coming out into the street, she heard her cell phone ringing. She took it from her bag and answered.

'Hey baby, where are you?' Michael's queried.

'I'm at the market and I'm heading home. I just finished with my shopping!' Sophia replied.

'Okay, I'm on my way home too. Hey Sophia, I found tickets for Saturday, on the first early morning route. Everything else is fully booked. Shall I get them?' he asked.

'Without a second thought, get them,' Sophia agreed. This trip had to be done as soon as possible. 'And I have a surprise for you. I will show you at the house. Kisses,' Sophia said, and hung up.

Loaded with bags, Sophia marched to the tram stop. Seeing an endless queue of people made her change her mind.

After much effort, she managed to share a taxi with an elderly gentleman traveling in the same direction.

She reached home feeling quite tired. As she walked in, she left all the things in the living room and threw her shoes off her feet.

She walked barefoot into the kitchen, enjoying the coolness of the marble, and poured a glass of juice.

Michael would appear any minute now. At the hallway, Sophia stopped in front of the big mirror and looked at herself.

'Perfect! I like me!' she said to herself with satisfaction.

Michael found Sophia sitting in the living room, among clothes, shoes and hats spread out across the sofas, armchairs and tables.

Michael was speechless at the sight. He stared at Sophia and then at the small public market she had set up in his living room. Finally, he centred on her. After taking the time he needed, his mind smiled.

'Nice colour!' Michael said with admiration, and left his bag next to the shoe case.

'You like it?' Sophia asked, waiting for more compliments.

'A lot and it suits you too!' Michael said, stroking her head.

'So the change was successful?'

'Amazing! Just like emptying all the shops!'

'Not all of them! I just bought what I needed,' Sophia justified.

'Come on you idiot, I'm teasing you!'

In the end, Sophia gathered and put everything on the side, turned towards him and said seriously:

'Because it's lunch time and the lady of the house did not have time to prepare anything, I suggest we eat out. In ten minutes, I'll be ready,' thus allowing herself the appropriate time to freshen up.

Over the next two days, Sophia chose to take care of herself. She had planned to prepare her CV for jobs, but that thought was postponed until Monday. She wanted to clear her soul of the weight she was carrying, and then tackle the job matter.

During the hours Michael was at work, Sophia would find time to do things in the house: cooking (although it was not her favourite pastime) and spending several hours browsing topics on the Internet, from medical updates to cosmetics.

On Saturday morning, very early, Michael and Sophia were ready and in good spirits. They called a taxi to take them to the port of Piraeus.

APOCALYPSE

'A soul filled with love'

Michael and Sophia were met by the sunrise outside the ship. The beautiful start to the day also foreshadowed a beautiful journey. The beloved light blue queen of the Aegean welcomed them, wearing her sweetest and most peaceful mood.

It was almost evening when their gaze embraced the 'emerald island'. Everything was so familiar, so intimate, so calm. In their every move and at every point Michael and Sophia stood or looked up, a sweet memory emerged for both of them. Even though, during their previous visit, Michael had endured some hard times, he made sure, in a very discreet way, not to mention those at all. He always brought his best self forward. Sophia rightly recognised this magnanimity as one of his best traits.

Michael never dwelt upon small, embarrassing situations that had hurt him, despite the fact this specific one had hurt him very, very much.

As the taxi drove them up to Chora, a glimpse, the moment they reached the point of intersection with the road to the Holy Cave, whispered something in Sophia's heart.

'Here I will confess to him everything I've been hiding from him for so long,' Sophia thought, 'under the olive trees, within the peaceful power this place emits.'

The taxi, struggling to ascend, continued its upward journey.

The summer season had not started yet. On the island, there was a scene of great calm, reminiscent of some other times.

Sophia asked the driver to make a stop at the estate agency. She took the house key from them and returned to the taxi immediately.

Soon, she was opening the door of the 'blue paradise': the gift of her beloved grandmother Sophia.

Michael and Sophia left their things in the living room, near the front door.

Sophia opened the shutters and let the golden light in to fill the space. Unable to resist the desire, she went out onto the balcony to the magic she perceived in the vastness of the sea. Her very first childhood vision was still there, and so unchanged. Although she had reached to the end of the earth, that vision always had the same taste. This perplexed her. For two minutes, she remained thoughtful.

'But still it is here and it has the same power!' Sophia said gazing at the sea. It was not the right moment for analysing, but she promised herself to look inside her heart and mind, and find what she did not understand.

She turned around and re-entered the house.

They spent some time cleaning the minimal dust that had found the time and freedom to spread over the surfaces of any uncovered furniture.

They collected the spreads from the couches and organised their two-day stay.

While Sophia was sorting out their clothes in the closet, Michael took it upon himself to try and fix the sink tap, which was dripping defiantly into a bright white bowl. He was quite good with DIY, so much so that, awakening the plumber inside him, he decided to also check and test all of the other taps in the house.

The sun was ready to set when they finished with the chores. They threw some water over themselves to drive the dust and sweat away, then they sat in the evening coolness of the courtyard. In the harbour of Skala below, the lights began to shine as the darkness slowly fell. A peace embraced the stillness of the night.

The cool breeze from the sea forced Sophia to get up.

'I'm going to put something on because I've started to get cold,' she said, and tightened the bathrobe she was wearing around her.

She made two steps when the voice of Michael made her stop.

'Shall we go have dinner at Apostolis Taverna?' he suggested.

She turned around, folding her arms across her chest.

'How come you remembered him?!' Sophia said with surprise.

'The blue-eyed philosopher... yeah... You think there's even a tavern there after so many years?' she asked him.

'I don't know, but if there is, I would like to go back there. We could keep the promise we gave him to go back sometime,' Michael said, stroking Sophia naughtily, burying his hand under her bathrobe.

Sophia playfully hit his hand and pulled it away from her.

'Come on, come on... Your proposal was to have dinner, if I'm not mistaken!' Sophia said in a supposedly strict tone.

'I'm going to get dressed and you'd better get up as well. And please fill your glass with water in the sink so that we don't get any ants. The moment those ants sense there's sugar around, they gather like an army!'

'They have to eat something too...' Michael said, supporting the animal kingdom, as he rose from his chair and laughed.

Hand in hand, they walked up the narrow streets of Chora. Most shops were still shut and had not yet opened for the summer season. Many were at the stage of preparation. Boxes with paints, paint brushes and cardboard spread in and out of shop display windows. A dozen plastic pots in various sizes, loaded with geraniums, waited patiently in line to be painted. Michael and Sophia went past them and turned into a narrow alley on the left.

A smile was painted on their faces.

The lit lanterns were playfully dangling between the foliage of a huge ivy.

'Michael, he is open!' Sophia said with joy, and pointed with her hand.

The large wooden sign standing outside the entrance informed customers of the varieties of food offered by the taverna.

They stood there for a while, in front of the narrow passage that the kind green sentry was guarding. A group of people were sitting at a table deep in the covered courtyard.

And at the familiar table 'for friends', Apostolis was sitting.

Although the lighting did not help much, Sophia saw tiredness on his face. Despite the distance separating them, the traces were distinct.

Michael and Sophia descended the stone steps and went towards him.

Feeling the presence of customers, Apostolis got up hurriedly and approached to offer his service.

By the time their eyes met, an authentic smile of joy changed the colourless demeanour.

'Welcome my friends, welcome!' he said, giving them his hand to greet them.

They reciprocated the warm welcome with the same cordiality.

'You have forgotten about me! It's been a long time!' Apostolis complained.

Michael was the first to speak.

'You're right, Apostolis my friend, but we couldn't. Sophia was away, overseas, for some time... It has only been a few days since she came back and the first place she wanted to visit was the place she was born.'

On hearing this, Apostolis was satisfied. He put his hand around Michael's shoulder and led them to the table at which they chose to sit.

'The truth is, we wondered whether you'd still have the tavern. We're so pleased to have found it open,' Sophia added, trying to place her bag on the chair next to her.

'It moves me a lot when I see that my friends remember me. So, what nice things would you like to eat?' Apostolis asked with interest.

'I think we should let the expert choose for us… you know best… some fresh fish and raki. You know, the strong one that lights fires!' Michael teased him.

With one glaring laugh, Apostolis disappeared inside the restaurant to prepare their order.

Once he had retreated from their vicinity, Sophia expressed her concern to Michael.

'I think he has been "tortured" by something all these years. Did you see his face? His forehead is full of wrinkles, as if he has sailed through some big storm in his life.'

'I think your observation is spot on. So it seems,' Michael agreed. 'If he wants to talk to us, I think he definitely will later,' he concluded in the end.

'But how does he do it? His tavern always exudes this sweet warmth!' Sophia said changing the subject, and looking with admiration at the romantic environment around them.

'I think he gives this place his soul Sophia: his entire inner world. He is a sweetheart! Don't you agree?' Michael asked.

Sophia nodded her head, expressing her concurrence.

'We, of course, and the customers in general, undoubtedly can't all observe with the same sensitivity. We must be the appropriate receivers. What we see and perceive, you and I, is not similarly understood by the group of friends sitting at the next table,' Michael said, and indicated with a nod of his eyes, being careful not to be nosy.

Seeing Apostolis arriving with the tray in his hand, Michael softly nudged the ashtray towards the edge of the table to make room for the dishes.

Apostolis put the raki on the table, along with a dish of sun-dried octopus, two glasses for them and another glass for himself. He put the tray on the adjacent empty table and sat down with them to drink to their 'good health'. He used to do this with 'good old friends', as he used to say.

He wished for Michael and Sophia to always have a good time and, as a good old friend, he asked, with interest, to hear their news.

He listened carefully to Michael's update on his work regarding human psychological problems. Apostolis showed that he understood enough from the little things he commented upon: evidence that the lights of communication between them were on.

But Apostolis was more delighted with the interesting things Sophia described regarding her long journey and her experiences of America, a country most people would want to visit. But she explained that she was happier to have returned home.

'Offer your knowledge over here, my girl! This place needs good doctors! Most of them are held back by their aspirations or their obligations. Well done! Well done!' Apostolis said with passion.

'But you haven't told us: how have all these years been for you?' Sophia asked, looking with her eyes for his reaction.

'I had some problems with my health… but they are gone now!' Apostolis said, trying to overcome the issue. 'I am fine now!'

'What problems?' Sophia insisted.

'Some tubes in my heart have made my life difficult! I had to have a triple bypass,' he continued. 'Now I have to watch what I eat, and I can't drink like before… I try to obey…' Apostolis apologised like a child.

Sophia looked at him with sympathy.

'Be careful, Apostolis, to follow your doctor's instructions and be certain that everything will go well,' Sophia said, and gave him a friendly pat on the back.

Apostolis' eagle eye noticed that the cook had just prepared their order and it was sitting on the serving counter.

'I'm going to fetch the fish. Eat them while they're hot!' he said, and stood up.

He returned with a platter of red mullet, golden and crunchy, that were still steaming from the fryer.

He wished them a good appetite and went back to his table. He did not get a chance to sit, as two groups of friends who had just arrived attracted his attention and interest.

The evening was flowing gently to welcome the start of a new day. It was carrying with it beautiful feelings, delivered in a religiously bright sun that emerged with grace on the distant blue horizon.

Sophia stretched out her hands, unfolding some pink thoughts on this bright morning. She turned to her side and, full of tenderness, she lay still looking at Michael's calm face.

From her soul, hot breaths of love sprang. She leaned over his lips and placed those breaths gently on Michael's lips. With full haste, they ran to nest in his heart, but were making so much noise in their course that they woke the two brown guards, who arrested two emerald eyes looking sweetly at those breaths reflected back.

Feeling satisfaction and safety, Michael closed his eyes again, moving his body towards her. He stretched out his hand and touched the soft valley of her waist.

Sophia enjoyed this touch, which arrived like a comet on the planet of her soul, completing, in this way, the magic circle of love.

Sophia got out of bed softly and went into the living room. She turned the radio on and found some soft music. She danced around briefly, following the rhythm, and continuing her airy dance, she pressed the button of the coffee machine to accompany this melody with its fragrant rumbling.

Sophia was seated in the courtyard enjoying her coffee when she felt Michael's warm breath on her neck as he bent over to kiss her. He sat beside her, holding a cup in his hand, and asked:

'Today is the day of revelation?'

Sophia struggled, but managed to smile in the end. She had mentioned something to him last night before they went to bed.

'Yes, today,' Sophia answered, almost calmly.

'And I want us to go down to the Holy Cave.'

He looked at her in amazement.

'Why there, especially?' Michael asked.

'I thought I'd talk to you there. In the courtyard with the olive trees and His help right next to me. What I'm going to tell you is not easy! I wish… I didn't have to say anything to you. I find it painful…'

From that point onward, Sophia entered a circle of memories that reached all the way up to her eyes, forcing them to reveal what they saw in her mind.

She stood up abruptly.

'I'm going to get ready. The sooner, the better,' Sophia said, and went into the house in a rush.

Michael followed her silently, conscious of the weight she was carrying.

Their taxi was waiting for them at the usual place. Michael told the driver where they wanted to go and also asked for his phone number. They would let him know as soon as they decided to return.

Sophia was behaving as if in a different world.

Michael stared at the shadow that hung in her green eyes. He said nothing, but tightened inside.

'What is it that torments her so?' he wondered.

A beautiful day was unfolding before them, but they could not see it, at least not for now.

They arrived at the intersection. The driver turned right and drove down the narrow road. He entered the parking lot.

It was almost empty. Two cars on one side were getting ready to go. Michael and Sophia got out. The taxi driver turned around and departed.

Sophia looked around and then said to Michael:

'Come on. Let's go up there to the little kiosk facing Scala.'

'You have planned everything in your little head!' Michael said, trying to lighten the heavy mood.

No one was in the courtyard. Only the noise of nature's mumbling was heard, as it dressed the air with musical notes.

They sat on the wooden bench. The port of Skala was full of life at this time of day. The ferry had just moored up.

Sophia fought to keep her body still as best she could. The psychological pressure was transported into it, with strikes of numbness that made her feel uncomfortable.

She took a deep breath and said, looking into his eyes:

'I want you to listen to me carefully first, and then you can ask me whatever you want.'

'I don't know if I did the right thing, but when I considered my options, it felt salutary. And of course, with the bad psychology that had taken over me at the time, I could not see another solution.'

Michael sat quietly beside her and tried to understand.

'Do you remember the last ordeal I had with my health? Or rather a part of it? The one you also went through beside me, and I thank you once again for your sympathy.' She took another breath and continued.

'The second part of that ordeal, Michael, the most painful part for me, I hid from you! I did not want to hide it from you, but with the way things had evolved with your visa situation, I had no choice. Remember when you returned to Greece and were expecting a phone call from me, waiting to hear the results of the biopsy?'

Michael nodded his head understandingly, and a dark wave made him lower his eyebrows, giving all his attention to her words.

'I didn't tell you the truth about the biopsy results. They were not negative, Michael, they were positive! They couldn't have been more positive!' An excruciating sigh came from her lips and her eyes filled with tears as she relived those difficult times. She wiped her eyes discreetly. She did not want to charge the situation more, as it was already heavy in itself.

Michael did not react. He only listened and lowered his head, looking at the stone floor that resembled his soul.

'I tortured myself so much deciding whether or not I should tell you. You couldn't come. I was thinking about how upset you'd get. I feared you'd make some desperate move and I couldn't stand it, baby. I chose to go through it on my own because, anyway, there was no way I could avoid it.'

'The hardest thing for me was forcing my lips to tell you things other than what they wanted to say to you.'

'A few days after you left, I was re-hospitalised for complete removal! My surgery was done by Professor Davis himself.'

'I went through some tough times my darling... I was hurting both mentally... and physically...' Sophia's voice was now drowning in the tears running uncontrollably from her eyes.

Michael embraced her tenderly, allowing to defuse whatever she had kept inside all this time. His eyes filled with tears seeing her shake from crying. He was hurting with her. With a slow voice, he whispered while holding her gently,

'You went through all this on your own baby... My baby!'

The pain was tearing their souls apart.

'And I was away... I had no clue...'

He could not comprehend this in his mind.

Sophia pulled herself back together. She had to continue. She wiped her eyes with a handkerchief she took from her bag, and continued.

'After the surgery, I had to go to a plastic surgeon for prosthetics. I have the impression you figured that out right away, despite the fact that you said nothing. I also had to undergo a series of chemotherapy treatments. I was watching my hair fall out and I was living in a crazy situation, in two opposing worlds. It took a lot of sweat for me to manage to balance and learn to live with this.'

'I was talking to myself all the time. I was quarrelling with her, I would swear at her... a doctor who spent so many years fighting cancer was now backing off like a coward! I had reached my limits. The only person who could support me in

those internal wonderings was my professor. I hope he is well! Slowly but surely, I started finding me again.'

'Of course, my family there didn't leave my side for a single moment during the days I was hospitalised. Aris commuted each day and supported me in his own way. He told me jokes so I could laugh and forget my pain... my darling Aris...'

A couple appeared behind them. They went past, greeting Michael and Sophia, and made their way into the chapel.

Michael looked as if he had swallowed his tongue.

He could not utter a word. He just listened, dumbfounded.

Sophia continued, asking him:

'Michael, did you understand what I just told you? I took it all out! Do you understand what that means?'

He was looking at her, yet he could not digest how she could have withstood all this alone. Deep inside him, he ached, but he also admired her.

'This could only have happened to Sophia!' he thought.

She asked him again, firmly.

'You know what that means Michael? I never will be able to be a mother! I will never be able to conceive a child, our own child!'

'And this specific issue concerns you. I want you to think long and hard. Take all the time you need to digest it. Besides, I will always have before me this beast, which might wake up at any moment. I have come to terms with its existence. I have learned to live with the idea that it could possibly re-occur.'

'But you, my baby,' she embraced him tenderly, 'I don't want to hurt you anymore. Please think about it very carefully! Take as much time as you need, but please measure yourself well; measure what you can really bear.'

'That's all I had to tell you, my sweetheart, and I want you to know that only you know. I haven't mentioned anything to my father and I don't intend to. After my mother's death, he is very sensitive to this issue. If I tell him, it will take over his mind and it will ultimately devour him.'

Michael turned his head and looked at her. He held her hands within his own and told her tenderly:

'Even though I need time to realise everything you've been through, I have to say a big thank you.'

'For me, it was the greatest proof of love that you gave me, generously sacrificing yourself to protect me.'

'This, baby, cannot be deleted by anything in the world.'

His eyes looked at her with so much love, so much adoration. Her heart leaped.

'Whatever happens from now on, we will face together; we will fight it together. Through all this time we spent apart, I realised that my life has substance and meaning only with you; through thick and thin.'

'An "I love you" is so little to express my feelings. You are my life, with all the meaning that a person can give to that word!'

Sophia felt happy; free.

'What about the child... issue?' Sophia whispered, out of breath.

'Do you know how many kids in foster homes are waiting for parents? Many, Sophia darling. Too many!' Michael replied, and took her in his arms. Sophia became lost in herself, flooded with joy.

She now felt invulnerable. She could face even the most difficult problems, with a soul full of strength, courage, faith and love...

Lots of love...

THE END